MW01129531

RAPPER'S DELUXE

RAPPER'S DELUXE

HOW HIP HOP
MADE THE WORLD

TODD BOYD

CONTENTS

THINKIN' OF A MASTER PLAN

WORDPLAY

PUT SOME RESPECT ON IT

Run on the track like Jesse Owens / Broke the record flowin' / Without any knowin' / That my wordplay run the 400 meter relay / It's on once I grab the baton from the DJ.
GZA, Wu-Tang Clan, "Protect Ya Neck (The Jump Off)," 2000

Muhammad Ali, the GOAT (Greatest of All Time), once made a particularly compelling statement while appearing as a guest on an episode of the *Mike Douglas Show* in 1974, alongside Sly Stone of Sly and the Family Stone, Wayne L. Hays (a member of the U.S. House of Representatives), and performer and activist Theodore Bikel. At some point during a heated conversation with Hays about racism, politics, and American society—while Sly Stone was playing the comic foil—Ali drops an explosive truth bomb: "Words are more powerful than fists." Considering this came from the world's most famous pugilist, whose exploits in the sweet science of boxing required him to "put hands" on his opponents, the statement carries even more weight. Of course, Ali had discovered firsthand how his words resonated when he announced that he was a member of the Nation of Islam, changed his name from Cassius Clay, and subsequently refused to serve in the Vietnam War. He understood that words had the capacity to be far more influential, or more devastating, than the physicality inherent to his sport.

When one considers the central role that language has played in rap music and hip hop culture, the idea that words are more powerful than fists aptly describes the profound impact that the movement has had in the United States and worldwide. Since the time when DJ Kool Herc first developed his merry-go-round turntable technique, hip hop's astronomic rise to global dominance demonstrates in no uncertain terms how powerful words can be.

In the interest of clarity, it's necessary to point out that the terms "rap music" and "hip hop" will be used throughout the book, and while often considered interchangeable, they actually have distinct meanings: rap is a music genre, while hip hop is the larger culture that encompasses the genre. To put it another way, "Rap is what you do, hip hop is what you are." With this in mind, *Rapper's Deluxe*, is, as the title implies, a book about rap music, but more so it is about the culture that surrounds it. Using the music as its framework, *Rapper's Deluxe* explains how rap laid the foundation for the cultural movement known as hip hop.

It is generally understood that "Rapper's Delight," the Sugarhill Gang's 1979 single, is the song that introduced the public to rap music. Not long after its release, acts such as Kurtis Blow and the all-female trio the Sequence, featuring future R&B star Angie Stone, would put out records as well, followed a few years later by underground artists Afrika Bambaataa and the Soulsonic Force as well as Grandmaster Flash and the Furious Five. Aside from these early pioneers, and perhaps a few others, trying to enjoy rap music in the early 1980s was not as easy as one might imagine, especially for those who lived outside of New York and relied on the radio. In other words, there was a greater desire for more rap music than existed at the time to fully satisfy such demands.

The early 1980s was also a time when rap was not always taken seriously. Rapping was perceived to be a stylistic fad, a passing trend. There were some who criticized the music as lacking the traditional sound qualities that audiences had become accustomed to: Rappers were not singers and did not possess the vocal chops of, say, Minnie Riperton or Marvin Gaye; and the music was not performed live in the studio by actual musicians, such as James Brown's drummer Clyde Stubblefield or celebrated Motown bass player James Jamerson. Rapping was rarely considered a skill, and sampling music that other people had already recorded was thought to be especially unoriginal, with many seeing this as a form of theft. Perhaps one of the most insulting misconceptions about rapping was that it was nothing more than slick talk and nursery-school rhymes, a comical act that anyone could conceivably do. But as Big Daddy Kane says in "Smooth Operator" (1989), "I'm not animated like a cartoon / I'm for real / Shootin' lyrics like a harpoon."

Songs from the early 1980s like "Rappin' Rodney"—Rodney being the middle-aged white comedian Rodney Dangerfield—exemplify this less-than-serious consideration for the music. A frequent guest on late-night talk shows in the 1960s and 1970s, Dangerfield was a headliner on the Las Vegas scene, where he was known primarily for his recurrent, self-deprecating comedy bit "I don't get no respect." "Rappin' Rodney" was a corny rap song and video that played on the "no respect" riff that he was famous for. One may have found the whole spectacle funny, momentarily, if weed were involved, but otherwise both the song and video were beyond horrible.

Another example of this tomfoolery was the song "Rappin' Duke" (1985) by Shawn Brown. Many only know the reference from Biggie Smalls's "Juicy" (1994), but unfortunately it was a real thing. It is performed in a voice that attempts to imitate that of John "the Duke" Wayne, the quintessential image of white masculinity whose tough-guy cowboy persona was popularized in previous decades. The absurdity of the song is fully exposed when one considers Wayne's history of reactionary right-wing

politics, demonstrated in a May 1971 interview in *Playboy* magazine: "We can't all of a sudden get down on our knees and turn everything over to the leadership of the blacks. I believe in white supremacy until the blacks are educated to the point of responsibility." He adds later in the interview, among other incendiary comments: "I don't feel guilty about the fact that five or ten generations ago these people were slaves." Wayne's reprehensible comments help explain why Public Enemy would later rap on "Fight the Power" (1989), "Elvis was a hero to most / But he never meant shit to me / You see / Straight out racist / That sucka was simple and plain / Muthafuck him and John Wayne!" Songs like "Rappin' Rodney" and "Rappin' Duke" demonstrate the worst impulses of opportunistic commercialism and an overall lack of appreciation for what rap music truly had to offer. The game needed to be elevated in order to convince people that rap was an art form, as opposed to a cyclical novelty open for anyone to exploit.

It was the great Rakim, the God MC, who stepped up, speaking for himself and for the culture, when he declared, "I ain't no joke" ("I Ain't No Joke" 1987). Performing as part of the duo Eric B. & Rakim, he took on the challenge of advancing rap's lyrical content, with new intricate rhyme schemes, a distinct delivery style, and an ever-evolving flow to his work. MCs had originally been known for their ability to move the crowd, but over time they began focusing more on the content of their lyrics, as well as on how best to express those lyrics. Rakim was a former saxophone player who was highly influenced by John Coltrane and attempted to incorporate the jazz virtuoso's distinct style of playing into his own process of writing and rhyming.

There is a story from the jazz world about a conversation Coltrane once had with fellow saxophone player Wayne Shorter, during which Trane described the act of improvising as if he were starting in the middle of a sentence with the ability to move back and forth in the sentence at the same time. Jazz is replete with koans like this, wisdom dropped by legends like Coltrane that if fully understood can lead to musical enlightenment. Creatively speaking, Rakim adopted his own version of this approach for hip hop. His idea of applying rigorous jazz methods to rap music is a brilliant one—and the execution of such an effort is indeed next level.

I start to think / And then I sink / Into the paper / Like I was ink / When I'm writing I'm trapped in between the lines / I escape / When I finish the rhyme.
<div align="right">Rakim, Eric B. & Rakim, "I Know You Got Soul," 1987</div>

Rakim effectively modernized rap, raising the bar by adding highly skilled lyrical artistry to the writing process, thus making it much more difficult for corny opportunists to use the music as a way to make a quick buck. Rakim's artistic incursion and other stylistic developments occurring across the genre, such as Dr. Dre's monumental advances in music production, put hip hop in position to be taken seriously as an art form. In other words, rap was no longer considered something that anyone could do. In order to participate one needed the "skills to pay the bills"; otherwise, not only would you embarrass yourself, but if your rhymes were wack, you may well get your ass kicked for wasting people's time. Though the impact of Rakim's innovations were apparent in real time, it would take many years for his

lyrical legacy to fully manifest itself, becoming the standard by which future MCs—their rhymes and delivery—would be judged.

FOR THE CULTURE

As the music's influence and popularity spread during the 1980s, other aspects of the culture began to speak the same language. The emergence of a new generation of Black filmmakers, whose experiences and creative visions often reflected the stories being told within hip hop, set the stage for a strong and ongoing collaboration between the two industries. Within sports, athletes such as boxer Mike Tyson and multi-sport star Deion Sanders showcased personas and appealed to audiences in ways that directly resonated with hip hop artists and their followers. The athletic dominance and sartorial flair of superstar Olympic sprinter Florence Griffith Joyner, aka Flo-Jo, inspired Fat Joe to say that he "came out the gate on some Flo-Jo shit" (Terror Squad, "Lean Back," 2004), while Charles Barkley's style of play was used as a metaphor in Public Enemy's song "Rebel Without a Pause" (1988): "Simple and plain / Give me the lane / I'll throw it down your throat like Barkley." Both serve as examples of the long-running, cross-cultural exchange between sports and hip hop. Coincidentally, the artist Jean-Michel Basquiat, heavily influenced by music in his work, was supposed to attend a Run-D.M.C. concert the night he passed away. Hip hop and fashion, meanwhile, would become inseparable allies in the move toward mainstream visibility.

These early connections with film, sports, art, and fashion indicate the extent to which hip hop would not be defined by music alone. Rather, it was developing into a distinct cultural platform championing multiple modes of expression but with music at its root. The historical arc of *Rapper's Deluxe* documents the manifestation of this culture, from the root to the fruit.

I have always thought of and experienced hip hop as a cultural movement. The music is like a soundtrack that amplifies the elements of a scene, creating a mood, setting a tone, and defining a vibe. One does not experience the music in isolation, however. Instead, it works as a framework for illuminating the bigger picture. Hip hop, in this case, becomes a lifestyle, or perhaps a design for living.

The 1970s were my formative years, and when I think of my earliest memories, when the world was just starting to come into focus, they are flooded with images from the culture. I can remember the James Brown T-shirt that my aunt gave me, which stated, "Say It Loud, I'm Black and I'm Proud," as she took me to get my shoes shined for the first time. While most kids I knew were still caught up listening to the Jackson 5, the first album I owned was Ramsey Lewis's *Sun Goddess* (1974), purchased from LaGreen's Records and Tapes in downtown Detroit. Even at a young age I realized that I could spend hours in a record store. The music was always bumpin', creating a festive vibe as people went about their business. Captivated by all the

album covers, I often wondered how the music contained on the record would match the image on the sleeve. Barry White and the Ohio Players at Olympia Stadium would be my first live concert experience.

My father loved watching movies, or, as he would call it, "goin' to the show." The 1970s was the era of both New Hollywood and Blaxploitation, and he watched everything, so that meant I was exposed to a broad range of films, regardless of the ratings. This would include Francis Ford Coppola's *The Godfather* (1972) and *The Godfather Part II* (1974), of course, but also others such as Bernardo Bertolucci's *Last Tango in Paris* (1972) and Peter Bogdanovich's *Paper Moon* (1973), in addition to Blaxploitation classics like Gordon Parks Jr.'s *Super Fly* (1972) and Michael Campus's *The Mack* (1973).

There were multiple theaters in downtown Detroit at the time, including the Adams, the Grand Circus Park, the Fox, the State, and the Plaza. These theaters primarily showed Blaxploitation and kung fu titles, such as those featuring Bruce Lee, and depending on the film, the audience's audible reaction could be just as entertaining, sometimes even more so, than whatever was playing on screen. Smelling the theater's butter popcorn and vibing to the incredible film soundtracks meant that "goin' to the show" was an all-around sensory experience for me; it encapsulated not only watching the film and its associated trailers but also soaking in the various film posters, lobby cards, and other promotional images that advertised the upcoming attractions.

"The Fight of the Century," the first of three Muhammad Ali–Joe Frazier bouts, which took place in March 1971 at New York's Madison Square Garden, was promoted endlessly on television and discussed repeatedly among the adults around me. On fight night these same adults donned their Sunday best and went to watch it live on closed-circuit television playing at a local movie theater. Later, in 1974, my mother and my stepfather moved the one television in the house from their bedroom to the living room so that everyone could watch the baseball game in which Hank Aaron of the Atlanta Braves broke the New York Yankees legend Babe Ruth's cherished home-run record. This historic sporting event was bound up with all sorts of racial implications as Aaron, the Black hero, came to displace Ruth, an icon of the game whose legendary status was cemented in those early days before 1947, when Black players were still barred from Major League Baseball. The year 1974 was also when I was first introduced to the National Basketball Association (NBA). In my young mind, the experience of watching Kareem Abdul-Jabbar hoop for the Milwaukee Bucks against my home team, the Detroit Pistons, in downtown Detroit's Cobo Arena, was akin to witnessing a deity.

Walking the streets meant seeing members of the Fruit of Islam, the Nation of Islam's security detail, selling newspapers or their famous bean pies while attired in black suits, white shirts, and black bow ties. Black nationalists, Black Panthers, and those representing Afrocentric personas, along with numerous pimps, players, and hustlers, or at least those who dressed as such, dotted the urban landscape as well. The fashion visible on the streets, the 1970s version of streetwear, began to draw my attention and included the official military-issued jackets still worn by a large number of returning Vietnam soldiers. These early

experiences of fashion and style would be the catalyst for my overall sartorial evolution. While many of my friends were reading comic books and what I considered silly shit, like *Mad* magazine, I was waiting for my monthly *GQ* to arrive in the mail.

Street style would not be complete without sneakers though. Long before the term "sneakerhead" was coined, I found myself becoming especially fond of what were then referred to as tennis shoes. Converse Chuck Taylor's were the most popular model by far, but my desire to be independent from the masses, even at a young age, meant that I wanted shoes not worn by everyone else. As an avid fan of NBA and college basketball, I had been introduced to a variety of sneaker styles, and using the money that I had earned delivering the *Detroit Free Press*, I made my way to Griswold Sporting Goods to cop a pair of blue suede PRO-Keds like the ones worn by Jo Jo White of the Boston Celtics. I am not sure if the shoes were officially called Jo Jo White's, in fact, I highly doubt it, but that's what I called them. I later went back to Griswold's and purchased a pair of the Walt Frazier suede Clyde Pumas, in the blue and yellow colorway. I have always loved suede, be it suede sneakers, suede Chelsea boots, or suede jackets. I have even owned a few suede shirts in my life. The butter-soft, plush texture of the material has always felt luxurious to me. What I also remember from my trips to Griswold's in the mid-1970s was the salesperson trying to persuade me to buy a pair of sneakers from a fairly new company with an unfamiliar name based in Oregon. He told me a story about the creator using a waffle iron to design the shoe. I did not dig the vibe of these shoes, so I passed on the Nike Waffle trainers. A few years later, though, after seeing John Drew of the NBA's Atlanta Hawks wearing Nike Blazers on Ted Turner's fledgling "Superstation" cable network, my mother bought me a pair for my birthday.

In addition to my father's appetite for culture, he was also a voracious consumer of current affairs, so all this compelling cultural content I was absorbing in the 1970s coexisted alongside some equally compelling news content. Since there was only one television in the house, I had to watch what he watched. This often meant sitting down to the *Robert MacNeil Report* on PBS, in addition to the nightly newscasts from one of the three major networks. On Sundays my father read the *New York Times* and the *Detroit Free Press* while watching the morning political news shows. The story that really captivated his attention at this time was the Watergate scandal. He watched the Watergate hearings religiously and often a recap of the day's activities at night. These alternating images from the worlds of culture and politics, digested through television or in newspapers and magazines, would thereafter become connected in my mind. Whether it was the multiple assassination attempts on Gerald Ford, the kidnapping of Patty Hearst, or the Jonestown massacre in Guyana, news events merged with cultural events to become part of the same experience for me. Thus, cultural politics very much informed my understanding of how the world worked.

Perhaps unsurprisingly, these cultural connections were not only informing me but also the development of hip hop. So when hip hop emerged publicly, it was easy for me to relate because the primary cultural influences were so familiar. My coming of age would coincide with hip hop's coming of age. The seeds planted in youth often bear fruit over the rest of our lives; the 1970s serve

as the foundation upon which both my own cultural identity and the broader cultural identity of hip hop would be built.

DIGGIN' IN CRATES

One of the aspects of hip hop that was so unique at its inception was the fact that the music over which rappers spit their lyrics, as mentioned previously, was not performed live by musicians. Instead, the backing track relied on extracts from preexisting records or other audio sources, otherwise known as samples, which were then refashioned into a new sound. Sometimes the sample might be from a well-known track such as Chic's "Good Times" (1979) or the Isley Brothers' "Between the Sheets" (1983); other times the music could use, say, the drum pattern from a James Brown record or an Ahmad Jamal piano riff. Sampling was a creative practice that allowed the reuse of old music in the service of making new music. Beats, melodies, and vocals were all up for grabs. Eventually, with advances in technology, sampling could include multiple sounds from multiple sources: records, television commercials, movie dialogue, or sound effects, for example. Though some considered this practice unoriginal, in time it became clear that sampling was a genuinely sophisticated art form. In the interest of originality, one wanted to avoid using the same samples as others. DJs and producers immersed themselves in the research of it all, visiting second-hand record stores on the hunt for obscure finds that could potentially serve as a unique sample. This practice came to be known as crate diggin', referencing the plastic crates that held the records.

Another artistic sound practice made popular by hip hop is the remix. In this case a song is altered with the addition or subtraction of different elements but otherwise remains unchanged. The key is retaining enough of the original to remain recognizable while ultimately creating something new. A good example of the remix is Craig Mack's "Flava in Ya Ear" (1994). The original, released the same year, was the breakout single for Mack on Sean "Puff Daddy" Combs's new Bad Boy Entertainment label. The remix retained Mack's chorus, and added a new verse by him, as well as verses by Puff, Notorious B.I.G., LL Cool J, Busta Rhymes, and Rampage. Though the original was very popular, the remix tends to be cited just as much, if not more, with special praise reserved for Biggie's astute wordplay and miraculous flow. Like sampling, the remix creates something new out of something preexisting. Both practices offer a fresh take on the original, and a great deal of artistic freedom and creative expression in the process.

My creative approach to *Rapper's Deluxe* has been inspired by similar artistic impulses, which I liken to Dr. Dre producing an album or, perhaps, filmmaker Quentin Tarantino remixing history in *Django Unchained* (2012). Sampling and remixing serve as both inspiration and metaphor: the book samples from various cultural sources and remixes these into a new understanding of the culture, history, and politics that have defined American

society over the last half century. The samples may include music, fashion, art, film, sports, or other cultural stimuli, which are then contextualized through the history, politics, and social dimensions of their respective eras. Framed around hip hop's ascendant social mobility over the last fifty years, *Rapper's Deluxe* looks to remix the notion of the American dream from a hip hop perspective, ultimately explaining through these samples how, in the process of becoming one of the most dominant influences imaginable, this once marginal culture "made the world."

THE HIP HOP DREAM

Rap became a version of Malcolm and Martin.
Nas, "The Last Real Nigga Alive," 2002

One of the most consistent themes throughout hip hop history involves the metaphor of dreams, perhaps epitomized by Notorious B.I.G. (aka Biggie Smalls), who opens "Juicy," his 1994 anthem on social mobility, with the famous line, "It was all a dream." In 1996 Nas flipped the Eurythmics song "Sweet Dreams (Are Made of This)" (1983) into a track of the same name. In "Dreams" (2005), the Game states, "The dream of Huey Newton / That's what I'm livin' through / The dream of Eric Wright / That's what I'm givin' you," linking Newton, the leader of the Black Panther Party to the late N.W.A. icon Eazy-E. In "Mafia Music" (2009), rapper Rick Ross says, "Martin had a dream / Bob got high / I still do both / But somehow I got by," connecting Martin Luther King Jr.'s famous speech to Bob Marley's penchant for smoking cannabis; Kendrick Lamar echoes this same King speech when he repeatedly shouts, "Martin had a dream / Kendrick have a dream," in "Backseat Freestyle" (2012). Meek Mill's "Dreams and Nightmares (Intro)," the title track from his 2012 album, opens with "I used to pray for times like this / To rhyme like this / So I had to grind like that / To shine like this."

The concept of realizing one's dreams has a particular resonance in American history, with the American dream serving as something akin to a marketing slogan for American exceptionalism in a country that has often been described as a "nation of immigrants." However, Native Americans and Black Americans, who are descendants of slaves, did not immigrate to the United States and thus do not fit so neatly into the nation of immigrants categorization. Slaves and immigrants have had two very different experiences in the United States. The American dream has historically been an aspiration applied to immigrants, so the descendants of slaves would need to come up with their own version. King described his notion of the dream in his celebrated 1963 speech. To those generations of Black Americans coming of age after King's speech, hip hop would offer a range of potential ruminations, some of which are cited here, on what the dream means to them.

To phrase it another way, there is the American dream and then there is the hip hop dream. The two are not so much in competition as they are complementary. The hip hop dream

stepped in to fill the void created when the American dream was still inaccessible. As hip hop's dream grew and evolved, ultimately and against all odds reaching a point of cultural dominance, it amassed enough clout to be able to remix the American dream in such a way that it created a new version for those who were once denied it.

GET YOUR MIND RIGHT

During my early college years, the Last Poets' notion of "party and bullshit," lyrics from their 1970 track "When the Revolution Comes," quite accurately described my life. At the University of Florida in the early 1980s, Black social life revolved around weekly fraternity and sorority parties, or jams, as they were often called. Since the Black fraternities and sororities did not have their own houses like white Greek-letter organizations, these parties were usually thrown in some rented campus space. My friends and I often hung out at these Black frat parties, but some of my friends had issues with them, or, more to the point, they had issues with some of the people throwing them. Inevitably, on the walk back to the dorm afterward, we would toss around the idea of having our own party, and eventually we made it a reality. Following the example set by DJ Kool Herc a decade earlier, the idea was to rent the rec room in our old-ass dormitory and put on the coolest party ever. We decided to call ourselves M Team, after Murphree Hall, the name of the dorm we lived in.

My role in all of this was to be the MC for the evening. I can't remember if I volunteered for this or if someone suggested it, but everyone was in agreement that I was the most qualified to rock the mic. This was the era when MCs were expected to move the crowd. My ability to talk shit had long been evident; my skills with the spoken word defined my identity. "T. Boyd / The MC / In the place to be" was a no-brainer. Hyping up the crowd, putting a vibe on the evening, being the "microphone controller" —it was a natural fit. Eventually, I came to be known as Real, as in "Real / On the wheels of steel." We threw several parties during this time, our reputation expanding with each event. They never got as big as the fraternity/sorority ones, but they were a nice alternative for people who had grown bored of the status quo. Over time, and following certain professional accomplishments, my Real moniker was replaced with the Notorious Ph.D. In other words, I have been "on the mic" in one form or another, for much of my life.

Another of my formative college experiences took place one night with another group of friends as we were getting ready to go out. Someone had hooked up the VCR and put on a videotape of Brian De Palma's *Scarface* (1983). I was familiar with the fact that Al Capone had once been called Scarface, but as I had missed the film's run in the cinema, I didn't know much about it. I sat transfixed for the next three hours. And though I did not know it at the time, *Scarface* would change the course of my life.

Al Pacino's Tony Montana, as his portrayal of Michael Corleone had done in *The Godfather* films, especially *The Godfather Part II*, gave me a character whose plight I could identify with. A Cuban-born immigrant, Montana was the ultimate outsider, whose lack of access inspired him to do whatever it took to change the circumstances of his life. He did this on his own terms and he did it with style. An over-the-top style, perhaps, but style nonetheless. Montana laid out a blueprint for success in the United States for those who did not fit neatly into the nation's social hierarchy. Then, after defying the odds, achieving his goals, and reaching the top, he fucked it all up. Montana violated one of the key rules of the game: he got high on his own supply, literally and figuratively. He got caught up in his own ego. To quote Rick James, "Cocaine is a helluva drug."

I had no idea of the impact that this film was having on other people until I started hearing rappers rhyme about it in their lyrics. For me, *Scarface* was always a cautionary tale. When Montana begins his path of self-destruction this makes the film especially real. I had seen and heard many stories of people who got caught up in the streets, never to recover. This was Montana's fate, but it was not going to be mine. I was determined to succeed where Montana had failed. Over time I came to connect more with the character of Alejandro Sosa, the Bolivian cartel boss. His measured "business, never personal" approach mirrored that of Corleone. Whereas Montana was colorful and larger than life, Sosa was cool. He was not some impulsive, easily triggered hothead acting out his emotions; instead, he was thoughtful and deliberate, yet he was not to be played with, as Montana eventually finds out.

Honestly, I cannot you tell how many times I have watched *Scarface*. I lost count a long time ago. There were weeks at a time when I watched certain sections of the film on a daily basis. Back then, I was looking for something, anything, that might push me in the right direction. *Scarface* gave me the game plan; it was now my job to execute it.

Later, when I was taking a media-studies course, the professor explained that we would be analyzing movies and television shows including *The Godfather*, *Scarface*, and *Miami Vice*. What? You mean, there are classes on this? Professors get paid to deal with this material in their classes? People write books about this shit? Really? Who knew?! It's safe to say, I was hooked.

While my cultural journey was well and truly underway by this point, my intellectual one only really began after I read Alex Haley's *The Autobiography of Malcolm X* (1965). It was my father's suggestion to read it, annoyed that I always defaulted to some clichéd response about Martin Luther King Jr. whenever the topic of racial politics came up. I wasn't much of a reader at the time, but that would change after Haley's book. Malcolm X's life helped me to "get my mind right"; it was a transformative experience. After that I read everything I could get my hands on: James Baldwin, Toni Morrison, Eldridge Cleaver, Iceberg Slim, Angela Davis, and Frantz Fanon, among many others. My eyes had been opened. Thereafter I would be in pursuit of knowledge.

A few years later, when I was in graduate school, my father gave me the album of Malcom X's speech, "Message to the Grassroots," delivered in Detroit in 1963, an event he had

attended in person. I had the speech on cassette tape and listened to it almost daily, in much the obsessive manner that I had watched *Scarface* a few years earlier. Malcom X was quite conversational in tone, insightful yet funny at the same time. He could talk like a cat on the street or drop historical analysis as though he were a professor. Malcolm X's ideas, his speaking skills, and the example that he set through his own life informed the basis of my own intellectual and professional development. Mix this with the myriad cultural influences that I had been consuming since childhood and you can start to understand how my own academic and creative framework came together.

THE CADILLAC EFFECT

One of the main themes covered in *Rapper's Deluxe* is the evolving relationship between hip hop and what might be termed luxury culture, which includes everything from expensive cars to high fashion and contemporary art. While some may regard such examples of consumption as misguided materialism, those who take that position clearly do not understand the important social history that informs them. Take Cadillac, for instance. These days, luxury American car brands such as Cadillac do not have the cultural clout that they once did. But in the 1970s, when hip hop first started, prior to the emergence of German, British, and Italian luxury markets, Cadillac was considered the gold standard. A trip even further back, to the 1930s, helps to explain the racial politics of luxury that has informed hip hop throughout its existence.

Prior to the early 1930s, General Motors (GM), Cadillac's parent company, discouraged its dealerships from selling to Black customers. Similar to racist and discriminatory real-estate practices, which deemed that the presence of Black families in traditionally white neighborhoods would lower property values, Cadillac engaged in a practice that judged Blackness as incompatible with the notion of prestige that it had cultivated. Nicholas Dreystadt, head of the brand's service division at the time, is credited with influencing a change in this policy after seeing Black owners bringing their cars in for service, despite being denied the opportunity to purchase them. Clearly, Black people were buying the cars, but how? It turns out that the customers were using white middlemen. GM came to realize that determined buyers, willing to pay an additional fee to purchase the car, represented money that they were leaving on the table. They eventually reversed their policy, opening up sales to Black customers. Though this unofficial discriminatory practice was now officially over, I would imagine that the buyer's experience likely varied based on the individual dealership that they happened to be patronizing. I still remember my father telling me that some dealers required an under-the-table payment in addition to the sticker price if you were a Black customer trying to buy a Cadillac. Though Cadillacs no longer register as the most prestigious luxury vehicle, the brand's past relationship to the Black consumer and its embrace by older generations of Black buyers had profound implications within hip hop culture many years later.

The idea of prestige as it relates to cars is, of course, a construction dependent on marketing. Cars at their most basic level serve the purpose of transportation, yet as prices vary wildly, ad campaigns can help convince people who are willing to spend more that they are buying something beyond basic transportation. Cadillac sold this concept as a means of justifying the more expensive price point. Other people may have been buying a car, but the select few were buying a *Cadillac*. This was an appeal to class politics at its finest. However, this elite buying experience was not available to Black people. Prestige was not for sale, even if one could afford it.

What is the notion of prestige if not another form of respect? And respect has always been an elusive commodity relative to race in the United States. Being able to buy respect is a shortcut to earning it, yet, if they will not accept your money, if indeed there is something that your money cannot buy in capitalist America, then this denial of respect is especially magnified. So those who had the means were determined to buy the prestige (read: respect) that Cadillac was selling, even willing to go above and beyond to make this happen. Let's call this the *Cadillac Effect*. When something is denied to someone, it often intensifies their desire to have it. When that something is respect, liberty, and human dignity, then the attempts at attaining it become political. It is perhaps difficult for some to imagine that buying a luxury car is a political act. However, when one considers the history of American racism, and the denial of basic respect at the center of it, then the Cadillac Effect offers an interesting bit of social commentary.

Throughout the history of hip hop, rappers have been accused of flaunting their money, cars, clothes, watches, and jewelry, among other things. To flex like this has often been considered bad taste by those whose views are based on elitist WASP notions of appropriate decorum. Yet viewed another way that does not privilege this elite point of view but instead interrogates it, what these rappers are really saying is, "This was once denied me, but now that I have the means, I am not only going to buy it, but I will also openly celebrate my purchase." This is as much an act of defiance as it is of consumption, and this sentiment, the acquisition of luxury as an act of racial defiance, is one that sits at the root of hip hop culture. As the culture grew more lucrative, the possibilities of what it could purchase expanded exponentially. These days, owning a Basquiat painting is a much bigger flex than owning a Rolls Royce. The ultimate flex, however, was the point at which the culture became so prestigious, so respected, that others, including those people and companies who once shunned it, began lining up to connect with hip hop so as to elevate their own prestige.

CLASSICAL HIP HOP

Fuck this rap shit, I listen to classical.
 Baatin, Slum Village, "Fall in Love," 2000

Hip hop has come a long way since the 1970s, a time when perhaps no one could have foreseen a collaboration between hip hop and classical music, or more specifically the National Symphony Orchestra, PBS, and the John F. Kennedy Center for Performing Arts in Washington, D.C. In spite of this lack of imagination, however, this is exactly how far hip hop has come. These seemingly disparate elements would all become intricately linked when the celebrated Queens-born rapper Nas performed his classic album *Illmatic* (1994) at a concert backed by the National Symphony Orchestra at the Kennedy Center in 2014. The performance was broadcast on PBS as an episode of *Great Performances* in 2018 as "Nas Live From the Kennedy Center: Classical Hip Hop." By 2014 hip hop had reached a place within American culture far beyond its humble roots, earning itself respect from various institutions that might have once snubbed such an alliance. Yet hip hop did not openly seek their approval; conversely, these cherished American entities came in search of it from hip hop.

On the surface of things, hip hop and classical music would appear to be polar-opposite genres. Informed by social perceptions about what is considered high or low culture, one might think that classical music, with its European origins, and hip hop, which emerged from the hoods of the United States, imply different sensibilities, suggest difference musical approaches, represent radically different styles, and appeal to very different audiences. The obvious race and class connotations relative to each genre further complicate the picture. Yet Nas's powerful collaboration with the National Symphony Orchestra represented a triumph of cultural exchange. Classic lines like, "Life's a bitch and then you die / That's why we get high / Cause you never know when you're gonna go," which Nas performed in a tuxedo, as opposed to the "suede Timbs on my feet" that he name checks on "The World Is Yours," were particular highlights. Nonetheless, the incongruity was not lost on Nas, as he stated during the rehearsal: "It's crazy, you know, I wrote this in the projects in New York City. Here we are in the capital of America, Washington, D.C., and you know, a bunch of white people with strings and all that, playing this album, and they feelin' it."

The whole event speaks to the evolution of hip hop. Dated perceptions on the value and relevance of the music may still linger for some, but not for those paying attention. In many ways hip hop's transformation from rejected to respected is the story of race, American history, and popular culture. From the 1970s on—the first decade following the passing of the landmark Civil Rights and Voting Rights Acts of the 1960s, which effectively freed Black people, one hundred years after the end of the Civil War—rap music has helped to shape the United States socially, culturally, and politically, and, by extension, has also assisted in shaping the larger world. Nas's partnership with the National Symphony Orchestra is but one example of what I call "hip hop in high places," an idea that speaks to the culture's move into areas of society previously considered off-limits.

DAMN

When Nas described himself as the "most critically acclaimed Pulitzer Prize winner / Best storyteller / Thug narrator / My style's greater" on his song "Hate Me Now" (1999), he was foretelling something monumental on the horizon. The Pulitzer Prize for Music is considered one of the nation's most distinguished honors. First awarded in 1943, it recognizes "a distinguished musical composition by an American that has had its first performance in the United States during the year."

During the prize's first eighty years, the award for music was given annually except on four occasions, in 1953, 1964, 1965, and 1981, as the jury decided that no singular work was deserving of it. However, in 1965 they recommended that a special citation be awarded to Edward Kennedy "Duke" Ellington for his entire body of work. Ellington is arguably the United States' greatest composer and one of the most important figures in the history of American music. Yet, in spite of the jury's unanimous recommendation, the Pulitzer advisory board rejected the endorsement and decided against giving out any award that year. Two jury members eventually resigned in protest.

When the board informed Ellington of the rejection, he responded in an especially Ellingtonian way, famously stating, "Fate is being kind to me. Fate doesn't want me to be too famous too young." He was sixty-seven years old at the time. Speaking further in a September 12, 1965, *New York Times Magazine* article, Ellington would highlight the bias inherent in his chosen genre: "I'm hardly surprised that my kind of music is still without, let us say, official honor at home. Most Americans still take it for granted that European music—classical music, if you will—is the only really respectable kind." It wouldn't be until 1997 that Wynton Marsalis would become the first jazz artist to win the Pulitzer Prize for Music for his epic work "Blood on the Fields," with Jazz at Lincoln Center Orchestra. Ironically, Marsalis's oratorio, like a great deal of his work with the orchestra, was largely inspired by Ellington.

The Pulitzer took a surprising turn when it was announced in 2018 that rapper Kendrick Lamar would be the recipient of the music award for his album *DAMN.* (2017). Kendrick was the first musical artist from a genre other than jazz or classical to earn this honor. So while Nas's "Pulitzer Prize winner" proclamation might have sounded simply like hip hop braggadocio, he was onto something. Kendrick was the one who fulfilled the prophecy.

While the slighting of Ellington was indicative of the racism and cultural bias that existed in the 1960s, the recognition of

Kendrick's work made the Pulitzer board appear open-minded and culturally connected. Jazz and hip hop share certain similarities in terms of how both genres have at various points been dismissed, ignored, marginalized, stereotyped, and regarded as threatening, before proving all of this negativity wrong via their individual successes. The difference is that jazz, unlike hip hop, was more a cultural success than a commercial one, and came to be associated with high art and the height of musical sophistication. Ellington was an elder statesman, who was dissed after creating a hugely impressive body of work over a career spanning multiple decades. Kendrick, on the other hand, is a contemporary artist who was recognized with a Pulitzer relatively early in his career. This is no slight on jazz: the music has always been over the head of the masses, appealing to the hip, while marginalizing the square. Instead, it is a testament to how transformative hip hop has become, managing to remain popular while also, eventually, achieving the broadest critical acclaim.

The journey from residential rec-room parties in the Bronx to Pulitzer Prizes and the Kennedy Center has been a long and storied one. Inherent to this trajectory is the desire to rise up, the ability to transcend, the impulse to prevail.

IN MY BAG

A 2021 *New York Times* article described the iconic fashion designer Ralph Lauren as "an architect of aesthetics and an engineer of vibes." In true hip hop style, I want to sample that phrase and remix it in the context of *Rapper's Deluxe*. Perhaps, instead of an *engineer* of vibes, I would describe myself as a *curator* of vibes, and my curation is what defines the words and images that make up the book. Further, as a connoisseur of both culture and cool, this curation works to reframe the way that people imagine hip hop.

The words contained here were inspired by all of the great wordsmiths I have encountered throughout my life, be they rappers, street cats, actors, musicians, athletes, revolutionaries, writers, or intellectuals. As Tupac Shakur would say, "Picture paragraphs unloaded, wise words bein' quoted" ("Hail Mary," 1996). The images, meanwhile, were inspired by the massive collage of newspaper and magazine photos that adorned my bedroom wall when I was in the fifth grade. And the way they have been put together—this stylistic flood of visual references—is also inspired by the image editing seen in Oliver Stone's film *JFK* (1991). Ultimately, though, *Rapper's Deluxe* is hip hop like you have never conceived it before, making connections across the culture, through the culture, for the culture, and beyond.

RIGHT ON FOR THE DARKNESS

THE FIRST DAY OF SCHOOL

BLACK POWER

+ SOUL

SOUL POWER

ALL BLACK EVERYTHING

Blaxploitation

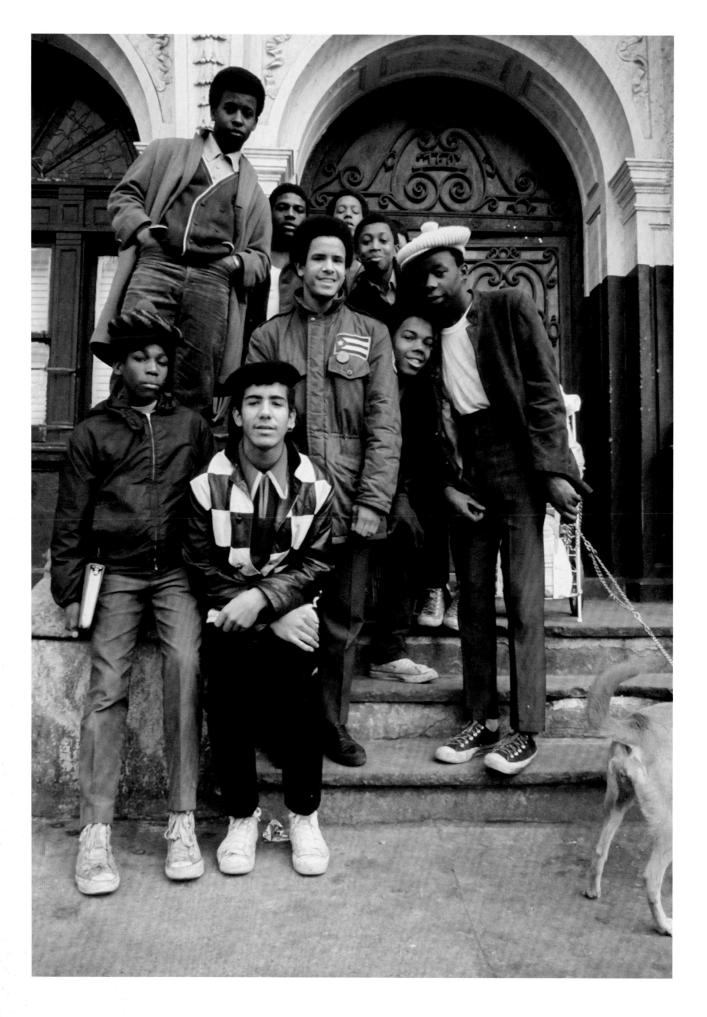

THE FIRST DAY OF SCHOOL

Growing up in the 1970s, I remember the first day of school always felt like a holiday. Symbolically, this was a new beginning, but besides getting reacquainted with old friends, and making new ones, the first day of school was all about style—and, in the aspirational Black culture of the 1970s, it was an unstoppable fashion show. Like Easter Sunday, everyone wanted to wear something that was both new and fashionable: in a word, something *fresh*.

It was with this impulse to dress your best, as the story goes, that young Cindy Campbell decided to throw a party on August 11, 1973. Cindy's idea was to use the funds collected from the party to go shopping for new school clothes. The rec room in her Bronx, New York, apartment building located at 1520 Sedgwick Avenue, where she and her family lived, would serve as the setting for this particular affair. Cindy's brother, Clive Campbell—who came to be better known as Kool Herc—was the DJ for the "Back to School Jam." Herc had recently developed a slick technique where he used two turn-tables to isolate and extend the instrumental break of a tune right before it flowed into the song's chorus. He called this process the merry-go-round. Dancers seemed to be the most energized during this break section, so extending it, he discovered, was a crowd pleaser. The early 1970s music of James Brown and his band the J.B.'s would be a common source of these breakbeats. While Herc indulged this merry-go-round technique, his friend Coke La Rock would dip into the Black oral tradition and shout out the names of various friends, acknowledging those who were in attendance. Eventually, Coke began to recite various improvised rhymes over Herc's break beats.

Cindy and Herc's Back to the School Jam was a huge success. Cindy could now "cop" the new clothes she wanted and show up fresh on the first day of school. Herc's reputation grew exponentially throughout the Bronx after this party and eventually his name would resonate across the five boroughs. He would become the patriarch in hip hop's mythological origin story, with Coke La Rock, for all intents and purposes, becoming the culture's first MC, as in "master of ceremonies" or, better yet, "microphone controller."

A few days after this now-legendary party, on August 15, 1973, the Jack Hill film *Coffy*, starring Pam Grier, would achieve the number one spot at the box office. *Coffy* was the first of several signature performances for Grier during this era. A year later, in 1974, she would star in the film *Foxy Brown*, also directed by Hill. Grier was so popular by the end of the decade that she had become one of the reigning cultural icons of the 1970s, appearing on magazine covers that ranged from *Players*, the Black men's pictorial, to the feminist *Ms*. magazine. A 1975 *New York Magazine* cover identified her as a "New Kind of Hollywood Star."

While Herc's hip hop was expansive and influential as it developed across the Bronx and other parts of New York, it was generally unknown beyond these boundaries at the time. Hip hop was an underground movement throughout most of the 1970s, spreading among lower- and lower-middle-class Black youth and young adults but barely registering with older, more bougie members of Black middle- and upper-middle-class communities.

The symmetry of the Back to School Jam, the birth of hip hop, and Grier winning the domestic box office during this moment in August 1973 would, in hindsight, prove to be more than a coincidence. Though it would be years before hip hop would emerge outside of its localized provenance, Blaxploitation films like *Coffy* and *Foxy Brown* would signal a shift as Black culture entered the American mainstream. Their popularity would spark public controversy, however, as issues of race and representation became contested lines of demarcation, prompting debate on the politics of American popular culture. These conversations, ongoing in broader cultural circles, would influence the development of hip hop, before hip hop fully emerged from the underground. The cosmic connections forged by simultaneous, although uneven, cultural development would become abundantly clear in the years and decades to come.

OPPOSITE: Teenagers in the Melrose neighborhood, South Bronx, NY, 1970, photographer Camilo José Vergara.

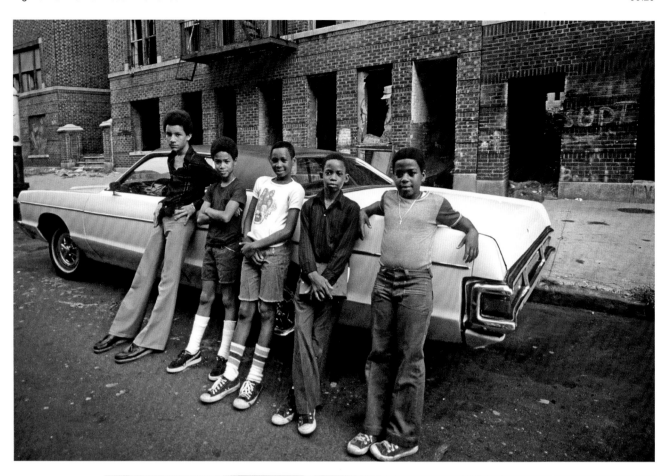

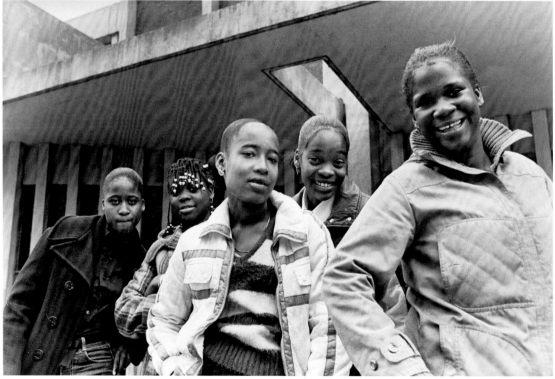

TOP: Teenagers in front of burnt-out tenement buildings, South Bronx, NY, 1977, photographer Alain Le Garsmeur. **BOTTOM:** Teenagers in front of the Junior High School on Third Avenue, Bronx, NY, c.1976–82, photographer Mel Rosenthal.

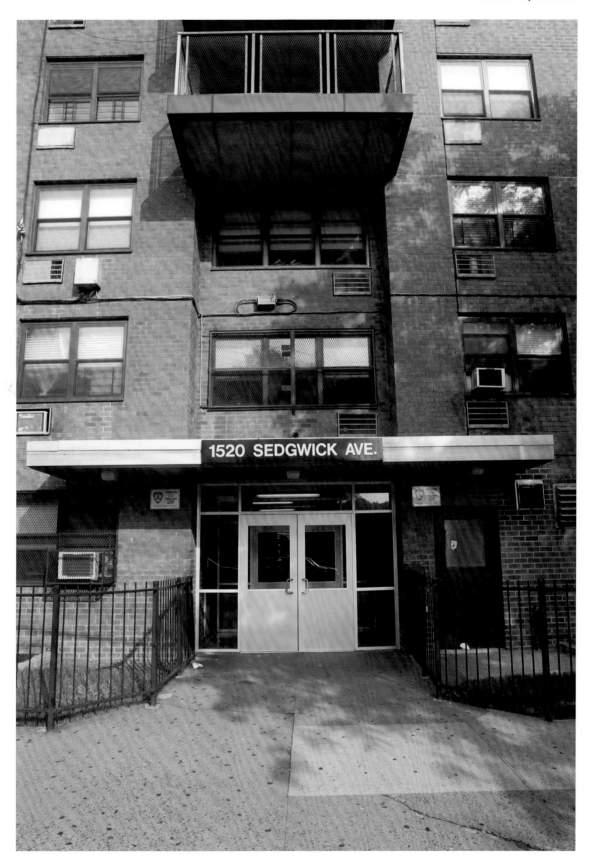

1520 Sedgwick Avenue, recognized as the official birthplace of hip hop, Bronx, NY, August 16, 2007, photographer Peter Kramer.

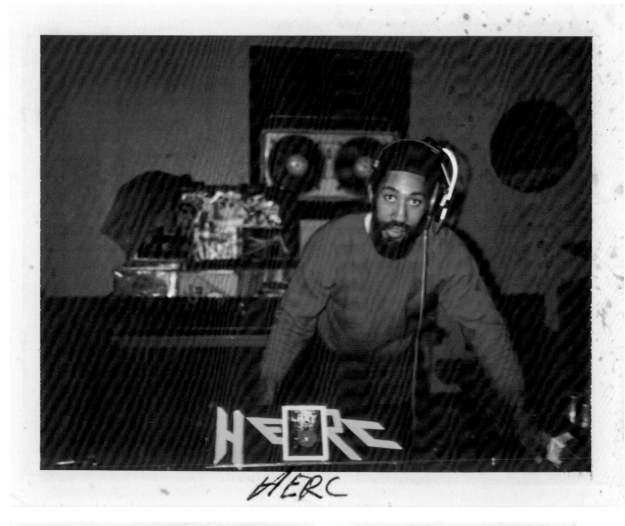

TOP: DJ Kool Herc at Stafford Place Club, University Avenue, Bronx, NY, mid-1970s, photographer unknown. **BOTTOM LEFT:** Cindy Campbell, "The First Lady of Hip Hop," Bronx, NY, 1974, photographer unknown. **BOTTOM RIGHT:** Coke La Rock and DJ Kool Herc, 1520 Sedgwick Avenue, Bronx, NY, c.1976, photographer unknown.

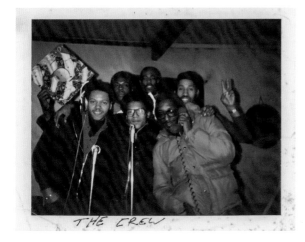

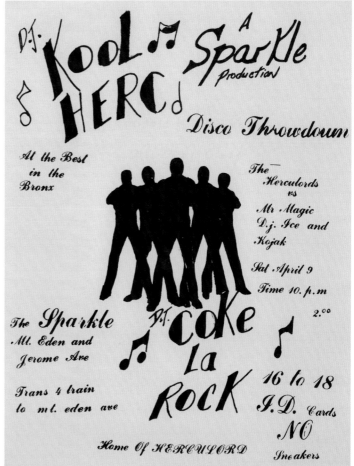

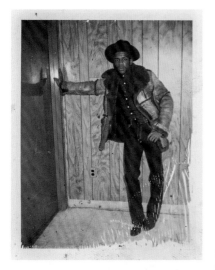

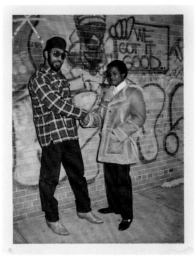

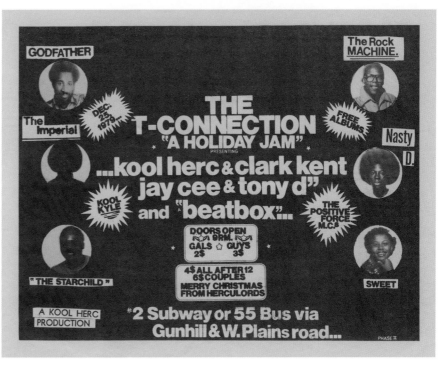

TOP LEFT: The Crew: (front row from left) Mike Mike with the Lights, Clark Kent, Coke La Rock, DJ Kool Herc (back right), and two friends, Stafford Place Club, University Avenue, Bronx, NY, mid-1970s, photographer unknown. **TOP RIGHT:** A Sparkle Production flyer featuring the Herculords, April 9, 1977. **CENTER LEFT:** DJ Tony Tone, Cold Crush at Ecstasy Garage, Bronx, NY, c.1976, photographer unknown. **BOTTOM LEFT:** DJ Kool Herc and Bow, Boston Road and Seymour Avenue, Bronx, NY, c.1976, photographer unknown. **BOTTOM RIGHT:** A Kool Herc Production flyer promoting "A Holiday Jam" event at T-Connection, Bronx, NY, December 25, 1979.

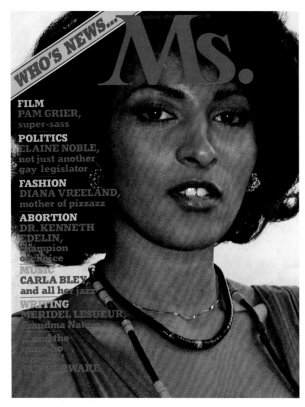

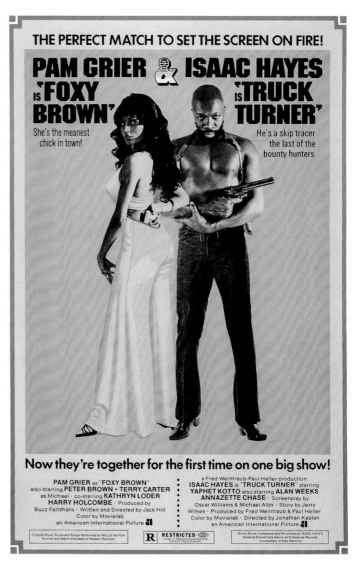

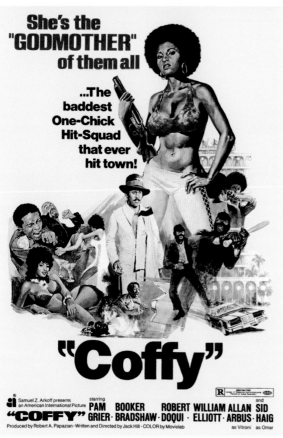

TOP LEFT: "Super-Sass," Pam Grier on the cover of *Ms.*, August 1975, photographer James Hamilton. **TOP RIGHT:** Combination movie poster for *Foxy Brown* and *Truck Turner*, starring Pam Grier and Isaac Hayes, American International Pictures, 1974, dirs. Jack Hill and Jonathan Kaplan. **BOTTOM LEFT:** Movie poster for *Coffy*, starring Pam Grier, American International Pictures, 1973, dir. Jack Hill.

Pam Grier photographed for *New York Magazine*, New York, 1975, photographer Dan Wynn.

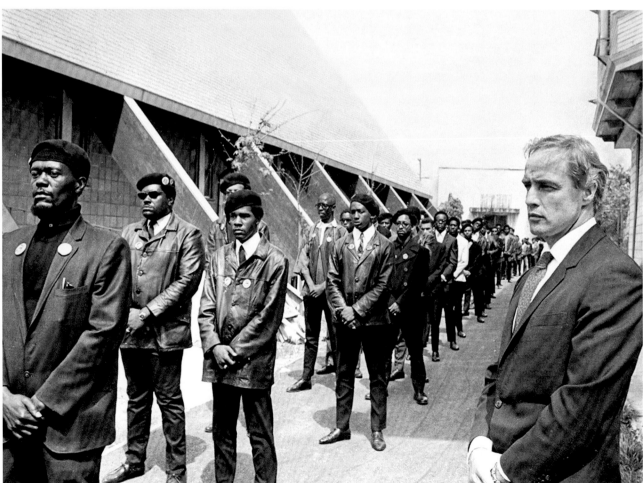

BLACK POWER + SOUL

SOUL POWER

Black Power was a political movement informed by ideas of independence and self-determination. Inspired by the teachings of Malcolm X and influenced by anticolonial liberation struggles taking place across the developing world during the Cold War, Black Power was concerned with challenging the system and elevating Black people in American society. Though Black Power referred to a specific ideological agenda, as articulated in examples ranging from Stokely Carmichael, aka Kwame Ture, and Charles V. Hamilton's *Black Power: The Politics of Liberation* (1967) to the Black Panther Party's "Ten Point Party Platform," its manifestation was often subject to one's own personal interpretation.

The influence of Black Power on the people would be literal, figurative, and profound. For the purpose of understanding and examining the history and evolution of hip hop, Black Power was expressly cultural as well. Images of Black Power across music, film, art, fashion, television, and sports often reached the wider public in distilled form, as representations of empowerment relative to everyday life. The expression itself—Black Power—resonated at both public and personal levels, in ways that both affirmed and transcended the political aims of its concept.

Simultaneous with the growing influence and representations of Black Power, the concept of *soul*, though emergent in previous eras, exploded in popularity during the 1970s. This shift represented the rise of a dominant cultural impulse that sought to affirm those things regarded as essential to Black identity in the United States. Soul music embraced traditional genres such as gospel and blues, while also working to modernize them. This revival was best expressed in the popular syndicated weekly television show *Soul Train* (1971–2006), which brought together the music, dance, fashion, and style representing the cutting edge of Black expression. For his contributions to the industry, legendary musician James Brown, with his anthem "Say It Loud—I'm Black and I'm Proud" (1968), would be deemed the "Godfather of Soul." The talk show *Soul!* (1968–73), hosted by Ellis Haizlip, featured a dazzling array of writers, musicians, actors, artists, and political figures who were not getting proper recognition in other cultural spaces but who were received with respect and love on this historic, though underappreciated, program. Alongside more popular forms of expression, Black artists in the 1970s such as David Hammons, Barkley L. Hendricks, Faith Ringgold, and Betye Saar—all of whom were featured in the *Soul of a Nation: Art in the Age of Black Power* exhibition that opened at London's Tate Modern in 2017—created work that echoed some of the same racial, cultural, and political themes.

Soul food celebrated historical Southern Black cooking as a form of physical and spiritual nourishment, while affectionate designations such as "soul brotha" and "soul sista" spoke to a recognition of each other, as well as to a broader sense of community. Expressions of soul could also be seen as far away as Vietnam, where the stylized handshakes of Black soldiers, often referred to as "dap" ("dignity and pride"), were used to signify cultural and racial unity. Similar to the adoption of camouflage and other military-issue jackets as fashion and street-style staples, dap came "back to the world" with the returning soldiers, its evolving styles and variations, along with other forms of cool Black handshakes, becoming a social staple across generations to come. At its core, the idea of soul, with its obvious spiritual connotations, suggested a cultural authenticity that was considered preferable to the opportunistic sellout mentality that so many of those desiring to assimilate into the white mainstream at any cost had come to embrace.

The merger of Black Power and soul, Soul Power, can be understood as a philosophy, an aesthetic, and a guide for living in the 1970s. Political and economic empowerment meets a spiritual and cultural sensitivity. This concept fueled a great deal of creativity in a boldly expressive era, while hip hop was emerging, just under the radar.

OPPOSITE TOP: Black Panther Headquarters, San Francisco, CA, 1970, photographer Gordon Parks. **OPPOSITE BOTTOM:** Marlon Brando attends the Black Panther Party rally held as a memorial for Bobby Hutton, a young Panther killed by police, Merritt Park, Oakland, CA, April 12, 1968, photographer Dan Cronin.

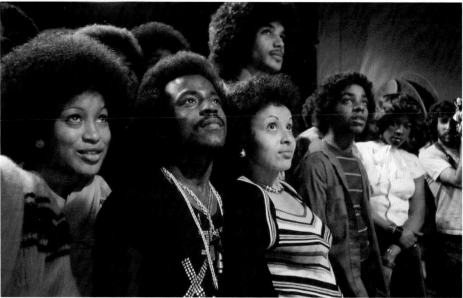

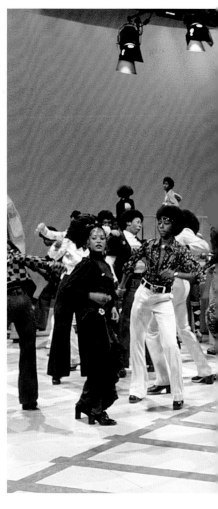

TOP LEFT: Ellis Haizlip, host of *Soul!*, 1968–73, featured in the documentary *Mr. SOUL!*, Shoes in the Bed Productions, 2018, dir. Melissa Haizlip.
CENTER LEFT: *Soul Train* dancers look up at a performance, February 15, 1975, photographer unknown. **CENTER:** Host Don Cornelius (right) on *Soul Train*, mid-1970s, photographer Howard Bingham.

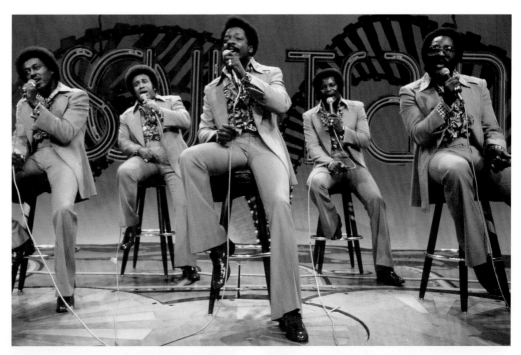

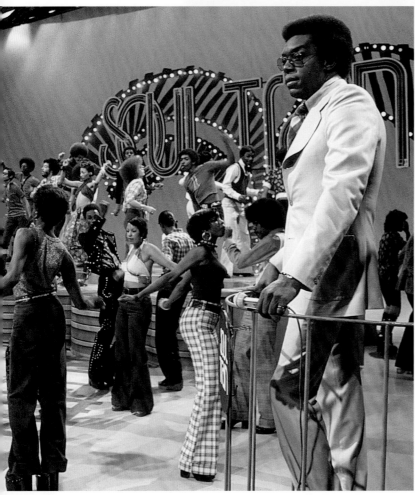

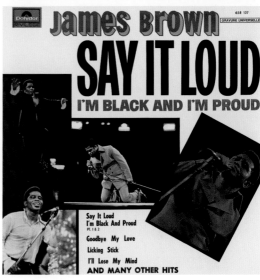

TOP RIGHT: The Spinners perform on *Soul Train*, October 2, 1976, photographer unknown. **CENTER RIGHT:** Album cover for *Say It Loud, I'm Black and I'm Proud*, James Brown, King Records/Polydor, 1968, photographer unknown.

David Hammons, *Black First, America Second*, 1970. Grease, pigment, and silkscreen on paper, 41¼ × 31¼ inches (104.8 × 79.4 cm).

Soldiers in Vietnam exchange "dap" ("dignity and pride"), a stylized greeting used to signify shared Black culture and racial unity, De Nang, 1969, photographer Wallace Terry.

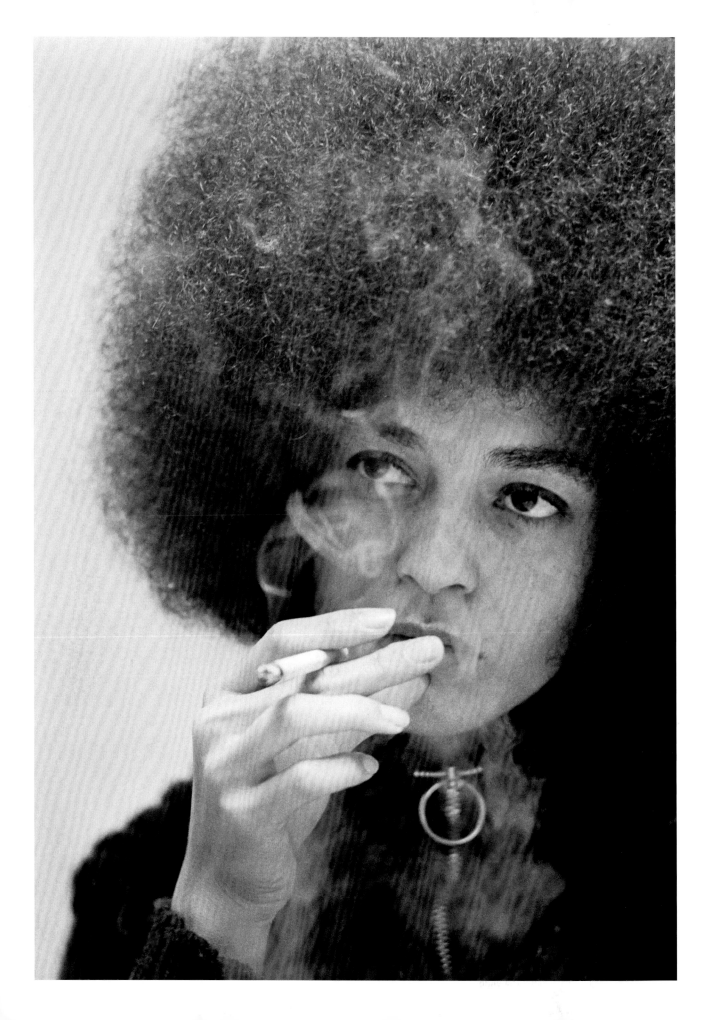

ALL BLACK EVERYTHING

The politics of Black Power resonated throughout young urban Black communities during the early 1970s, even as targeting by law enforcement sought to neutralize such groups as the Black Panther Party. The FBI's counterintelligence program, known as COINTELPRO, did in fact succeed in dismantling the Panthers, and while the party may have lost the battle, it could be argued that they nevertheless won the war—at least culturally speaking.

Images of Black Power were everywhere during this time, as much a personal, cultural, and aesthetic statement as a political one. The defiant revolutionary profile of leftist intellectual Angela Davis, throwing up the Black Power sign while rockin' her signature afro, would become emblematic of the era. Individual expressions ranged from pro-Black hair statements, also known as a "natural," along with the clenched black-fist hair picks used to style these 'fros, and the ubiquity of red, black, and green iconography, referencing Marcus Garvey's Black Liberation flag of 1920, to the hip, ever-changing street vernacular and evolving handshakes. The all-black-everything aesthetic—black leather attire and prominent black berets—Panther signatures from the beginning, now proliferated. Meanwhile, the art and graphic design work of Black Panther Emory Douglas, seen across party newspapers, posters, and other paraphernalia, demonstrated the effectiveness of art used as a means of communication, further articulating and defining the ideas and iconography of the movement. Black Power was no longer a mere subculture but part of everyday political, conversational, and personal lifestyle. This connection between politics and culture, with its emphasis on both style and substance, is what made Black Power so cool, and thus so influential among many people who may never have attended a political rally or read an ideological manifesto. The recognition that power in all of its manifestations was essential to any forward movement of the culture helped set the stage for the birth of hip hop.

While the Black Panthers represented one version of Black Power, others attempted to imagine the possibilities of Black political empowerment in more traditional ways. The William Greaves documentary *Nationtime* focused on the 1972 National Black Political Convention held in Gary, Indiana. The film utilized the setting of a political convention, with delegates from across the country attending—speakers included Reverend Jesse Jackson,

icons of the movement Coretta Scott King and Betty Shabazz, writer Amiri Baraka, comedian Dick Gregory, musical artist Isaac Hayes, and several publicly elected politicians, among numerous others. The speakers called for an independent Black political agenda separate from the Democratic and Republican parties, for more Black people to be elected to positions of power, and for across-the-board social and economic change. Shirley Chisholm, a member of the U.S. House of Representatives from Brooklyn, would be the first Black person to run for President of the United States from one of the two major political parties. She ran under the emblematic campaign slogan "Unbought and Unbossed." Barbara Jordan, from Houston, became the first Black woman elected to the House from a Southern state, offering a riveting opening statement about the impeachment of Richard Nixon to the House Judiciary Committee. Her speech would come to be regarded as one of the great examples of American political oratory.

The year 1973 saw Black mayors elected to office for the first time in places like Detroit, where former union leader Coleman Young prevailed; Atlanta, as Maynard Jackson emerged to run the municipality representative of the so-called New South; and Los Angeles, a city without a majority Black population, which elected former LAPD officer Tom Bradley to the mayoral post. That same year, Bobby Seale, the cofounder of the Black Panther Party, would himself run for mayor of Oakland. Though Seale was not successful in his bid, the shift from revolutionary to mainstream politics was itself instructive on the changes coming about in the early 1970s. As these examples indicate, advocates for Black Power varied from those attempting to work within the system to those who pursued more independent means of accumulating influence and power for the purpose of uplifting their communities.

OPPOSITE: Angela Davis, jailed for more than a year on murder-conspiracy charges, has a cigarette as she talks during an exclusive interview with Associated Press reporters Edith Lederer and Jeannine Yoemans in a tiny green interview room at Santa Clara County jail, Palo Alto, CA, December 27, 1971, photographer Sal Veder.

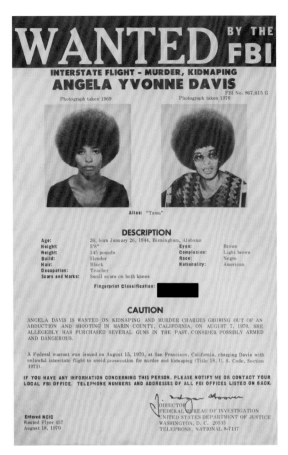

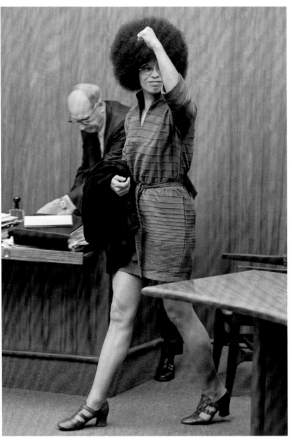

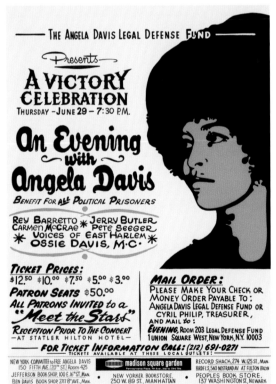

TOP LEFT: FBI wanted poster for Angela Davis, August 18, 1970. **TOP RIGHT:** Angela Davis arrives for a pre-trial hearing, San Rafael, CA, June 28, 1971, photographer unknown. **BOTTOM LEFT:** Flyer advertising "An Evening with Angela Davis," a celebratory benefit event following Davis's release from prison, New York City, NY, June 29, 1972.

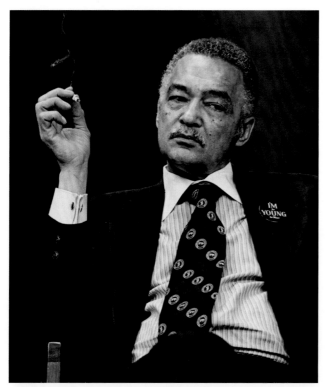

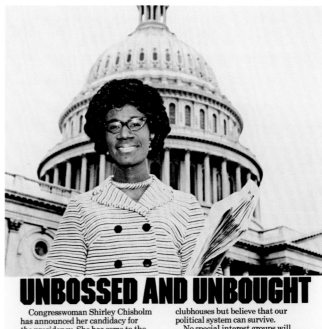

UNBOSSED AND UNBOUGHT

Congresswoman Shirley Chisholm has announced her candidacy for the presidency. She has come to the decision to run without consulting any political bosses.

Her support comes from the millions of Americans who shun the political clubhouses but believe that our political system can survive.

No special interest groups will contribute to her campaign. So the success of her candidacy depends upon people like you.

The unbossed and the unbought.

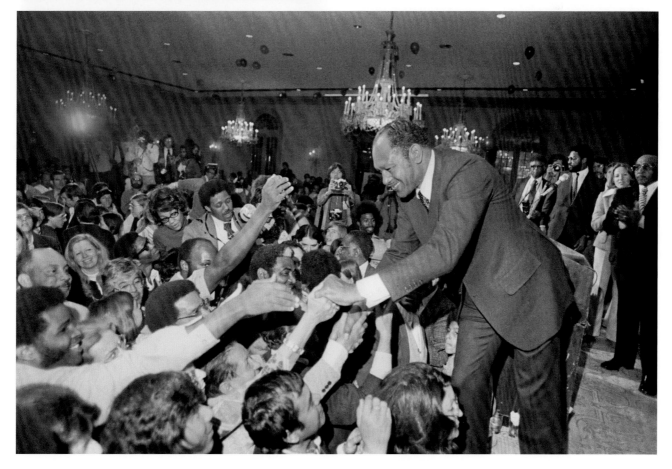

TOP LEFT: Coleman Young, Mayor of Detroit, MI, October 7, 1973, photographer unknown. **TOP RIGHT:** "Unbossed and Unbought," pamphlet advertising Shirley Chisholm's presidential campaign, 1972, photographer unknown. **BOTTOM:** City councilman Tom Bradley shakes hands with well-wishers, Los Angeles, CA, April 4, 1973, photographer unknown. Bradley would be elected as Mayor of Los Angeles the following month. **OVERLEAF:** Emory Douglas, *Seize the Time*, September 27, 1969.

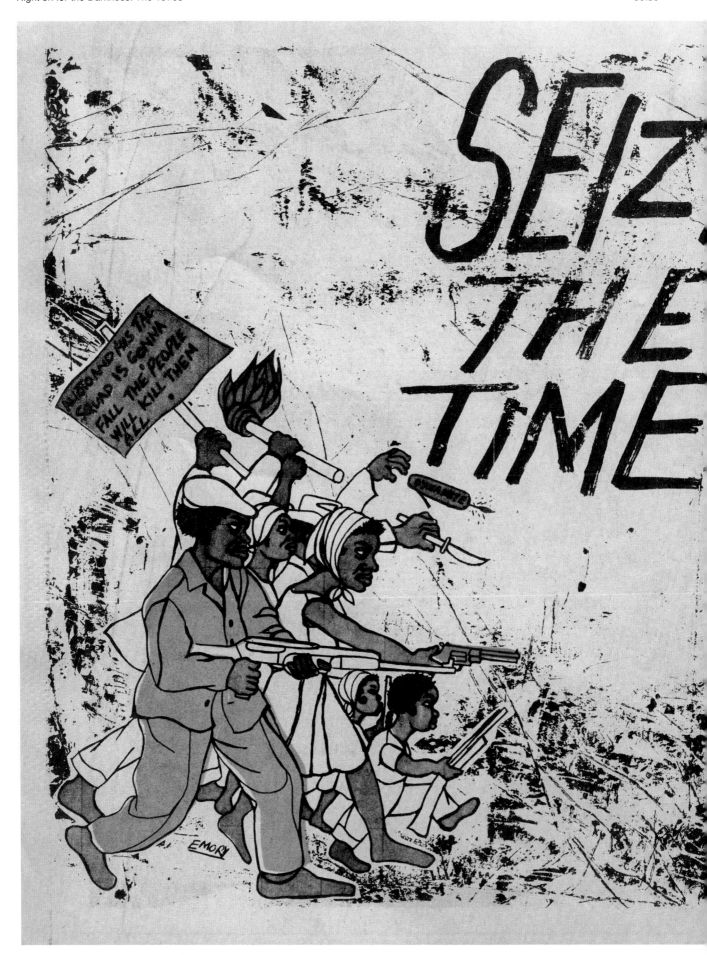

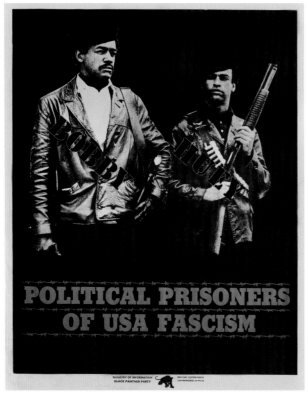

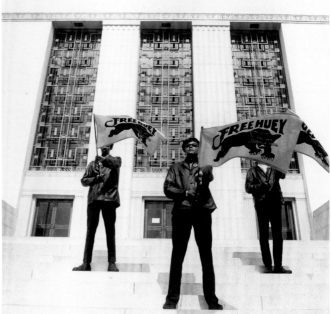

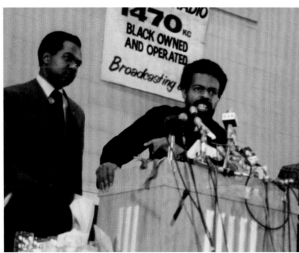

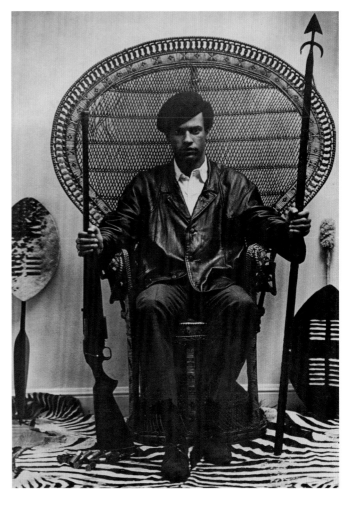

TOP LEFT: Emory Douglas, "Political Prisoners of USA Fascism," the Black Panther Party newsletter, November 1, 1969. **TOP RIGHT:** Black Panther demonstration during Huey P. Newton's trial, Alameda County Court House, Oakland, CA, July 30, 1968, photographer Pirkle Jones. **BOTTOM LEFT:** D.C. delegate Walter Fauntroy (left) and writer and activist Amiri Baraka in *Nationtime*, a documentary about the National Black Political Convention held in Gary, IN, 1972, Kino Lorber, 2020, dir. William Greaves. **BOTTOM RIGHT:** Black Panther Party poster featuring Huey P. Newton, the party's Minister of Defense, 1968, photographer Blair Stapp.

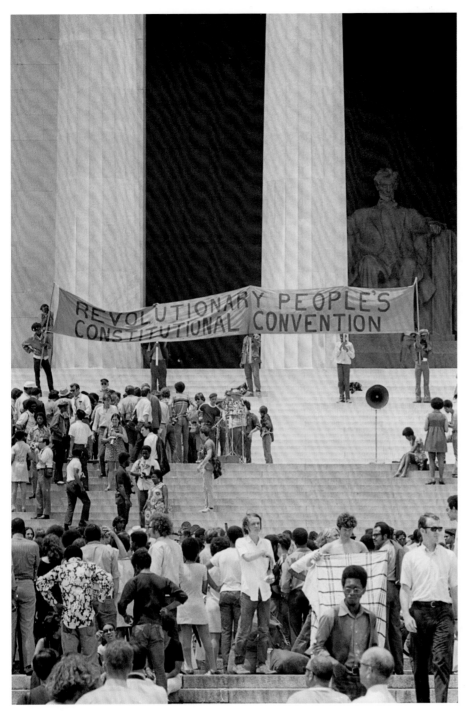

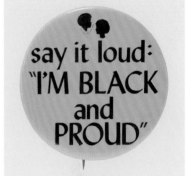

LEFT: Black Panther convention at Lincoln Memorial, Washington, D.C., June 19, 1970, photographers Warren K. Leffler and Thomas J. O'Halloran.
TOP RIGHT: "Black Roots, the Soul of the Earth," pinback button, date unknown. **CENTER RIGHT:** "Say it Loud: I'm Black and Proud," pinback button, c.1969. **BOTTOM RIGHT:** Afro hair pick with black fist design.

Ain't no one crosses WILLIE "D"
He's tight, together, and mean.
Chicks, Chumps, he uses 'em all.
He's got to be Number-One.

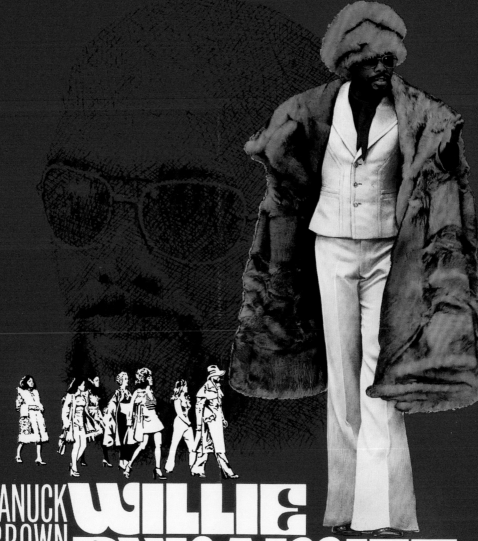

A ZANUCK /BROWN PRODUCTION

WILLIE DYNAMITE

STARRING
ROSCOE ORMAN · DIANA SANDS · THALMUS RASULALA · ROGER ROBINSON

AND INTRODUCING
JOYCE WALKER

SCREENPLAY BY
RON CUTLER

STORY BY
JOE KEYES JR. and RON CUTLER

DIRECTED BY
GILBERT MOSES

PRODUCED BY
RICHARD D. ZANUCK and DAVID BROWN

A UNIVERSAL PICTURE
TECHNICOLOR ®

MUSIC BY
J.J. JOHNSON

LYRICS BY
GILBERT MOSES, III

Original Soundtrack
Album available exclusively
on MCA Records & Tapes

R RESTRICTED
Under 17 requires accompanying
Parent or Adult Guardian

One of the best examples of the Panthers' impact and the broader influence of Black Power on culture involves Melvin Van Peebles and his celebrated independent cinema classic *Sweet Sweetback's Baadassssss Song* (1971). Made on an especially low budget through hustle and creative financing by a maverick auteur using a guerrilla filmmaking approach—qualities that anticipated narratives of enterprising rappers selling tapes and CDs out of the trunks of their cars—*Sweetback* starred "the Black community" and was "rated X by an all-white jury," as Van Peebles's provocative tagline stated.

Drawing on elements of European and avant-garde film, mixed with Black folklore, street philosophy, revolutionary rhetoric, and heightened sexual representation, *Sweetback* became required viewing for members of the Black Panther Party. Panther leader Huey P. Newton wrote a provocative critical essay, "He Won't Bleed Me: A Revolutionary Analysis of *Sweet Sweetback's Baadassssss Song*" (1971) extolling the virtues of "the first truly revolutionary Black film." For Newton, the film was an extension of the revolutionary ideas that the Panthers had been espousing. With the Earth, Wind, and Fire soundtrack released prior to the film as a way of kick-starting the production's street-team-style marketing efforts, its popularity would spread over time to broader audiences in cities throughout the country. *Sweetback* spent four weeks atop the domestic box office in 1971, becoming a huge financial success in the process, in spite of its humble origins.

Yet not all were pleased with the film's success. Lerone Bennett Jr., editor of *Ebony* magazine, the bible of Black middle-class respectability politics, criticized *Sweetback* for promoting negative stereotypes of the culture. In an essay entitled "Emancipation Orgasm: *Sweetback* in Wonderland" from the September 1971 issue, Bennett excoriated the film for its suggestive linking of sexual activity with racial freedom:

It is necessary to say frankly that nobody ever fucked his way to freedom. And it is mischievous and reactionary finally for anyone to suggest to Black people in 1971 that they are going to be able to screw their way across the Red Sea. Fucking will not set you free. If fucking freed, Black people would have celebrated the millennium four hundred years ago.

Bennett's sentiment would be shared by others who felt that films like *Sweetback* glorified images of street culture in ways that hindered the progress of mainstream Black social mobility. Former president of the Beverly Hills/Hollywood chapter of the NAACP, Junius Griffin, is often credited with coining the word Blaxploitation ("black exploitation"), arguing that the films were racially exploiting Black movie-going audiences and Black culture more broadly. The phrase caught on and subsequently came to define a proliferation of Black films released during the era.

In spite of these vocal criticisms, however, the success of *Sweetback* set the stage for numerous films that would be immersed in an environment of urban street culture. Released the following year, in 1972, Gordon Parks Jr.'s *Super Fly* operated from the perspective of a cocaine dealer pondering the meaning of life while trying to make one last big drug deal before exiting the dope game. This proves more difficult than one might imagine, and in the process, the main character Youngblood Priest must navigate a world of racist cops, disloyal friends, desperate junkies, and manipulative white lovers. Yet he looks ever so stylish while doing so, as he moves through the streets of New York City with much swagger, often driving his eye-catching "hog," a customized Cadillac Eldorado, the car of choice among the ballers, bosses, and big steppers of the day. In an era before exotic foreign cars became symbolic of one's status on the streets, American behemoths like the Eldorado, the Cadillac Seville, and the Lincoln Continental defined the meaning of luxury in the car game.

Audiences loved the film's cathartic conclusion. Priest outsmarts the corrupt racist cops. He "cusses" them out in the most humorous yet humiliating way possible, whups their collective ass, and further threatens their lives, all while snorting cocaine in their faces, before walking off to his elaborate chariot of an automobile. Moviegoers also embraced the narrative of the triumphant Black underdog defying the odds and overcoming obstacles. Many found the subversion of Hollywood's traditional sense of white morality to be empowering. Directly taking on images of a racist establishment, while looking cool and talkin' shit, and in general displaying a calculated indifference, thus "not givin' a fuck," as it were, came to define this moment in film history.

Super Fly was so successful that it even managed to knock Francis Ford Coppola's *The Godfather* off the box office top spot for a few weeks in 1972. Both films had famously flipped the script in foregrounding the point of view of the gangster in their critique of American capitalism. Relatively speaking, Paramount Pictures' budget for *The Godfather* was not necessarily considered large, but *Super Fly* was a Black independent film, so replacing *The Godfather* as number one in the country was an especially impressive feat. It was the first to feature the drug dealer as the kingpin of 1970s street lore, and was so popular and emblematic that when real-life Harlem street legend Nicky Barnes appeared unapologetically flaunting his status on the cover of the *New York Times Magazine* in 1977 it was as if *Super Fly* had come to life.

While *Super Fly* was ahead of its time, prefiguring the emergence of the drug dealer as the dominant symbol of urban entrepreneurship in the 1980s and beyond, perhaps the most ubiquitous representation of street culture during the Blaxploitation era was that of the pimp, who was seen as sitting atop the social hierarchy. The success of former-pimp-turned-author Iceberg Slim (Robert Beck) and his 1967 book *Pimp: The Story of My Life* spawned films such as *The Mack* (Michael Campus, 1973), *Willie Dynamite* (Gilbert Moses, 1973), and *The Candy Tangerine Man* (Matt Cimber, 1975). Iceberg Slim would go on to write a series of books for Holloway House publishers, including *Trick Baby* (1967), which would be adapted into a film in 1972. Books such as Susan Hall and Bob Adelman's *Gentleman of Leisure* (1972) and Christina and Richard Milner's *Black Players* (1973) brought an intellectual and artistic focus to this sub-genre. Pimp style, in fashion and language, articulated a certain flamboyance, use of hyperbole, and an overall extravagance associated with the concept of pimpin', which would become a staple of 1970s urban culture and its representation. This focus on style could be considered transgressive and empowering, or stereotypical and problematic, depending on the audience. Similar to the way in which the mafia was deployed as a critical cipher of American culture in *The Godfather* films, pimpin' also came to stand in for larger societal questions about capitalism, labor, and exploitation.

Beyond the success of the films themselves, Blaxploitation soundtracks were influential as well. *Super Fly*—which features perhaps one of the greatest soundtracks in Hollywood history—highlighted the music of Curtis Mayfield, who also performs in the film. Mayfield's evocative lyrics, often openly critical of the impact that drugs were having on the community, add an introspective layer of cultural commentary to what is going on in the film while maintaining a consistent groove and overall vibe throughout. The soundtrack achieved multiple hit singles and at some point came to stand as a landmark musical achievement beyond the film itself. In fact, Blaxploitation films would feature some of the top musical artists of the time. These would include Isaac Hayes (*Theme from Shaft,* 1971), Marvin Gaye (*Trouble Man*, 1972), James Brown (*Black Caesar*, 1973), and Willie Hutch (*The Mack*, 1973). Mayfield would produce other prominent soundtracks as well, including Gladys Knight and the Pips for *Claudine* (1974), the Staples Singers for *Let's Do It Again* (1975), and Aretha Franklin for *Sparkle* (1976).

Though films set in the world of urban street life are often regarded as defining the Blaxploitation genre, I understand the term to be emblematic of an era, one that encompasses a much wider range of subjects. One of the most interesting films of the time,

Ivan Dixon's *The Spook Who Sat by the Door* (1973), had little to do with street life. In the film, the main character Freeman (free man) becomes the first Black "spook" in the CIA. Spook has dual meaning here, as it is both a racial slur about Black people and a slang term for a spy. Freeman initially plays a subservient role while at the same time absorbing the lessons of the CIA and eventually using these lessons to start a Black revolution across the country.

According to Sam Greenlee, the author of the 1969 book that the film was adapted from, *The Spook* was actually pulled from theaters after prodding from the FBI, as it was feared that the film might inspire similar uprisings to that witnessed on screen. Some suggested, for instance, that the novel had inspired the Symbionese Liberation Army, the erstwhile revolutionaries of the predominantly white organization who abducted heiress-turned-gangsta Patty Hearst, aka Tania. While the FBI story has never been verified, it nevertheless became part of the urban legend, with the movie's title becoming a metaphor for Black life attempting to move through institutional white spaces.

While Blaxploitation, thematically and visually, came to represent a vibe unique to the 1970s, it would be referenced and copied many times over in future generations, and ultimately laid the foundation for emerging cultural trends, including the birth of gangsta rap in the late 1980s and the films of Quentin Tarantino starting in the 1990s. Despite the genre's frequently low budgets and being considered less sophisticated in traditional industry terms, urban audiences could identify with the environment represented and often embraced them as affirmative of their own existence. Other audiences, more favorable to a respectable and upwardly mobile sense of Blackness, rejected the films as stereotypical and retrograde. The tension between these two polarities would become a preview of more entrenched debates over Black imagery during the rise of hip hop in the 1980s and 1990s. Though many at the time dismissed Blaxploitation as mindless stereotypical trash, its place in hip hop's history and American culture more broadly is undeniable.

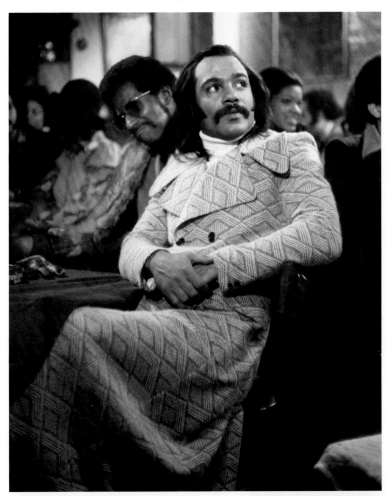

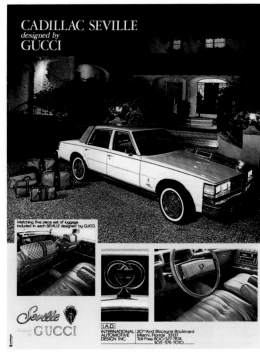

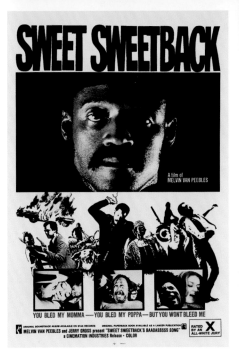

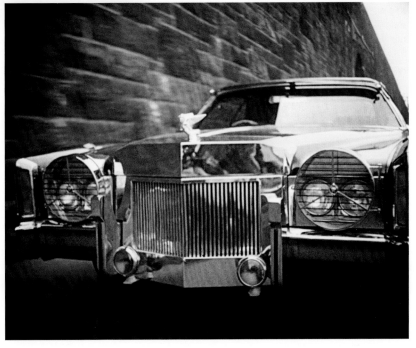

TOP LEFT: Ron O'Neal in *Super Fly*, Warner Bros. Pictures,1972, dir. Gordon Parks Jr. **TOP RIGHT:** Cadillac Seville Gucci edition advertisement, 1979. **BOTTOM LEFT:** Movie poster for *Sweet Sweetback's Baadasssss Song*, starring Melvin Van Peebles, Cinemation Industries, 1971, dir. Melvin Van Peebles. **BOTTOM RIGHT:** The Cadillac owned by Youngblood Priest in *Super Fly*, Warner Bros. Pictures,1972, dir. Gordon Parks Jr.

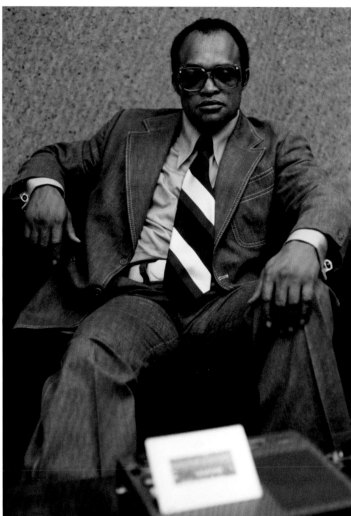

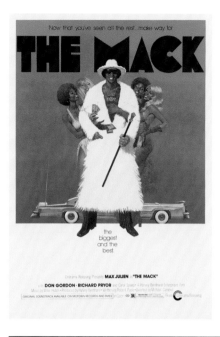

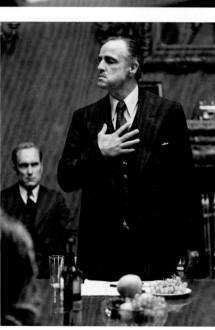

TOP LEFT: Harlem gangster Leroy "Nicky" Barnes, 1977, photographer Alex Webb. **TOP RIGHT:** Movie poster for *The Mack*, starring Max Julien, Cinerama Releasing, 1973, dir. Michael Campus. **BOTTOM LEFT:** Marlon Brando and Robert Duvall in *The Godfather*, Paramount Pictures, 1972, dir. Francis Ford Coppola. **CENTER:** Max Julien and George Murdock in *The Mack*, Cinerama Releasing, 1973, dir. Michael Campus.

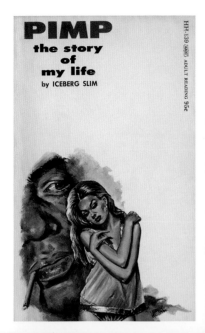

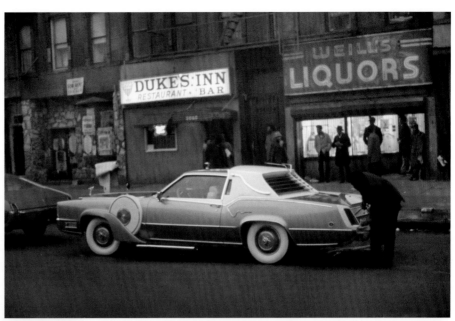

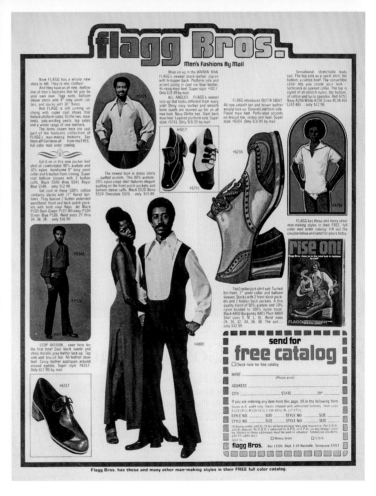

TOP LEFT: Book cover for *Pimp: The Story of My Life*, Iceberg Slim, Holloway House, 1967. **TOP RIGHT:** A heavily customized 1973 Cadillac Eldorado "pimpmobile," with El Deora custom trim, parked on a street in Harlem, New York City, NY, 1970s. **BOTTOM RIGHT:** Flagg Bros. catalog advertisement, 1972.

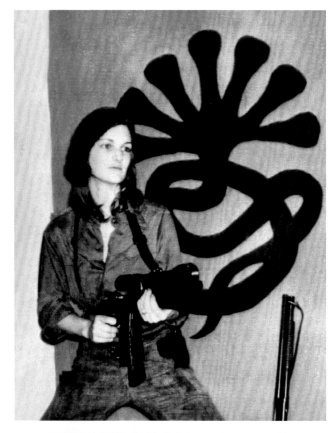

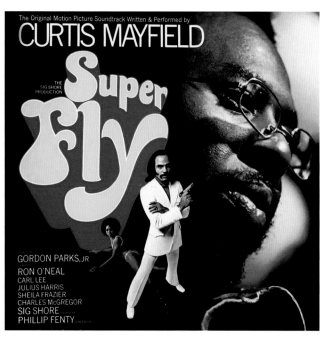

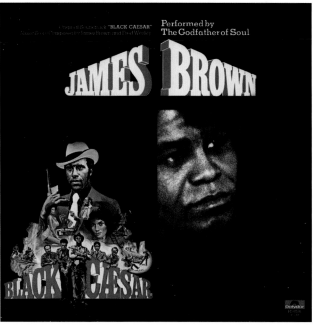

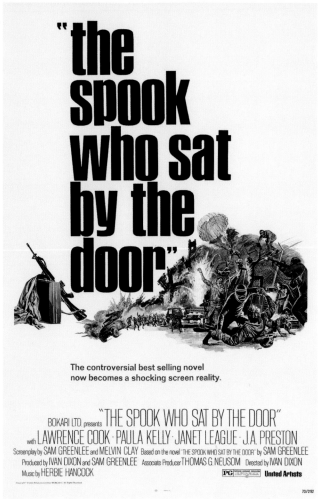

TOP LEFT: Heiress Patty Hearst, who was kidnapped by the Symbionese Liberation Army (SLA), poses as "Tania," the self-described urban guerrilla, in front of the SLA flag, April 3, 1974, photographer unknown. **TOP RIGHT:** Album cover for the *Super Fly* soundtrack, Curtis Mayfield, Curtom Records, 1972, art direction Glen Christensen. **BOTTOM LEFT:** Album cover for the *Black Caesar* soundtrack, James Brown, Polydor, 1973, artwork by Haywood E. Moore and Charles Bobbit. **BOTTOM RIGHT:** Movie poster for *The Spook Who Sat by the Door*, starring Lawrence Cook, United Artists, 1973, dir. Ivan Dixon.

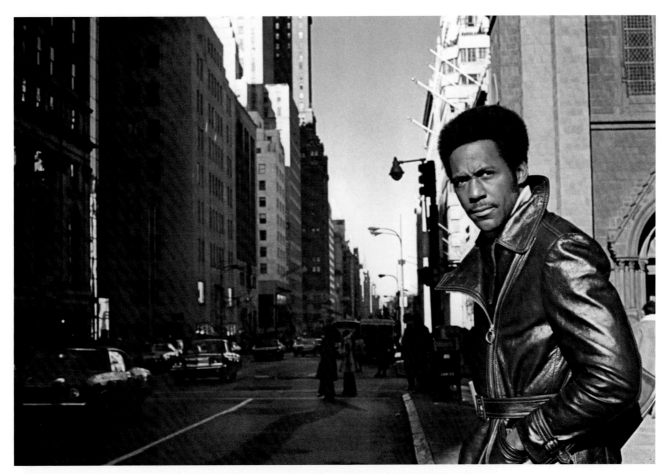

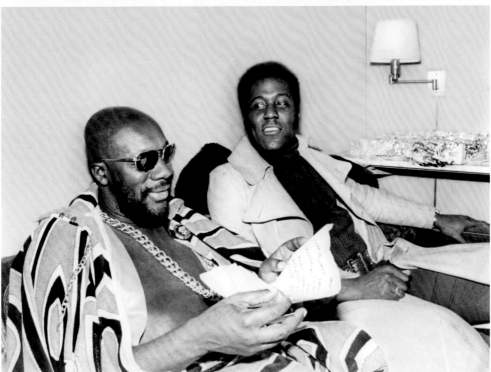

TOP: Richard Roundtree in *Shaft*, MGM, 1971, dir. Gordon Parks. **BOTTOM:** Isaac Hayes and Richard Roundtree chat during a break in the music recording session for *Shaft*, 1971, photographer unknown. Hayes won an Academy Award for Best Original Song for *Theme from Shaft* in 1972.

Music of my Mind

As the 1960s transitioned into the 1970s, Motown, the popular Black-owned, Detroit-based record label, which had been known as the "sound of young America," relocated from Detroit to Los Angeles. The label's celebrated pop hits of the 1960s were no longer sufficient in a world where political assassinations, Richard Nixon's "law and order" presidency, and the U.S. military's continued presence in Vietnam dominated headlines. Motown's founder Berry Gordy, ever the businessman, did not initially support artists like Marvin Gaye, who had taken a creative turn and was now addressing social and civic concerns in his music. Assuming that politically themed music would not sell, Gordy was resistant, but ultimately he relented, and the landmark album *What's Going On?* was released in 1971, altering Motown's history and that of popular music in the process.

When young Stevie Wonder reached the age of twenty-one and his contract with Motown expired, he was able to leverage a new deal in such a way that it unleashed an incredible string of albums that would redefine the concept of the Black singer-songwriter. Wonder's albums *Music of My Mind*, *Talking Book*, *Innervisions*, *Fulfillingness' First Finale*, and *Songs in the Key of Life*, all released between 1972 and 1976, have been described as "the greatest creative run in the history of popular music" and represent what has come to be regarded as the artist's classic period.

Together, Gaye and Wonder ushered in a new era of musical excellence at Motown. Yet by the early 1970s Motown was no longer exclusively a record label. In 1972 the company ventured into film, with their release of the Billie Holiday biopic *Lady Sings the Blues* (Sidney J. Furie) starring another of the label's biggest names, Diana Ross, as Holiday. The film would garner multiple Academy Award nominations, including a Best Actress nomination for Ross. In 1975 Motown would release another Ross star vehicle with the film *Mahogany*, directed by Berry Gordy. Motown proved that Black-owned businesses could change with the times, expand beyond initial blueprints, and thrive across entertainment entities, coming to represent a prominent success story in the industry that would often be cited in retrospect as a model of financial achievement and racial empowerment.

Political consciousness continued to permeate the work of Black musical artists during this time: Billy Paul's single "Am I Black Enough for You?" (1972), Curtis Mayfield's album *Curtis/Live* (1971) recorded at New York's Bitter End, and Aretha Franklin's live album *Amazing Grace* (1972), recorded at the New Temple Missionary Baptist Church in Los Angeles, which took the Queen of Soul back to her gospel roots, are just a few examples. The album cover for *Amazing Grace* features Franklin in Afrocentric style, merging traditional gospel with an updated aesthetic of Black consciousness, uniting elements that had previously been in opposition to each other. This legendary concert would later be released in the Sydney Pollack and Alan Elliott documentary *Amazing Grace* in 2018.

Artists such as Gil Scott-Heron and Brian Jackson, the Last Poets, and the Watts Prophets combined poetry and spoken word with militant Black advocacy in ways that prefigured the type of conscious hip hop that would start to emerge in the late 1980s. While this politically inspired music was generally embraced throughout the community, its direct confrontation with the ills of American society also faced backlash. In the early 1970s the war in Vietnam raged on, with thousands of Black men having been drafted to fight a controversial and incredibly unpopular war. Though a prominent figure like Muhammad Ali would famously refuse to participate in the war, other ordinary citizens were not so fortunate. Racial concerns about the number of Black soldiers being killed, which was disproportionately high relative to the actual percentage of Black people in the American population, would be referenced in the famous Do Lung Bridge sequence of Francis Ford Coppola's *Apocalypse Now* (1979), which depicted Black soldiers stationed in areas where the fighting was the most intense and the most dangerous. Back in the real war, a group of Black marines in Vietnam would face a court martial after playing the Last Poets' "The White Man's Got a God Complex" (1971) on board a ship. This controversial episode would highlight that the intense cultural battles taking place in the United States around race and identity were present among the soldiers in Vietnam as well.

Black consciousness and culture took on more avant-garde forms, too, with musicians like forward-thinking Betty Davis and Parliament Funkadelic's George Clinton, whose collaboration with graphic artist Pedro Bell emphasized a certain Afrofuturism in the work.

OPPOSITE: Isaac Hayes poses for the cover of his album *Black Moses*, Enterprise, 1971, photographer Joel Brodsky.

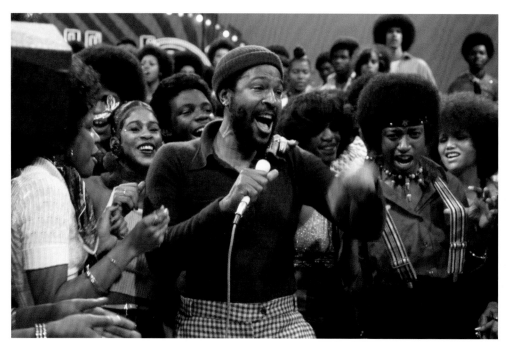

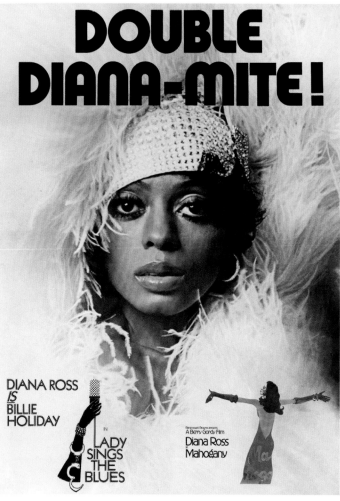

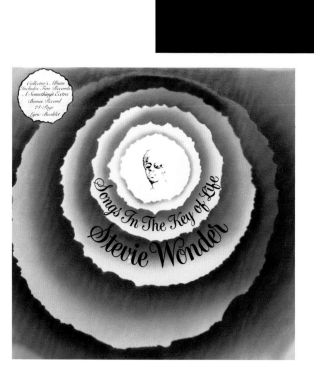

TOP LEFT: Marvin Gaye performs "Let's Get It On" on *Soul Train*, February 16, 1974, photographer unknown. **BOTTOM LEFT:** Movie poster for *Lady Sings the Blues*, starring Diana Ross, Paramount Pictures, 1972, dir. Sidney J. Furie. **BOTTOM RIGHT:** Album cover for *Songs in the Key of Life*, Stevie Wonder, Tamla, 1976.

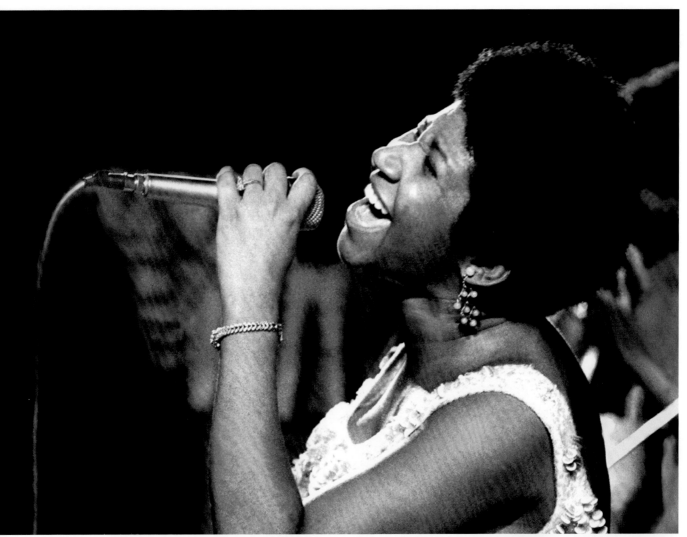

TOP: Aretha Franklin performs at the Palermo Pop festival, Palermo, Sicily, August 1, 1970, photographer Jan Persson. **BOTTOM LEFT:** Album cover for *Innervisions*, Stevie Wonder, Tamla, 1973, artwork by Efram Wolff. **BOTTOM RIGHT:** Album cover for *Amazing Grace*, Aretha Franklin with James Cleveland and the Southern California Community Choir, Atlantic Records, 1972, photographer Ken Cunningham.

TOP: Laurence Fishburne in *Apocalypse Now*, United Artists, 1979, dir. Francis Ford Coppola. **BOTTOM LEFT:** Gil Scott-Heron, c.1972, photographer unknown. **BOTTOM RIGHT:** Album cover for *This Is Madness*, The Last Poets, Douglas, 1971, artwork by Abdul Mati Klarwein.

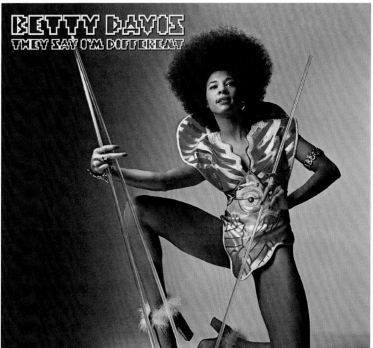

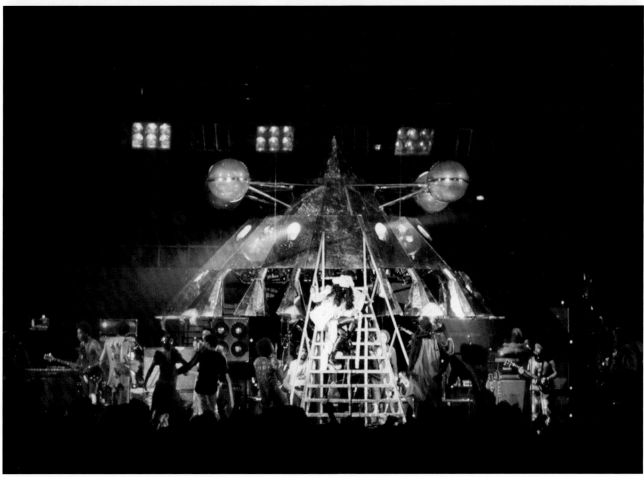

TOP LEFT: George Clinton of Parliament Funkadelic performs onstage at the Coliseum, Los Angeles, California, June 4, 1977, photographer unknown. **TOP RIGHT:** Album cover for *They Say I'm Different*, Betty Davis, Just Sunshine, 1974, photographer Mel Dixon. **BOTTOM:** The Mothership of Parliament Funkadelic lands onstage at the Coliseum, Los Angeles, CA, June 4, 1977, photographer unknown.

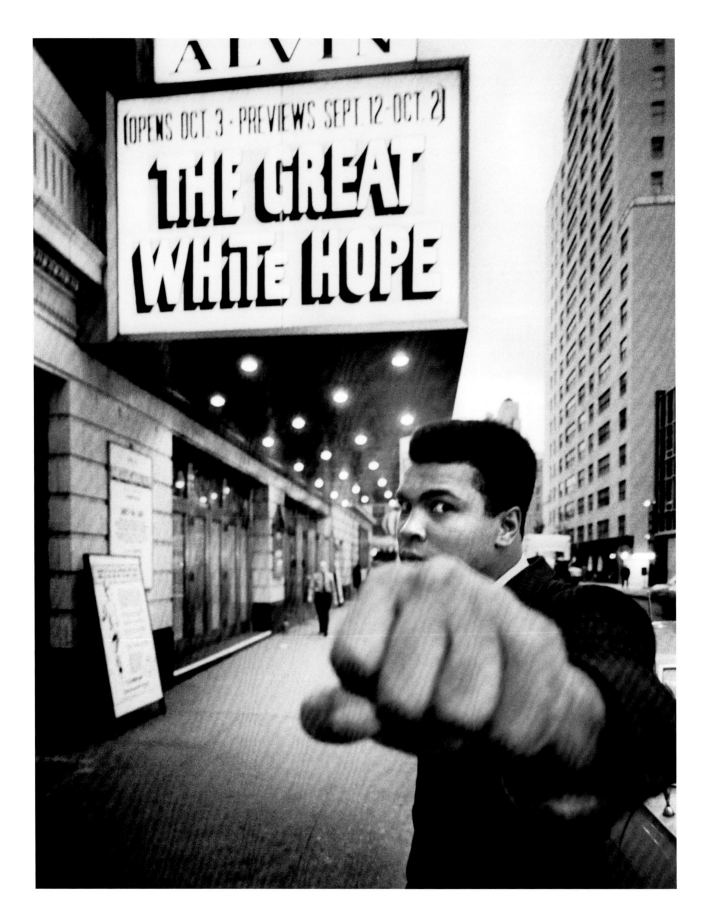

As hip hop moved from parties in rec rooms and local parks onto the global scene, it incorporated the world around it, including, among other political and cultural influences, elite icons of the 1970s: those making history on the biggest of stages.

Perhaps the most significant of these iconic figures was the individual who first embodied the acronym GOAT, as in "Greatest of All Time." That individual is, of course, none other than world-renowned boxer Muhammad Ali. After winning the heavyweight title, joining the Nation of Islam, changing his name, refusing to fight in Vietnam, and being forced into exile because of this during the 1960s, Ali would reemerge in the 1970s to reclaim his throne. His fights would become the stuff of legend. "Fight of the Century" (1971), "Rumble in the Jungle" (1974), and "Thrilla in Manila" (1975) were like their own best-selling novels or individual cinematic classics. They were also the place to be, attracting a who's who of society from every walk of life. Ali's subsequent victory in the Supreme Court would vindicate his decision to refuse the draft, proving him right all along, and reinforcing a sizable percentage of the country who agreed with his position as a conscientious objector.

Much like in the previous decade, Ali was everywhere in the 1970s, traveling the globe, meeting with heads of state, being a regular on a variety of talk shows, featuring in films, constantly being photographed, and appearing on magazine covers. His influence transcended boxing. In the 1960s he told the world that he was the greatest of all time and, a decade later, much of the world seemed to agree. Ali had become a global icon.

Long before hip hop, Ali had his own rhymes, used to promote his fights. His "hype man," who shouted encouragement, engaged in spirited call and response, and generally amped Ali up from the boxer's corner, was Drew Bundini Brown. Hype men are now a familiar part of a rapper's entourage, but Bundini occupied this role prior to such a distinct job title having even entered the lexicon. Ali's larger-than-life celebrity, his carefully crafted persona, and his boasts of greatness and superiority over his opponents—"The champ is here!" and "I am the greatest and I'm knocking out all bums!"—were hip hop before hip hop.

A master at the game of lyrical and psychological warfare, with the skills to crush his opponents verbally or physically, a comedian versed in the use of humor as diss, Ali was in many ways the prototype of how rappers would come to be seen. Hip hop owes a huge debt to Ali, in spite of the fact that he never officially rocked the mic.

Richard Pryor was another prominent cultural figure whose work across the entertainment spectrum dominated the 1970s. His stand-up comedy albums redefined the genre. In numerous movie appearances, both as the star and in supporting roles, he left an indelible mark. Pryor was one of several cowriters on the film *Blazing Saddles* (1974), with Mel Brooks, who also directed it, but he was deemed uninsurable by the studio over concerns about his reported volatility. In 1975, *Saturday Night Live* wanted him to host their new show so badly that they agreed to delay the broadcast so as to accommodate the network's concerns about his language. However, his own short-lived NBC television show was considered too provocative for prime time. The edgy, racially confrontational material that Pryor created was as groundbreaking as it was controversial. Yet he was so good at his craft that conservative studios and networks did what they had to do in order to benefit from the clout that Pryor added to their enterprise.

His open embrace of street life and street culture in his stand-up routines highlighted pimps, sex workers, dope fiends, and drug dealers, gangstas, hustlers, corrupt cops, sellouts, and haters —just the types of characters who would define hip hop in the years to come. Pryor's own personal encounters with cops, drugs, and sex all ended up in his act; nothing was off-limits. His fierce refusal to accommodate the parameters of what was considered legitimate expression on broadcast television prompted broadcast television to change its practices, not the other way around. Pryor's persona was what in future decades would be defined as that of a rap star, long before such definitions existed.

Pryor also consistently and strategically deployed what has come to be known as the n-word. He used the word as a title on multiple album covers and spoke it freely on stage. Before the more specific hip hop spelling of the word began to circulate, Pryor used the traditional spelling with the hard *r* sound, taking the word out of the hood and dropping it on mainstream America as though it were a linguistic bomb. Future debates

OPPOSITE: Muhammad Ali poses in front of the Alvin Theater during production of the play *The Great White Hope*, New York City, NY, 1968, photographer Bob Gomel.

about who should and should not use the term all got their start during Pryor's reign in the 1970s.

Icons who left their impression and identifiable influence upon hip hop came from across the cultural spectrum. Take, for example, jazz giant Miles Davis, who exhibited a version of celebrity that accentuated hipness while merging an empowered cultural defiance with an impeccably luxurious lifestyle. By the late 1960s Davis was moving in a new direction, musically and sartorially, and by the early 1970s he had fully executed this transition. No longer playing the acoustic jazz that had made him famous, he took a controversial turn and began to fuse jazz with rock, funk, and electronic instrumentation. Davis's 1970 album *Bitches Brew* embodied these changes, both for himself and for the larger music world. His personal style would change also. Previously known for a bespoke, tailored look, the musician, deeply influenced by Black rocker Betty Davis (née Mabry), his second wife, began wearing the type of psychedelic stylings that had been more commonplace in rock culture. As indicated by his appearance on the cover of *Rolling Stone* in 1969, Davis was an influencer and cultural tastemaker who became known for changing the direction of music multiple times throughout his career. Davis possessed abundant "swag"—driving a Ferrari, an exotic foreign sports car, when the American-made Cadillac was still considered the height of luxury—and he mixed it with a pronounced sense of defiant Blackness. His message to the public, was, in essence, "You can't fuck with me. I'm over your head and beyond your comprehension." These attributes of distinction anticipated the "Big Willie," "king," and "boss" personae that would emerge later in hip hop.

Other trailblazers of the era who deserve a mention include the R&B singer Millie Jackson, whose extended "raps" and use of profanity (which was especially rare at the time), along with explicit sexual stories and jokes, helped lay the groundwork for the emergence of rappers such as Lil' Kim and Foxy Brown in the 1990s. Martial arts star Bruce Lee could not get a shot as a leading man on American television of the early 1970s; he used the rejection as motivation and began making movies in Hong Kong, quickly becoming an international icon when these movies exploded in popularity across the globe. Though he died unexpectedly right before his first Hollywood feature, *Enter the Dragon*, directed by Robert Clouse, was released in 1973, he had already cemented his larger-than-life persona, whose influence could be seen years later in the merger of Black street culture and martial arts cinema embodied by the Wu-Tang Clan. Lee died tragically while making the film *Game of Death*, which he also directed, and which was released posthumously in 1978; his celebrated fight scene with NBA legend Kareem Abdul-Jabbar, who had studied martial arts under Lee, would assume an especially prominent spot in pop cultural history.

Born Ferdinand Lew Alcindor Jr., Jabbar cultivated a cool, introspective jazzlike persona on and off the court, becoming one of the nation's eminently visible sports figures and ultimately one of the greatest players ever. His conversion to Islam and subsequent name change, the mainstream visibility in *Game of Death*, and the art-world clout he gained from being one of Andy Warhol's Polaroid portrait subjects, cemented his iconic status, as well as his relevance to the emerging hip hop scene.

The world of sports has consistently overlapped with hip hop—from "the jump." Rappers have long name-checked prominent athletes in their rhymes. Sports and hip hop would also serve as a primary influence on sneaker culture and streetwear in general. In this regard, the sport most often associated with hip hop has been basketball; its athletes have been most visible in hip hop spaces, and "the game" is often used as a metaphor to define the cultural politics inherent to navigating both hip hop and hoops.

Basketball was undergoing an especially important cultural transition in the 1970s, as the racial dynamics of the sport were changing rapidly. As more Black players came into prominence, stylistic conflicts between the traditional way of playing what was known as "textbook" basketball and the free-flowing, improvisational form of urban "street ball" began to surface between the two professional basketball leagues: the National Basketball Association (NBA) and the American Basketball Association (ABA). The NBA was the more established league, and thus more traditional, while the upstart ABA was more experimental. By the mid-1970s the ABA was on its last leg financially, ultimately going out of business, though four teams from the ABA would merge with the NBA in 1976, bringing with them some of the style of street-ball gameplay.

Perhaps the most iconic hooper of the time was Julius Erving, otherwise known as Dr. J. The Doctor, often identified by his uniquely 1970s afro, carried the ABA on his shoulders before moving to the NBA's Philadelphia 76ers once the ABA dissolved. Dr. J was known for his spectacular dunks, winning the first dunk contest, while making this shot something of a signature style statement. In his merger of a street-ball aesthetic with expressive athletic creativity, Doc would become one of the NBA's greatest stylists. Though his career lasted into the late 1980s, Dr. J in many ways became synonymous with 1970s basketball and popular culture.

Another icon of the NBA was Walt "Clyde" Frazier of the New York Knicks, the first with his own signature shoe, the Puma Clyde, and a player who embodied *Super Fly* swag in his off-the-court Blaxploitation-style persona. In a similar fashion, Detroit's own George Gervin, better known as the Iceman, created a lasting image of this era when he appeared on a Nike poster sitting on blocks of ice while wearing a classic gray tracksuit with his name, "Ice," displayed across the chest. The now-famous poster "sampled" the album cover of Iceberg Slim's *Reflections* (1976), a reference that drew on the iconography, hipness, and overall swag of the original to create something instantly memorable. Nike was still a fairly unknown brand in the 1970s, but the Iceman poster demonstrated the marketing acumen that would come to define it in future decades and was an early indicator of why Nike would enjoy celebrated status in hip hop going forward. It highlighted the brand's ability to recognize trends and capitalize accordingly.

In other sports such as baseball—a conservative world where an old-school sensibility reigned—Dock Ellis, the man who became famous for pitching a no-hitter while trippin' on LSD, could be seen donning a head full of hair curlers so as to maintain his perm, a popular style in 1970s street culture. This was an astounding feat and an entertainingly incongruous sight when one considers the inherently reactionary culture of Major League Baseball. Yet it also demonstrates how this energized aesthetic of Blackness was moving into cultural spaces previously thought to be out of reach.

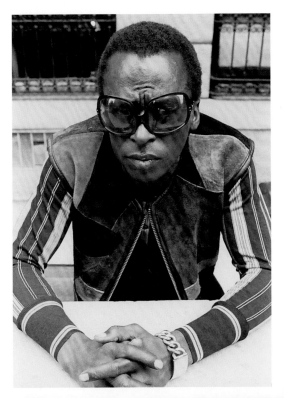

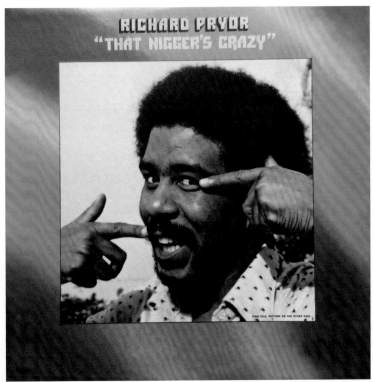

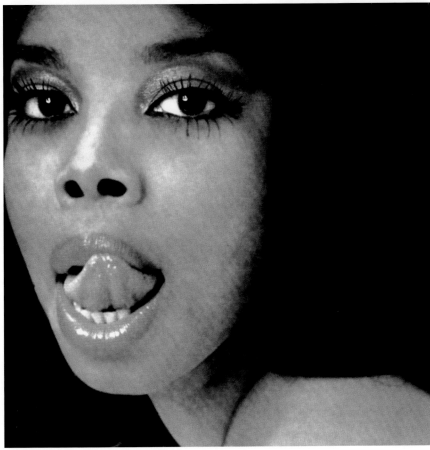

TOP LEFT: Miles Davis photographed for *Rolling Stone*, New York City, NY, December 1969, photographer Don Hunstein. **TOP RIGHT:** Album cover for *That Nigger's Crazy*, Richard Pryor, Partee Records, 1974, photographer Howard Bingham. **BOTTOM:** Millie Jackson poses for the cover of her album *Feelin' Bitchy*, Polydor, 1977, photographer Nima Yakubu.

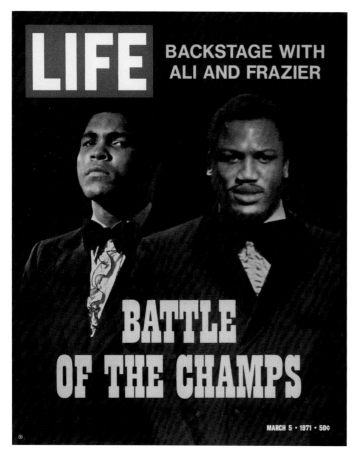

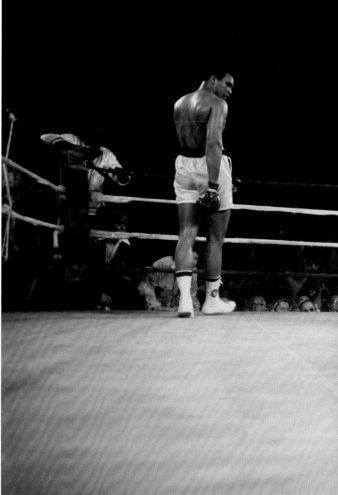

TOP LEFT: "Battle of the Champs," Muhammad Ali and Joe Frazier on the cover of *LIFE*, March 5, 1971, photographer John Shearer. **TOP RIGHT:** A fan in a fur hat at the Muhammad Ali–Oscar Bonavena fight, Madison Square Garden, New York City, NY, December 7, 1970, photographer Bill Ray. **BOTTOM LEFT:** Surrounded by his bodyguards and the world press, President Mobutu Sese Seko receives Muhammad Ali in his palace by the Zaire (Congo) River, Kinshasa, Zaire (DRC), 1974, photographer A. Abbas.

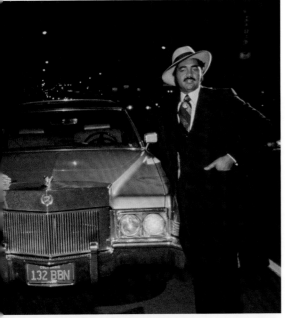

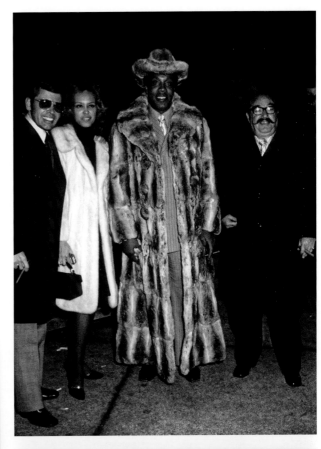

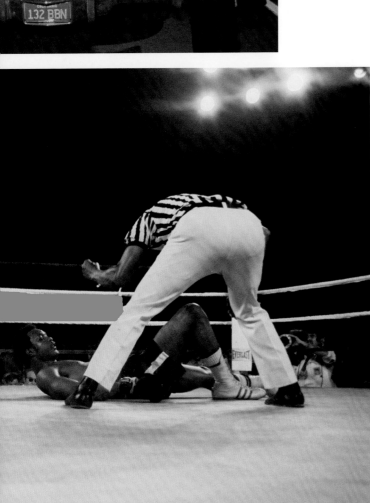

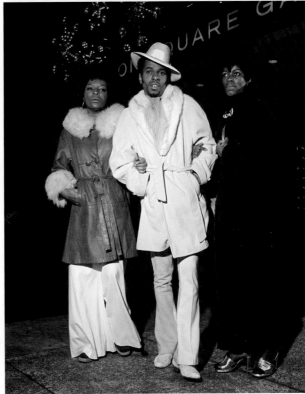

TOP CENTER AND BOTTOM RIGHT: Fans arrive for the Muhammad Ali–Oscar Bonavena fight, Madison Square Garden, New York City, NY, December 7, 1970, photographer Bill Ray. **TOP RIGHT:** Frank Lucas arrives at the Muhammad Ali–Joe Frazier fight in a chinchilla coat and hat, Madison Square Garden, New York City, NY, March 8, 1971, photographer Wil Blanche. **BOTTOM CENTER:** A referee bends over George Foreman, who has been knocked out by Muhammad Ali during the World Heavyweight Boxing Championship, Kinshasa, Zaire (DRC), October 30, 1974, photographer A. Abbas.

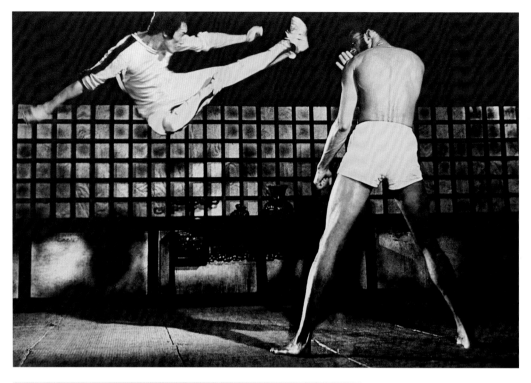

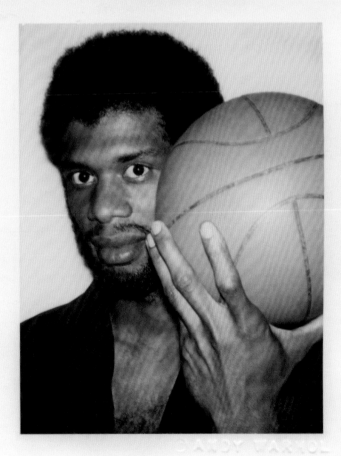

TOP LEFT: Bruce Lee and Kareem Abdul-Jabbar in *Game of Death*, Golden Harvest, 1978, dirs. Bruce Lee and Robert Clouse. Lee wrote, directed, produced, and starred in the film, which was incomplete when he died in 1973. Versions of the film were released posthumously in 1978 and 2000. CENTER: Julius Erving of the New York Nets soars to the basket during an ABA game at the Nassau Coliseum, Uniondale, NY, 1974, photographer Jim Cummins. BOTTOM LEFT: Andy Warhol, *Kareem Abdul-Jabbar*, Century City, Los Angeles, CA, November 4, 1978. Polacolor Type 108, 4¼ × 3⅜ in (10.8 × 7.7 cm).

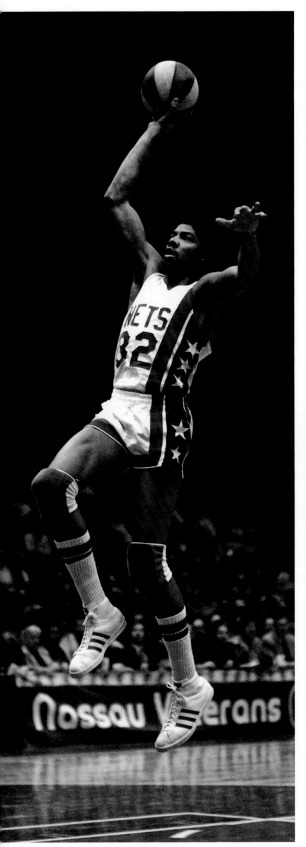

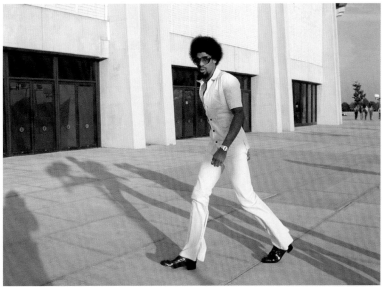

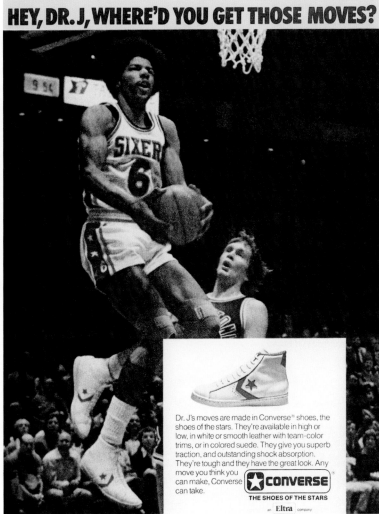

TOP RIGHT: Julius Erving of the New York Nets enters the arena before game four of the ABA Championship against the Denver Nuggets at the Nassau Coliseum, Uniondale, NY, May 8, 1976, photographer Manny Millan. **BOTTOM RIGHT:** "Hey, Dr. J, Where'd You Get Those Moves?", Converse All Star Pro Leather advertisement featuring Julius Erving, aka Dr. J, 1977.

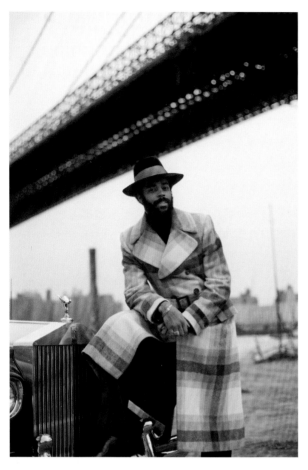

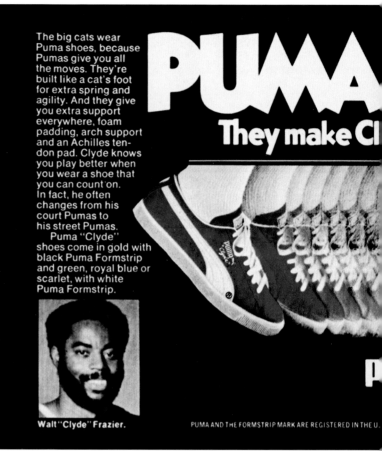

The big cats wear Puma shoes, because Pumas give you all the moves. They're built like a cat's foot for extra spring and agility. And they give you extra support everywhere, foam padding, arch support and an Achilles tendon pad. Clyde knows you play better when you wear a shoe that you can count on. In fact, he often changes from his court Pumas to his street Pumas.

Puma "Clyde" shoes come in gold with black Puma Formstrip and green, royal blue or scarlet, with white Puma Formstrip.

PUMA

They make Cl

Walt "Clyde" Frazier.

PUMA AND THE FORMSTRIP MARK ARE REGISTERED IN THE U.

TOP LEFT: Walt "Clyde" Frazier of the New York Knicks, New York City, NY, c.1972, photographer Ken Regan. **TOP CENTER:** "Puma Paws. They Make Clyde a Cool Cat," Puma Clyde advertisement featuring Walt "Clyde" Frazier, 1976. **BOTTOM:** Pittsburgh Pirates pitcher Dock Ellis arrives in the bullpen at Wrigley Field, home of the Chicago Cubs, with his hair in curlers, Chicago, IL, July 28, 1973, photographer unknown.

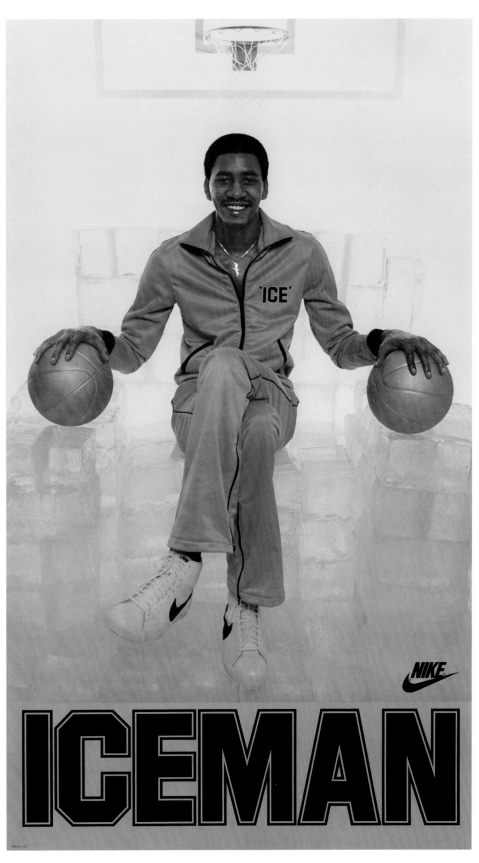

RIGHT: "Iceman," Nike advertisement featuring George Gervin, 1978, photographer Denny Strickland. **BOTTOM CENTER:** Album cover for *Reflections*, Iceberg Slim, ALA, 1976 (1980 re-issue), photographer Robert Wotherspoon.

BIG CITY OF DREAMS

While countless cultural influences circulated throughout the decade in which hip hop was formally born, the social, economic, and political conditions in New York City would also factor into its evolution. As a postindustrial economy began to take hold, the reality of urban decline came to define the city in the eyes of many.

The federal government's perceived indifference to New York's plight was broadcast in a now-infamous 1975 newspaper headline: "Ford to City: Drop Dead," which suggested that Gerald Ford's speech announcing his initial refusal to offer the city an economic bailout to avoid it filing for bankruptcy was, in essence, his way of telling New York to do just that. While Ford never actually uttered those words and the city did eventually receive federal loans, the damage was done, as this headline came to represent its rather dismal state of being at the time.

By September 1976, as Muhammad Ali was scheduled to defend his title in his third fight against Ken Norton outdoors at Yankee Stadium, the impact of the city's struggles had become undeniable. Layoffs of municipal workers, including a large number of cops, created a volatile situation. While the police amassed in protest outside the stadium, chaos reigned, with an avalanche of street crime descending upon the attendees who dared to make the trek to watch the fight. A year later, during the broadcast of the World Series from Yankee Stadium, iconic sportscaster Howard Cosell made repeated references to a burning building in the South Bronx while audiences were shown live footage of the fire. This imagery and the media's misattribution of the now-ubiquitous quote "Ladies and gentlemen, the Bronx is burning" came to represent wider public perception of an out-of-control New York City. The citywide blackout of 1977 would further solidify these attitudes.

Martin Scorsese's classic *Taxi Driver* (1976) is one of the most emblematic cultural representations of this era of New York history. Other films shot in the gritty urban landscape of New York City's streets spoke to the experience as well: *Shaft* (Gordon Parks, 1971), *The French Connection* (William Friedkin, 1971), *Across 110th Street* (Barry Shear, 1972), *Dog Day Afternoon* (Sidney Lumet, 1975), and *The Warriors* (Walter Hill, 1979), among others, embodied, visually and metaphorically, the transitional, decaying cityscape of 1970s New York. Such iconography would also be used to fuel the burgeoning hip hop movement across the city, which was created against a backdrop of structural racism, white flight, postindustrial urban decline, institutional breakdown, and financial hardship. This potent mix of societal tension urged a creative response; the developing underground culture was now feasting off its combustible energy.

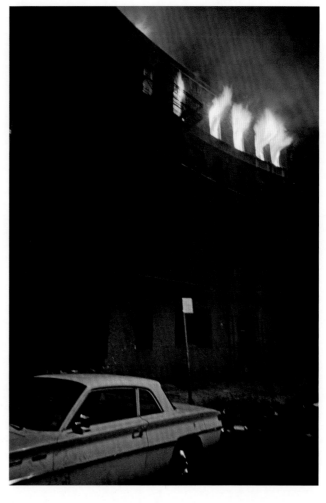

OPPOSITE: "Ford to City: Drop Dead," Mayor Abe Beame, in front of Gracie Mansion, holds up the famous *New York Daily News* front-page headline from October 30, 1975, New York City, NY, November 3, 1976, photographer Bill Stahl. **BOTTOM RIGHT:** Abandoned tenement building on fire, South Bronx, NY, 1977, photographer Alain Le Garsmeur.

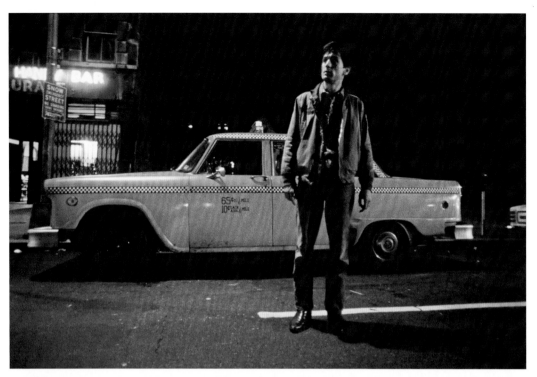

TOP LEFT: Robert De Niro in *Taxi Driver*, Columbia Pictures, 1976, dir. Martin Scorsese. **BOTTOM:** Montage of neon signs on Times Square and Broadway, New York City, NY, c.1970, photographer unknown.

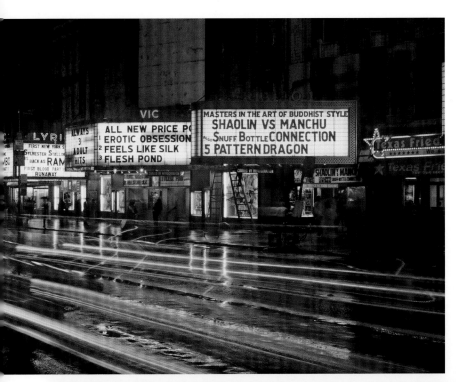

TOP CENTER: Cinema signs advertise adult and martial arts films on Forty-Second Street, New York City, NY, c.1977, photographer George Freston. **TOP RIGHT:** Movie poster for *Dog Day Afternoon*, starring Al Pacino, Warner Bros. Pictures, 1975, dir. Sidney Lumet.
BOTTOM: Roger Hill in *The Warriors*, Paramount Pictures, 1979, dir. Walter Hill.

WHAT YOU HEAR IS NOT A TEST

In the mid-1950s singer Sylvia Robinson performed as part of a duo known as Mickey & Sylvia, who had a big hit in 1956 with the song "Love Is Strange," which would feature prominently in Martin Scorsese's film *Casino* (1995). In the mid-1970s, now performing as just Sylvia, she scored another hit with the song "Pillow Talk" (1973). The single earned her an appearance on *Soul Train* at the peak of the show's cultural influence in the 1970s. Beyond these accomplishments, however, Sylvia's musical legacy will forever be tied to her identity as the "Godmother of Hip Hop," having founded the label Sugar Hill Records, which would release the first rap single, "Rapper's Delight," in 1979. This record would achieve huge global success, introducing hip hop to the world outside of New York, thus exposing it, or at least a commodified version of it, for all to enjoy, regardless of location. By condensing hours of what was previously a live experience onto a twelve-inch single that could be played on the radio, Sylvia gave the world a sample of what had otherwise only been accessible in person. "Rapper's Delight" moved hip hop from the underground to aboveground, turning street culture into a viable commercial vehicle and setting in motion the next forty years of American cultural history in the process. The Godmother, indeed.

Though hip hop would go on to conquer the world, the origin story of the Sugarhill Gang itself is a bit suspect. The trio of Big Bank Hank, Master Gee, and Wonder Mike were not rappers and had not worked as a group until they recorded the hit song for Sugar Hill Records. They were not legends from the underground now getting their chance to finally put their work out on wax so that others could experience their talent. Instead, they were basically three lucky-ass dudes who happened to be in the right place at the right time when Sylvia was trying to find a way to capture the live New York hip hop experience on record.

Big Bank Hank, a former club doorman and New Jersey pizza-parlor employee who also moonlighted as a manager for the well-known MC Grandmaster Caz, was "discovered" rapping along to one of Caz's rhymes while flippin' pizzas. After hearing Hank's karaoke-like performance of Caz's rhymes, Joey Robinson, Sylvia's son, invited him to the studio. Hank "brought two friends along," and they set off on what would become a historic journey, recording a rap song over the beat of Chic's popular song "Good Times" (1979).

As Hank was not a rapper himself, he had no lyrics of his own to "spit," so he asked Caz if he could borrow his rhyme book. But rather than simply using Caz's rhymes as inspiration, Hank lifted them directly for "Rapper's Delight." He was so "wack" as an MC, an occupation where authenticity, originality, and precise lyrical skills had become paramount, that he even spelled out one of Caz's nicknames, Casanova Fly, as opposed to his own, while rapping on the record: "Check it out / I'm the C-A-S-A-N / The O-V-A / And the rest is F-L-Y / You see I go by the code of the doctor of the mix / And these reasons I'll tell you why."

The Sugarhill Gang had been created in the studio and had never performed together before this song. Nonetheless, the fifteen-minute single would become the biggest selling twelve-inch in history. The fact that "Rapper's Delight," the song that introduced hip hop music to the world, was recorded by a group of nonrappers pulled together in a music studio is quite ironic considering the extent to which the aesthetics of realism would come to dominate hip hop culture. Perhaps this was the only way that such a culture dipped in authenticity could be transformed into something popular and fit for a mass audience? That notwithstanding, "Rapper's Delight" introduced the culture to the public, and the culture has never looked back. A few months later rapper Kurtis Blow, managed by a young Russell Simmons, released his 1980 single "Christmas Rappin," a Christmas rap song that, for me, humorously evokes the famous 1963 George Lois–designed *Esquire* magazine cover of boxer Sonny Liston wearing a Santa Claus hat. The release of "Christmas Rappin" indicated that "Rapper's Delight" was not just a one-off novelty song, but instead it marked the beginning of a movement. Hip hop was on its way.

I have always found the shady origin story of the Sugarhill Gang to be quite funny, actually. Hip hop got to be popular on a lark. There's something very American about this story of opportunism and facsimile cashing in on itself. Yet for people outside of the insular world of New York hip hop at the time, "Rapper's Delight" would, for better or for worse, represent an introduction, however inauthentic it might have been in its creation. That said, Hank's stolen lyrics speak directly to the concept of *Rapper's Deluxe*. Though Hank worked in a pizza parlor, his appropriated lyrics celebrate a life that is clearly not his own, but one that he can inhabit when rapping. The references to clothes, cars, and the

money to purchase such things highlight the culture's aspirations of social mobility. A desire to "shine," to make a name for yourself, to have enough money to be able to "style and profile" are at the core of hip hop's existence. As the genre grew beyond Sylvia's studio, themes of upward social mobility would become commonplace, even central, to the music. The desire to build wealth, get money, and secure the bag, the ambition to fully participate in capitalism, something denied to previous generations of Black Americans, was from the jump a vital element of hip hop culture. This was the American dream for those who had previously been excluded from dreaming. Yet this was not a scenario of compliance and obedience. It was not a desire to assimilate in any traditional sense. Instead, it was an attempt to place an indelible Black stamp on the meaning of American culture going forward.

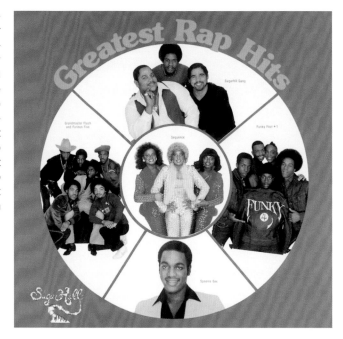

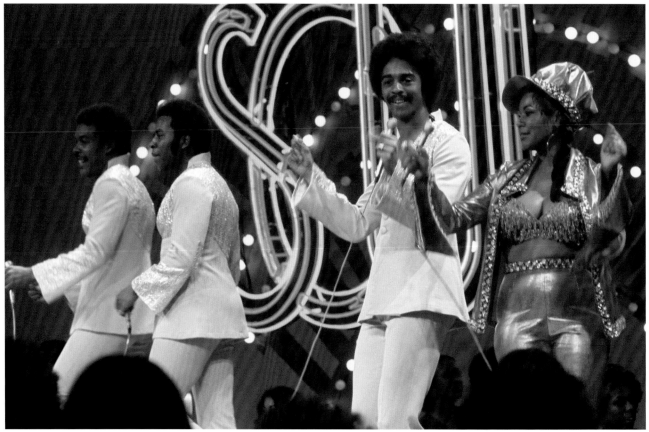

TOP RIGHT: Album cover for *Greatest Rap Hits*, various artists, Sugar Hill Records, 1980, artwork by Hemu Aggarwal. **BOTTOM:** Sylvia Robinson performs with the Moments on *Soul Train*, May 11, 1974, photographer unknown.

TOP: The Sugarhill Gang performs on *Soul Train*, May 16, 1981, photographer unknown. **BOTTOM LEFT:** Sugarhill Gang promotional photograph featuring (from left) Guy O'Brien, Henry Jackson, and Michael Wright, c.1975, photographer unknown. **BOTTOM RIGHT:** Kurtis Blow at the Peppermint Lounge nightclub, New York City, NY, 1980, photographer Stephanie Chernikowski.

HOW YOU
LIKE ME NOW?

TRADING PLACES

MOST ~~YOUNG~~ KINGS GET THEIR HEADS CUT OFF

OUT THERE! FOR YOU AIN'T NOTHING

IT'S LIKE THAT AND THAT'S THE WAY IT IS

FRESH DRESSED
Like A
MILLION BUCKS

From The Court
To The Street

THE KNOCK-UP

THE WORLD IS YOURS

YO! MTV RAPS

TRADING PLACES

As rap music entered a new decade, it was still early in its journey toward popular recognition. By the end of the 1980s this would no longer be the case. Larger-than-life "crossover" superstars, such as Eddie Murphy, Michael Jackson, Whitney Houston, Bill Cosby, and Prince, would come to dominate the mainstream, and hip hop culture would evolve from its marginal underground status to become a massive cultural force. Though hip hop was destined for greatness, it was routinely dismissed in these early years, championed by only a dedicated few. In time those few would be joined by a new generation whose cultural presence could no longer be denied.

In June 1980 comedian Richard Pryor shocked the nation when stories about his dramatic self-immolation during a drug binge began to spread. Pryor setting himself on fire while freebasing cocaine fulfilled the doomsday prophecy that had long loomed over his head, indicating that he was headed for self-destruction. Yet, as sensational as this story was, and despite the difficulties surrounding his recovery, Pryor would ultimately survive the incident. He would also make jokes about it in *Richard Pryor: Live on the Sunset Strip* (Joe Layton, 1982). The once edgy, provocative, and confrontational comic, who had fully embodied the concept of street credibility during the 1970s, soon transitioned into a more conventional mainstream actor who starred in middle-of-the-road comedy movies.

As Pryor came to occupy his new position in popular culture, a young comedian following in his footsteps began to emerge into the public consciousness. Eddie Murphy was only nineteen when he first appeared on *Saturday Night Live* (*SNL*), and, similar to Pryor, became so popular that *SNL* did everything it could to give him as much air time as possible. With characters such as Velvet Jones and Gumby, impersonations of celebrities like Stevie Wonder and James Brown, and skits such as the assassination of Buckwheat and "Mr. Robinson's Neighborhood," a riff on the popular educational children's series, *Mr. Rogers' Neighborhood*, Murphy was carrying the show on his back. Famously, in 1982, the comic hosted the show while also appearing as a cast member.

Murphy's two stand-up comedy performances, *Delirious* (Bruce Gowers, 1983) and the concert film *Raw* (Robert Townsend, 1987), were phenomenally successful. He also appeared in scene-stealing roles for films like *48 Hrs.* (Walter Hill, 1982) and *Trading Places* (John Landis, 1983) before becoming a leading man in the especially popular *Beverly Hills Cop* (Martin Brest, 1984). His film *Coming to America* (John Landis, 1988) is perhaps his best work.

At the outset of the 1980s Pryor could have been considered the MC of the culture; by the middle of the decade, the mic would pass to Murphy. The image of Pryor and Murphy on stage, Black men with microphones in their hands, breaking down what was going on in the world, came to serve as a metaphor. "A lot of truth is said in jest," goes the saying, and both performers were elevating the form and function of the Black comic as the ultimate truth teller.

The symbolism of the microphone is key to understanding the role that Pryor and Murphy played within the culture—and it is also what connects them to hip hop. As hip hop stepped into the limelight, it would be the MC, the microphone controller, who would take center stage. Though hip hop culture had originally been defined by its "four elements"—deejaying (DJing), emceeing (MCing), break dancing, and graffiti—it was the MC who translated most easily into the world of commodified popular music. The MC came to be regarded as the leader, the figure around whom the record industry could build and market an identity. In time the other elements began to recede into varying degrees of visibility, much to the chagrin of many hip hop purists. But before MCs took over the game, it was cats like Pryor and Murphy who rocked the mic.

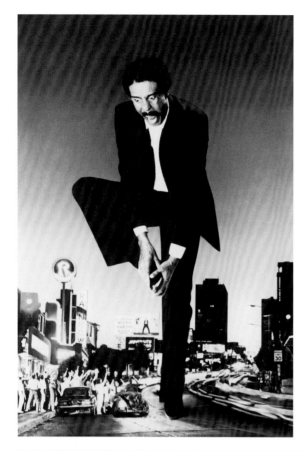

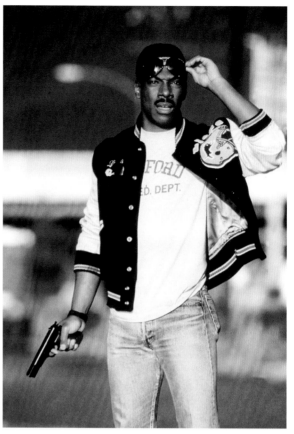

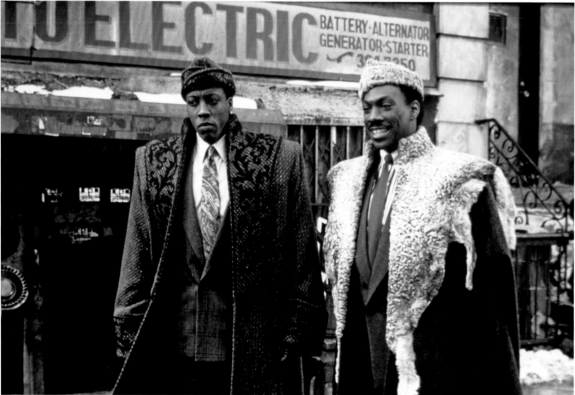

TOP LEFT: Movie poster for *Richard Pryor: Live on the Sunset Strip*, Columbia Pictures, 1982, dir. Joe Layton. **TOP RIGHT:** Eddie Murphy in *Beverly Hills Cop*, Paramount Pictures, 1984, dir. Martin Brest. **BOTTOM:** Eddie Murphy and Arsenio Hall in *Coming to America*, Paramount Pictures, 1988, dir. John Landis.

I went to jail for income tax evasion,
right, you know? I didn't know
a motherfucking thing 'bout no taxes
I told the judge, said "Your Honor,
I forget," you know? He said,
"You'll remember next year, nigger."
They give niggers time like it's
lunch down there.
You go looking for justice
that's what you find: just us.

TOP: Installation view of Glenn Ligon, *Live*, 2014, Regen Projects, Los Angeles, CA, 2015. Seven-channel video, 80 mins, edition of 3 and 1 AP.
BOTTOM: Glenn Ligon, *Just Us (Gold) #7*, 2007. Oil stick and acrylic on canvas, 32 × 32 in (81.3 × 81.3 cm).

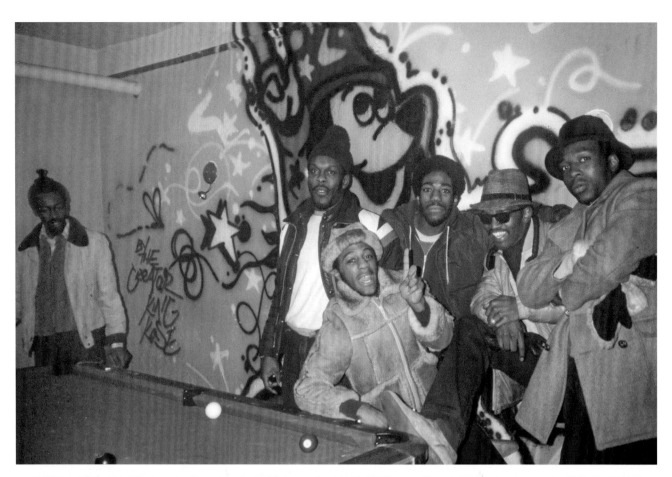

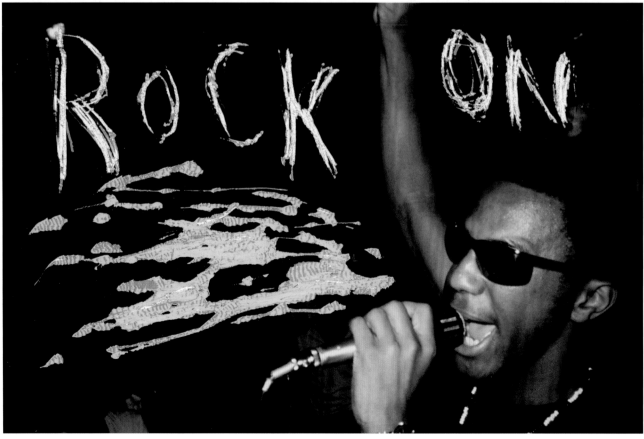

AIN'T NOTHING OUT THERE FOR YOU

As hip hop moved increasingly into public view and its reach extended beyond the boundaries of New York, one of the first films to chronicle its expanding culture was the independent Charlie Ahearn production *Wild Style*, released in 1983. The documentary *Style Wars* (Tony Silver), which covers similar territory, was released the same year. Shot on location in and around the Bronx, *Wild Style* featured several MCs—Busy Bee, the Cold Crush Brothers, and Grandmaster Flash—along with various break dancers and graffiti artists, including the film's protagonist, Zoro, played by Lee Quiñones. *Wild Style* mixed elements of reality and fiction in creating a visual representation of this underground subculture. Though the graffiti movement unfolded far away from the museums and galleries of New York's elite art world, its signature street artistry was nonetheless quite visible throughout the city in the late 1970s and early 1980s, appearing on subway trains, walls, and vacant buildings, basically anywhere in the urban environment where a tagger could display their work. Yet the authorities, the status quo, haters in general, did not appreciate the art, and regarded graffiti as a public nuisance. Elected officials, law enforcement, and many others considered it vandalism, a criminal act deserving of punishment.

As the film opens, Zoro is arguing with his brother, who recently arrived home from the military and is upset that Zoro has tagged the wall of his bedroom. Critical of graffiti in general, and especially of how Zoro has chosen to spend his time tagging, the brother's hostile comments echo the prevailing attitude toward the practice at the time. He calls the work "fuckin' garbage," tells Zoro that people are "sick of it," and asks him if he's been arrested yet for tagging. Zoro suggests that his brother is not hip and that graffiti is over his conformist, military-minded head. The brother tells Zoro to "stop fuckin' around and be a man," admonishing him, describing his investment in graffiti as a waste of time: "There ain't nothin' out there for you." Zoro responds emphatically, "Oh yes there is. This!" as a subway train adorned with graffiti enters the frame and a slick break beat underscores the point.

This conversation between Zoro and his brother draws many parallels with concurrent debates happening around hip hop. While the status quo regarded graffiti as a nuisance or, worse, a criminal act, hip hop culture, which was similarly attempting to give a voice to the voiceless, recognized it as a game-changing form of cultural expression that could and would eventually rock the world.

In *Wild Style*, Fab 5 Freddy (Fred Braithwaite) plays Phade, a former graffiti artist who introduces a white writer from the *Village Voice* to the exclusive, underground hip hop scene. True to life, Fab would be instrumental in bridging the gap between the worlds of hip hop and other burgeoning musical genres such as punk, in addition to connecting hip hop to bohemian cultural platforms like the *Village Voice* and the downtown art scene. Fab 5 appears in the Blondie video for "Rapture" (1980), where Debbie Harry name-checks him: "Fab 5 Freddy told me everybody's fly / DJ spinnin' / I said / My my." Freddy's friend, artist Jean-Michel Basquiat, is another notable feature in the video. In it he plays a DJ, a role that was intended for Grandmaster Flash, who Harry also shouts out in the song. Flash was a no show that day, so Basquiat took his place.

OPPOSITE TOP: (from center left) Busy Bee, King Kase (aka Kase 2), Fab 5 Freddy, and friends at the Cheeba Spot, Bronx, NY, 1980, photographer Charlie Ahearn. OPPOSITE BOTTOM: Busy Bee "Rock On" scratch slide, 1980, photographer Charlie Ahearn. OVERLEAF: Campbell's Soup train piece by Fab 5 Freddy, Bronx, NY, 1980, photographer Charlie Ahearn.

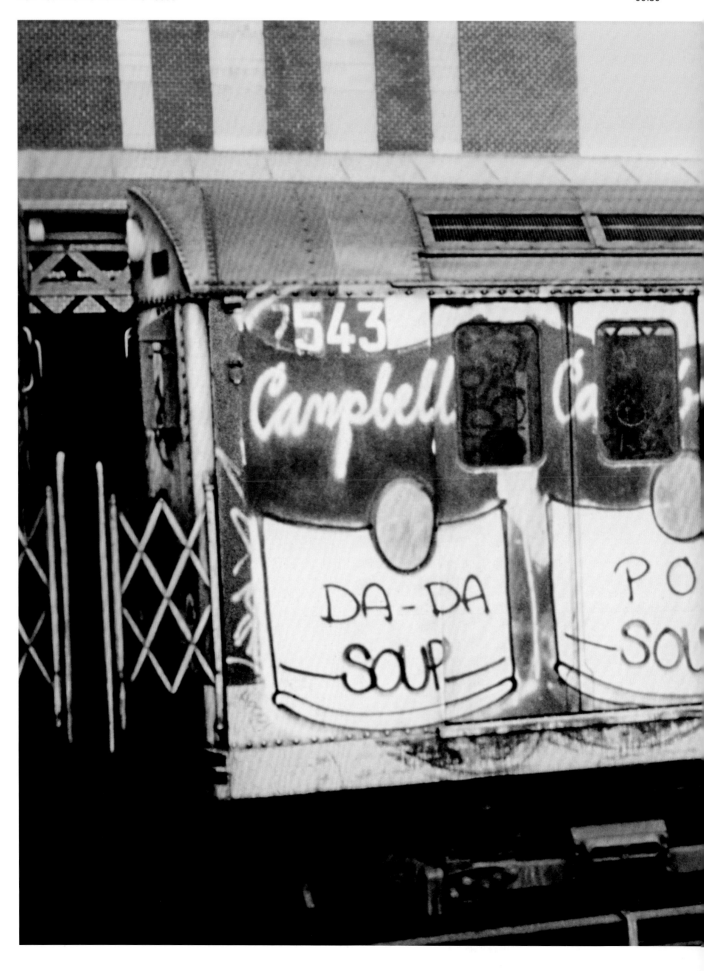

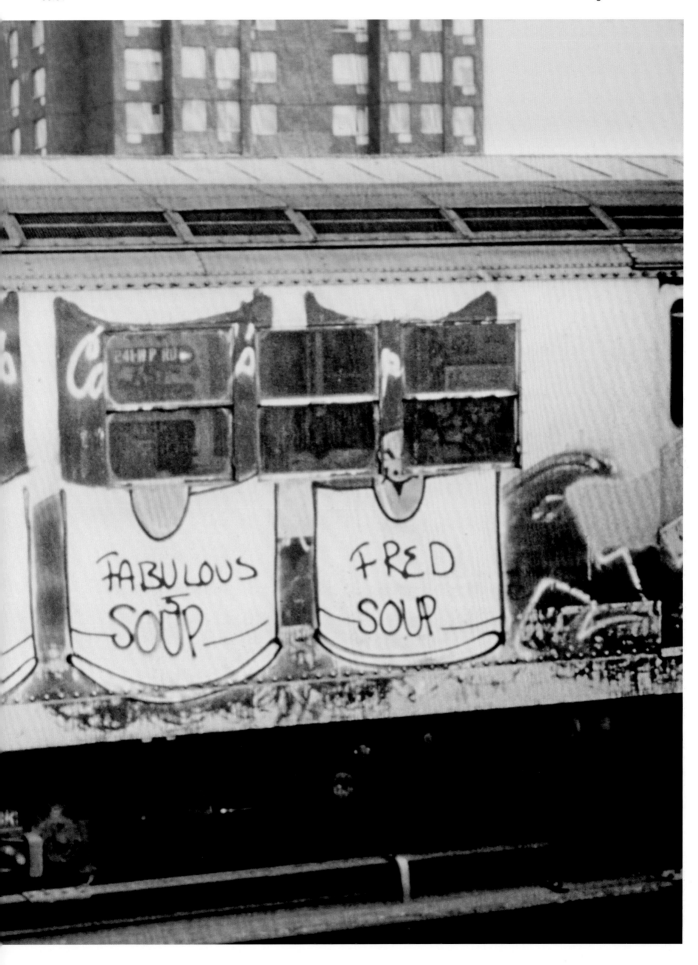

TOP: Crush Nod train piece on the #1 IRT line, Bronx, NY, 1980, photographer Henry Chalfant. **BOTTOM LEFT:** Gman (center) and two friends with his homemade speaker at a park jam on 144th Street and 3rd Avenue, Bronx, NY, 1983, photographer Henry Chalfant. **BOTTOM RIGHT:** Electric Boogie dancer at a park jam on 144th Street and 3rd Avenue, Bronx, NY, 1983, photographer Henry Chalfant.

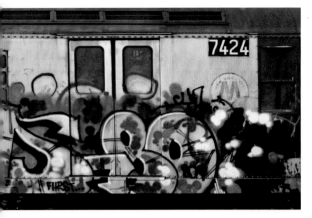

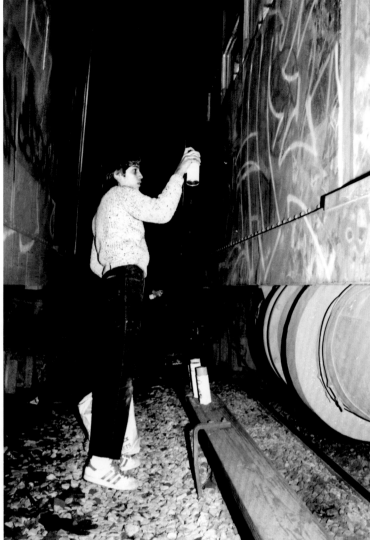

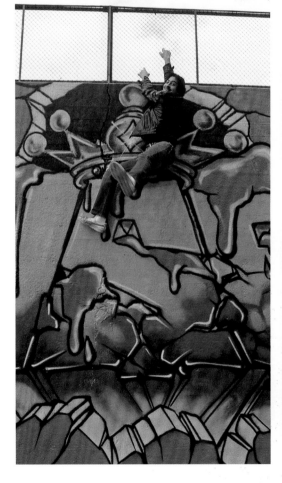

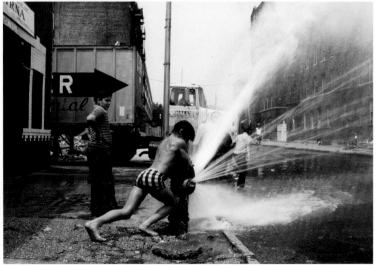

TOP RIGHT: Mare paints at New Lots Yard, Brooklyn, NY, 1981, photographer Henry Chalfant. **BOTTOM LEFT:** Seen climbs atop his mural, Bronx, NY, 1985, photographer Henry Chalfant. **BOTTOM RIGHT:** Summer hydrant spray game, Bronx, NY, c.1984, photographer Henry Chalfant.

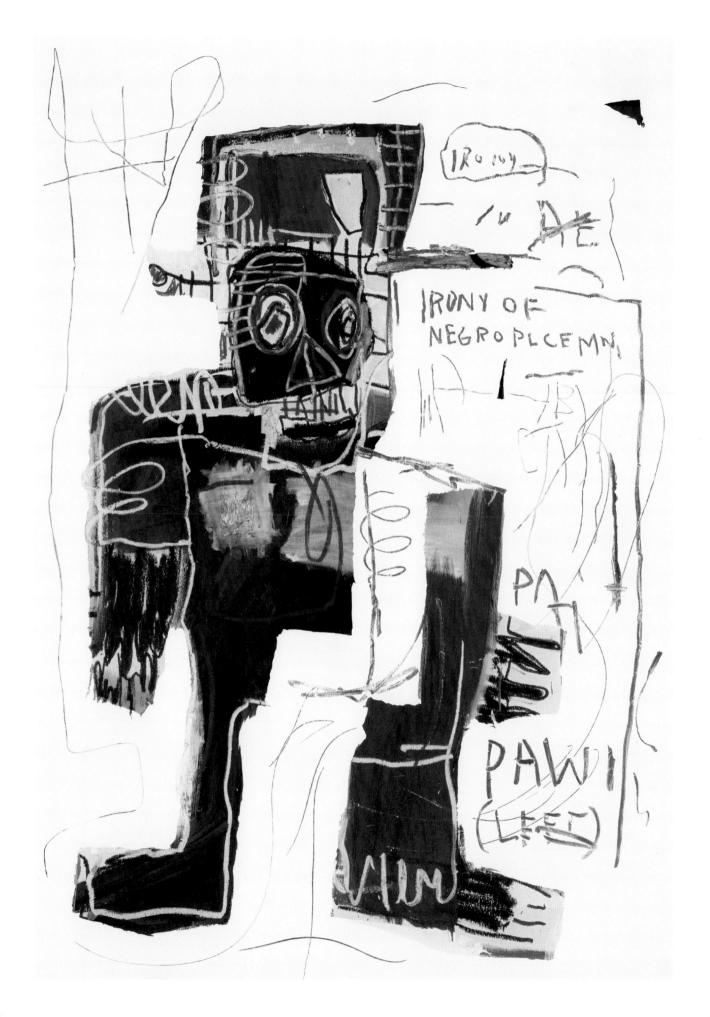

MOST ~~YOUNG~~ KINGS GET THEIR HEADS CUT OFF

Jean-Michel Basquiat was much more than just a fill-in for an absent Grandmaster Flash in a Blondie music video. The artist, whose identity and overall body of work have gained worldwide renown in the years since his passing in 1988, was under-appreciated in his time, as was his influence on hip hop. Between the early 1980s and his death, as hip hop began its ascent from subcultural to cultural, Basquiat shook up the elitist, racially exclusive white art world in ways similar to what hip hop was doing relative to popular culture. Initially with his provocative downtown New York tags under the SAMO moniker, later with his masterly and uniquely original paintings, and ultimately with his larger-than-life persona, Basquiat made an indelible impact in a place where his presence was hardly welcome.

Whether it was starring in the semi-autobiographical independent film *Downtown 81* (Edo Bertoglio, 2000), appearing on the cover of the *New York Times Magazine* in 1985 wearing an Armani suit with no shoes on, or posing with Andy Warhol in boxing attire to promote their collaborative exhibition, Basquiat was a cultural celebrity before the culture itself could fully accommodate him. Like hip hop, Basquiat's work sampled the worlds of jazz and sports, often shouting out prominent Black legends in the process. In other instances, the paintings provided ironic commentary on social ills, such as police brutality, that have long been topics of critique in Black culture. In a piece like *Irony of Negro Policeman* (1981) Basquiat anticipates Ice Cube's line from N.W.A.'s anthem "Fuck tha Police" (1988): "But don't let it be a Black and a white one / 'Cause he'll slam you down to the street top / Black police showin' out for the white cop." The repeated motif of the crown in his paintings calls to mind jazz greats like Duke Ellington and Count Basie, who took on such monikers of royalty as a way of elevating themselves in an environment where racism had repeatedly worked to denigrate them.

The crown also points to hip hop's future emphasis on Black kings, the "King of New York" concept—an honor ascribed to the rapper considered the best in the city—and the image of "African kings" as authoritative status symbols denied their reign because of the American slave trade. More recently, the term *king* has served as a hip hop-style greeting of affirmation used to address various individuals within the culture—as in, "What's up, King?"

Basquiat's distinct, organized-chaos painting style aligns with elements of hip hop in several ways: his artworks draw from and remix a variety of historical, cultural, and artistic influences simultaneously; the crossing out of text is akin to scratching on a record; and his work is characterized by a wordsmith-like rhetorical sophistication.

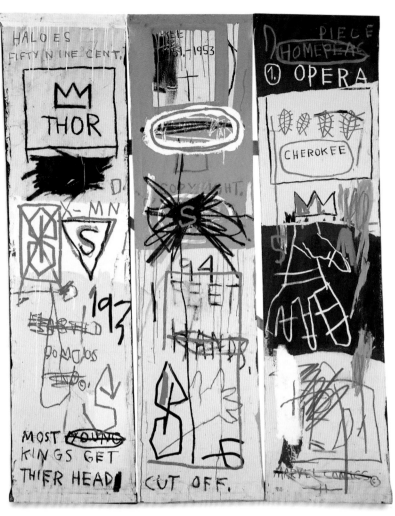

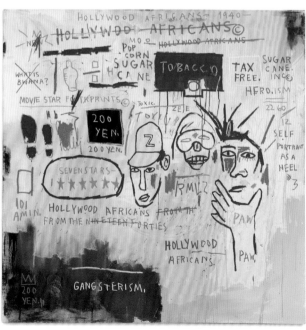

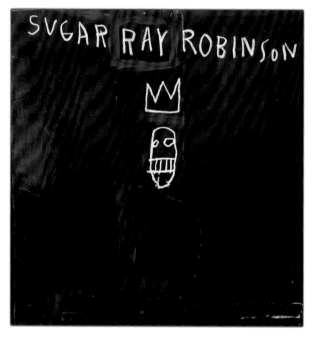

TOP LEFT: Jean-Michel Basquiat, *Charles the First*, 1982. Acrylic and oil stick on canvas, 78 × 62 in (198 × 158 cm). **BOTTOM LEFT:** Jean-Michel Basquiat, *Hollywood Africans*, 1983. Acrylic and oil stick on canvas, 84¹⁄₁₆ × 84 in (213.5 × 213.4 cm). **BOTTOM RIGHT:** Jean-Michel Basquiat, *Untitled (Sugar Ray Robinson)*, 1982. Acrylic and oil stick on canvas, 42 × 42 in (106.7 × 106.7 cm).

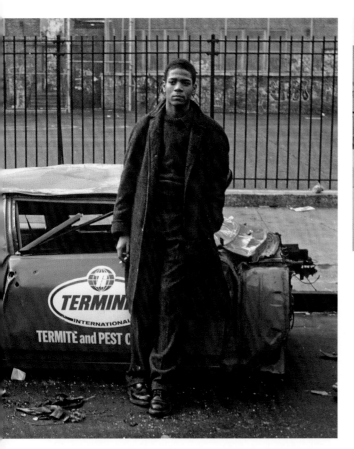

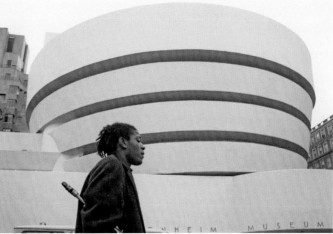

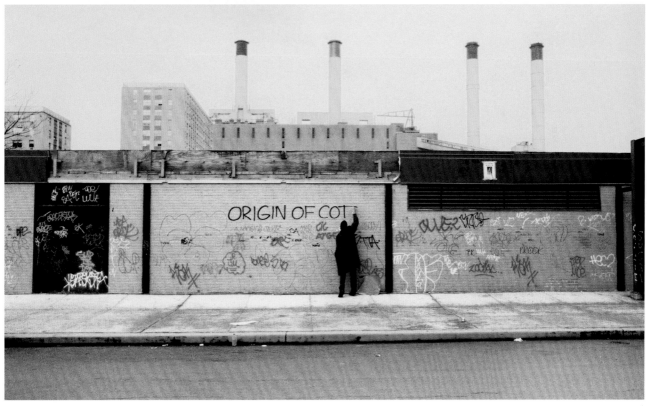

Basquiat's Car Wreck (top center); *Basquiat's Guggenheim* (top right); *Basquiat's Origin of Cotton* (bottom), New York City, NY, 1981, Jean-Michel Basquiat on the set of *Downtown 81*, New York Beat Films, 2000, dir. and photographer Edo Bertoglio.

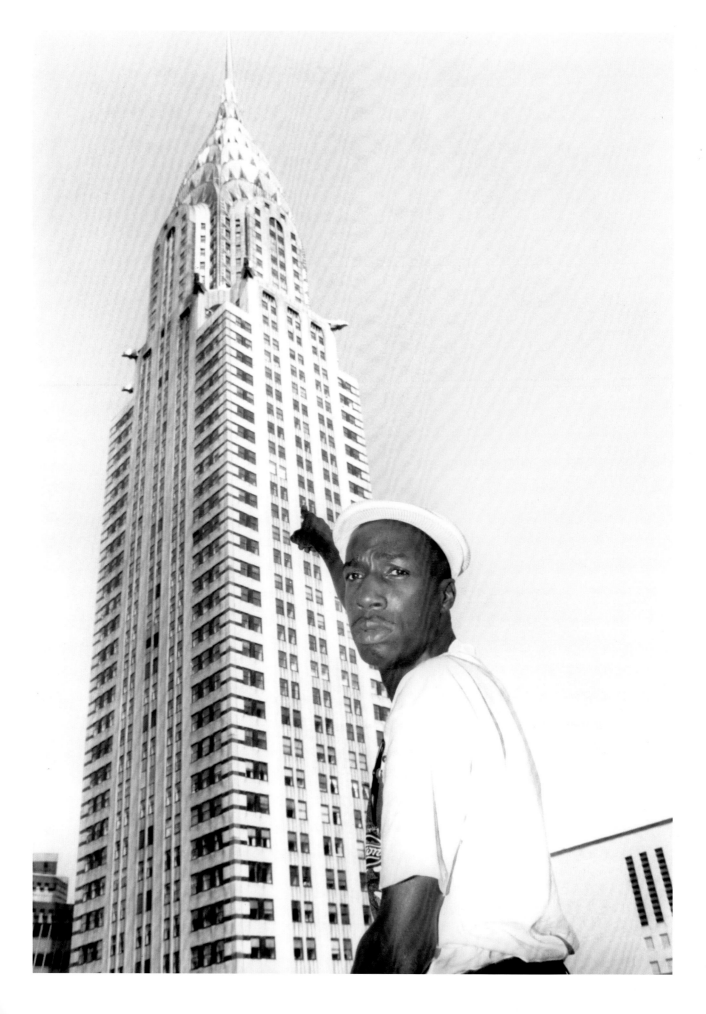

The JUNGLE

Blame Reagan for making me into a monster / Blame Oliver North / And Iran Contra / I ran contraband that they sponsored.
Jay-Z, "Blue Magic," 2007

The year 1980 featured a presidential election that would prove to be especially consequential in American history, as well as in the development of hip hop culture. Incumbent President Jimmy Carter was running against the former actor and governor of California Ronald Reagan, who in the 1960s and 1970s had burnished his political credentials by going after student radicals and Black militants such as Angela Davis and the Black Panthers. While still a candidate for governor in 1966, Reagan infamously stated that "if an individual wants to discriminate against Negroes or others in selling or renting his house, he has the right to do so," clearly signaling his opposition to fair housing legislation. Though Reagan represented an alternative to the Southern segregationist image that was most often associated with the racism of the era, his politics were no less problematic.

After Reagan won the Republican presidential nomination in 1980, he began his campaign against Carter by making an appearance at the Neshoba County Fair, just outside of Philadelphia, Mississippi. Philadelphia is the county seat of Neshoba County and the location of the infamous abduction and murder of three civil rights activists, James Chaney, Andrew Goodman, and Michael Schwerner, in 1964. During his speech to the crowd that day, Reagan stated, "I believe in states' rights." The phrase "states' rights" had, of course, been the more politically acceptable phrase for white Southerners who continued to embrace segregation in opposition to the efforts of the civil rights movement and subsequently the federal government. Reagan's hostility toward racial progress was not new, but the direct appeal in such a symbolic location spoke volumes. This was Reagan's version of what Richard Nixon called the "Southern strategy," which boiled down to openly pursuing the votes of the white Southerners who vehemently opposed integration and civil rights for Black citizens. These voters had deserted the Democratic Party after Lyndon Johnson signed the Civil Rights and Voting Rights Acts during the 1960s. Nixon, Reagan, George H. W. Bush, and later Donald Trump would all employ elements of this corrupt strategy in the interest of attracting such voters.

With "Let's make America great again" as a prominent campaign slogan, Reagan often spoke in code as it pertained to racial issues. Unlike his comment supporting housing discrimination in 1966, he now seldom approached the discussion of racial issues directly; instead, he used what is sometimes referred to as "dog whistle" language. This included his repeated references on the campaign trail to the "welfare queen" and the "strapping young buck," disgustingly stereotypical images of Black women and men, respectively, who were, in his framing, exploiting the government's welfare and food-stamp programs, while people who he described as hard-working, tax-paying, law-abiding (white) citizens were struggling to make ends meet. With such references, he did not explicitly say that Black people were lazy, dishonest thieves who were living large while the working-class white taxpayer footed the bill, but the implication was undeniable.

Reagan also made an appearance in the Bronx during his 1980 campaign. Perhaps unsurprisingly, as he stood among the rubble of urban blight, the gathered audience was not nearly as moved by his stale political rhetoric as those in Mississippi had been. Attempting to give a typical stump speech, Reagan was shouted down by the boisterous crowd. He failed to suppress his annoyance. The exchange was quite chaotic and generally contested. Reagan's inability to engage the poor and working-class residents of color in the borough that had given birth to hip hop would foretell the rejection of his ultraconservative agenda among racially marginalized citizens during his eventual presidency.

As the 1980s unfolded, Reagan came to represent the institutional and systemic forces, such as the War on Drugs, that would have a devastating impact on Black communities. Reaganomics, often used to describe the drastic economic agenda enacted under Reagan, spoke to the massive rates of unemployment that defined the lives of communities of color who suffered extensively as the United States transitioned into a postindustrial society.

Evidence of scathing sentiments directed toward Reagan and the version of America that he represented were summarized especially well in the Gil Scott-Heron song "B Movie," released in 1981, the year that Reagan took office. Similar to "The Revolution Will Not Be Televised" (1971) and "Winter in America" (1974),

among other Scott-Heron tracks, "B Movie" laid out a social critique that thoroughly excoriates Reagan, along with the motivations behind his agenda. Using the old Hollywood metaphor of a B movie, the low-budget productions meant to serve as a companion to the main attraction, which Reagan appeared in when he worked as an actor, Scott-Heron explains how pop culture mingled with ideology, white mythology, and misinformation, leading to the unfortunate election of Reagan in 1980.

Yesterday was the day of our cinema heroes / Riding to the rescue at the last possible moment / The day of the man in the white hat / Or the man on the white horse ... And when America found itself having a hard time facing the future / They looked for people like John Wayne / But since John Wayne was no longer available / They settled for Ronald Reagan.

"B Movie" lampooned Reagan's right-wing dogma, exposing it for the bigotry, prejudice, and overall assault on the rights of disenfranchised individuals that it represented, connecting Reagan's own personal history with what this portended for the United States: "Call in the cavalry to disrupt this perception of freedom gone wild / Goddammit / First one wants freedom / Then the whole damn world wants freedom."

With this song playing on urban radio in 1981, displaying its distinct combination of spoken-word delivery and cultural commentary, Scott-Heron would inspire new modes of expression within hip hop, as the genre came to find its voice in a new era. One year later, a rap song would emerge that demonstrated the influence of "B Movie" and other examples of socially conscious Black music that had come before it. That song was called "The Message."

Broken glass / Everywhere / People pissin' on the stairs / You know they just don't care ... Rats in the front room / Roaches in the back / Junkies in the alley / With a baseball bat / I tried to get away / But I couldn't get far / 'Cause a man with the tow truck repossessed my car.

In 1982 hip hop was still very much considered party music and DJs had become popular based on their ability to "move the crowd." Afrika Bambaataa and the Soul Sonic Force scored a huge hit with "Planet Rock." Inspired by Kraftwerk, the innovative German group regarded as pioneers of electronic music, Bambaataa managed to merge the electro sound with the vibe of a live hip hop affair. If someone put on "Planet Rock" in 1982, it was a sure sign that the dance floor was about to fill up at the first beat: "Rock / Rock / To the planet rock / Don't stop."

Sugar Hill Records studio musician Ed Fletcher, better known as Duke Bootee, was less enthusiastic about the emerging trend. Though not a rapper, Bootee had previously written poetry and had only started getting into hip hop once he joined Sugar Hill in the early 1980s. Like a lot of other rap skeptics in the early days, he was rather unimpressed with what he considered superficial lyrical content or what the Last Poets referred to as "party and bullshit," the type of hedonistic music that dominated the music industry at the time.

Staying true to his tastes, Bootee started writing a track that he called "The Jungle," a politically conscious observation on society, somewhat similar to the work of Scott-Heron. Sylvia Robinson liked the song and wanted one of the groups on her Sugar Hill Records label to record it, but initially she found no

takers. In this era of party music, the idea was that people wanted to get away from the struggles of the world when they came out to dance, and "The Jungle" was considered too slow to be danceable.

Drawing inspiration from Brian Eno, the Tom Tom Club, and Zapp, Bootee created a new backing track that was somewhat trippy and minimalist but that helped focus the listener's attention on the lyrics. This updated version would eventually be released under the group name Grandmaster Flash and the Furious Five, featuring Melle Mel and Duke Bootee, but superstar DJ Grandmaster Flash was not a fan. To try and remedy this, Melle Mel, a member of the Furious Five, added a verse from another track that he had recorded but hadn't had much exposure. The finished article, cocreated by Duke Bootee and Melle Mel, but credited to Flash and the entire group, became "The Message."

Like the Last Poets and Scott-Heron, but updated with a specific hip hop flow, "The Message" was the perfect song to describe the difficulty of urban Black life in the United States under Reaganomics. The rampant unemployment, racism, poverty, crime, and an overall lack of hope are perhaps best summed up in Melle Mel's verse, now used at the end of the new song: "A child is born with no state of mind / Blind to the ways of mankind / God is smiling on you / But he's frownin' too / 'Cause only God knows what you'll go through." The song's hook spoke of the post-traumatic stress that living life under these circumstances entailed: "Don't push me / 'Cause I'm close to the edge / I'm tryin' not to lose my head / It's like a jungle sometimes / It makes me wonder / How I keep from going under."

"The Message" demonstrated that hip hop could be both knowledgeable and funky at the same time, and the lyrics were a stark departure from the stylized, hyperbolic braggadocio that most MCs were "spittin'." Stylish and substantive, it was an example of rap music as social critique, pointing the way to a more serious focus on lyricism and the emergence of politically minded "conscious" hip hop in the years to come.

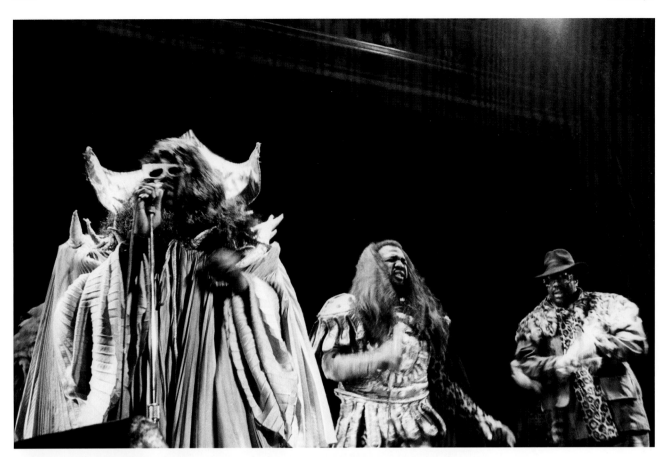

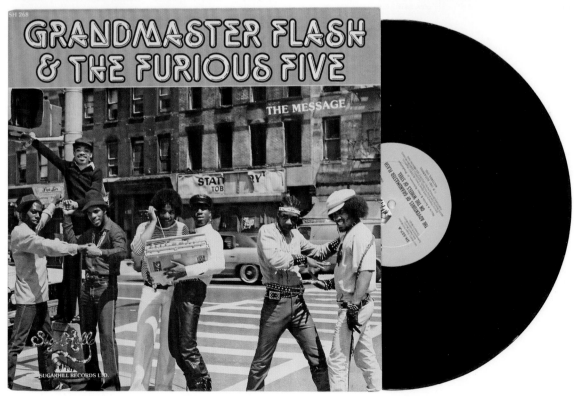

TOP: Soul Sonic Force performs at the Ritz-Carlton hotel, New York City, NY, 1984, photographer Josh Cheuse. **BOTTOM:** Single cover for "The Message," Grandmaster Flash and the Furious Five, Sugar Hill Records, 1982, photographer Hemu Aggarwal. **OVERLEAF:** Ronald Reagan visits the South Bronx during his presidential campaign, New York City, NY, August 5, 1980, photographer Dave Pickoff. The Republican candidate, who traveled to the Bronx after addressing the National Urban League conference in New York, cited this neighborhood as a prime example of urban decay.

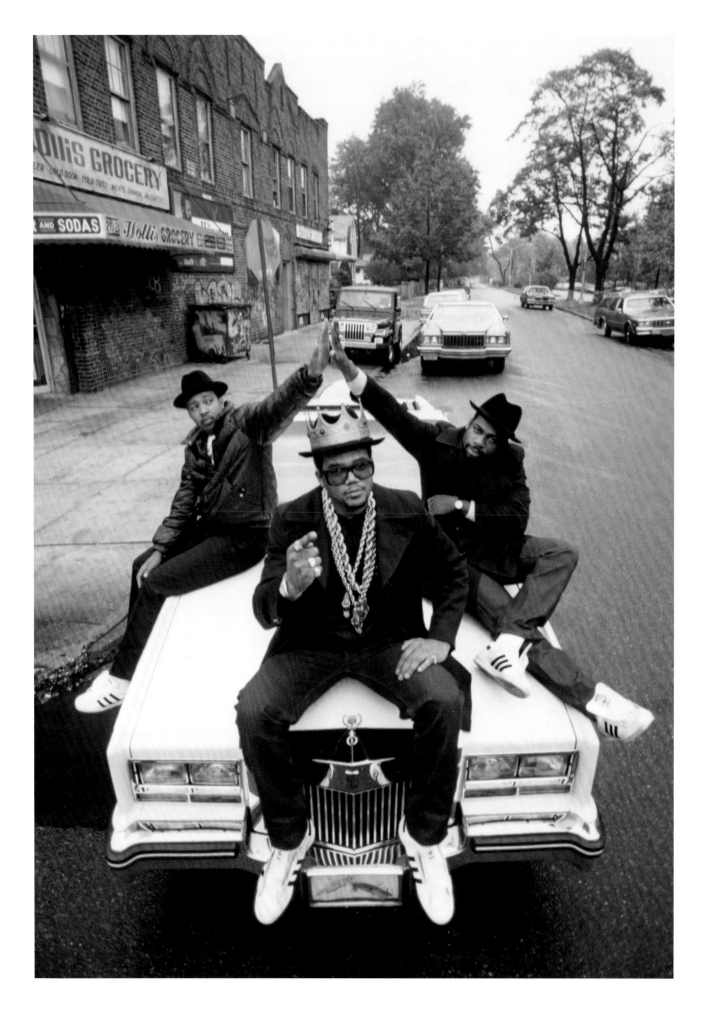

IT'S LIKE THAT

AND THAT'S THE WAY IT IS

The influence of Melle Mel and Duke Bootee in hip hop circles became especially evident a year later, when the group Run-D.M.C. released the single "It's Like That" in 1983. Over minimal drum-machine instrumentation, Run-D.M.C. crafted a song that spoke to the living conditions of contemporary Black life. Though lacking the lyrical detail and depth that had characterized "The Message," Run-D.M.C. had done enough to announce their arrival—but it was the B side of the single, "Sucker M.C.s," that really made hip hop heads pay attention.

Run-D.M.C. was composed of Run (Joseph Simmons), D.M.C. (Darryl McDaniels), and the group's DJ, Jam Master Jay (Jason Mizell). They were managed by Simmons's older brother, Russell, who would go on to become cofounder of Def Jam Records and hip hop's first mogul. Russell's marketing acumen and other pioneering efforts would subsequentially extend rap music's influence into the areas of film, television, and fashion.

Run-D.M.C. represented something new in an era when hip hop was expanding its public profile. Whereas the Sugarhill Gang was a novelty and figures like Afrika Bambaataa and Grandmaster Flash were representative of the culture's underground origins, Run-D.M.C. would become the first rap superstars. The rise of Run-D.M.C. was aided, in no small part, by the increasing popularity of music videos, especially those played on the recently established American cable channel MTV.

Launched in 1981, MTV had a problematic history in its early days, as it seldom played music videos by Black artists, choosing to hide behind its identity as a network devoted to rock and roll, another way of saying music by white artists—ironic, considering the Black origins of rock and roll. After public criticism by artists such as Rick James and David Bowie for its racially exclusionary practices, and the rampant popularity of the videos from Michael Jackson's landmark *Thriller* album (1982), things slowly began to change. Run-D.M.C. became the first rappers to appear in regular rotation on MTV.

Run-D.M.C.'s music often included the type of rock guitar riffs that aligned well with MTV's stated identity as a network. One of the group's biggest hits was their collaboration with Aerosmith, doing a cover of their song "Walk This Way" (1975). Though the cover was not necessarily well received among Black audiences, it was so popular with the MTV demographic that it allowed the group to substantially expand their visibility. At the time, if the music of a Black artist made the crossover to white audiences, it was considered a major achievement throughout the music industry.

Aside from the Aerosmith track, Run-D.M.C. were quintessential hip hop. The video for "King of Rock" features the group kicking in the door of a rock and roll museum, wreaking havoc as they take over the space while critiquing the appropriation of rock and roll by white musical artists. In another bold statement they remove from a display stand, and proceed to stomp on, a sequined glove representative of Jackson, the "King of Pop," who was at the height of his powers following the success of *Thriller*. Hip hop has always been competitive, both lyrically and also in wanting to dominate the record charts. So going after Jackson, the biggest pop star in the world at the time, was in keeping with this competitive tradition. It's like they were saying, "Michael may be the King of Pop, but we're Run-D.M.C. and we're here to take over." There was no chance they were going to dethrone Jackson, but the courage to challenge someone of his caliber spoke to the confidence of their conviction.

It is also noteworthy that the group identify here as the "King of Rock," as opposed to, say, the "King of Rap," as it suggests that their ambitions extended beyond simply representing hip hop. Run-D.M.C. linked their music with the legacy of exploited Black artists from an earlier generation who had been appropriated in white rock circles while at the same time signaling that hip hop would be a threat, overtaking this cultural space in due time.

OPPOSITE: Run-D.M.C., Queens, NY, 1986, photographer Ken Regan.

FRESH DRESSED Like A MILLION BUCKS

In the early to mid-1980s music television was transforming the way that people experienced music. The rise of video saw music shift from a singularly sonic experience to a visual one too—and hip hop's emergence coincided perfectly with this change. With Run-D.M.C. as the first rap superstars of this new era, one in which music videos played a defining role in an artist's identity, how you looked had a great deal to do with how potentially successful you could become. The music video functioned like the combination of a short film and a television commercial.

Run-D.M.C. capitalized on this format to introduce viewers to their music, but they were also putting their style on display. The black leather jackets, fedoras, tracksuits, sneakers, even the glasses that D.M.C. wore represented *street style*—long popular in urban communities, it was now visible to all of America. Yet Run-D.M.C. made it clear that they were not simply following popular fashion trends but creating them, straight from the street. On "Rock Box" (1984) Run asserts, "'Cause Calvin Klein's no friend of mine / Don't want nobody's name on my behind / Lee on my legs / Sneakers on my feet / D by my side and Jay with the beat." Here Run is dismissing Calvin Klein jeans and the popular Brooke Shields ads endorsing them.

Calvin Klein was the denim brand that transformed jeans from quotidian casual wear to a luxury fashion statement in the 1980s. Instead of Calvin Klein's designer denim, Run opts for the more commonplace Lee jeans, and chooses to accessorize his look. This act suggests that making a personal style statement is more important than simply wearing brand names because they are popular. D.M.C. famously paired his Lees with the distinct Goliath Ultra II eyeglass frames, an exclusive brand originally designed in Holland and seen worn by entertainment industry mogul Lew Wasserman. The stylish oversized frames would also later be worn by fictional characters such as Robert De Niro's Sam "Ace" Rothstein in Martin Scorsese's *Casino* (1995) and Elliott Gould's Reuben Tishkoff character in Steven Soderbergh's remake of *Ocean's Eleven* (2001).

Perhaps most famously, Run-D.M.C. were known for wearing adidas, the German sneaker brand identified by the three-stripes motif and sported by foreign Olympic athletes and many NBA players, including Kareem Abdul-Jabbar. Run-D.M.C. specifically wore the adidas Superstar, often referred to as "shell toes,"

the low-top version of the brand's Pro Model basketball shoe. The shoes had been popular among break dancers, known as B-boys, who tended to wear their shoes with what they called "fat laces," colorful extra-wide shoestrings. Though these shoes were originally intended for playing basketball, they were now worn casually, as a staple of street style.

In 1986 Run-D.M.C. released "My Adidas," a song that celebrated their fondness for the shell toes. Like the B-boys, though, it was the *way* the group wore the sneakers that made such an individualized statement—notably, without shoelaces. Run raps, "Funky fresh and yes / Cold on my feet / With no shoestring in 'em / I did not win 'em / I bought off the ave with the black Lee denim." Such a small alteration to the traditional way of wearing sneakers was a significant expression of individuality. The shell toes and the Lee jeans expressed style by way of antistyle. While Run-D.M.C. were not averse to representing brands, the conventional deployment of such brands as status did not interest them. Even so, adidas would eventually sign an endorsement deal with the group, the first of its kind between an athletic apparel brand and hip hop artists. Subsequent re-releases of the shell toe often reference Run-D.M.C. in the marketing, and adidas occasionally offers versions of the shoe without laces, in honor of the historic collaboration.

Run-D.M.C.'s success ushered in a new wave of rappers who both advanced the art of hip hop and served as style influencers, marketing their image through the increasing visibility offered by music videos. This would range from LL Cool J's signature Kangol bucket hat and Slick Rick's crown, eye patch, maximalist jewelry, and penchant for the Swiss fashion brand Bally to groups like Public Enemy and N.W.A. wearing baseball caps and other associated sports gear featuring the logos of various professional teams. Queen Latifah's Afrocentric style served as another example of rappers as new fashion icons during the 1980s.

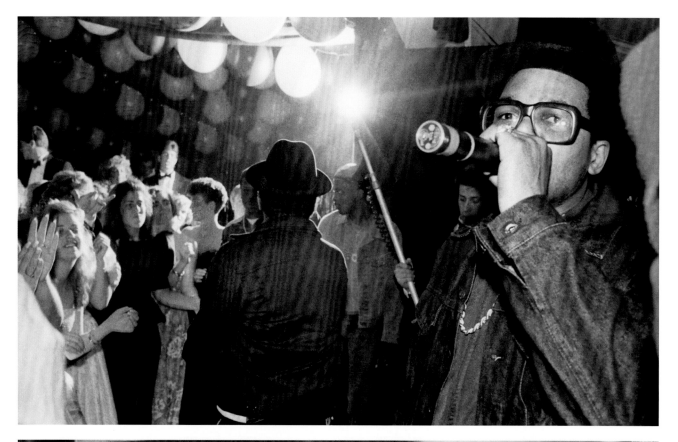

TOP: Run-D.M.C. performs at a music business bat mitzvah, Long Island, NY, 1985, photographer Josh Cheuse. **BOTTOM:** Run-D.M.C. at the Fresh Fest press conference, New York City, NY, 1984, photographer Josh Cheuse.

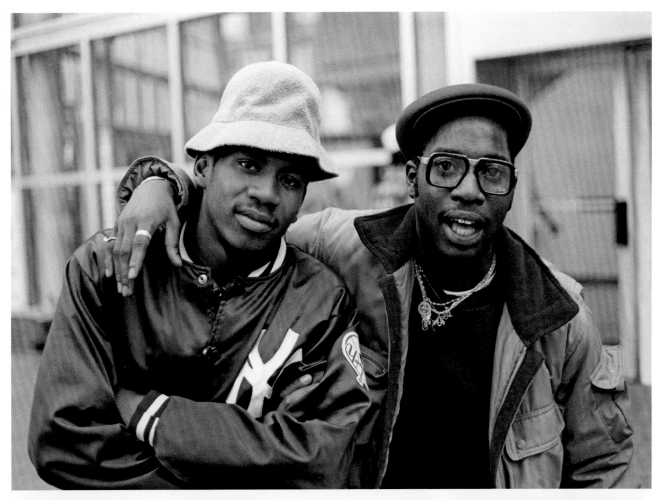

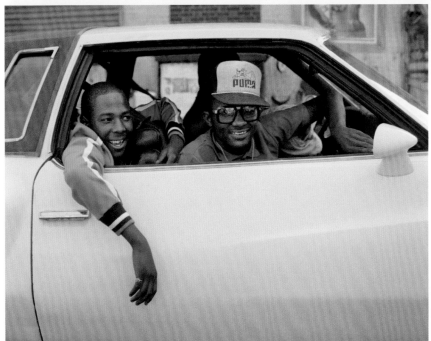

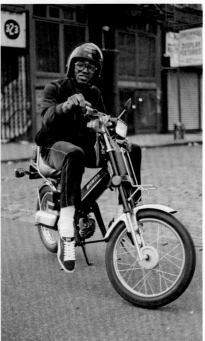

TOP: *Rolling Partners*, Downtown Brooklyn, NY, 1982, photographer Jamel Shabazz. **BOTTOM LEFT:** *The East Flatbush Connection*, Brooklyn, NY, c.1980, photographer Jamel Shabazz. **BOTTOM RIGHT:** *Rolling Solo*, Lower East Side Manhattan, New York City, NY, 1982, photographer Jamel Shabazz.

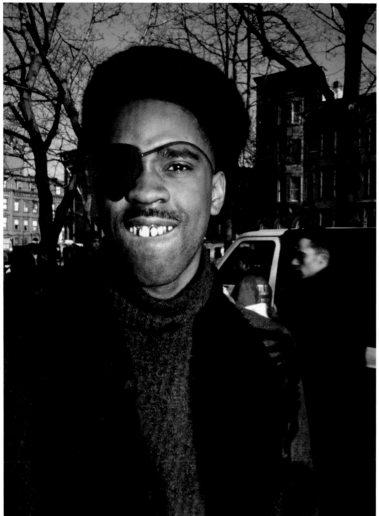

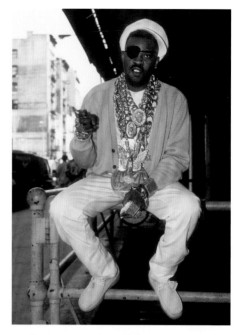

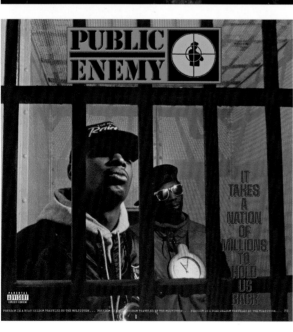

TOP LEFT: Slick Rick in Marcus Garvey Park, Harlem, New York City, NY, 1989, Ernie Paniccioli. **TOP RIGHT:** Slick Rick, New York City, NY, May 15, 1991, photographer Al Pereira. **BOTTOM LEFT:** Album cover for *It Takes a Nation of Millions to Hold Us Back*, Public Enemy, Def Jam, 1988, photographer Glen E. Friedman. **BOTTOM CENTER:** (from left, top row) Sparky D, Sweet Tee, Yvette Money, and Ms. Melodie; (middle row) Millie Jackson, MC Peaches, and unidentified; (bottom row) unidentified, Roxanne Shanté, MC Lyte, and Synquis, New York City, NY, late 1980s, photographer Janette Beckman.

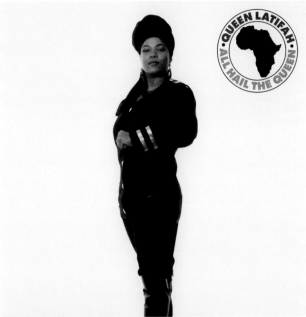

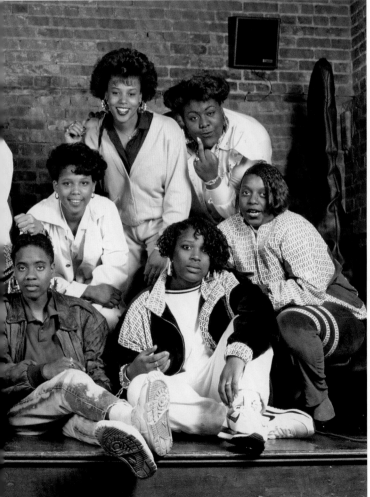

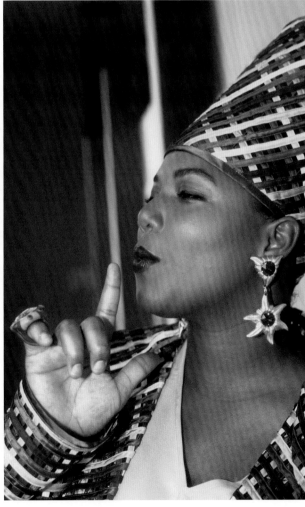

TOP LEFT: LL Cool J at the School of Visual Arts, New York City, NY, 1984, photographer Josh Cheuse. **TOP RIGHT:** Album cover for *All Hail the Queen*, Queen Latifah, Tommy Boy Records, 1989, photographer Bart Everly. **BOTTOM RIGHT:** Queen Latifah backstage during the video shoot for "Fly Girl," New York City, NY, June 28, 1991, photographer Al Pereira.

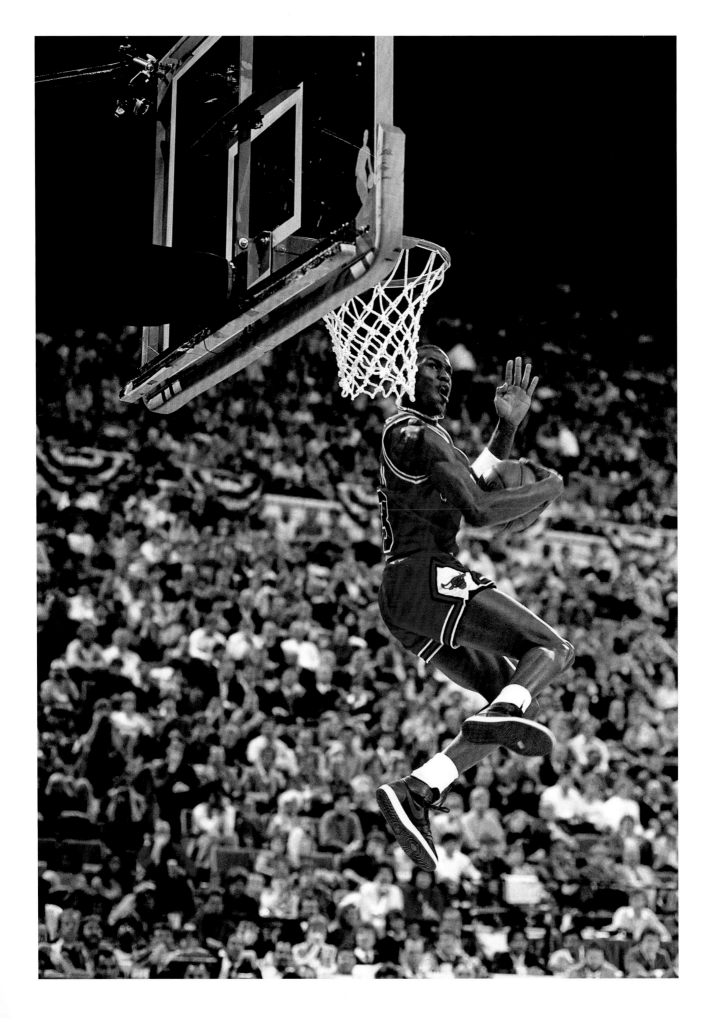

BANNED

The transition of the adidas shell toe from the basketball court to the street is but one example of the cultural connection between hoops and hip hop. In 1984 Chicago Bulls rookie Michael Jordan stepped on court wearing his own signature sneaker, the Nike Air Jordan 1. At the time, Converse supplied the dominant basketball shoe. Jordan had some name recognition from his time at the University of North Carolina, where he hit the game-winning shot in the 1982 NCAA championship game, and as a member of the gold-medal-winning U.S. men's basketball team at the 1984 Olympics. Though early in his NBA career, he was already receiving attention for his athleticism and creativity as a young player—nonetheless, having a signature shoe as a rookie was unheard of. So when Jordan debuted his own kicks during an NBA game, he was making history. The NBA, however, was not so impressed.

While there are differing stories about what transpired, it has become accepted legend that the Air Jordan 1 violated the NBA's uniform rules, which stipulated that the shoes needed to match those of a player's teammates and also be at least 51 percent white in color. The original Air Jordans were black and red, or "bred" as the colorway is often referred to now. Jordan was reportedly fined every time he wore the shoes during a game. Nike agreed to pay the fines. The brand followed with a commercial showing Jordan in the sneakers and a voiceover stating, "On September 15, Nike created a revolutionary new basketball shoe. On October 18, the NBA threw them out of the game. Fortunately, the NBA can't stop you from wearing them." The shoes were then blocked out with black censor bars.

The combination of Jordan's eye-catching play on the court and the controversy around the "banned" Nike Air Jordan 1 made the shoes notoriously cool and created a huge demand for them. Following their success, a new numbered version of the shoe was released annually. The second iteration, the Air Jordan 2, was manufactured in the high-fashion capital of Italy, and the Air Jordan 3 was the first version of the shoes to feature the now iconic Jumpman logo. Over time, Jordan would go from promising young phenom to one of the greatest athletes in history, while Air Jordans would make the crossover from the court to the streets, from pop culture to high fashion. By 1997 Jordan had become its own brand, and, at the time of writing, new versions of the shoes continue to be released—though Jordan himself, who became the owner of the Charlotte Hornets in 2010, has not played in the NBA since 2003.

In 1988 filmmaker Spike Lee directed a series of TV commercials for the Air Jordan 3 while also appearing in the commercials as the Mars Blackmon character from his debut feature, *She's Gotta Have It* (1986). The commercials proved especially popular and solidified the shoes' status within the realm of pop culture. Lee also featured a prominent scene in his masterpiece *Do the Right Thing* (1989) in which a white neighborhood gentrifier inadvertently steps on the Air Jordan 4s worn by the Buggin' Out character, adding to the shoes' already legendary cultural cachet.

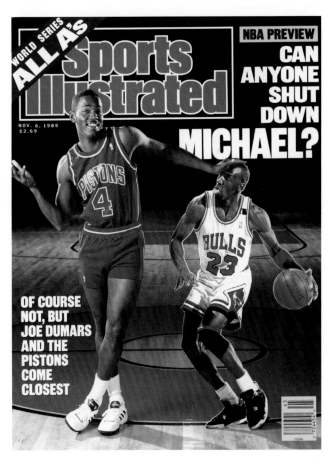

OPPOSITE: Michael Jordan of the Chicago Bulls goes for a dunk during the NBA All Star Slam Dunk Contest at the Hoosier Dome, Indianapolis, IN, February 10, 1985, photographer Andrew D. Bernstein. BOTTOM RIGHT: "Can Anyone Shut Down Michael?", Joe Dumars of the Detroit Pistons with a cutout of Michael Jordan on the cover of *Sports Illustrated*, November 6, 1989, photographers Theo Westenberger and Manny Millan.

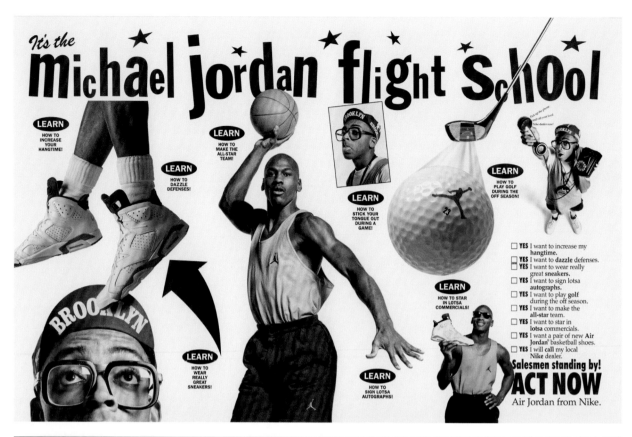

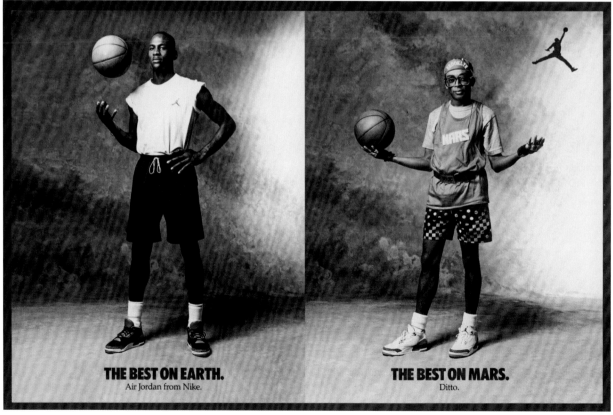

"Spike and Mike," Nike Air Jordan advertisements featuring Michael Jordan and Spike Lee, 1988.

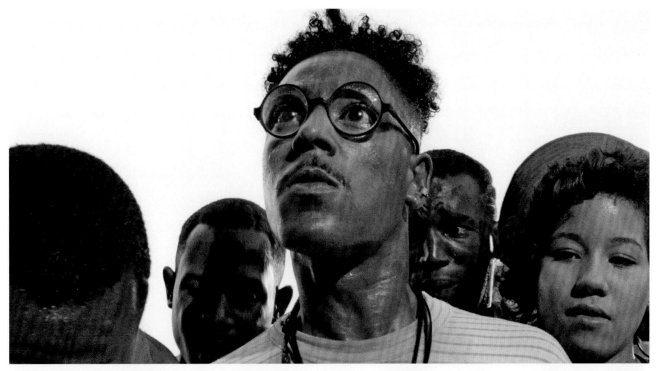

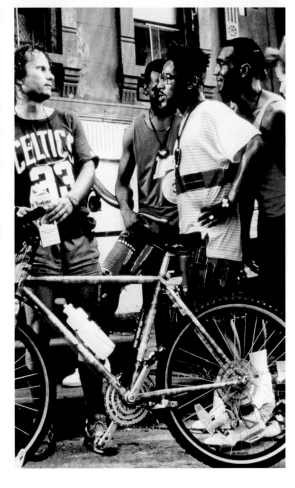

TOP AND BOTTOM RIGHT: Giancarlo Esposito in *Do the Right Thing*, Universal Pictures, 1989, dir. Spike Lee. **BOTTOM LEFT:** "Banned," Nike Air Jordan 1 commercial featuring Michael Jordan, 1985.

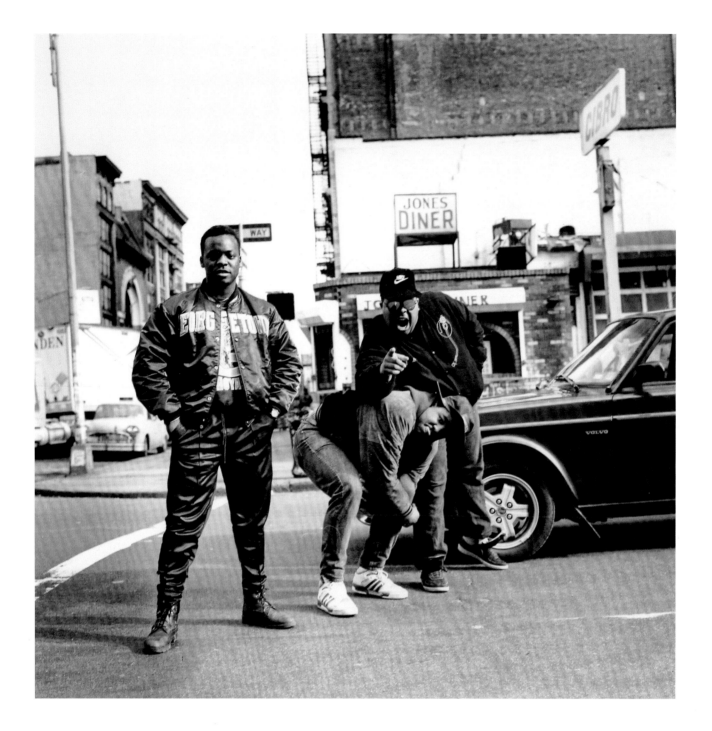

From The Court
To The Street

The success of the Air Jordans continued to bolster the Nike brand, and the company's swoosh logo soon became ubiquitous and universally recognizable. As another form of marketing, Nike often outfitted college football and basketball teams in their gear, including the Georgetown University basketball team, a dominant force in the early to mid-1980s. Between 1982 and 1985, the team appeared in three NCAA championship games, and in 1984, it won the national title. Georgetown was a predominantly Black team, playing in Washington, D.C., often referred to as Chocolate City, and their head coach, John Thompson, was one of a small number of Black head coaches of major college basketball teams at the time. Their perennial success meant that they played on television frequently, and some viewers who were unfamiliar with the prestigious Jesuit university assumed that Georgetown was a historically Black college (HBCU). The visibility of the squad on television transformed them into style icons. The blue and gray Nike Terminators that they wore on the court became very popular, and are now Nike classics, and the satin Georgetown bomber jacket made by the Starter brand was one of the coolest streetwear items one could have at the time.

To discuss how sports gear like the Terminators and Georgetown jacket became streetwear staples during this era is also to discuss the literal streets—which, in the mid-1980s, witnessed the birth of the crack-epidemic era in American culture. As the devastating drug entered urban social life, it proved lucrative for some, giving rise to a new wave of street entrepreneurs. Drug dealers had expendable cash, which was often used to purchase the freshest gear. Thus these dope dealers were also fashion influencers, primarily because they could afford what others could only fantasize about. On the other hand, the streets also created "stick-up kids," the thieves who would rob people for their hottest fashion items. The combination of a prestigious, predominantly white university like Georgetown, its Black coach and all-Black basketball team, popular sports gear, and the role of drug dealers in defining the hottest streetwear trends is indeed an interesting mix of many, perhaps even contradictory influences. Yet in its constellation of seemingly mismatched components that ultimately work to inform one another, this is so hip hop.

Another example of these cross-cultural influences includes the FILA brand, generally associated with the white world of tennis. FILA's T-1 sneakers were an especially popular shoe on the streets, so popular that in 1985, Sibley's, a local Detroit shoe-store chain, threatened to stop selling them because people were constantly being robbed for the shoes. Similar stories circulated about people getting jacked for their Air Jordans. The Gucci Tennis sneakers, released in 1984, occupied a similar place in street culture. The high-fashion brand was generally cost prohibitive for most civilians, so wearing these expensive luxury sneakers might imply that one was in the dope game, whether this was the case or not. What is also interesting to illustrate here is the relationship between sneakers, street culture, and high fashion, which was flipped in such a way that previously white representations of elite tennis culture were being redefined as Black in a reverse sense of appropriation and rebranding. This is but another example of how sampling and remixing manifest themselves in hip hop's narrative; instead of happening on a record, they are taking place within the culture itself.

OPPOSITE: Original Concept outside the old Great Jones Diner on the corner of Lafayette and Great Jones Street, New York City, NY, 1990, photographer Janette Beckman.

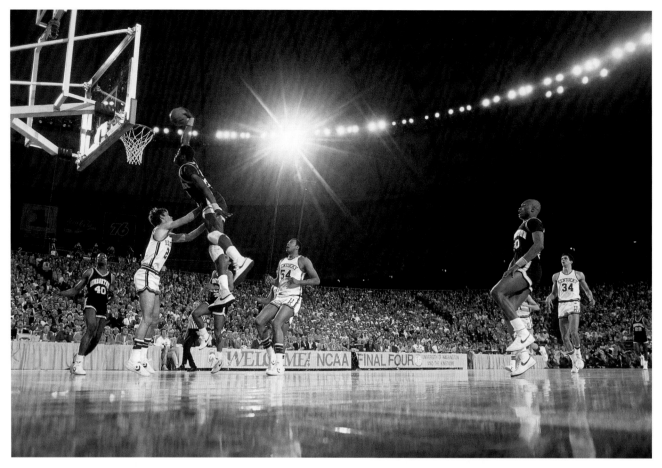

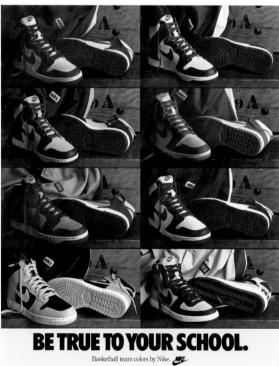

TOP: Patrick Ewing (#33) of Georgetown goes for a dunk against Kentucky during the NCAA semifinals at Kingdome, Seattle, WA, March 31, 1984, photographer Rich Clarkson. **BOTTOM LEFT:** Starter Georgetown University college basketball jacket, 1980s. **BOTTOM RIGHT:** "Be True to Your School," Nike Dunk High and Terminator advertisement, 1985.

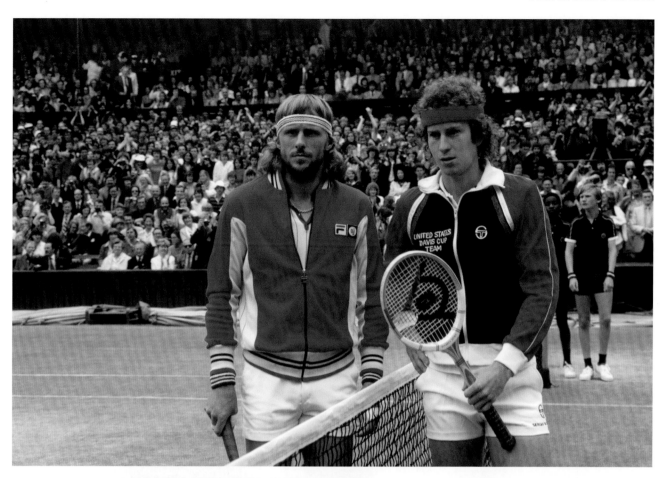

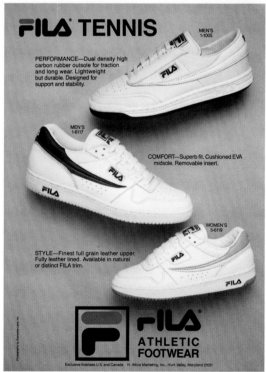

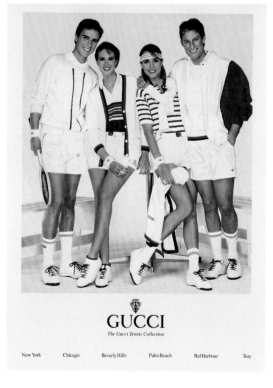

TOP: John McEnroe (right) and Björn Borg pose together prior to the final of the men's singles tournament at the Wimbledon tennis championships, London, July 5, 1980, photographer unknown. **BOTTOM LEFT:** FILA Tennis advertisement, 1986. **BOTTOM RIGHT:** Gucci Tennis Collection advertisement, 1984.

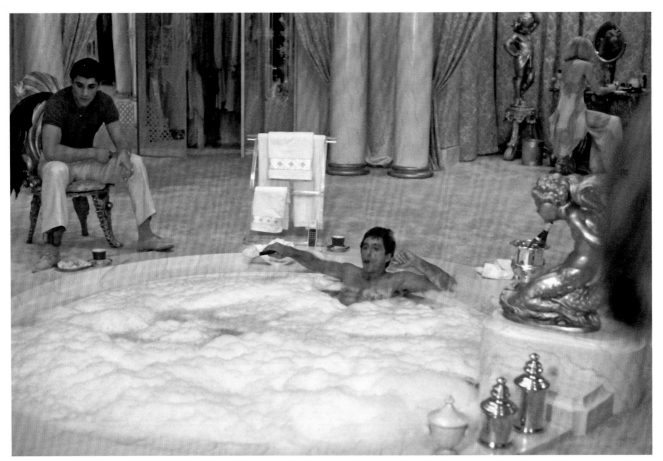

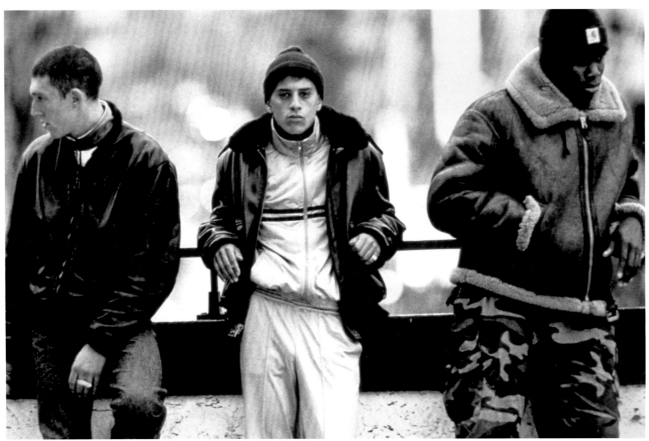

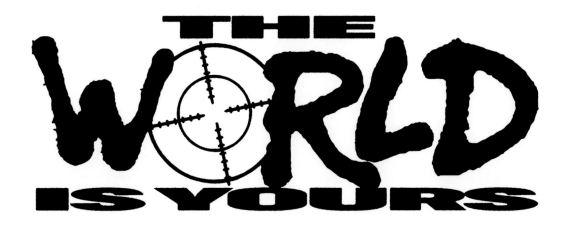

THE WORLD IS YOURS

When Brian De Palma's *Scarface* was released in 1983, no one could have imagined that it would one day be considered a hip hop classic. Against the backdrop of the 1980s crack epidemic in the United States, the film would come to be regarded as a master narrative of sorts, appropriated by the streets and remixed into its own version of the American dream. Though *Scarface* did respectable numbers at the box office, this was offset by the film having gone substantially over its production budget. Where it was especially successful, however, was on videotape; it was in this format that the film would be discovered by a new generation of rappers. The film's main character, Tony Montana (played by Al Pacino), a Cuban immigrant, arrives in the United States as part of the Mariel Boatlift in 1980. Originally placed in a Miami detention center, he agrees to carry out a hit on a former Cuban government bureaucrat in exchange for his freedom. Montana's journey from lowly dishwasher to drug kingpin was an especially dramatic rise. His ambition to succeed was fueled by his passionate self-confidence. Though Montana was a poor, uneducated immigrant, he pursued the American dream on his own terms. His style was maximalist. From the all-white wedding sequence, which included the appearance of a tiger, to scenes in his massive circular bathtub, everything about Montana was larger than life. As he looks out of the window in one especially memorable scene, he notices a blimp passing by. The message scrolling across the blimp reads, "The World Is Yours." This underscores his mission. Montana has reached the top.

Yet *Scarface* is also a cautionary tale: be careful what you wish for. Montana broke one of the dope game's most important rules, as articulated in the film, "Don't get high on your own supply." His arrogance, jealousy, overall embrace of excess, and especially ravenous appetite for cocaine lead to his downfall. But even his death is a spectacle, as he single-handedly takes on a small army before finally going out in a blaze of glory.

Montana's journey struck a chord with young urbanites who were trying to make it in Reagan's America, and he became the role model for "doin' it big." His all-out drive to succeed inspired hustlers, as well as rappers. Such was its influence that the film became what I often refer to as the canonical text of hip hop. The American dream was here transformed into the hip hop dream.

Quoting lines from *Scarface* or making other references to the film, as in Biggie Smalls's "Ten Crack Commandments" (1997), became especially common in hip hop. Houston rapper Brad Jordan took on the moniker Scarface; Nas dropped a tune called "The World Is Yours" (1994), citing the message on the blimp; the French film *La Haine* (*Hatred*, 1995) by Mathieu Kassovitz references *Scarface* but flips things a bit with a billboard that reads "Le Monde est à Nous" (the world is ours); Jay-Z's album *Reasonable Doubt* (1996) opens with a monologue from the film; and Miami rapper Trick Daddy bragged about living in a "Scarface environment" on *MTV Cribs*—the popular celebrity television series from the early 2000s—when he showed viewers around his home, decorated with various images from the film. In fact, the homes of many rappers that featured on *MTV Cribs* included framed *Scarface* film posters. In celebrating his own mansion, another Miami rapper, Rick Ross, talks about "elevators like Frank's on *Scarface*," referring to the lavish layout of character Frank Lopez's stylish "crib."

The energy generated by *Scarface* was bolstered by parallel narratives about the crack epidemic unfolding in the media, creating a ripple effect far beyond the film. The Michael Mann–produced television show *Miami Vice* (1984–89) revolved around two undercover cops who are immersed in the world of drug culture. The show's extravagant styling and lifestyle depictions created a kind of cocaine-chic aesthetic in the process. One of the main characters, Sonny Crockett (Don Johnson), drove a white Ferrari Testarossa, while other rarified sports cars such as the Lamborghini Countach could be counted on to make an appearance as well.

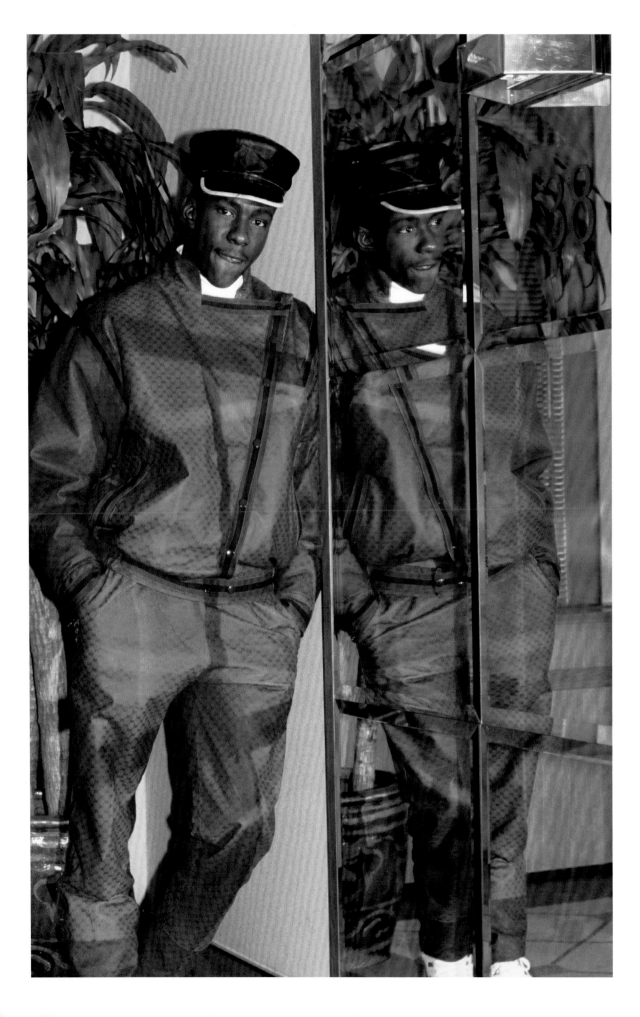

THE KNOCK-UP

In June 1988 heavyweight boxing champion Mike Tyson, aka Iron Mike, was at the height of his powers as he disposed of his biggest challenger Michael Spinks in a fight that lasted only ninety-one seconds. The "Baddest Man on the Planet" was not to be fucked with, inside or outside of the ring. A few months later Tyson found himself in another fight, but this one did not take place in the boxing ring. While patronizing the Harlem haberdashery of one Dapper Dan, Tyson got into it with another boxer, Mitch "Blood" Green. Tyson had defeated Green in a sanctioned boxing match in 1986, but this impromptu bout was not fought under boxing's Marquess of Queensberry rules. Instead, the laws of the street applied. Tyson whupped Green's ass decisively, but this time there was no referee to stop the fight.

As reports of the squabble hit the media, the fact that Tyson defeated Green was only one part of the story that attracted attention. The fight occurred around the unusual hour of four in the morning, not a time normally associated with an open clothing store. Yet Dapper Dan's was open twenty-four hours a day so as to best serve his clientele, many of whom worked through the night. The boutique was originally popular among gangsters and hustlers, but the alluring street credibility of these early patrons meant that rappers and athletes soon gravitated toward Dapper Dan's as well.

Dapper Dan specialized in making custom garments featuring the logos of well-known, high-fashion luxury brands such as Gucci, Fendi, MCM, and Louis Vuitton. To create his pieces, he developed a prorietary silk-screening process to print (in any color) directly onto a variety of textiles, including leather, which were then cut and sewn into garments. All production was handled in-house at his Harlem boutique. Dapper Dan called these garments "knock-ups," as opposed to "knock-offs." Rappers like Eric B. and Rakim, aka the God MC, could be seen wearing the bespoke Dapper Dan creations on their album covers and in personal appearances. But much of this was unknown outside of New York before the Tyson–Green incident. The fight meant notoriety for Dapper Dan, but it also brought unwanted attention. Dapper Dan would eventually be sued for copyright infringement by Fendi, with future Supreme Court justice Sonia Sotomayor working as one of the lawyers on the case. In 1992 Dapper Dan had to close his boutique, but not before etching his name and his fashion into hip hop

history. He had to "fall back," but, as we will see in a future chapter, this setback created the conditions for a comeback.

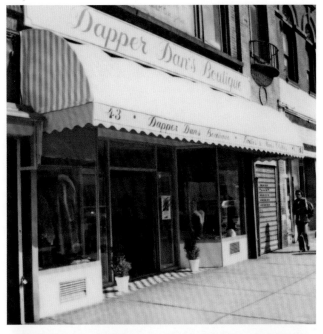

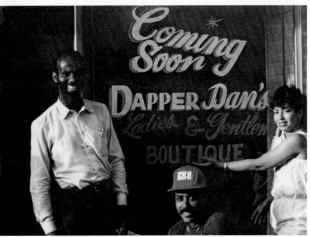

OPPOSITE: Bobby Brown in a custom-made Dapper Dan Gucci outfit, New York City, NY, 1988, photographer Ernie Paniccioli. **CENTER RIGHT:** Dapper Dan's Boutique, which opened on 125th Street, Harlem, in 1982, photographer unknown. **BOTTOM RIGHT:** Dapper Dan (left) outside his boutique, Harlem, New York City, NY, 1983, photographer unknown.

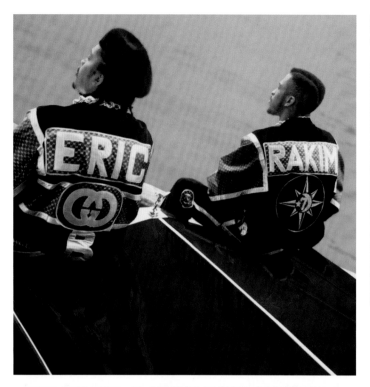

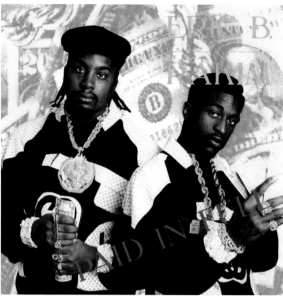

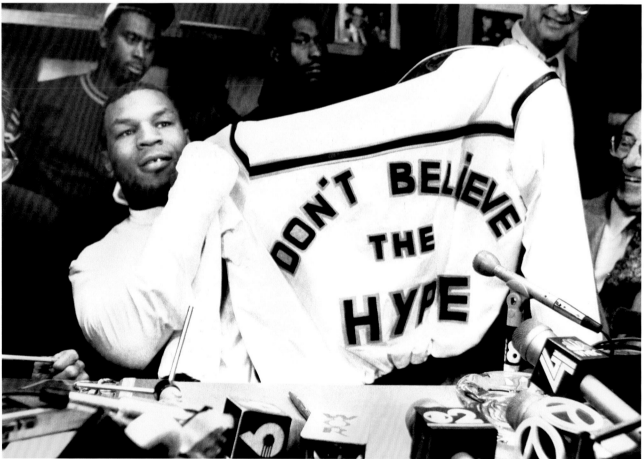

TOP LEFT: Eric B. and Rakim pose for their album cover *Follow the Leader*, Uni Records, 1988, photographer Drew Carolan. **TOP RIGHT:** Album cover for *Paid in Full*, Eric B. & Rakim, 4th & Broadway, 1987, photographer Ron Contarsy. **BOTTOM:** Mike Tyson holds up a Dapper Dan-designed jacket reading "Don't Believe the Hype" at a press conference following a street brawl with Mitch "Blood" Green outside the Harlem tailor's boutique, New York City, NY, August 23, 1988, photographer Carmine Donofrio.

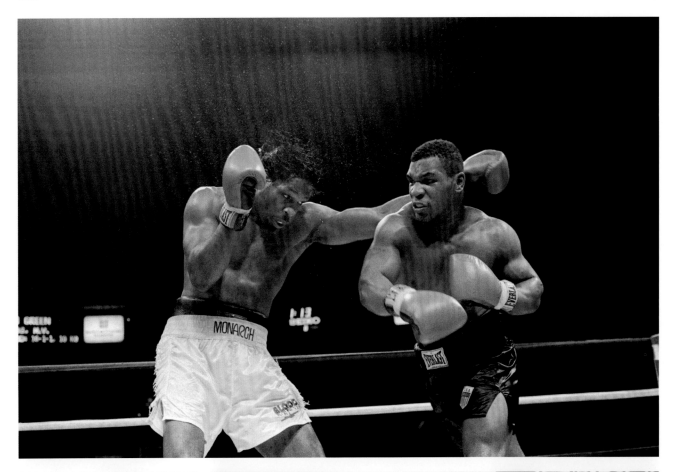

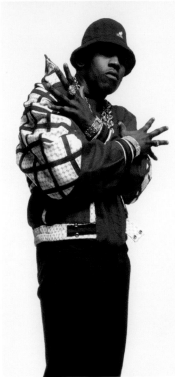

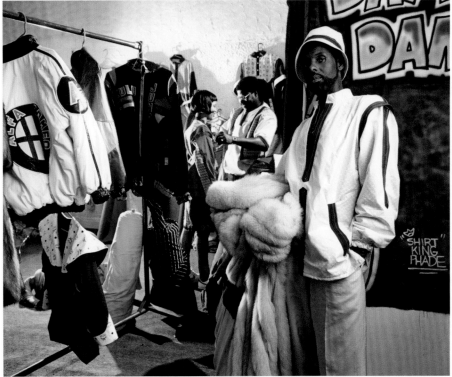

TOP: Mike Tyson lands a right hook to Mitch Green's face during the eighth round of their heavyweight bout at Madison Square Garden, New York City, NY, May 24, 1986, photographer unknown. Mike Tyson won the fight in a tenth-round decision. **BOTTOM LEFT:** LL Cool J wears a Dapper Dan jacket, New York City, NY, 1987, photographer Drew Carolan. **BOTTOM RIGHT:** Dapper Dan in his Harlem boutique wearing a white Gucci sweatsuit jacket and matching hat. Behind him, his tailor Big Sek takes the measurements of a customer, New York City, NY, 1989, photographer Wyatt Counts.

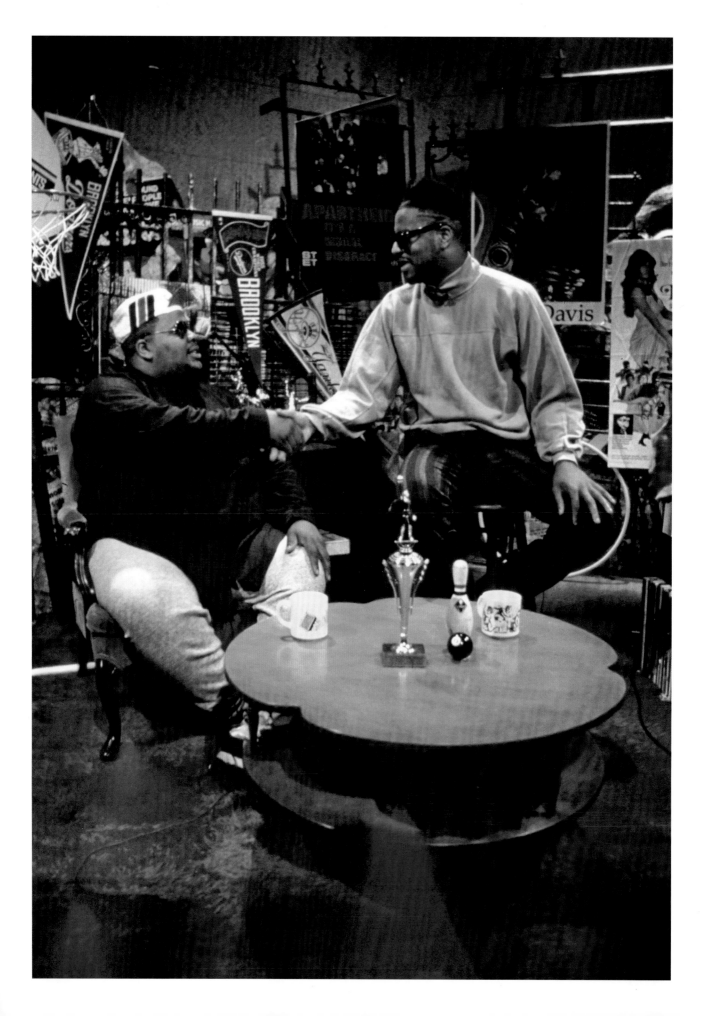

YO! MTV RAPS

In 1988 MTV's first program devoted exclusively to hip hop music, *Yo! MTV Raps*, debuted on American television. The cable network with its troubling racial history had finally come to recognize the increasing popularity of hip hop. *Yo! MTV Raps* aired with Fab 5 Freddy as the host and Run-D.M.C. as the inaugural guests. The launch of this groundbreaking show coincided with what is often referred to as the golden age of hip hop, a period from the late 1980s through the 1990s when the genre was expanding rapidly and evolving artistically. The range of artists and their various styles were no longer confined to New York. Los Angeles, and the West Coast more broadly, also emerged to offer its own unique perspective on Black life in the United States through music.

Yo! MTV Raps was a popular program on a network with far-reaching influence, and it helped to spread hip hop into locales previously lacking such access. The show soon became so popular that it expanded from its solo Saturday slot, adding a daily version as well, hosted by Doctor Dré and Ed Lover. In 1989 Black Entertainment Television (BET) debuted their own hip hop music video show called *Rap City*. It not only played the same popular videos available on MTV but also featured those from a broader range of emerging artists who might not have initially been given airtime on more mainstream programs.

Shows like *Yo! MTV Raps* and *Rap City* gave the energized expression of hip hop a new marketing platform, beyond the traditional role that radio had always played, which it capitalized on to full effect. As the 1990s loomed on the horizon, new voices, new styles, and new images emerged, but this time on a much bigger stage. The artistry and creativity spurred on by these new developments set hip hop on a course of expanding influence that would forever change the face of the industry— and American culture at large.

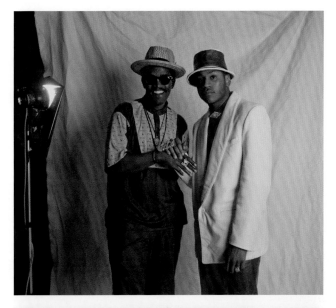

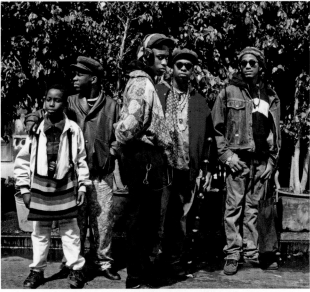

OPPOSITE: Doctor Dré (left) and Ed Lover on *Yo! MTV Raps*, MTV, 1988–2004. **CENTER RIGHT:** Fab 5 Freddy, inaugural host of *Yo! MTV Raps*, and LL Cool J, c.1988, photographer unknown. **BOTTOM RIGHT:** A Tribe Called Quest during filming for a segment on *Yo! MTV Raps*, New York City, NY, 1990, photographer Janette Beckman.

IT WAS ALL A DREAM

BY ANY MEANS
NECESSARY

BOYZ N THE
HOOD

NIGGAZ4LIFE
EFIL4ZAGGIN

HER STORY

SLICK
WILLIE

THE CHRONIC

THE SOUTH GOT
SOMETHIN' TO SAY

WU-TANG CLAN AIN'T NUTHING TA FUCK WIT!

IT AIN'T **HARD** TO TELL

KINGOFNEWYORK

for us, by us

A Great Day in...

HIPHOP

HOOP DREAMS

My EMANCIPATION Don't Fit Your EQUATION

BY ANY MEANS NECESSARY

Rap is our invisible TV network. It's the CNN that Black people never had.

Chuck D, Public Enemy, c.1989

Martin Luther King Jr. is regarded as the most prominent figure in the advancement of the 1960s civil rights movement. King's movement was a Southern, religion-based one that spoke to the social conditions of the segregated regions below the Mason–Dixon line. His embrace of nonviolent, turn-the-other-cheek protest was intended to demonstrate the brutality of Southern racism to people living outside of the South in the interest of building a larger moral argument over the particularly insidious treatment of Black American citizens. King's politics were suited for the segregated South, but his approach did not always resonate in other regions of the United States, especially in cities. This is where Malcolm X comes into the equation.

To the extent that hip hop has ever had what one might call a spiritual leader, it would have to be El-Hajj Malik El-Shabazz, the gentleman otherwise known as Malcolm X. Despite being assassinated in 1965, long before hip hop arrived, his ideas, image, and inspiration resonated loudly with the hip hop generation. As a minister and human rights activist, Malcolm X confronted racism and white supremacy directly, and his powerful rhetoric and advocacy of Black self-defense in the face of racial violence struck a chord with urban communities in the North, Midwest, and West. Though he introduced himself as the chief spokesman for the Nation of Islam and their leader, the Honorable Elijah Muhammad, his strident message was embraced by many who had little or no interest in the religious organization that he represented. Malcolm X's media appearances and speeches offered thorough critiques of American racism in terms that many would only dare articulate in private. Where others tended to shy away from such confrontational language, Malcolm X used a potent mix of historical and political analysis, comedy, street slang, and charisma to go after the perpetrators, and their Black enablers as well. The fullness of his legacy would be realized many years later, in the late 1980s, by hip hop artists such as Public Enemy and Ice Cube referencing his teachings in their lyrics and invoking his celebrated image in their videos.

Writer Alex Haley first interviewed Malcolm X in 1963 for *Playboy* magazine. The interview would become the foundation for Haley's 1965 book *The Autobiography of Malcolm X*, one of the most important nonfiction works of the twentieth century. However, the road to making a feature film about the activist took some time to unfold. By the 1970s another iconic writer, James Baldwin, would be commissioned with this task: to write a Hollywood screenplay that translated Malcolm X's life to film. Considering that the Hollywood studio system was then a rigid, immovable object, unaccustomed to dealing with Black creative talent, and that the independent-minded Baldwin was an unstoppable force, with his erudite critiques of American racism, it is fair to say that these two entities were destined to clash. Baldwin's screenplay would be published in his book *One Day When I Was Lost* (1972), but his name did not end up making it to the screen; instead, Arnold Perl, the script's cowriter, was credited.

Next in line to take on the project was director Norman Jewison, whose previous films included *In the Heat of the Night* (1967), starring Sidney Poitier, and *A Soldier's Story* (1984), the film version of Black playwright Charles Fuller's stage drama, featuring a young Denzel Washington in his first decisive Hollywood role. Jewison was to direct the Malcolm X film based on a new screenplay by Fuller.

With the emergence of hip hop, however, making this film took on added significance; hip hop put Malcolm X back into the public conversation, his image now roundly embraced as an example of nonconformity and uncompromised Blackness. This renewed investment in Malcolm X's legacy meant that any depiction of him, and the context under which it would be rendered, would be highly scrutinized. The film version of his life would need to exist under the terms dictated by this new cultural environment.

Filmmaker Spike Lee understood these demands and staged a public campaign to direct it himself, arguing that the importance of Malcolm X's life required that any film about him be directed by a Black filmmaker. This argument, that projects about Black figures and Black life should be helmed by Black creatives, prompted controversy, and in the midst of it all, Jewison dropped out of the film, claiming that he was never satisfied with the script. With Jewison no longer attached, Lee obtained the opportunity to make the film. Yet the controversy did not end there, as celebrated African-American writer Amiri Baraka (formerly LeRoi Jones) openly criticized the choice of Lee, suggesting that

the young filmmaker would potentially exploit Malcolm X's life. This Black generational conflict spoke further to how important custody of Malcolm X's image had become in the hip hop era.

Lee had clever ideas about marketing, including selling apparel and other merchandise related to his movies. Much like the enterprising rappers who sold tapes out of the trunk of their cars, Lee's entrepreneurial approach was especially hip hop. Eventually, he opened a store, Spike's Joint, where he sold this film memorabilia, including a baseball cap imprinted with the letter X. Michael Jordan, one of the dominant influencers of the era, often wore the X cap during interviews, so it was only a matter of time before it became a highly sought-after fashion accessory, adding to the intense interest that had developed around the film.

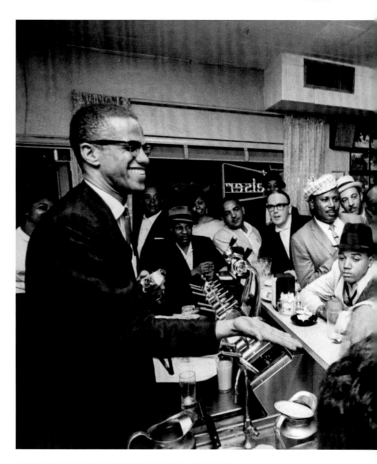

Lee's film was to be a three-hour epic, in the tradition of David Lean's *Lawrence of Arabia* (1962). The studio, Warner Brothers, wanted a shorter film, however. Lee argued that since Oliver Stone's film *JFK* (1991) was three hours long, his film about Malcolm X deserved equal time. Warner Brothers disagreed, and according to Lee, when he refused to cut the run time, the studio allowed the Completion Bond Company to take over the film for being overbudget. A bond company guarantees a film's investors in the event of cost overruns. This meant that it would be taking over financial control of *Malcolm X* and would not approve any more funds.

In response, Lee reached out to several Black celebrities, solic-iting donations that would allow him to complete the film on his own terms. The list of celebrities is a who's who of prominent Black cultural figures of the 1990s: Jordan, Magic Johnson, Oprah Winfrey, Prince, Janet Jackson, Tracy Chapman, Bill Cosby, and Peggy Cooper Cafritz, founder of the Duke Ellington School of the Arts in Washington, D.C. Their donations ensured that Lee could finish making the film and also turned this impor-tant cultural project into a broader community effort. The optics of Black celebrity donors coming together in the interest of a project about the legacy of Malcolm X was a poignant example of racial pride and cultural solidarity in service to a higher goal.

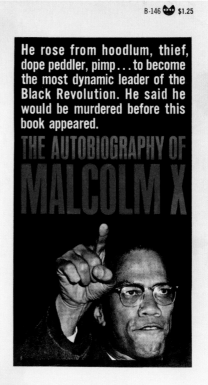

B-146 $1.25

He rose from hoodlum, thief, dope peddler, pimp...to become the most dynamic leader of the Black Revolution. He said he would be murdered before this book appeared.

THE AUTOBIOGRAPHY OF MALCOLM X

Malcolm X was released in late 1992, and the premiere felt more like a presidential inauguration than a movie release. The opening sequence of the film features video footage of the police beating Rodney King that eventually burns into an X, with a voiceover of Washington delivering one of Malcolm X's speeches. This scene brought Malcolm X into contempo-rary Black life and demonstrated that while he may have died in the 1960s, his message was still relevant almost three decades later. After a long, challenging process, Lee had succeeded in portraying Malcolm X on the big screen, adding to the massive cultural legacy that his image had built.

In 1999 a portrait of Malcom X would appear on U.S. postal stamps. This seems particularly ironic considering the Public Enemy lyric, "most of my heroes don't appear on no stamps" from "Fight the Power," their theme song to Lee's *Do the Right Thing* (1989). Watching Malcolm X's journey unfold, from his early incarceration to eventual assassination, and his evolution from American pariah to American prince, was truly a sight to behold; hip hop culture and Lee's film were central to this evolution.

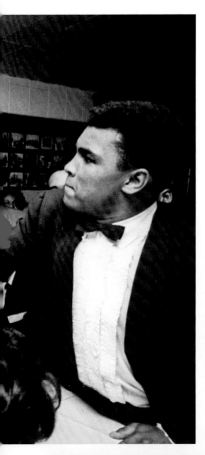

OPPOSITE TOP: Malcolm X and Muhammad Ali surrounded by fans after Ali beat Sonny Liston to become the World Heavyweight Champion, Miami, FL, March 1964, photographer Bob Gomel. **OPPOSITE BOTTOM:** Book cover for *The Autobiography of Malcom X*, Alex Haley, Grove Press, ed. 1966. **TOP RIGHT:** Nation of Islam (NOI) members outside Muhammad's Temple No. 2 holding the NOI newspaper, *Muhammad Speaks*, Chicago, IL, 1965, photographer Robert Sengstacke. **BOTTOM:** The Fruit of Islam, bodyguards for NOI leader Elijah Muhammad, during his annual savior's day message, Chicago, IL, March 1974, photographer John H. White.

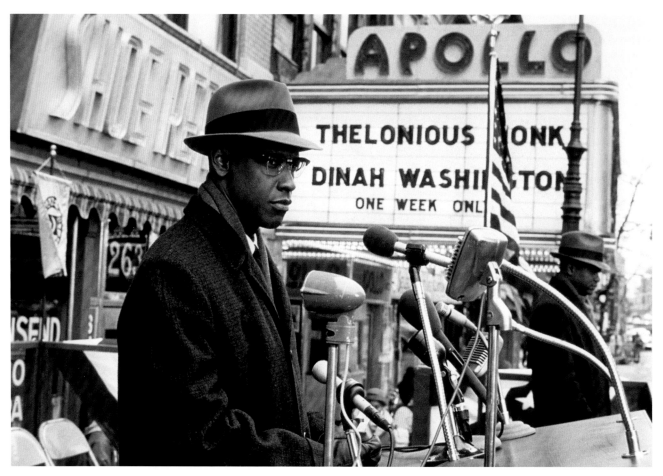

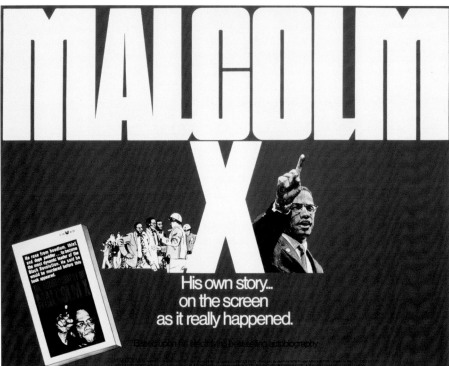

TOP: Denzel Washington in *Malcom X*, Warner Bros. Pictures, 1992, dir. Spike Lee. **BOTTOM:** Movie poster for the documentary *Malcolm X: His Own Story As It Really Happened*, Warner Bros. Pictures, 1972, dir. Arnold Perl.

TOP: Michael Jordan wears the Malcom X baseball cap, created by Spike Lee to promote his upcoming film, 1991, photographer Nick Ut.
BOTTOM: A group of young people wear T-shirts promoting Spike Lee's film *Malcom X*, New York City, NY, July 1, 1992, photographer Mario Ruiz.

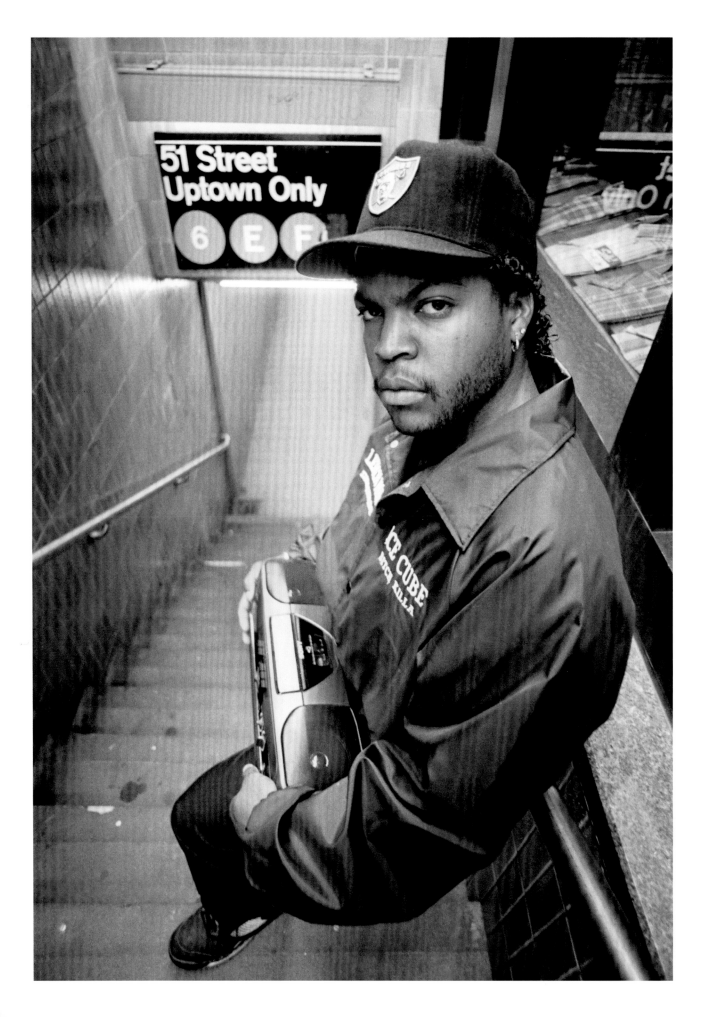

EFIL4ZAGGIN

In 1991 the respected music industry magazine *Billboard* began using data gathered from a new technology known as Nielsen SoundScan to determine its weekly best-selling album chart. In a shift that suggested the digital revolution to come, Nielsen SoundScan relied on computers and scanners to determine record sales, as opposed to the old method of individual record stores giving their sales figures by phone, which had been vulnerable to issues of inaccuracy and potential corruption.

The SoundScan results in early June 1991 indicated that N.W.A. had reached the top of the chart with the release of their second LP, *EFIL4ZAGGIN* ("Niggaz 4 Life" spelled backward). The most popular album in the country was a rap album with a Parental Advisory sticker on it and a title considered so inflammatory that it needed to be spelled backward. This level of chart success is even more impressive given that *EFIL4ZAGGIN*, like other hip hop albums at the time, received limited airplay on the radio—then the music industry's primary promotional source—due to language restrictions. The practice of artists releasing a clean radio edit version of their tracks (with curse words either changed or censored) was not yet common the early 1990s.

Similar to Blaxploitation films from the early 1970s reaching number one at the Hollywood box office, N.W.A.'s chart-topping album sales indicated that this particularly Black genre of music appealed to a large, multiracial audience, shattering previous assumptions about its limited appeal. Not only was the music embraced by Black consumers who lived in the types of communities that hip hop was speaking to and for, it also resonated with young white listeners, who were often doing what kids of every generation tend to do—using music to rebel against their parents.

Unlike *Straight Outta Compton* (1988), *EFIL4ZAGGIN* reveled in cartoonish violence, general debauchery, and a type of overall nihilism, without taking on the larger sociopolitical message that had informed the group's earlier offering. The new record embodied the shock value of a Hollywood horror film and often counted more dead bodies than a Clint Eastwood Western. This was all fictional, of course, and not a little theatrical, yet it operated under an aesthetic of realism. In other words, realism was a style. To speak an unvarnished truth was thought to be "real," but this realness was often achieved through fictional means.

In the mid-1980s hip hop was largely exclusive to New York. LA hip hop, like that pioneered by Ice-T with his 1986 song "6 'n the Mornin'," offered music from a different cultural vantage point. This emerging LA style would initially be referred to as "reality rap" because the music discussed the types of everyday issues that existed in poor Black communities but were seldom represented in the mainstream media. Reality rap, later known as gangsta rap, was an attempt to speak truth to power from the perspective of those embedded in the trenches of urban Black America.

One notable change that occured between N.W.A.'s landmark *Straight Outta Compton* album and *EFIL4ZAGGIN* was the departure of the group's primary writer and its best MC, Ice Cube, who left following a financial dispute with its manager Jerry Heller. Cube had infused the rawness of the material with a certain political consciousness, but his absence quickly revealed a shift from dramatic embellishment to full-on fiction. After leaving N.W.A., Ice Cube linked up with Public Enemy's New York–based producers, the Bomb Squad, releasing his first solo album *AmeriKKKa's Most Wanted* in 1990. His new music was influenced by both the Nation of Islam and LA gang culture; it was caustic, openly confrontational, and inherently political.

Meanwhile, news began circulating about N.W.A's founder Eazy-E attending a Republican fundraiser in Washington, D.C. Eazy's reported past life as a gang banger and drug dealer, as well as his fronting of a group that had defined the antiestablishment, seemed an odd fit for the Republican Party, and a hypocritical move in light of its racist policies. His appearance at the event was disconcerting, but Eazy emphatically denied being a Republican, suggesting instead that it was an orchestrated publicity coup. This supposed media stunt, however, provided Ice Cube with a golden opportunity. As acrimony between the parties increased, Cube recorded a song called "No Vaseline" (1991) in which he aggressively and explicitly disses his former groupmates and manager Heller, and calls out Eazy-E for his unfortunate misstep.

Eventually, Dr. Dre would leave N.W.A. as well. Ice Cube and Dre both benefited from their departures, as their careers flourished, while effectively ending N.W.A. in the process.

OPPOSITE: Ice Cube, New York City, NY, July 23, 1990, photographer Kevin Cummins.

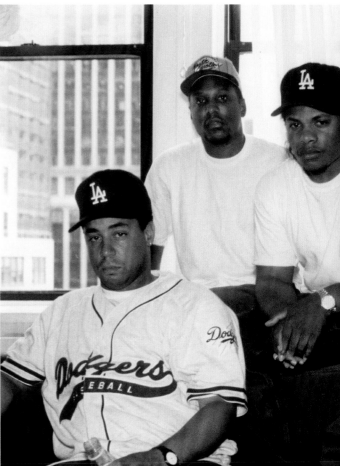

AmeriKKKa's
MOST WANTED
ICE CUBE

CALL 1-900-420-3360

Since he left N.W.A., Ice Cube's been on the run,
from L.A. to New York.

In N.Y.C. he joined forces with Public Enemy's
Chuck D. to record Ice Cube's solo debut album,
"Amerikkka's Most Wanted," a steel-hard collec-
tion of 14 new raps.

Don't wait to read about it in the papers. Find
out what's going on straight from Ice Cube. You
can even leave your own message for him.

YOU CAN'T
BEAT
THE RAP!

CALL 1-900-420-3360 ($2 per minute.)

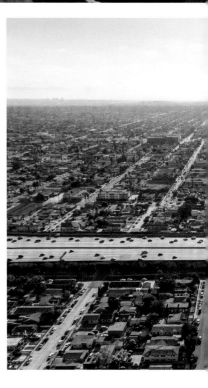

TOP LEFT: Album cover for *EFIL4ZAGGIN*, N.W.A, Ruthless Records, 1991, photographers David Provost and Peter Dokus. **TOP CENTER:** (from left) MC Ren, DJ Yella, Eazy-E, and Dr. Dre of N.W.A., New York City, NY, 1991, photographer Al Pereira. **BOTTOM LEFT:** Promotional poster for the release of *AmeriKKKa's Most Wanted*, Ice Cube, Priority Records, 1990, photographer Mario Castellanos.

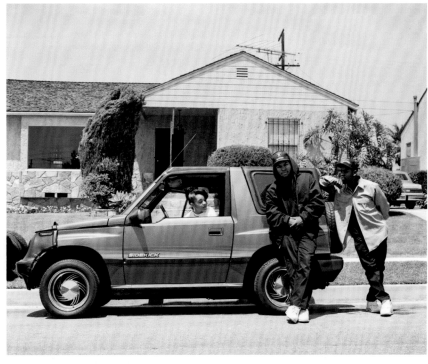

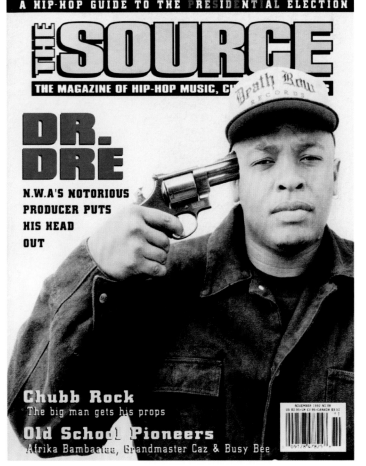

TOP RIGHT: Ice Cube and friends outside of his mom's house, Inglewood, CA, 1990, photographer Janette Beckman. **BOTTOM CENTER:** Aerial view of South Central Los Angeles and the 110 Harbor Freeway, CA, August 16, 2016, photographer unknown. **BOTTOM RIGHT:** "Dr. Dre: N.W.A's Notorious Producer Puts His Head Out," Dr. Dre on the cover of *Source*, November 1992, photographer Shawn Mortensen.

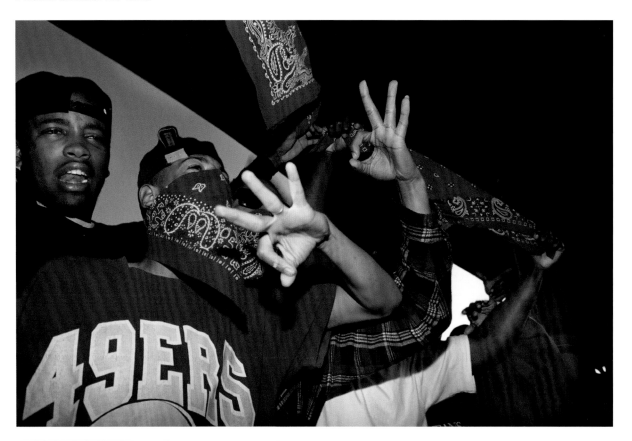

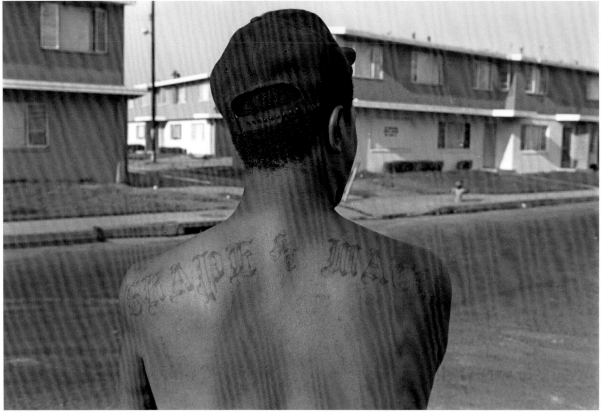

TOP: Bloods gang members gesture their sign during the filming of the music video for "Bangin' On Wax," the title track from the Bloods & Crips' debut album, Los Angeles, March 18, 1993, photographer Steve Starr. **BOTTOM:** Member of the Grape Street Crips shows off his tattoo, South Los Angeles, CA, 1988, photographer Axel Koester. The Grape Street Crips are an African-American street gang based in the Jordan Downs housing project in the Watts neighborhood of South Los Angeles.

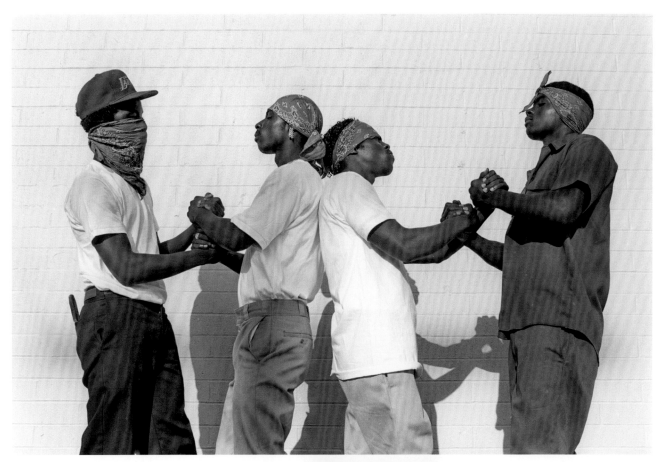

TOP: Grape Street Crips pose in their trademark purple bandanas, South Los Angeles, CA, 1988, photographer Axel Koester.
BOTTOM: Bloods gang members' clothes hang out to dry, South Los Angeles, CA, 1995, photographer Estevan Oriol.

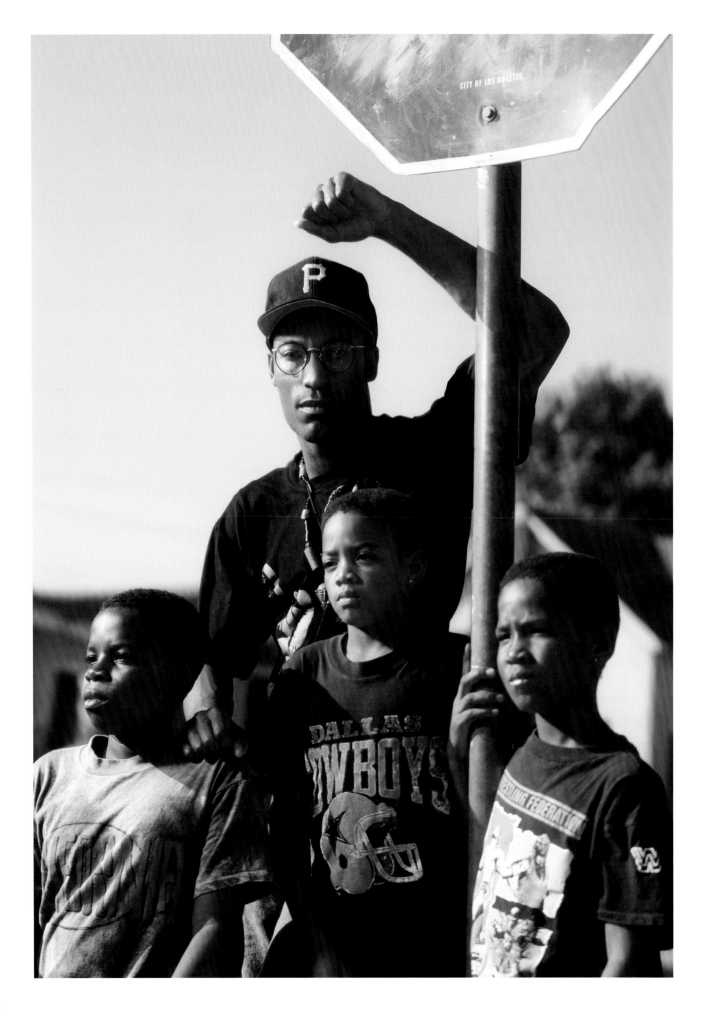

Boyz N the Hood

The early 1990s represented a new era in Black cinema. Spike Lee had become one of the most visible filmmakers in the country, and soon other Black filmmakers would enter the fray as well. Perhaps the most auspicious debut was that of John Singleton. The Los Angeles native, then a recent graduate of the University of Southern California's School of Cinematic Arts, wrote and directed *Boyz N the Hood* (1991), an urban coming-of-age drama set in the city's South Central region. The film took its title from a song by the same name, which had been written by Ice Cube and performed by Eazy-E. Ice Cube would also appear in the film as one of the main characters, Doughboy, a move that was considered controversial by some in the hip hop community, as they saw it as potentially selling out. Yet Cube's role was not only the beginning of an acting career for him but also established a trend that saw successful rappers make the crossover to movies.

Boyz N the Hood dramatized subjects such as police brutality, the crack-cocaine epidemic, gang culture, and urban violence, the same types of issues that N.W.A. had been rapping about in their music. The film was a critical and financial success, and Singleton was nominated for Academy Awards in both the Best Original Screenplay and Best Director categories. At only twenty-four years old, Singleton was the youngest person, as well as the first African American, to be nominated in the Oscars' Best Director category.

The film also helped to solidify LA as the new center of hip hop culture in the early 1990s. A few months prior to the release of the film, the videotaped police beating of Rodney King had captured the nation's attention. Figures like Singleton and Ice Cube were providing a cultural context for understanding what was really going on in LA's poor and working-class Black communities, and their work would serve as a warning for what was to come. When the "not guilty" verdict for the four cops involved in the King case was announced in April 1992, Singleton was standing outside of the Simi Valley courtroom where the trial was held. In response, Los Angeles famously erupted in a massive uprising, something that Ice Cube himself had predicted in his music.

In 1993 Allen and Albert Hughes would release their directorial debut, *Menace II Society*, based on a Tyger Williams script. In one sense, the film, also set in South Central Los Angeles, covers similar terrain to that of *Boyz N the Hood*, yet the approach to the material was quite different. Whereas *Boyz* offered a glimmer of hope to its main character, Tre, in his quest to get out of a troubled environment, *Menace* is a story told from the grave, as the main character, Caine, narrates having already been killed, à la *Sunset Boulevard* (Billy Wilder, 1950). *Menace* touched on some of the same issues as *Boyz*, but its tone was much darker, its vibe much more visceral. There is an inherent morality to *Boyz*, with an emphasis on the role of the Black father figure in the community, yet *Menace* avoids any overt moralizing, and the film is notably short on sentimentality. *Boyz N the Hood* was a much more successful film financially, but *Menace II Society* was able to tap into the aesthetic of realism circulating throughout this era in ways that left a more indelible mark on the viewer. The close release of the two films, along with others such as *Juice* (Ernest Dickerson, 1992), the movie that introduced Tupac Shakur as an actor, helped to define the new "hood" genre. The introduction of this term spoke to the proliferation of such urban, predominantly African-American narratives within wider culture while underscoring the influence of *Boyz N the Hood*. Hood also came to replace what previous generations had called the ghetto.

OPPOSITE: Director John Singleton, who in 1991 became the youngest Academy Award nominee for Best Director for his debut film *Boyz N the Hood*, Los Angeles, CA, 1991, photographer Aaron Rapoport.

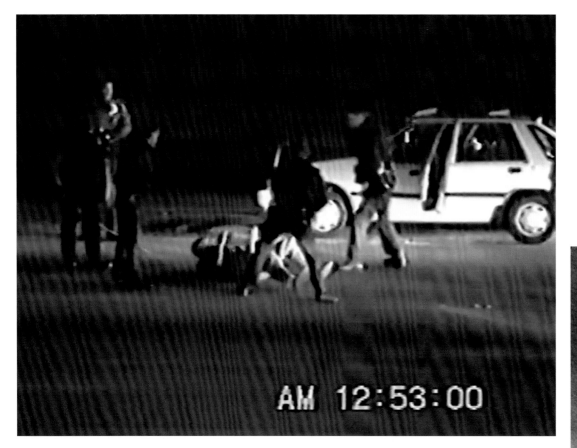

AM 12:53:00

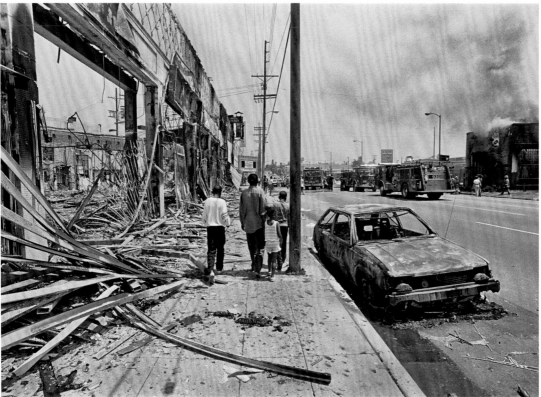

TOP: Still from the amateur video of the Los Angeles Police Department beating of Rodney King, March 3, 1991, filmed by George Holliday.
BOTTOM: *West Adams Boulevard*, a neighborhood is burnt down during the riots, South Central Los Angeles, CA, April 30, 1992, photographer Ted Soqui. The riots swept the city for days after all four police officers accused of the 1991 beating of Rodney King were acquitted of assault.

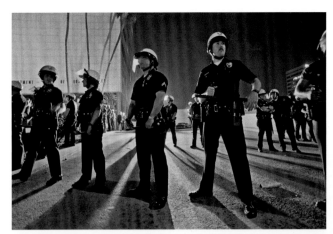
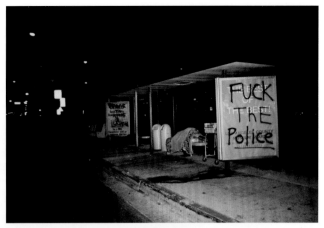

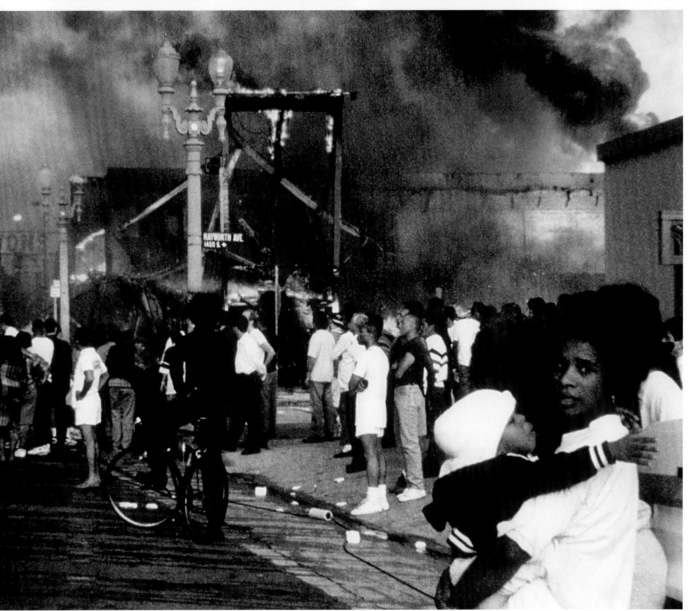

TOP LEFT: *Thin Blue Line*, scene in front of the Los Angeles Police Department Headquarters during the riots, Los Angeles, CA, April 29, 1992, photographer Ted Soqui. **TOP RIGHT:** A homeless person sleeps at a bus stop on Wilshire Boulevard following the riots, Los Angeles, CA, May 2, 1992, photographer Lindsay Brice. **BOTTOM:** A mother and child amid the mayhem—businesses burning, bystanders watching raging fires, a pedestrian in the street drinking from a forty-ounce—at the intersection of Pico Boulevard and Hayworth Avenue, the sky black with smoke, Los Angeles, CA, April 30, 1992, photographer Lindsay Brice.

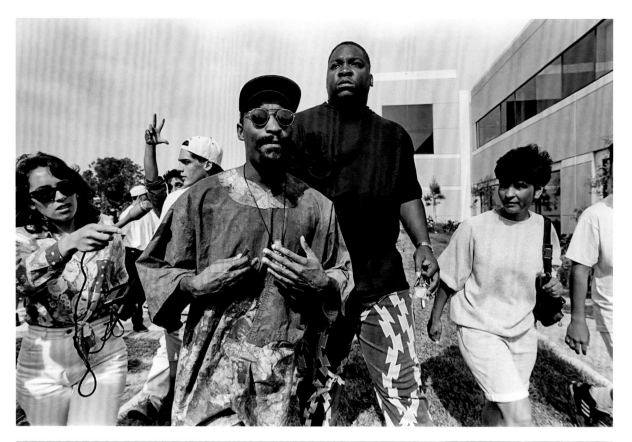

John Singleton (top), director of the 1991 film *Boyz N the Hood*, leaves the Ventura County Courthouse (bottom), Simi Valley, CA, April 29, 1992, photographer Ted Soqui.

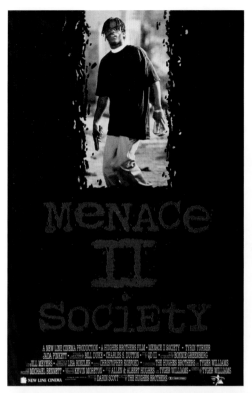

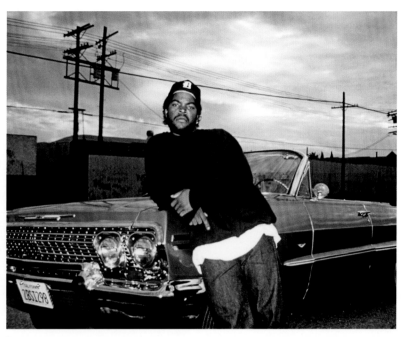

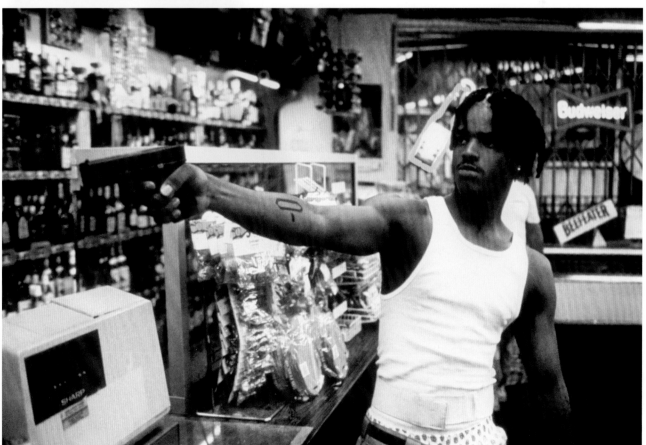

TOP LEFT: Movie poster for *Menace II Society*, starring Larenz Tate, New Line Cinema, 1993, dirs. Allen and Albert Hughes. **TOP RIGHT:** Ice Cube in *Boyz N the Hood*, Columbia Pictures, 1991, dir. John Singleton. **BOTTOM:** Larenz Tate in *Menace II Society*, New Line Cinema, 1993, dirs. Allen and Albert Hughes.

Newsweek

June 29, 1992 : $2.95

Rap and Race

**Beyond Sister Souljah—
The New Politics of Pop Music**

BY JOHN LELAND

SLICK WILLIE

The uprising in the wake of the Rodney King trial cast a large shadow. Racial history in the United States had entered a new era. In the immediate aftermath of the eruption, Democratic presidential candidate Bill Clinton arrived in Los Angeles to tour the areas where the events had taken place. During this trip, he made a famous appearance on *The Arsenio Hall Show*, where he played the saxophone with the house band, seemingly demonstrating his comfort with aspects of Black culture. In fact, throughout his political career, Clinton touted his close relationship with Black voters. Toni Morrison, writing in the *New Yorker* in the late 1990s, went so far as to call Clinton "our first Black President." But in time, Clinton would reveal his "Slick Willie" side. The moniker had originated during Clinton's time as governor of Arkansas; his critics would use it to suggest a certain *slickness*, what they regarded as opportunism and elusiveness, fueled by low moral character. With Clinton as president throughout much of the 1990s, when hip hop was in its prime, I have always thought of Slick Willie as akin to a rap name, albeit one Clinton did not select for himself.

Clinton acted in an especially slick way when he used a speaking opportunity at one of fellow party member Jesse Jackson's Rainbow Coalition meetings to castigate Sister Souljah, a rapper and former member of Public Enemy, who had a background in community activism. Clinton compared Souljah's rap lyrics from her hip hop album *360 Degrees of Power* (1992) to words that might have been spoken by the Ku Klux Klan, as a visibly annoyed Jackson sat on the stage next to him.

Clinton's move would come to be known as a Sister Souljah Moment, meaning a situation in which a politician engages in a calculated public repudiation of a member of their own political party as a way of boosting their own electability. To use another colloquial phrase, Clinton threw Souljah under the bus in order to demonstrate that he was not beholden to the influence of a prominent Black political figure like Jackson. Clinton's performance of racial politics, playing the saxophone while wearing dark sunglasses on a popular Black show, was providing cover for his antics toward Souljah. The increasing influence of hip hop culture in the public sphere could almost be measured by the incident: to witness a presidential candidate using a rapper's lyrics in this type of racial stunt was stunning. As 2Pac would later say, "Bill Clinton, Mr. Bob Dole / You're too old to understand the way the game is told" ("How Do U Want It," 1996).

OPPOSITE: "Rap and Race," Sister Souljah on the cover of *Newsweek*, June 29, 1992, photographer Burk Uzzle. **TOP:** Bill Clinton on *The Arsenio Hall Show*, Los Angeles, CA, June 3, 1992, photographer Reed Saxon. **BOTTOM:** Bill Clinton at a "Rebuild America" conference, held by Jesse Jackson's Rainbow Coalition, as Jackson listens, Washington, D.C., June 13, 1992, photographer Greg Gibson.

HER STORY

Much like Sister Souljah advancing the conversation around politics and hip hop, Queen Latifah was another powerful voice who helped to elevate hip hop culture in terms of social consciousness and, in particular, gender equality—her song "Ladies First" (1989) was among the first to introduce feminism to the culture. Later, she released "U.N.I.T.Y." (1993), which touched on issues of sexual assault, domestic violence, and women who amplify negative gender stereotypes while pointing a lyrical finger at the sexism and misogyny that existed in the industry. While some outside the culture often latched onto similar critiques in what was thought to be a disingenuous attempt to use sexism as a cover for more racist leanings, Latifah spoke from the inside, and her position could not be dismissed easily. Her work demonstrated once more that hip hop has always been its own best critic.

Latifah's contribution did not end there, as she joined the likes of Ice-T, Ice Cube, Will Smith, and others in adding acting to her resume. She made her big-screen debut in Spike Lee's film *Jungle Fever* (1991) and would also go on to star in the Fox sitcom *Living Single* (Yvette Lee Bowser, 1993–98).

The urban cultural landscape that 1990s hip hop represented was decidedly masculine. This is true of both rap music and the "hood" films of the era. A couple of notable exceptions are Leslie Harris's 1992 independent production *Just Another Girl on the I.R.T.* and F. Gary Gray's *Set It Off* (1996), which feels like a cross between *Thelma and Louise* (Ridley Scott, 1991) and *Heat* (Michael Mann, 1995), set in the hood. *Set It Off* is the story of four women—played by Queen Latifah, Jada Pinkett Smith, Vivica A. Fox, and Kimberly Elise—whose individual financial and family struggles prompt them perform a series of brazen bank robberies. Latifah's character, Cleo, is both a gangsta and a lesbian, making the film perhaps one of the first to feature a Black LGBTQ+ character.

A common route to solo hip hop success in the 1990s was through affiliation with an existing rap crew or individual star rapper and contributing verses to tracks on their album. If the public response was strong enough, this might lead to a featured rapper's album of their own. It also became increasingly popular to include a female rapper as a member of these crews. One such artist who started out this way was Yo-Yo, who made her debut

on Ice Cube's album *AmeriKKKa's Most Wanted* (1990). Yo-Yo brought an LA swagger and sound to her rhymes, and her work on solo albums such as *Black Pearl* (1992) cut against the topical grain of male-dominated gangsta rap, providing commentary on a range of topics, including women's sexuality, empowerment, and self-esteem. She also established her own crew, which she called the Intelligent Black Woman's Coalition.

The Lady of Rage was another key contributor to the LA scene—although originally hailing from Virginia—who featured prominently on Dr. Dre's landmark album *The Chronic* (1992) and Snoop Dogg's follow-up *Doggystyle* (1993). Her single "Afro Puffs" (1994) was a hit, but her highly anticipated solo album would suffer due to the overall environment of disarray at Death Row Records in the wake of 2Pac's murder. Circumstances never allowed her to fulfill her promise, but the buzz of anticipation around her name in the 1990s was immense.

Missy Elliott, another Virginia native, had been a behind-the-scenes player in the music industry for a while before she signed a deal with Sylvia Rhone, CEO at Elektra, in 1996 to establish her own label under the Elektra banner, the Goldmind. Elliott essentially emerged as a fully fledged rapper/producer/songwriter, and her collaboration with childhood friend and creative partner Timbaland brought an off-kilter, idiosyncratic persona and a wholly original style to the table.

For the release of "The Rain (Supa Dupa Fly)," the debut track off her first solo album *Supa Dupa Fly* (1997)—the title riffs on the Blaxploitation film classic *Super Fly* (1972), and the track samples Memphis soul singer Ann Peebles's song "I Can't Stand the Rain" (1974)—Elliott created an unforgettable video in which she performs in a shiny black vinyl jumpsuit that resembles a giant trash bag, while wearing helmetlike head-gear with built-in shades. The surreal aesthetic was amped up thanks to director Hype Williams's hyperstylized camerawork. The video also features camo appearances by Lil' Kim, Yo-Yo, Da Brat, and Puff Daddy. Elliott went on to accumulate huge record sales across multiple albums and is recognized worldwide as one of hip hop's biggest music-video icons ever for her uniquely identifiable, boundary-pushing work in this space. In May 2023 she was inducted into the Rock and Roll Hall of Fame, the first female hip hop artist to be awarded in the organization's history.

OPPOSITE: Yo-Yo in front of the Apollo Theater in Harlem, New York City, NY, June 19, 1992, photographer Al Pereira.

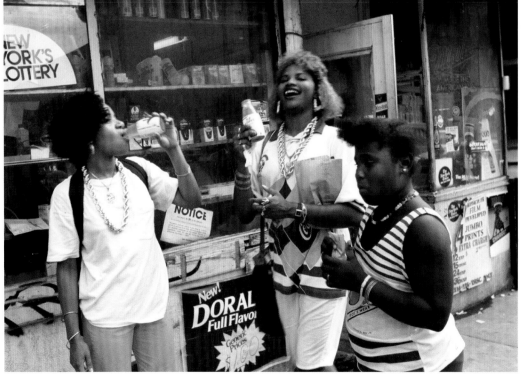

TOP: Sister Souljah on the street in Greenwich Village, New York City, NY, April 21, 1991, photographer Erica Berger. **BOTTOM:** Cheryl "Salt" James (left) and Sandra "Pepa" Denton (center), two members of Salt-N-Pepa, New York City, NY, 1986, photographer Janette Beckman.

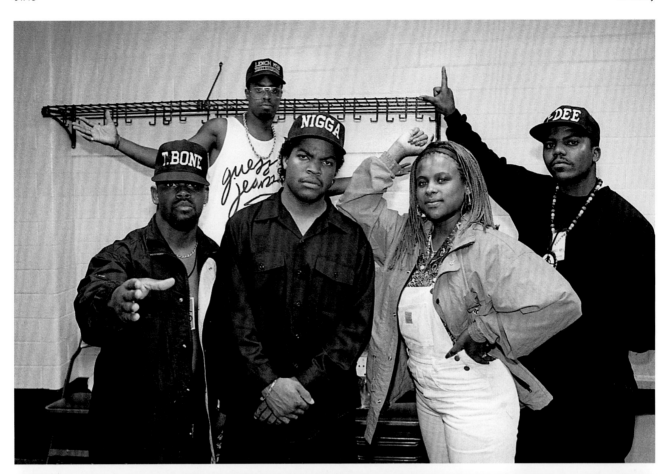

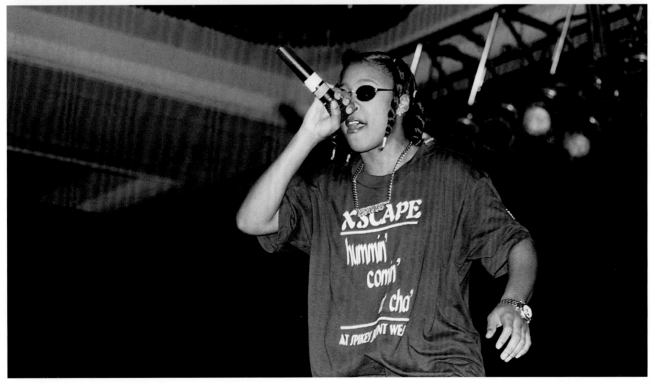

<u>**TOP:**</u> Ice Cube (center left) with Da Lench Mob group members, (from left) T Bone, Sir Jinx, Yo-Yo, and J-Dee, backstage at the Arena, St. Louis, MO, August 1990, photographer Raymond Boyd. <u>**BOTTOM:**</u> Da Brat performs at the Hyatt Hotel, Chicago, IL, June 1994, photographer Raymond Boyd. <u>**OVERLEAF:**</u> Queen Latifah at Yo-Yo's birthday party at the Village Gate, Greenwich Village, New York City, NY, 1994, photographer Ernie Paniccioli.

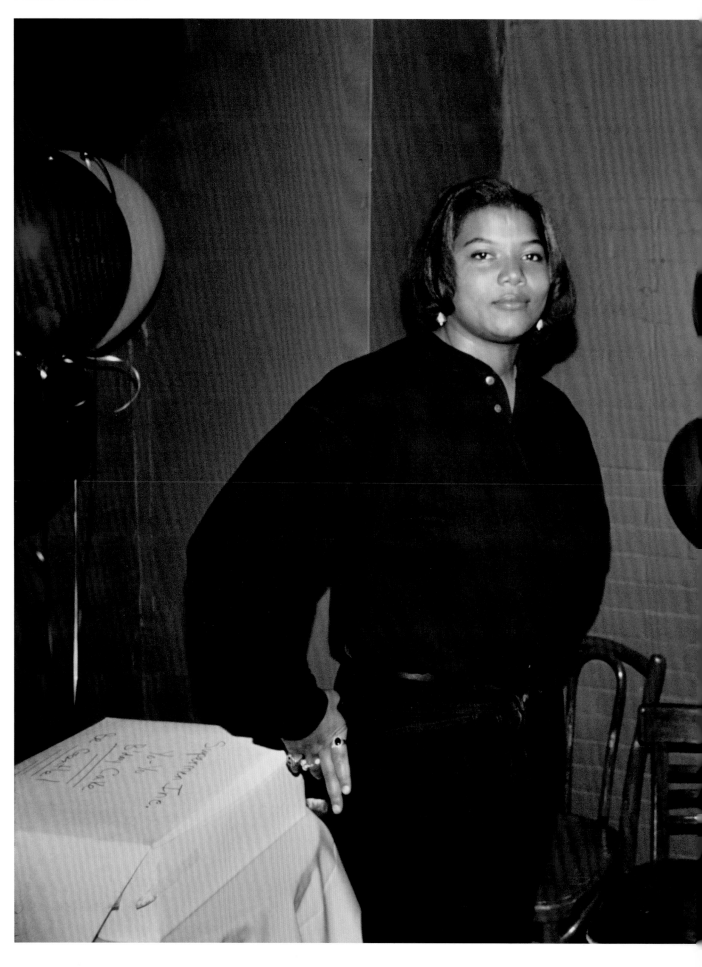

TOP: Mary J. Blige, New York City, NY, 1991, photographer Lisa Leone. **BOTTOM LEFT:** Erykah Badu, 1998, photographer Eric Johnson.
BOTTOM RIGHT: Lady of Rage with her dogs, Goldie and Max, Elysian Park, Los Angeles, CA, 1994, photographer B+.

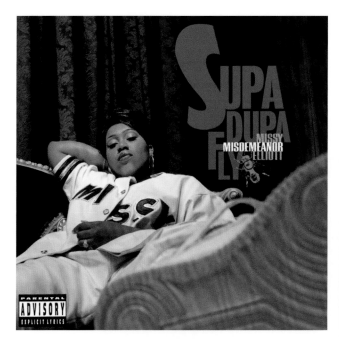

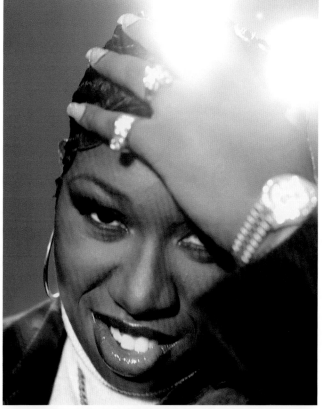

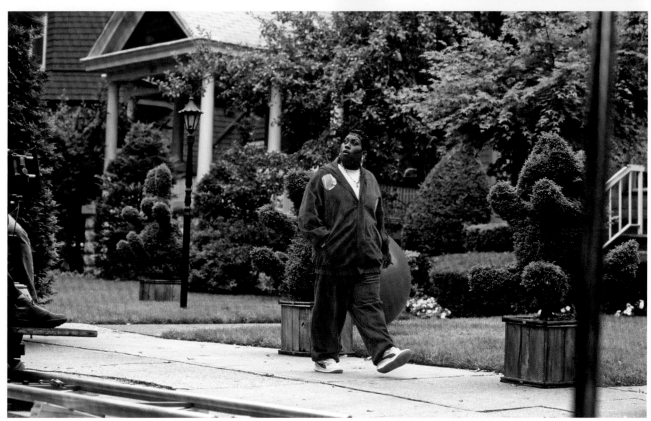

TOP LEFT: Album cover for *Supa Dupa Fly*, Missy Elliott, Electra Entertainment, 1997, photographer Kwaku Alston. **TOP RIGHT:** Missy Elliott, 1997, photographer Eric Johnson. **BOTTOM:** Missy Elliott on set during the filming of the music video for Lil' Mo's "5 Minutes," Brooklyn, NY, June 10, 1998, photographer Al Pereira.

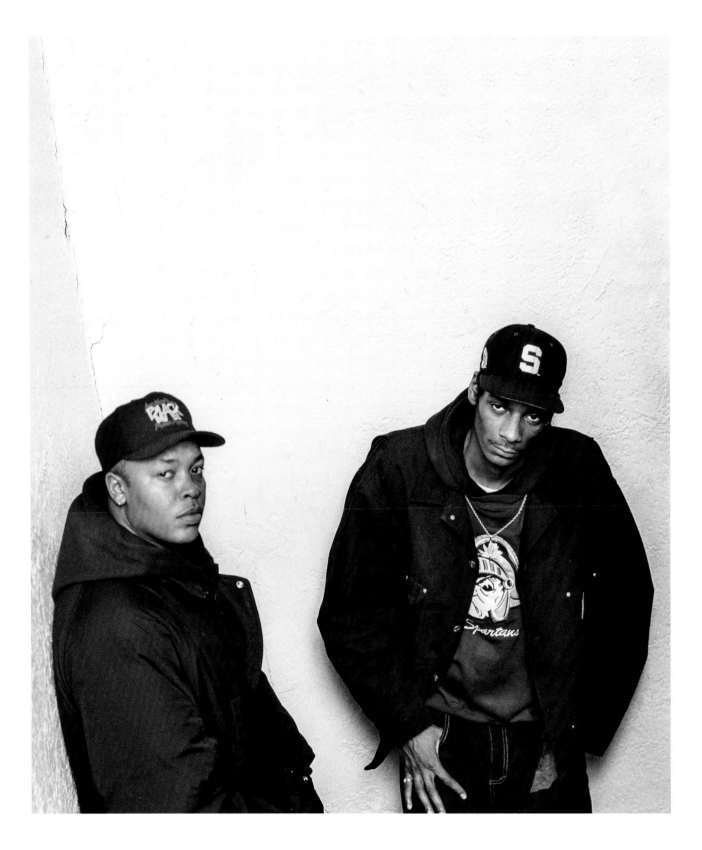

THE CHRONIC

Late in 1992, Dr. Dre released his first solo album after leaving N.W.A. As the metaphorical smoke from the Los Angeles uprising still lingered in the air, *The Chronic* hit the streets. The title of the album refers to high-quality cannabis, with the album artwork mirroring the famous cover illustration printed on Zig-Zag rolling papers. In other words, the music contained within was *dope*! Though Dre rapped on the album, it was his production and overall creative direction that distinguished this record. Utilizing funk beats like those made famous by George Clinton and Parliament Funkadelic in the 1970s, Dre crafted a sonically superior album that elevated hip hop production. The lyrics were raw, uncut, and straight from the streets, yet the production was smooth and sophisticated. Generally speaking, hip hop production up until this point had been either minimalist or otherwise lo-fi. There was often an unadorned quality that fit perfectly with hip hop's street ethos. But Dre managed to maintain the essence of the streets in the songs while making the overall production sound like a smoothed-out R&B or soul record.

Dre's rapping was less of a focus due to the presence of his young protégé, Long Beach, California native Snoop Doggy Dogg. The duo of Dre and Snoop had first been heard together on the soundtrack for the film *Deep Cover* (Bill Duke, 1992) from earlier that summer. *The Chronic* would make Snoop a household name and set the stage for his own solo album *Doggystyle*, which was also produced by Dr. Dre and released a year later in 1993. Snoop's rapping style was a game changer. His cadence, use of Cali-specific street slang, storytelling skills, and cool, laidback approach to rhyming shifted the culture, situating an LA rapper at the center of hip hop's stylistic frame of reference. Snoop displayed his affiliation with gang life prominently and also became known for his embrace of cannabis culture; he was often seen wearing a baseball cap emblazoned with a green cannabis leaf, several years before medical and recreational marijuana was legalized in various states throughout the country. A love for weed was displayed by other LA-area rappers as well: the Latino hip hop group Cypress Hill advocated for cannabis use, and Ice Cube's film *Friday* (F. Gary Gray, 1995) was relatively successful as a hip hop stoner comedy.

The Chronic itself was quite comedic. There were multiple skits throughout and a general sense of humor embedded into this articulation of urban street life. The album openly rejects any sense of politics in favor of hedonism, debauchery, vengeance, and outlandish violence. It affords a sort of transgressive pleasure in its defiance of conventions and rules. The album functions like a coda to the Rodney King riots, offering a postconflict expression of what transpired in ways that eschew both the sentimental and the serious.

From a style perspective, this era brought forth the influence of gang culture and LA's local swap meets, a type of indoor flea market, where residents of South Central often shopped for clothes. The LA uniform championed a no-frills, minimalist workwear aesthetic, and in general it reflected a blue-collar orientation, consistent with the notion of "puttin' in work": beanies, work jackets, and khakis, or perhaps white tees, gray sweatshirts, flannels, and a type of house shoes that were also known as croker sacks (a term traditionally associated with burlap bags common in Southern agricultural work, but here referring to the inexpensive rubber-soled shoes that could be bought at the swap meet). In a similar vein, the popular cars associated with this lifestyle were not expensive, foreign luxury brands, but instead older American sedans from the 1960s or 1970s. Known as lowriders or low lows, the cars had a lowered body and were meticulously refurbished, customized, and tricked out with hydraulic kits that allowed the driver to perform various stunts.

The early 1990s saw hip hop's center of gravity shift from New York to Los Angeles, from the East Coast to the West Coast. Perhaps one of the best examples of this shift was when Russell Simmons's pioneering New York label Def Jam signed West Coast artist Warren G. East and West Coast styles were very different at the time, and because hip hop originated in New York, its followers believed that its style was inherently superior. But while fans on the West Coast acknowledged New York's history, they insisted that it was now old news and that the West Coast had taken over. And when a legacy label like Def Jam signed Warren G, it indicated that regional pride had its limitations. After *The Chronic,* the appetite for the "new" style was so voracious that many now considered East Coast hip hop to be passé; the West was where both the energy and the money resided. Over time, stylistic debates would give way to an actual rivalry framed as East vs. West, one that would ultimately have deadly consequences.

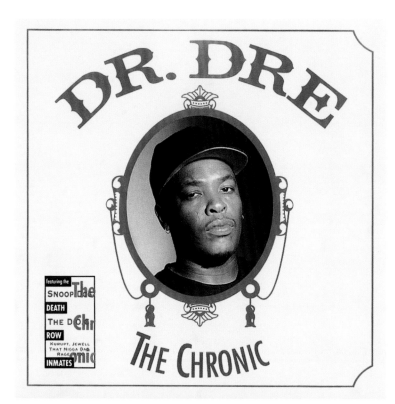

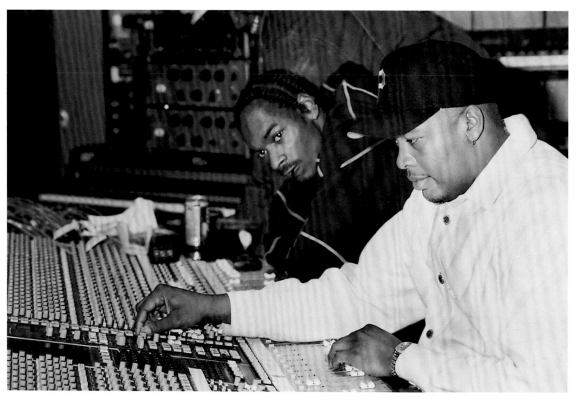

TOP LEFT: Album cover for *The Chronic*, Dr. Dre, Death Row/Interscope Records, 1992, artwork by Daniel Jordan and Kimberly Holt.
TOP RIGHT: Zig-Zag original white rolling papers, the illustration on which the design of *The Chronic* album artwork was based.
BOTTOM: Dr. Dre and Snoop Dogg in a recording studio, 1993, photographer Patrick Downs.

Snoop Dogg, Los Angeles, CA, 1999, photographer Mike Miller.

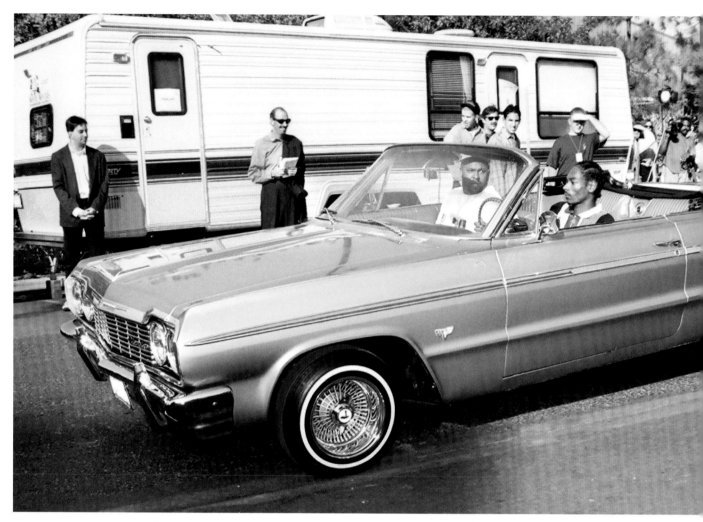

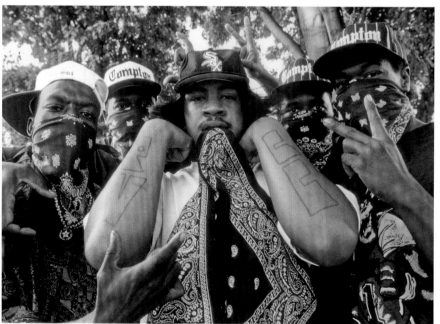

TOP: Snoop Dogg during the 1993 MTV Video Music Awards at the Universal Amphitheater, Los Angeles, CA, September 3, 1993, photographer Jeff Kravitz. **BOTTOM LEFT:** *Straight Outta Compton*, the Park Village Compton Crips during the Los Angeles riots, Compton, CA, 1992, photographer Susan C. Ragan. The Crips and Bloods formed a temporary truce and came together to celebrate. **BOTTOM CENTER:** 63 vs. 63, Chevrolet Impalas at the Damu Car Club Barbeque, Los Angeles, CA, April 23, 2005, photographer Estevan Oriol.

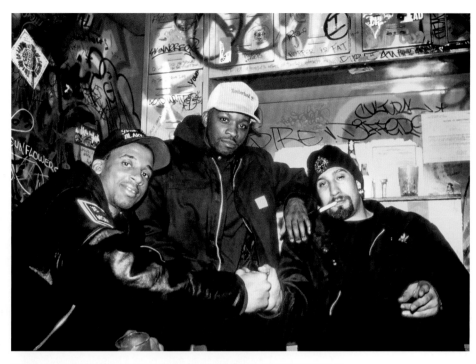

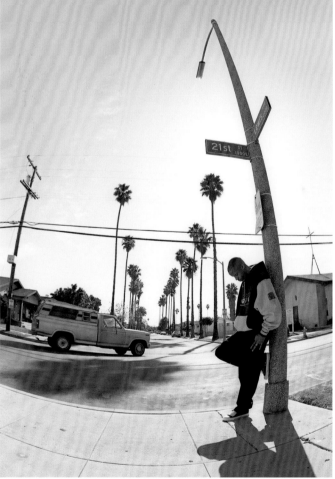

TOP: B-Real of Cypress Hill (right) at Wetlands Preserve, New York City, NY, February 26, 1992, photographer Steve Eichner.
BOTTOM: Warren G on the corner of Twenty-First Street and Lewis Avenue, Long Beach, CA, 1994, photographer Mike Miller.

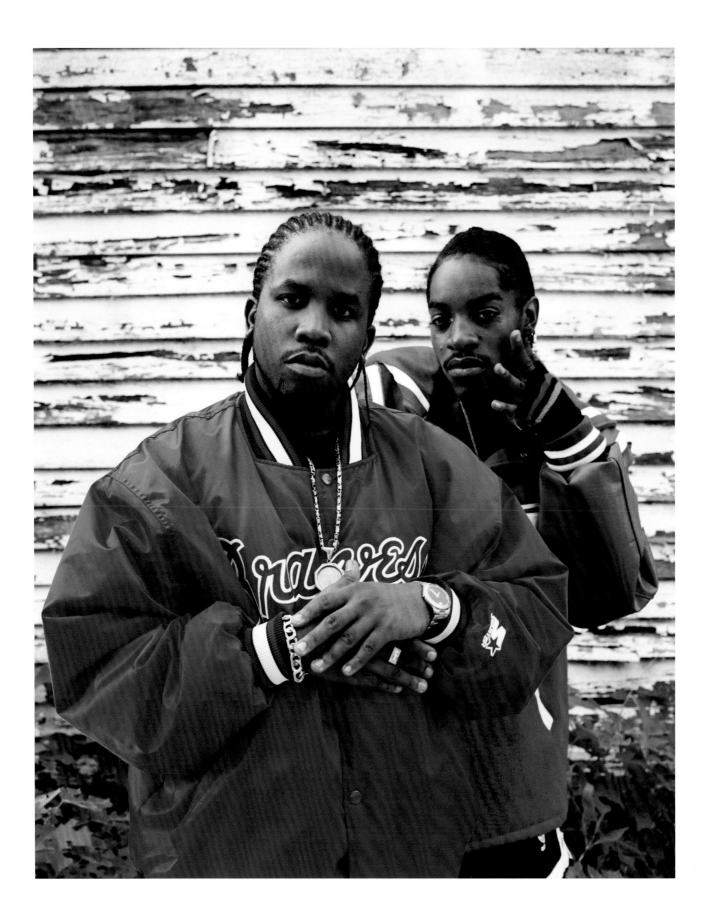

THE SOUTH GOT SOMETHIN' TO SAY

When Atlanta-based rap duo OutKast won the 1995 Source Award for New Artist of the Year (Group), its charismatic MC André Benjamin (Dre, or later André 3000) famously stated, amid a cacophony of boos from the audience, "The South got somethin' to say," suggesting that this U.S. region, previously marginal in hip hop circles, was now poised for takeover. Though it took some time, Dre would be proved right as the popularity of Southern hip hop grew, even coming to dominate in the 2010s. Yet the history of Southern hip hop actually began back in the 1980s.

Fronted by Luther Campbell (known at various times as Luke Skywalker, Luke, and Uncle Luke), Miami-based 2 Live Crew made a name for themselves making raunchy, comedic, sex-based rap music closely connected with Miami's Black strip-club culture. Their third studio album, *As Nasty As They Wanna Be* (1989), featured overtly sexual content, which many considered misogynistic, exaggerated for effect, the boorish approach serving as the record's calling card. The hugely popular single "Me So Horny" (1987) opens with a sample from Stanley Kubrick's Vietnam War–era drama *Full Metal Jacket* (1987), in which a prostitute solicits sex from the film's protagonist, Private Joker, played by Matthew Modine.

2 Live Crew were not known for poetic lyrical expression, nor were they regarded as articulators of substantive social critique. Instead, they represented something quite silly, if X-rated. Though many lyrical purists scoffed at their style, the record was a commercial success, and their dance-club-centric bass beats appealed to large audiences both within and beyond the South.

Perhaps victims of their own success, Campbell and the 2 Live Crew, in 1990, found themselves in the middle of a legal drama, one that would thrust the group into the unexpected role of free-speech avatars, when a federal judge ruled *As Nasty As They Wanna Be* legally obscene. Following the ruling, a record store owner in Fort Lauderdale, Florida, was arrested when he sold a copy of the album to an undercover cop. Shortly after, Campbell and another member of the group would also be arrested for performing material from the album at an adults-only show in Hollywood, Florida. Eventually, the group came to prevail in court on the grounds of free speech. While a relatively small number of people would argue that 2 Live Crew represented the best of

rap music, general opposition to censorship and a commitment to free expression made this an opportune moment to stand up against the increasing assaults being directed toward hip hop culture from the media, politicians, law enforcement, and the judicial system.

Another cultural battle playing out in rap music in 1990 saw Geffen Records refuse to release the album *Geto Boys* by the Houston-based group of the same name. The Geto Boys often merged horror-film-like themes with street culture, and Geffen cited the album's lyrics as too explicit, concerned that they glamorized violence and graphic sexual imagery. The decision not to distribute the record was seen as racially hypocritical, considering that Geffen had released work by comedian Andrew "Dice" Clay and the group Guns N' Roses, white acts whose material was undeniably problematic around issues of race, gender, and sexuality. The album would eventually be distributed by another label, but hip hop lyrics would continue to be scrutinized, with self-elected "social gatekeepers" voicing their increasing concerns about the influence that rap music was having on society. Meanwhile, within the hip hop community itself, rappers were frequently challenged with regard to sexist or homophobic content, and notions of free speech would form part of an ongoing debate.

In 1991 the Geto Boys released the album *We Can't Be Stopped* on the Black-owned Rap-A-Lot Records label founded by James Prince (better known as J. Prince). The graphic album cover featured the group's members, Scarface, Willie D, and Bushwick Bill, the last of whom was depicted in the hospital after having shot himself in the eye during a tussle with his girlfriend, following a suicide attempt fueled by grain alcohol and PCP. The album cover was intended to be disturbing, and it most certainly accomplished its goal. The group would score a huge hit with the paranoid-themed single "Mind Playing Tricks on Me," a compelling song that broke away from an overt desire to frighten, instead offering a glimpse into the mindset of young, urban Black men trying to navigate the terrain of 1990s America.

The trials and tribulations that confronted Southern groups like 2 Live Crew and the Geto Boys tell of the growing hostility projected toward hip hop as the culture grew. These high-profile examples also laid the foundation for the emergence of what we

OPPOSITE: Big Boi (left) and André 3000 of OutKast, Atlanta, GA, August 27, 1998, photographer Jonathan Mannion.

might call hip hop's "third way." The East and West Coasts had a new opponent to contend with as the South began its slow but determined takeover.

The city of Atlanta, alternatively known as the ATL or the A, represented a different prospect from either New York or LA in Black cultural history. From roughly the late 1910s through the early 1970s, Black people left the Deep South in the millions, moving to various cities in the North, Midwest, and the West Coast in search of economic opportunity. This movement to more industrialized areas of the country completely reshaped both Black culture and American society at large and came to be known as the Great Migration. As the civil rights movement took off in the South, Atlanta positioned itself as a unique Southern oasis, a place where Southern traditions attempted to coexist with the more business-friendly life of an urban center that was once marketed as the "City Too Busy to Hate."

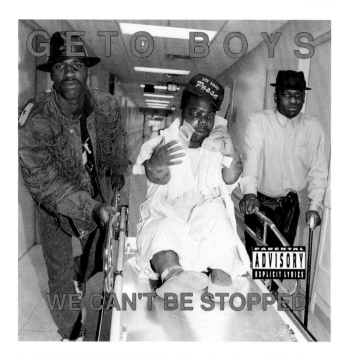

In 1989 Antonio "L.A." Reid and Kenneth "Babyface" Edmonds, former members of the R&B group the Deele, opened their new label LaFace Records in Atlanta. Much of the music industry by this time was based in Los Angeles or New York, so setting up in Atlanta was unusual. Looking back at this move, it was clearly a sign of things to come. In 1994 LaFace released OutKast's first album *Southernplayalisticadillacmuzik*; its unique rapping style, drenched in Southern accents and regional slang, the dope-ass beats provided by the production team Organized Noize, and the overall idiosyncratic identity presented something unapologetically different from the East or West Coast offering. Fronted by Dre and his partner Big Boi (aka Sir Lucious Left Foot), OutKast caused many to take notice of their arrival on the scene.

On the intro to the single "Player's Ball" (1993), Rico Wade, of Organized Noize, lays out the group's own Atlanta style preferences: "Man, the scene was so thick / Lowriders, '77 Sevilles, El Dogs / Nothin' but them 'Lacs / All the playas, all the hustlers / I'm talkin' 'bout a Black man heaven here…" The group's penchant for recycling and repurposing old Cadillacs ('Lacs) connects them with 1970s culture while creating a new context for these older American luxury cars and transforming them into a distinct ATL street-style statement. With Big Boi's playa vibe and Dre's lyrical poetics, OutKast represented street culture meets Black Southern identity. Perhaps most importantly, the group helped to expand the audience of Southern hip hop while also forcing an already divided industry to take them seriously as MCs.

As OutKast placed their names among the most celebrated and respected hip hop artists anywhere, a host of new MCs, hip hop groups, and industry moguls began to surface across the South, establishing a firm foundation for future geographic dominance. The pop group TLC (also of LaFace Records) represented another success story during this time, as did the work of Jermaine Dupri on his So So Def label. The vibe was not limited to Atlanta though. In New Orleans, Percy "Master P" Miller led No Limit Records, while the brothers Ronald "Slim" Williams and Bryan "Birdman" Williams ran the influential Cash Money Records, the label that first signed the future hip hop superstar Lil Wayne. Three 6 Mafia and 8Ball & MJG hailed from Memphis; UGK (Underground Kingz) put Port Arthur, Texas, on the map; while Trick Daddy and Trina were "holdin' it down" for Miami.

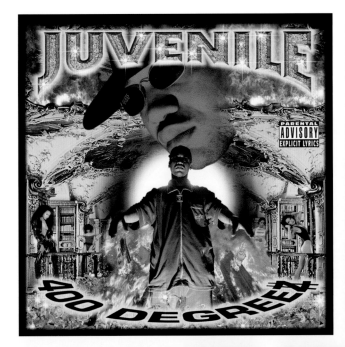

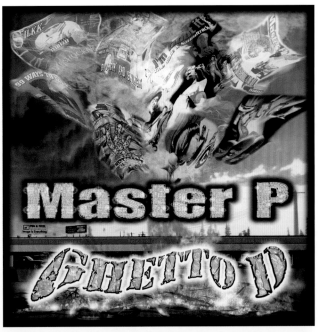

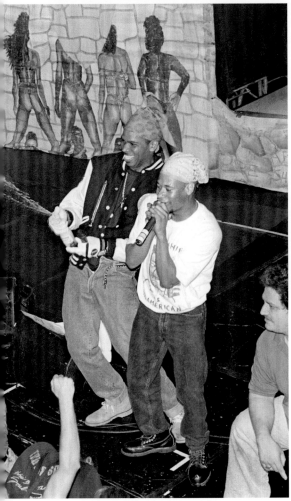

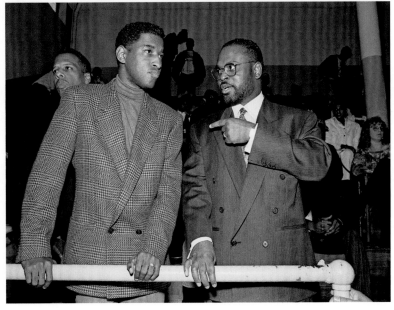

OPPOSITE TOP: Album cover for *We Can't Be Stopped*, Geto Boys, Rap-A-Lot Records, 1991, photographer unknown. **BOTTOM CENTER:** 2 Live Crew perform at the Palladium, New York City, NY, July 18, 1990, photographer Ebet Roberts. **TOP LEFT:** Album cover for *400 Degreez*, Juvenile, Cash Money Records, 1998, artwork by Shawn Brauch, Pen & Pixel Graphics. **TOP RIGHT:** Album cover for *Ghetto D*, Master P, No Limit Records, 1997, artwork by Shawn Brauch, Pen & Pixel Graphics. **BOTTOM RIGHT:** LaFace co-founders Kenneth "Babyface" Edmonds and Antonio "L.A." Reid host a community family holiday party, Atlanta, GA, December 18, 1992, photographer Rick Diamond.

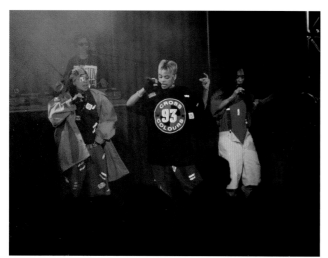

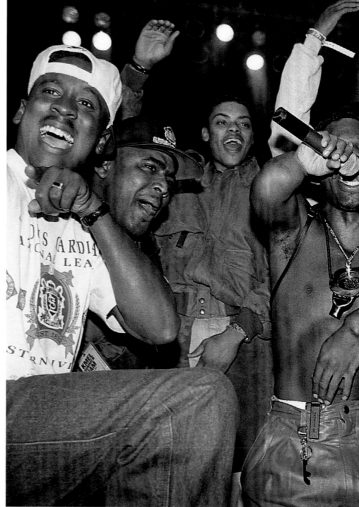

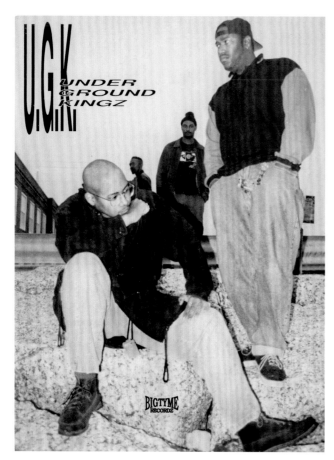

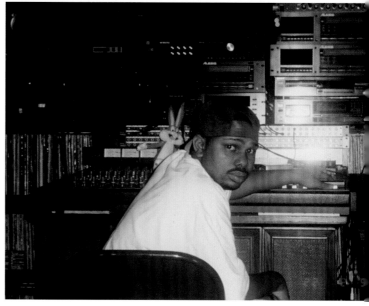

TOP LEFT: TLC perform on an episode of *The Oprah Winfrey Show*, Chicago, IL, November 17, 1992, photographer Paul Natkin.
TOP CENTER: Bushwick Bill (center) of the Geto Boys performs at the Arena, St. Louis, MO, October 1991, photographer Raymond Boyd.
BOTTOM LEFT: UGK promotional photograph for the release of EP *Southern Way*, Bigtyme Recordz, 1992, photographer unknown.
BOTTOM CENTER: DJ Screw at Samplified Digital Recording Studio during the recording of *3 'N tha Mornin'*, Missouri City, TX, 1996, photographer Demo Sherman.

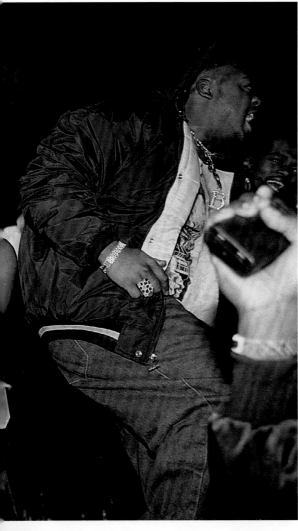

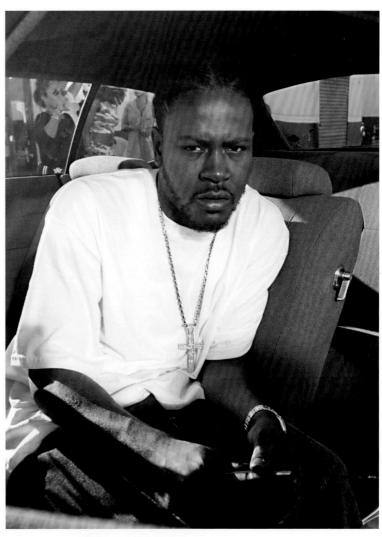

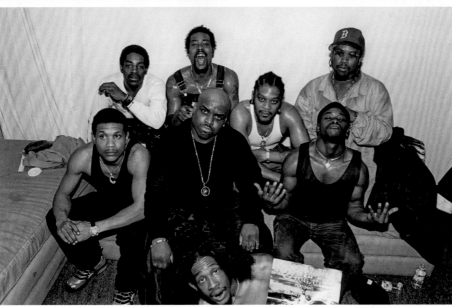

TOP RIGHT: Trick Daddy on set during the filming of his music video for "I'm a Thug," Miami, FL, April 11, 2001, photographer Scott Gries.
BOTTOM LEFT: Several members of the Dungeon Family, New York City, NY, March 1993, photographer Catherine McGann.

THE NEW KUNG-FU STYLE
THE MYSTERY OF THE 5 ELEMENTS! GOLD...WOOD... WATER...FIRE & EARTH TECHNIQUES!

THE MYSTERY OF CHESS BOXING

Produced & Directed by JOSEPH KUO • *Martial Arts Instructor:* WANG FU CHANG
Starring: JACK LONG, JEANIE CHANG, YUEN HSIAO TIEN, SIMON LEE, MARK LONG

WU-TANG CLAN
AIN'T NUTHING TA FUCK WIT!

Location, and how it is represented, has always been essential to the narrative of hip hop, a concept that started in New York's various neighborhoods and boroughs. As the culture expanded, cities, states, and entire regions of the country came to be defined by the stylistic differences—whether musical, lyrical, or visual—linked with each locale. The notion of representation would become increasingly prevalent as more artists entered the fray. To *represent* in hip hop is to identify with your location and promote this location at all times. Such promotion could involve lyrics that shout out, or celebrate, your location. Representin' could also involve wearing gear, such as sports-team apparel, that directly identifies with the place that is being promoted.

With Death Row Records headquartered in Los Angeles, its West Coast dominance from the early to mid-1990s put New York on the defensive, while the South waited in the wings. In time Midwestern cities such as Detroit and Chicago moved into the discussion as well. New York was down from its peak, and its representatives were forced to regroup. The competitive battle for stylistic dominance worked best when it inspired others to "step up their game." So New York had to stage a comeback of sorts.

In 1993 a hip hop collective known as the Wu-Tang Clan, representing the rather low-key borough of Staten Island, released their first album: *Enter the Wu-Tang (36 Chambers)*. Wu-Tang was composed of mutiple members—including RZA (pronounced "Riza"), Ghostface Killah, Method Man, Raekwon, Ol' Dirty Bastard, GZA (pronounced "Giza"), U-God, Inspectah Deck, Masta Killa, and Cappadonna—each with their own distinct identity. RZA was their ostensible leader, but the group did not adhere to a top-down structure. Instead, each member was regarded as a solo artist and simultaneously a member of the collective.

Wu-Tang were unique in that they frequently referenced Asian martial-arts films in their music. Recalling a time in the 1970s when Bruce Lee and other kung fu films played in the same theaters as Blaxploitation features, Wu-Tang merged low-budget Asian martial-arts film with Black street culture, forging an original and distinct identity. RZA's aesthetically stripped-down production style coupled with the group's lyrical poetics about street

life on tracks like "C.R.E.A.M." ("Cash Rules Everything Around Me") (1993) created a new, gritty, yet avant-garde sound and style that redefined notions of authentic New York hip hop—in an age when Dr. Dre's George Clinton–inspired G-funk style still commanded the day. As Inspectah Deck put it, Wu-Tang was "alive on arrival," and the revival of New York was set in motion.

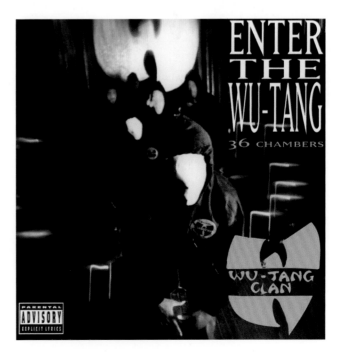

OPPOSITE: Movie poster for *The Mystery of Chess Boxing*, Hong Hwa International Films, 1978, dir. Joseph Kuo. **BOTTOM RIGHT:** Album cover for *Enter the Wu-Tang (36 Chambers)*, Wu-Tang Clan, BMG Music/RCA/Loud Records, 1993, photographer Danny Hastings.

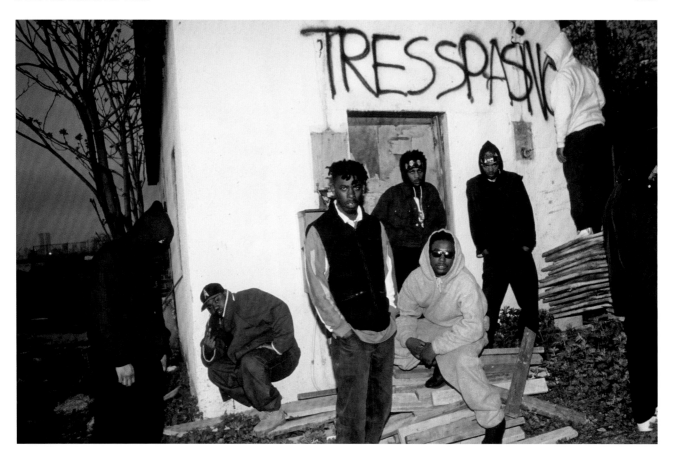

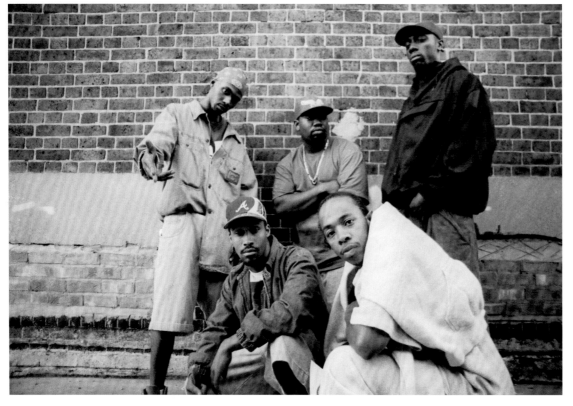

TOP: Wu-Tang Clan members (from center left) Raekwon, GZA, Ol' Dirty Bastard, RZA, and Method Man on Staten Island, NY, May 8, 1993, photographer Al Pereira. **BOTTOM:** (from left) Master Killah, Divine, Raekwon, U-God, and Inspectah Deck behind the Kentish Town Forum, London, September 1994, photographer Eddie Otchere.

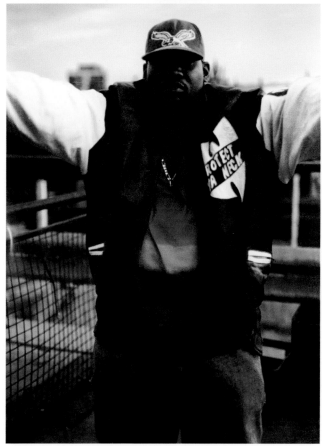

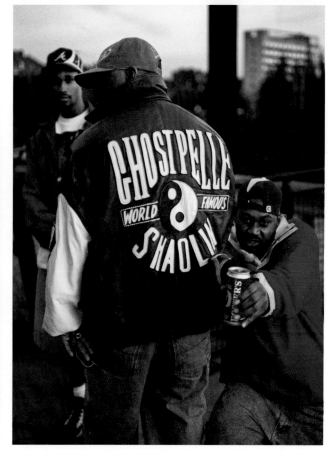

TOP LEFT: Ol' Dirty Bastard on set during the filming of the music video for "Shimmy Shimmy Ya" in Astoria, Queens, NY, April 21, 1995, photographer Al Pereira. **TOP RIGHT:** A mural honoring Ol' Dirty Bastard in Bedford-Stuyvesant, Brooklyn, NY, March 6, 2018, photographer Al Pereira. **BOTTOM:** (left) Raekwon and (right, from left) Divine, Raekwon, and Ghostface Killah behind the Kentish Town Forum, London, September 1994, photographer Eddie Otchere.

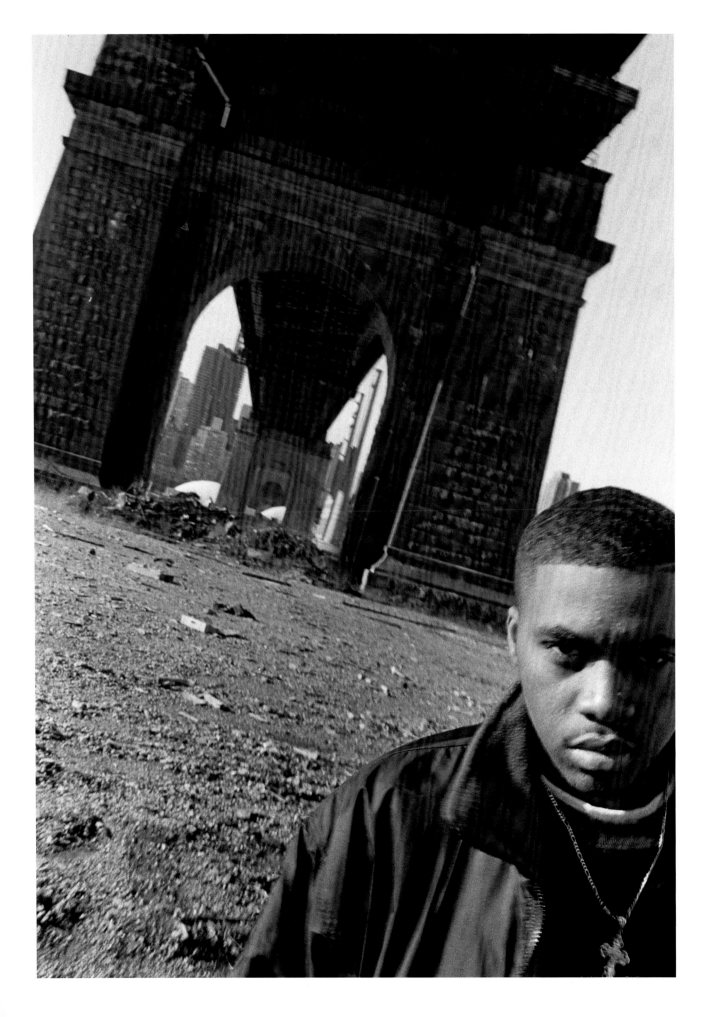

IT AIN'T HARD TO TELL

In early 1994 Nasir Jones, son of trumpet player Olu Dara, released his first offering, the now-legendary *Illmatic*. Nas, as he was known, offered a young, bird's-eye view of life in the mid-1990s, at the height of the crack era. His astute introspection and sophisticated rhymes reminded some of the God MC, Rakim, yet Nas was a phenomenon all his own. The album garnered critical acclaim, while generating much love in the streets. Nas, like Wu-Tang, became the voice of the New York rap revival and reflected on the legacy of hip hop's birthplace while fueling its resurgence.

Illmatic was quickly hailed as one of the greatest hip hop albums ever. This was lofty praise for a debut release and set a very high bar for the rest of Nas's career. On the release of his second album *It Is Written* (1996), many seemed ready to denounce the rapper as a one-hit wonder, but in spite of these haters, Nas continued to create great music. On the track "I Gave You Power," for instance, Nas raps from the perspective of a gun, engaging in a clever commentary on the impact of gun violence on the community. The video for the song "Sweet Dreams" features Nas and actor Frank Vincent recreating the 1970s Las Vegas milieu of Martin Scorsese's *Casino* (1995), in particular the colorful vintage wardrobe worn by Robert De Niro's character Sam "Ace" Rothstein. In the original film Vincent plays the character Frank Marino, the sidekick of Nicky Santoro, played by Joe Pesci.

"Sweet Dreams" was directed by Hype Williams, who became a well-known hip hop auteur during this time, bringing a cinematic flair to his music videos for a variety of artists, including Missy Elliott, Busta Ryhmes, and the Wu-Tang Clan. Williams would also direct Nas and his costar and fellow rapper DMX in *Belly* (1998), which brought the director's distinctly stylized hip hop approach to feature film. By the late 1990s rappers routinely appeared in movies, the questions about authenticity that Ice Cube had faced for appearing in *Boyz N the Hood* (1991) having since passed.

The Hughes brothers' second film, *Dead Presidents* (1995), utilizes a retro soundtrack of 1970s soul classics from artists such as Isaac Hayes, Sly Stone, and Curtis Mayfield, whose music has also served as samples on familiar hip hop tracks, to tell the story of Black Vietnam veterans and their struggles upon returning home. Filmmaker Quentin Tarantino followed up

his instant classic *Pulp Fiction* (1994) with a cinematic remix of sorts, as he cast 1970s icon Pam Grier in the lead role of *Jackie Brown* (1997). The title of Tarantino's *Jackie Brown* riffs on the original *Foxy Brown*, Grier's film from 1974, while also featuring the music of rapper Foxy Brown on the soundtrack. Foxy Brown, the rapper, had, of course, appropriated her name from Grier's earlier film. RZA of Wu-Tang makes a cool cameo appearance in the Jim Jarmusch film *Ghost Dog* (1999), which features a hilarious scene of an old Italian mobster boppin' out while rapping the lyrics to Public Enemy's track "Cold Lampin' With Flavor" (*It Takes a Nation of Millions to Hold Us Back*, 1988). The connections between hip hop and cinema also stretched beyond the boundaries of the United States, as we see in Mathieu Kassovitz's French film *La Haine* (*Hatred*, 1995), which navigated how issues of racism, poverty, violence, and policing play out in the *banlieues* of Paris.

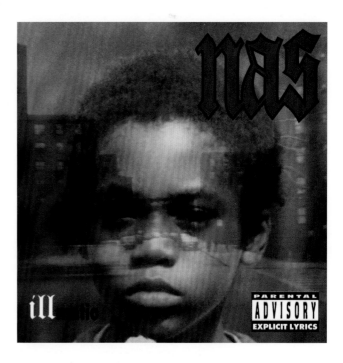

OPPOSITE: Nas during the photoshoot for *Illmatic*, Queens, NY, 1994, photographer Danny Clinch. **BOTTOM RIGHT:** Album cover for *Illmatic*, Nas, Columbia Records, 1994, artwork by Aimee Macauley.

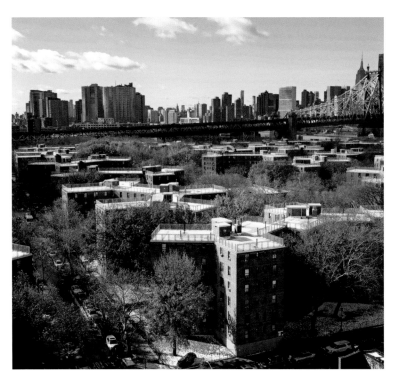

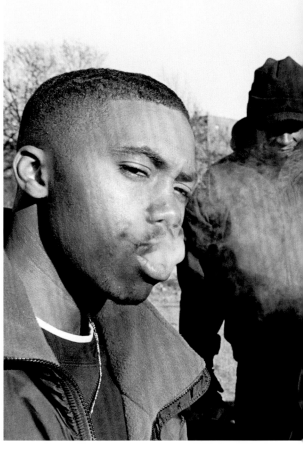

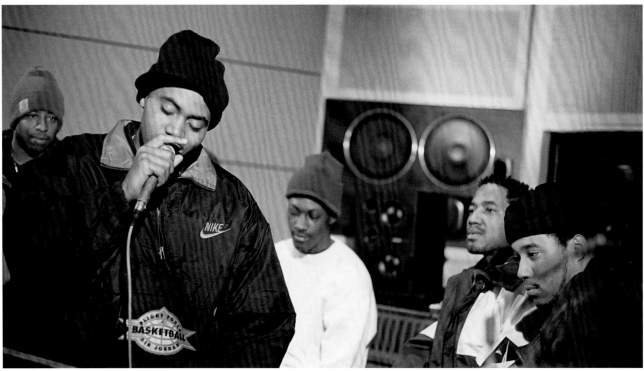

TOP LEFT: Queensbridge Houses, where Nas grew up, sit beneath the Ed Koch Queensboro Bridge, Queens, NY, November 16, 2018, photographer Mark Lennihan. **TOP CENTER:** Nas and friends during the photoshoot for *Illmatic*, Queens, NY, 1994, photographer Danny Clinch. **BOTTOM:** Nas in the recording studio during the recording of *Illmatic*, New York City, NY, 1994, photographer Lisa Leone.

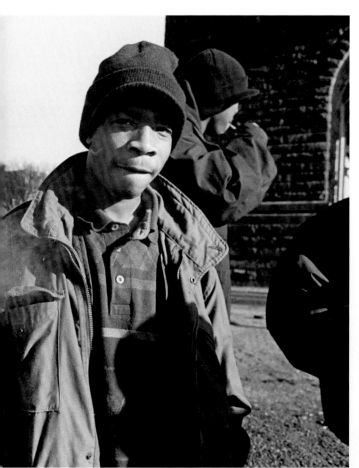

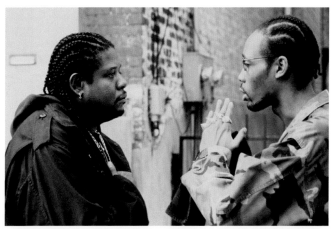

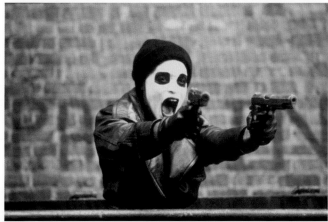

TOP RIGHT: Forest Whitaker and RZA in *Ghost Dog: The Way of the Samurai*, Artisan Entertainment, 1999, dir. Jim Jarmusch. **CENTER RIGHT:** N'Bushe Wright in *Dead Presidents*, Buena Vista Pictures, 1995, dirs. Allen and Albert Hughes. **BOTTOM:** Nas in *Belly*, Artisan Entertainment, 1999, dir. Hype Williams. **OVERLEAF:** Nas and friends during the photoshoot for *Illmatic*, Queens, NY, 1994, photographer Danny Clinch.

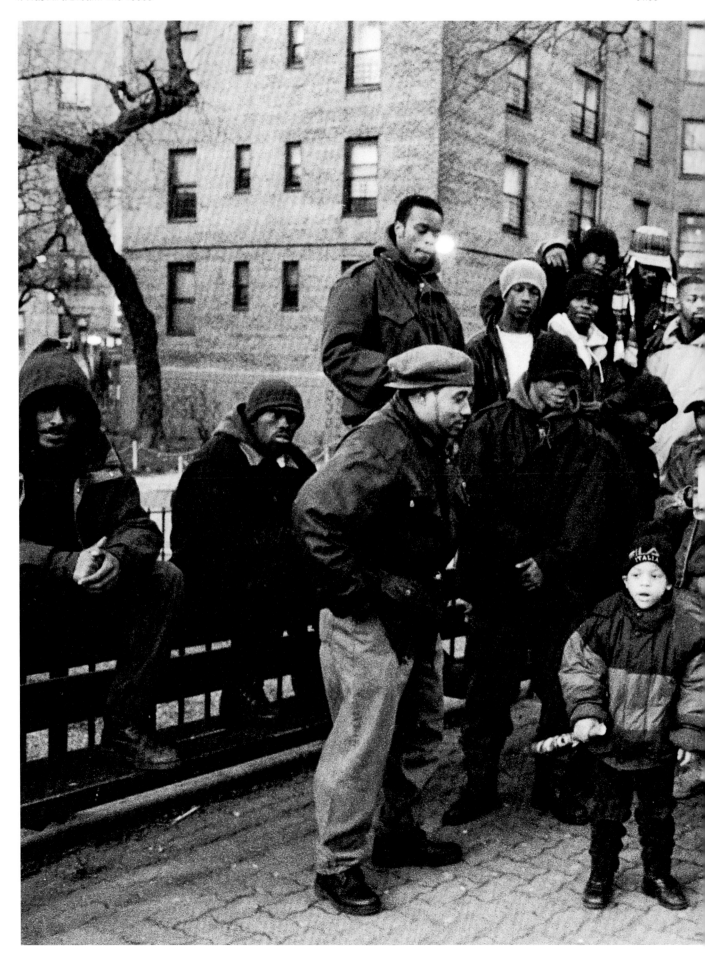

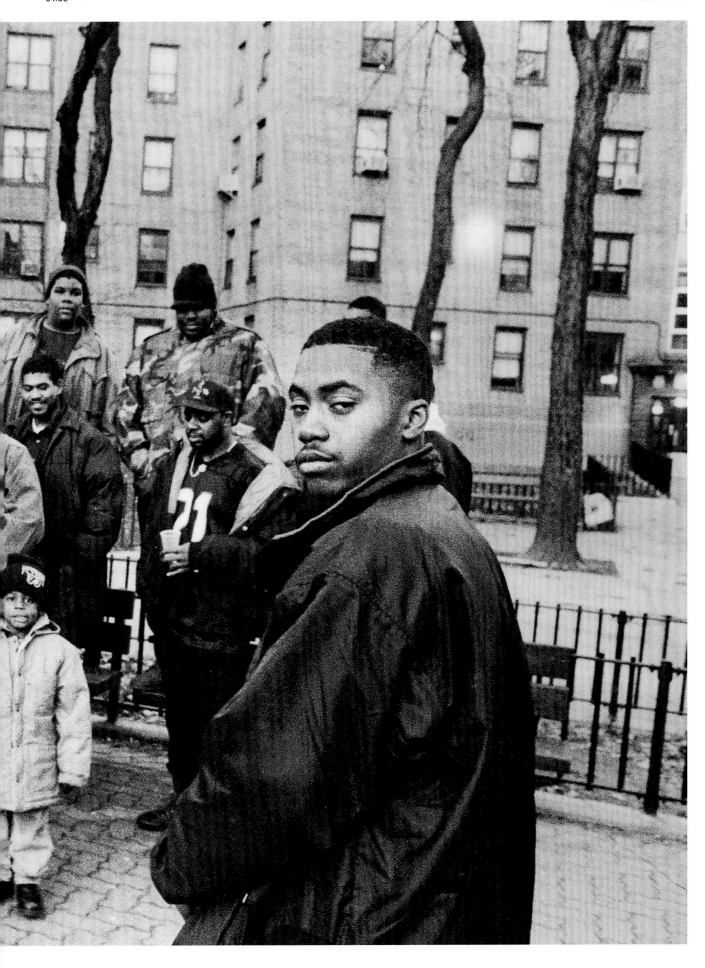

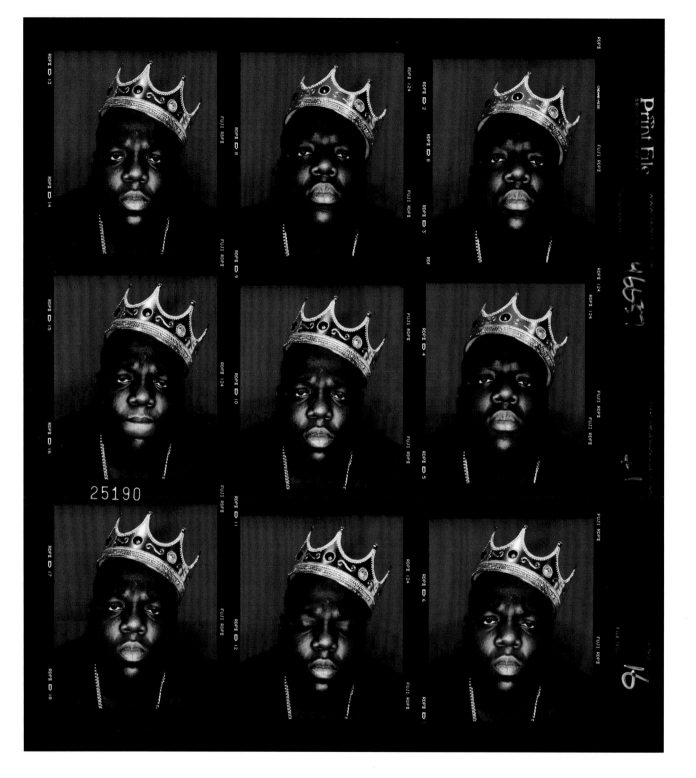

KINGOFNEWYORK

Abel Ferrara's independent gangster film *King of New York* (1990) is the story of fictional drug lord Frank White, played by Christopher Walken. Unlike Martin Scorsese's *Goodfellas*, released the same year, *King of New York* was not a lauded epic dealing with grand themes such as the role that organized crime plays in American life. Instead, it is the type of under-the-radar urban crime film that one might discover while looking for something to watch on home video. In this context *King of New York* found an underground audience among hip hop fans.

As mentioned in the previous chapter, the "King of New York" title also came to be applied to the rapper considered to be the city's best. Yet rhymes alone do not allow claim to this honor. The King of New York needs to be larger than life, iconic, and an overall boss, someone who can spit dope rhymes, dominate the charts, and make moves at the highest level, while being fully respected in the streets. When a young Christopher Wallace—who at times referred to himself as the "Black Frank White"—made the transition from the streets to the recording studio, it was clear that the game would never be the same.

Wallace, aka Biggie Smalls (a name adopted from a character in the Blaxploitation-era comedy *Let's Do It Again*, Sidney Poitier, 1975), aka the Notorious B.I.G., started out in the dope game. Well-known in the streets of his native Brooklyn, in 1994 Biggie signed with Sean Combs's then newly established Bad Boy label. Combs, then known as Puffy and Puff Daddy, had previously worked as an A&R executive—and before that an intern—at Andre Harrell's Uptown Records label. Puff's creative prowess had helped to power Harrell's success at Uptown, producing acts like Jodeci and Mary J. Blige. His already established eye for talent proved successful at his own label as well, validated by the out-of-the-blocks popularity of Bad Boy's first artist, Craig Mack. Puff had an especially hot hand. Biggie would be the artist to take his grand vision to the next level.

Biggie was blessed with some incredible skills as a wordsmith. He could rap in numerous styles, using the slickest wordplay. He was also cool and charismatic, equally menacing and charming, switching between personas with ease. The first single from his debut album *Ready to Die* (1994) was "Juicy," an up-from-the-hood tale about his rise to the pinnacle of the rap game. The opening line of the song, "It was all a dream," spoke of his own

desire for social mobility while also articulating the aspirations of hip hop culture at large. Big's dream was not Martin Luther King, Jr.'s dream, nor was it the traditional immigrant notion of the American dream. Instead, Biggie defined the hip hop dream, voicing the hopes and desires of a generation who had come up in the age of Reaganomics, the Rodney King riots, the crack epidemic, the prison-industrial complex, and at a time of overall pessimism relative to Black life in America. The song was a celebration of triumph in the face of adversity: "Birthdays was the worst days / Now we sip champagne when we thirsty."

Biggie was also a style icon, rapping about luxury labels like Versace while wearing colorful Australian Coogi knit sweaters. But he could keep it gangsta too, in his street staple Timberland boots. Together with Puffy, Biggie added a luxury lifestyle component to hip hop that was inspirationally elite. As Bad Boy's success and influence expanded, Big started a new group known as the Junior M.A.F.I.A. The breakout star from this group would be the rapper Lil' Kim.

Following the example set by Death Row's Lady of Rage and others, Lil' Kim dropped a now-legendary verse on the Junior M.A.F.I.A. song "Get Money" (1995), deftly demonstrating her authority on the mic. Weaving together X-rated lyrics, gangsta rap themes, and high-fashion references, Lil' Kim asserts a woman's perspective on the male-dominated narratives that defined hip hop at this time, namely, crime, money, and drugs. Her lyrical skills and rap flow basically jump off the track. No one else sounded like this, nor had anyone heard such explicit lyrics from a woman since the days of Millie Jackson, and even then Jackson spoke in code. But Lil' Kim was funny as well. Similar to the way in which male rappers weaponized language against white cultural suppression, Lil' Kim's highly sexual lyrics openly challenged sexist notions and respectability politics around what was considered appropriate for a woman to say and how to say it. Her defiance of conventional norms pushed the culture in new directions, expanding its influence in the process.

Lil' Kim's debut with Junior M.A.F.I.A. set her up for solo success. Her first album *Hard Core*, released in 1996—"You wanna be this Queen B / But you can't be / That's why you mad at me" ("Big Momma Thang")—and its follow-up *The Notorious K.I.M.*, released in 2000, resulted in multiplatinum album sales.

Her larger-than-life persona and iconic fashion looks consistently generated attention across the cultural spectrum. The provocative purple jumpsuit she wore at the 1999 MTV Video Music Awards, and Diana Ross's subsequent fondling of Lil' Kim's exposed breast on live television, was the type of cultural moment that these days would have broken the internet. Kim had become a bona fide star.

A week after Lil' Kim's *Hard Core* was released, the rapper Foxy Brown dropped *Ill Na Na* (the title was a reference to her vagina). Kim and Foxy shared a taste for high fashion and jewels, and while Foxy's rhymes were equally explicit, there was a distinct contrast between the two rappers' voices. They also played a similar role in the fictional gangsta/mafia crime family narrative that they inhabited. Foxy Brown grew under the mentorship of Jay-Z and would later team up with Nas, Dr. Dre, and AZ to form the hip hop supergroup known as the Firm. The success of Lil' Kim and Foxy Brown had a profound impact on 1990s hip hop and laid the foundations for an explosion of female rappers in the 2010s. Their sex-positive attitude and genre-defining sense of style would have a lasting influence on artists such as Nikki Minaj, Cardi B, and Megan Thee Stallion, among many others.

As for New York's place in the game, Biggie, Puffy, Lil' Kim, and the Bad Boy label added another layer to the city's resurgence. Unlike the LA gang-based ethos that Death Row represented on the West Coast, Bad Boy embraced a more street kingpin-like status. In terms of image and style, Death Row was to Bad Boy what Scorsese's working-class *Goodfellas* was to Coppola's executive-level *Godfather* gangster films. The increasing competition between labels and their respective artists had both personal and professional repercussions, ultimately playing a part in the murders of Tupac Shakur in 1996 and Biggie Smalls in 1997. The deaths marked a huge escalation in hip hop's rivalries, showing that the culture represented not just music and entertainment but an overall framework for understanding a generation of African Americans.

There have been numerous retellings of Biggie and Tupac's respective biographies and the circumstances surrounding their murders. The story of hip hop's rapid expansion in the 1990s, and the story told here, would be incomplete without devoting some attention to the impact that these events had. As elements of the street increasingly merged with the rap industry, it was inevitable that at some point something drastic might happen. Hip hop in these instances represented life and death, literally and figuratively; moreover, it represented the reality of being Black in the United States. When Nas uttered the line "Rap became a version of Malcolm and Martin," on "The Last Real Nigga Alive" (2002), he implied that history was repeating itself. Tupac and Biggie had become martyrs; their deaths were a cautionary tale.

New York–born, California-based Tupac Shakur (alternatively styled as 2Pac or simply Pac) spent his short time on earth building a complex and, at times, contradictory narrative for himself. His mother, Afeni, was a member of the Black Panther Party, and he got his start in the industry working as a roadie and MC for the Bay Area group Digital Underground before becoming a solo artist in 1991, with the release of his debut album *2Pacalypse Now*. Pac drew early attention with songs such as "Brenda's Got a Baby," a tragic tale of teenage pregnancy, poverty, and the Black female struggle, the sensitive focus of which set him apart from many of his male contemporaries.

His spirited yet obsessive performance as the trigger-happy character Bishop in the film *Juice* (1992) seemed to mark a shift in his public image and was followed by a series of incidents that put him in regular contact with the law. There were reports of fights, shoot-outs with undercover cops, a court case in which his lyrics were blamed for a state trooper's murder, among others.

For some, Pac embodied the word *thug*, not least because he had "THUG LIFE" tattooed across his chest—though, he explained, this was an acronym for "The Hate U Give Little Infants Fucks Everybody." Over time his run-ins with crime and punishment increased; in 1994, while standing trial on charges of sexual abuse, of which he would later be convicted, Pac was shot five times during a robbery at New York's Quad Recording Studios. Pac served eight months in prison, and upon his release signed with LA's Death Row Records, igniting a feud between himself and his former friend Biggie Smalls, amplified by his viciously personal diss track "Hit 'Em Up" (1996). As the conflict grew, fans and followers fell into factions representing East and West Coast hip hop, escalating a situation that was increasingly moving beyond the boundaries of rap music.

Just three months after the release of the track, in September 1996, Tupac was shot dead not far from the Las Vegas Strip, following a boxing match between Mike Tyson and Bruce Seldon. Six months later, Biggie was murdered while attempting to leave a party at the Petersen Automotive Museum in Los Angeles. Both murders remain unsolved to this day. Tupac and Biggie's untimely and tragic deaths immortalized the two rappers in hip hop history, prompting ongoing speculation about what could have been while offering concrete evidence of what was. Although these two towering figures were gone, hip hop would have to pick itself up and continue to push forward while hopefully having learned a valuable lesson in the process.

Following these huge losses, Dr. Dre left Death Row to start his new label, Aftermath Entertainment, while Snoop Dogg signed with Master P's No Limit Records. Puffy, meanwhile, transitioned from business owner to artist, releasing the Puff Daddy & the Family album *No Way Out* in 1997. His moving tribute to Biggie, "I'll Be Missing You" (featuring the late rapper's widow Faith Evans and the group 112), at the 1997 MTV Video Music Awards, included an appearance by Sting, whose song "Every Breath You Take" (with the Police, 1983) was sampled on the track.

The legacy of Biggie Smalls can also be linked to the emergence of another artist whose future impact on hip hop would be monumental. On Biggie's second album, *Life After Death* (1997), released posthumously, the song "I Love the Dough" featured his friend from Brooklyn, Shawn Carter, otherwise known as Jay-Z. Biggie also appeared on "Two of Brooklyn's Finest," from Jay-Z's independent Roc-A-Fella Records label debut, *Reasonable Doubt* (1996). While Jay's reign as the King of New York would commence in earnest in the next decade, his entry onto the scene in the late 1990s put him in prime position to assume the title that his friend had held for far too short a time. Jay-Z's song "Where I'm From" (1997) poses the ultimate question about who can rightly claim King of New York status when he says, "I'm from where niggas pull your card / And argue all day about / Who's the best MCs / Biggie / Jay-Z / or Nas?"

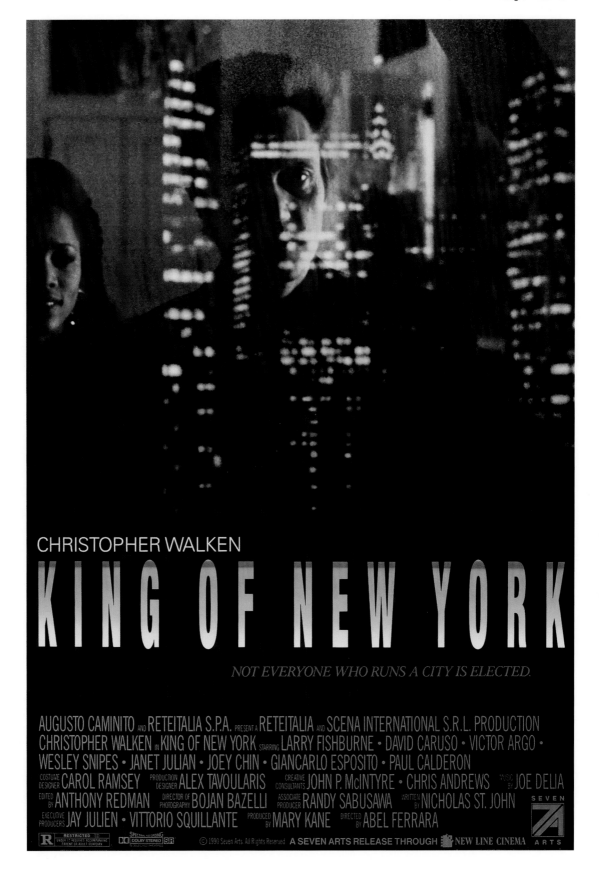

Movie poster for *King of New York*, starring Christopher Walken and Theresa Randle, New Line Cinema, 1990, dir. Abel Ferrara.

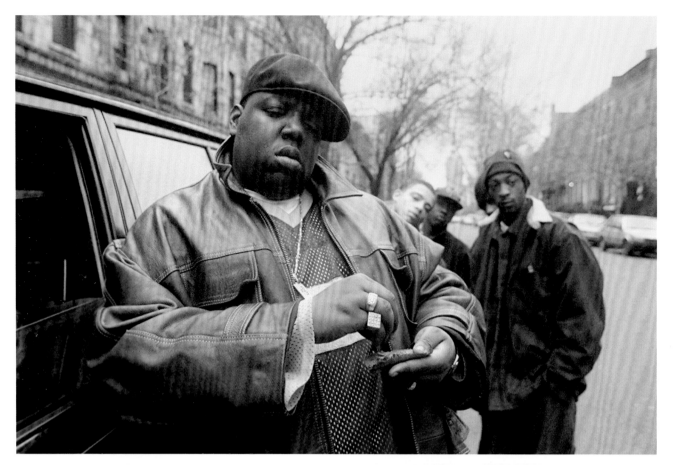

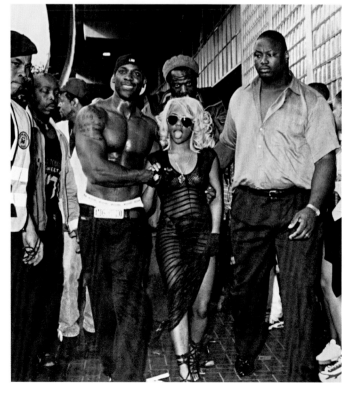

TOP: Notorious B.I.G. rolls a blunt outside his mother's house, Brooklyn, NY, January 18, 1995, photographer Clarence Davis.
BOTTOM LEFT: Foxy Brown, 1997, photographer Eric Johnson. **BOTTOM RIGHT:** Lil' Kim surrounded by bodyguards at Notting Hill Carnival, London, 1997, photographer unknown.

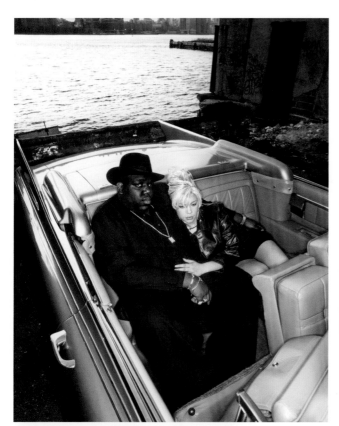

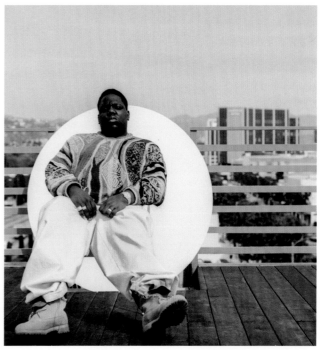

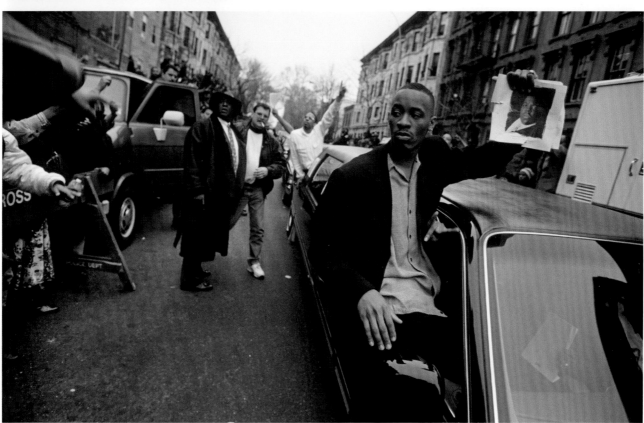

TOP LEFT: Notorious B.I.G. and Faith Evans, Brooklyn, NY, 1995, photographer Eric Johnson. **TOP RIGHT:** Notorious B.I.G. photographed for *Fine*, Beverly Hills, CA, 1995, photographer B+. Biggie was murdered less than a mile away in front of the Petersen Automotive Museum.
BOTTOM: The Clinton Hill neighborhood where Christopher Wallace, aka Notorious B.I.G., grew up, comes out to watch his funeral procession drive by, Brooklyn, NY, March 18, 1997, photographer Andrew Lichtenstein.

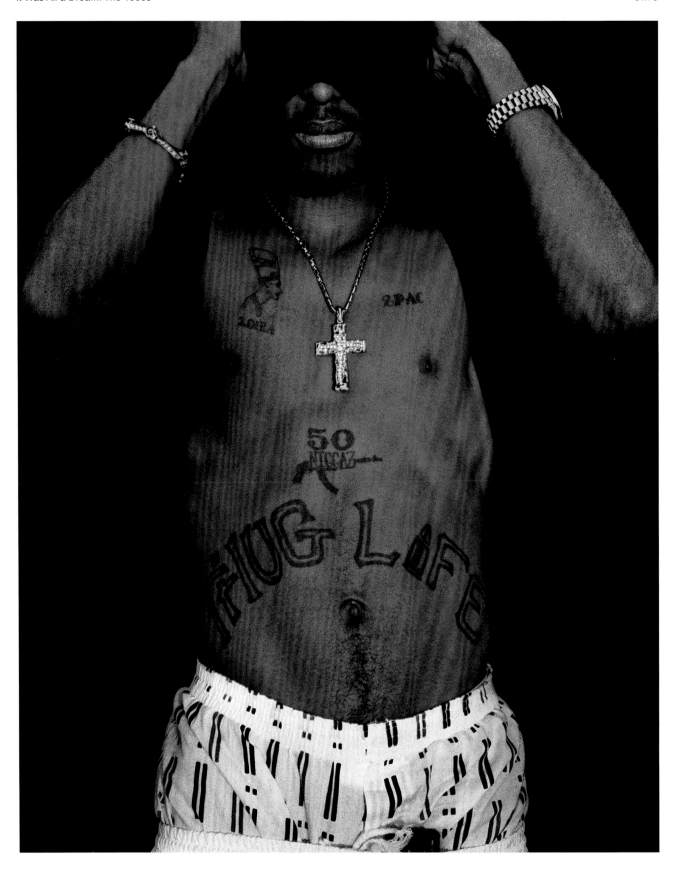

Thug Life, Tupac Shakur, East Los Angeles, CA, 1994, photographer Mike Miller.

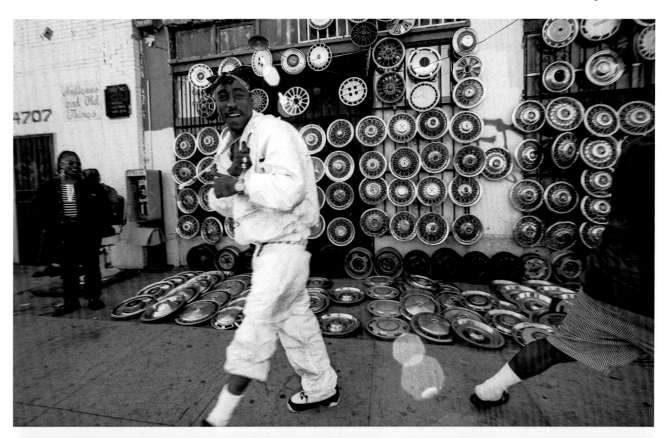

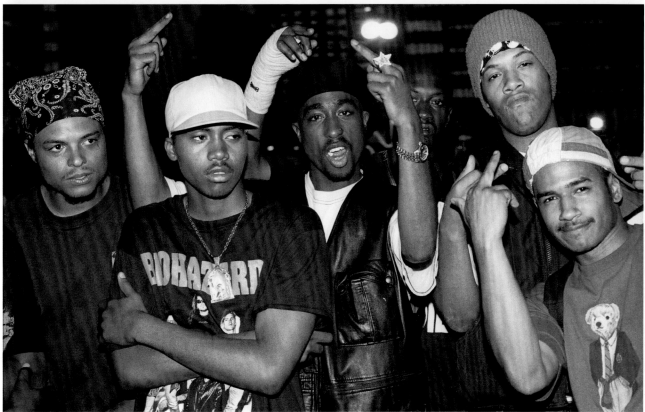

TOP: *Good Times*, Tupac Shakur, South Central Los Angeles, CA, 1994, photographer Mike Miller. **BOTTOM:** (from center left) Nas, Tupac Shakur, and Redman at Club Amazon, New York City, NY, July 23, 1993, photographer Al Pereira.

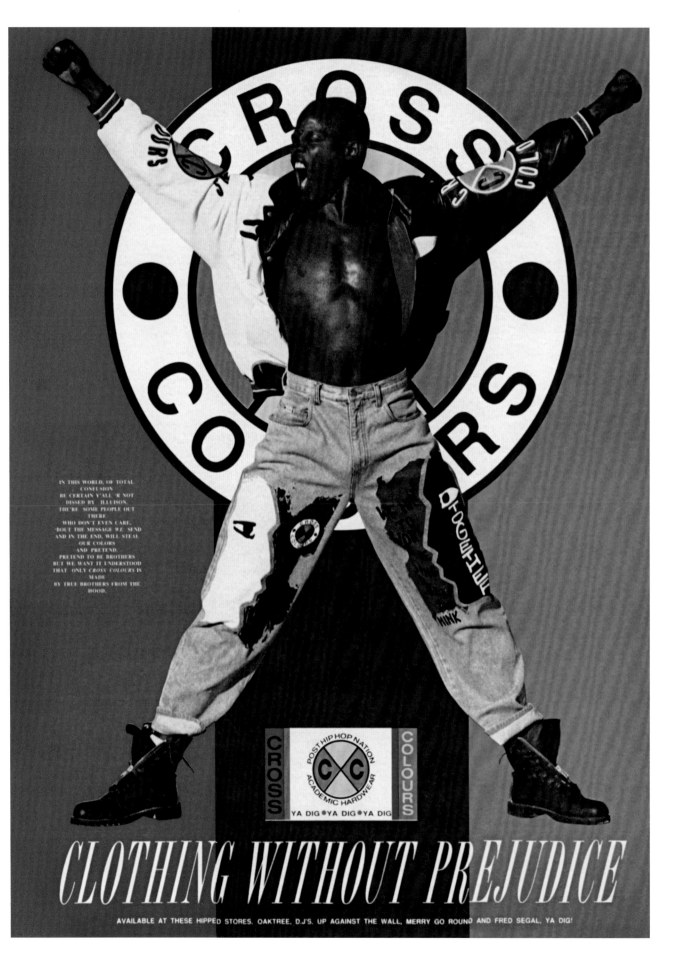

CLOTHING WITHOUT PREJUDICE

for us, by us

Hip hop has always been about individual expressions of style. Wearing a baseball cap turned backwards, or, "to the back," is one example; allowing one's pants to fall below the waist, known as "saggin'," is another. (The latter was said to have been inspired by individuals in prison who were not allowed to wear belts.) Such personal style tweaks were eventually adopted by the larger hip hop community, and as such became unique representations of hip hop as fashion.

While Biggie Smalls, Puff Daddy, and Jay-Z were busy representing the luxury aspects of 1990s hip hop fashion, another trend started to build around what we might call hip hop–specific fashion. It had its roots in a style that saw popular, logo-dominant labels such as Polo Ralph Lauren or Tommy Hilfiger worn oversized, creating big and baggy silhouettes. Hip hop has always had an independent, entrepreneurial streak and, not content to let Ralph Lauren and Tommy Hilfiger make all the money, some enterprising hustlers saw an opportunity to start their own fashion labels, offering clothes precut in the oversized style. Thus, there was no longer a need to remix existing pieces. The style was already baked into the design.

Labels such as Cross Colours and Karl Kani came to define this style segment of the industry. There were also lines associated with specific record labels and artists, such as Russell Simmons's Phat Farm, Roc-A-Fella's Roca Wear, and the Wu-Tang Clan's Wu Wear. LL Cool J famously rocked a FUBU (For Us, By Us) baseball cap from the Black-owned hip hop fashion label on screen—the twist was that it was in a television commercial for the much larger mainstream brand Gap. Using the visibility, advertising budget, and overall clout of Gap as a way of promoting a Black-owned business was remarkably savvy. His rap lyric in the commercial, "for us, by us, on the low," spoke to this particularly hip hop means of stealth marketing.

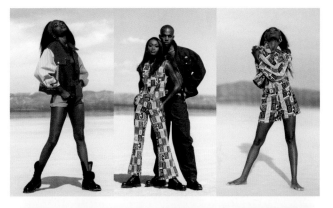

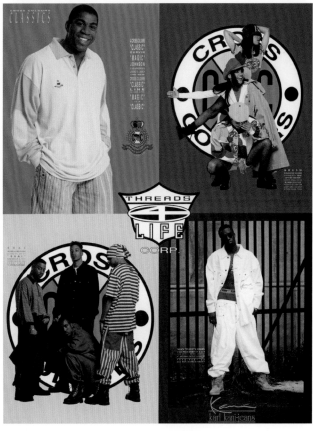

OPPOSITE: Cross Colours advertisement in *URB* featuring Djimon Hounsou, c.1991, photographer Michael Segal. **TOP RIGHT:** Cross Colours promotional photographs, c.1990s, photographer unknown. **BOTTOM RIGHT:** Cross Colours press kit featuring Magic Johnson (top left), Krush (top right), Shai (bottom left), and Sean "Puffy" Combs, c.1993, photographer Michael Segal.

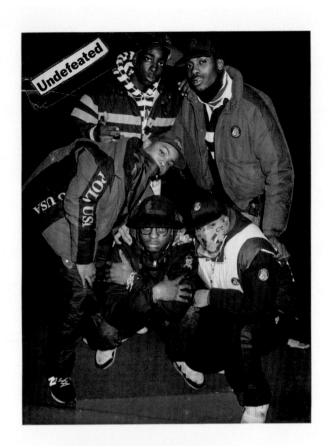

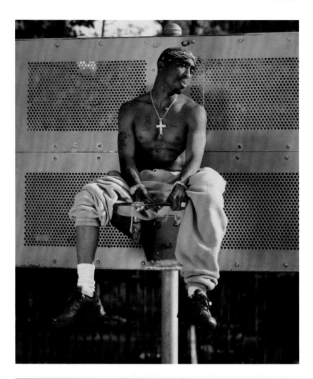

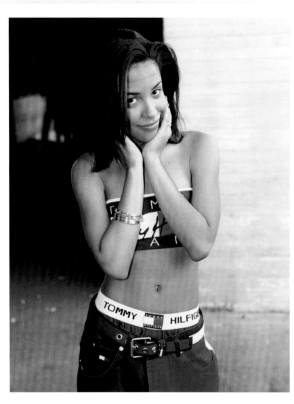

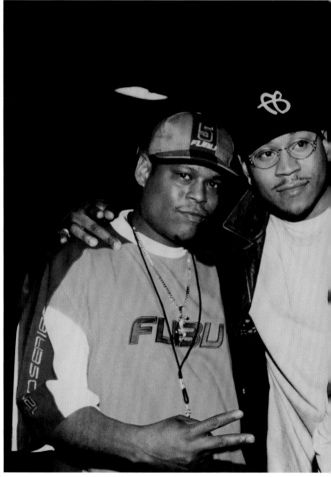

TOP LEFT: *Undefeated Mask Men*, Thirstin Howl The 3rd (front right) and the Lo Lifes, Forty Deuce (Forty-Second Street), Times Square, New York City, NY, 1989, Thirstin Howl The 3rd Archives. **TOP RIGHT:** Karl Kani photoshoot featuring Tupac Shakur, Harlem, New York City, NY, 1994, photographer unknown. **BOTTOM LEFT:** Tommy Hilfiger "Next Generation Jeans" campaign photoshoot featuring Aaliyah, April 28, 1997, photographer Alex Berliner. **BOTTOM CENTER:** LL Cool J (center) with Keith Perrin (left) and Daymond John, founders of the FUBU streetwear label, Queens, New York, c.1998, photographer unknown.

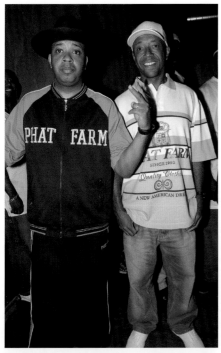

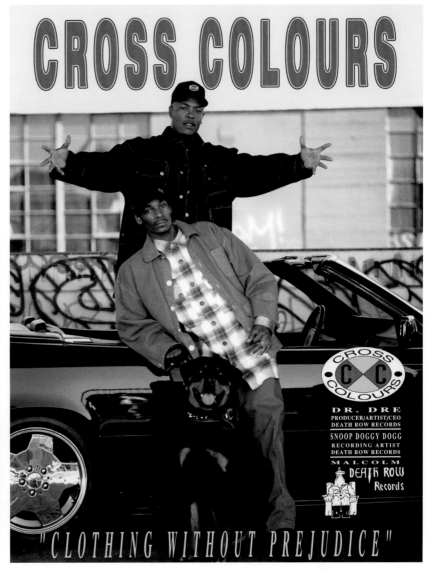

TOP LEFT: Joseph Simmons, aka Run, and Russell Simmons at a Phat Farm shoes launch event, Chicago, IL, 2003, photographer Johnny Nunez.
TOP RIGHT: "Clothing Without Prejudice," Cross Colours advertisement featuring Dr. Dre and Snoop Dogg, 1993, photographer Michael Segal.

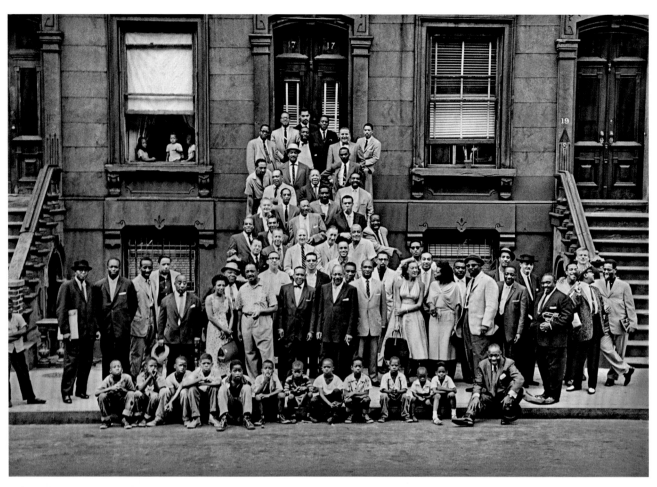

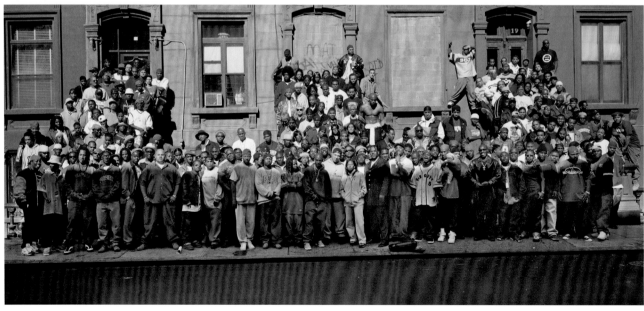

A Great Day in... HIP HOP

In August 1958 fifty-seven jazz musicians gathered on a stoop at 17 East 126th Street in Harlem to be photographed by Art Kane: Dizzy Gillespie, Lester Young, Mary Lou Williams, Thelonious Monk, and others appeared in the now-legendary image that has come to be known as *A Great Day in Harlem*. The photo was featured in *Esquire*'s January 1959 issue, *The Golden Age of Jazz*. It is more than simply a photograph of jazz musicians, however: it is a documentation of jazz culture at a moment when the music was at a critical creative juncture. The year the photograph was published Miles Davis's *Kind of Blue*, Charles Mingus's *Mingus Ah Um*, Ornette Coleman's *The Shape of Jazz to Come*, and Dave Brubeck's *Time Out* were released. These albums are now considered among the best and most culturally significant of their time, representing some of the greatest American music of the twentieth century. *A Great Day in Harlem* captures jazz and jazz culture at its peak.

Forty years later, in September 1998, the iconic photographer and cultural giant Gordon Parks created an homage to Kane's 1958 original. *A Great Day in Hip Hop* brought together 177 rappers, producers, and other influential hip hop figures on the same stoop in Harlem and was published on the cover of *XXL* magazine, issue no.7. In the same way as the original, this document bore witness to a moment when the culture and its creative output and significance was in its prime. Having Parks, one of the most important photographers in American history, create this photo added to its sense of legacy.

Like the two photographs, jazz and hip hop share a number of contextual and historical similarities. Both genres, at one time or another, overcame racism to shift the cultural landscape, despite being deemed a threat to the social fabric of the United States. Both genres used creative musical expression to elevate the culture, represent Black excellence, define notions of cool, and inspire through style. In a kind of cross-generational exchange, the influence of jazz *on* hip hop is also undeniable.

On their track "Verses From the Abstract" (1991), A Tribe Called Quest featured a sample of jazz bassist Ron Carter, an alumnus of Davis's Second Great Quintet and one of the instrument's all-time greats. Q-Tip even shouts him out on the record: "Thanks a lot / Ron Carter on the bass / Yes / My man Ron Carter / Is on the bass," indicating that Carter himself is playing, rather than it being a sample. To feature a vanguard jazz artist like Carter on the track connected the hip hop present with the jazz past while also demonstrating that the music Carter played transcended time, making hip hop "hipper" in the process.

The group Gang Starr, comprising producer DJ Premier and Guru (Gifted Unlimited, Rhymes Universal) the MC, offers other examples of this jazz/hip hop connection. The track "MC's Act Like They Don't Know" (1995), featuring KRS-One, samples trumpet maestro Clifford Brown, from his classic jazz album *Clifford Brown with Strings* (1955). Guru would also produce *Jazzmatazz: An Experimental Fusion of Hip-Hop and Jazz* (1993), the first volume in a series of albums that brought together the two genres, featuring jazz musicians from the genre's heyday such as Donald Byrd.

Though jazz had once been thought of as marginal, never attaining true mainstream success, by the 1990s it had become something akin to high art, now celebrated for its rich cultural legacy and often performed in some of the most distinguished venues. The music was still being created, but it was largely perceived as a sound of the past, thus according it a prestigious cultural identity with the trappings of elitism to go along with it. This evolution could be seen as signaling how hip hop might be perceived and appreciated in the future.

OPPOSITE TOP: *A Great Day in Harlem*, New York City, NY, 1958, photographer Art Kane. **OPPOSITE BOTTOM:** *A Great Day in Hip Hop*, Harlem, New York City, NY, 1998, photographer Gordon Parks.

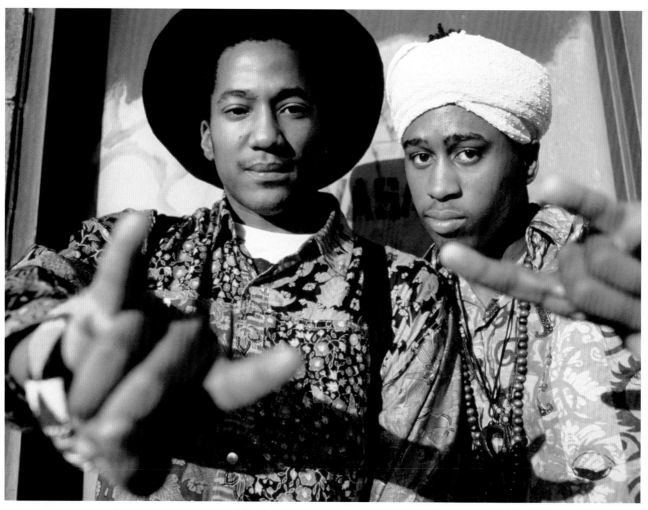

TOP: Q-Tip (left) and Ali Shaheed Muhammad of A Tribe Called Quest, c.1990, photographer Chris Carroll. **BOTTOM LEFT:** Album cover for *No Room for Squares*, Hank Mobley, Blue Note Records, 1964, photographer Francis Wolff. **BOTTOM RIGHT:** Album cover for *Jazzmatazz: An Experimental Fusion of Hip-Hop and Jazz*, Volume 1, Guru, Chrysalis, 1993, photographer Humphrey Studio.

Jazz bassist Ron Carter performs as part of the Miles Davis Quintet at the Salle Pleyel, Paris, October 1, 1964, photographer Patrick Habans.

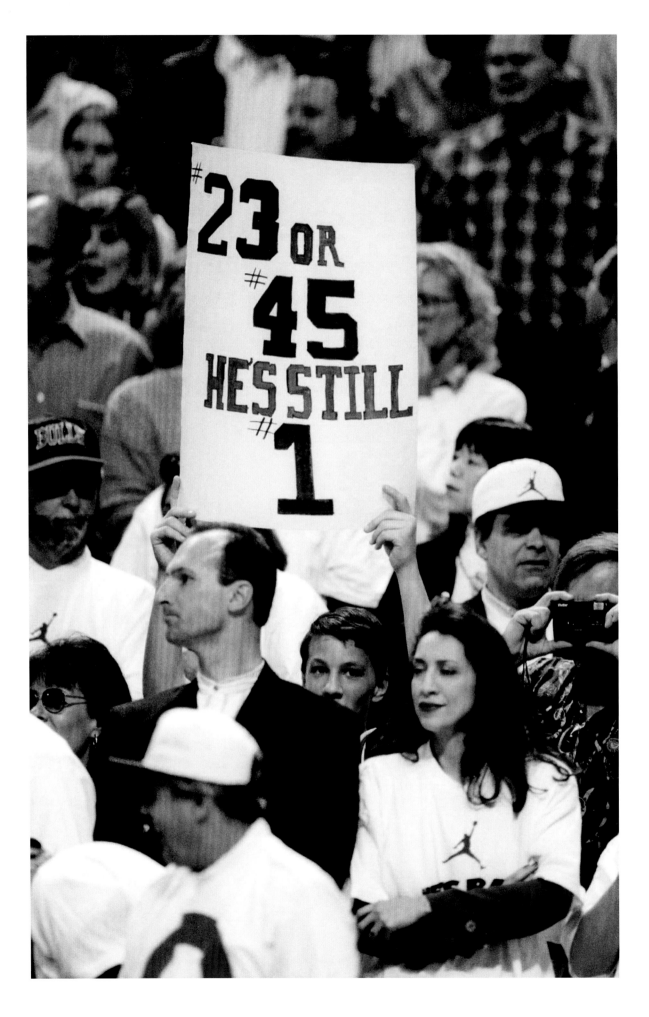

HOOP DREAMS

If I wasn't in the rap game / I'd probably have a key / Knee deep in the crack game / You see the streets is a short stop / Either you're slingin' crack rock / Or you got a wicked jump shot.

Notorious B.I.G., "Things Done Changed," 1994

In 1991, after being denied the opportunity to advance in the playoffs by the powerful Detroit Pistons three years in a row, between 1988 and 1990, Michael Jordan finally won his first NBA championship. Jordan had been the best player in the NBA for years, and by this point his place in the pop-cultural stratosphere was firmly established. Adding the championship hardware to his already massive lists of accomplishments merely reinforced his GOAT status. Between 1991 and 1993, Jordan won three NBA titles. During the 1992 Olympic Games in Barcelona, as the face of the ever-popular U.S. men's "Dream Team"—a collection of NBA superstars, including Magic Johnson, Larry Bird, and Charles Barkley—Jordan would demonstrate that his fame was not limited to the United States. He had become the most popular athlete, and arguably the most popular American, in the world.

Yet as the 1993–94 NBA season dawned, with Jordan very much at the peak of his career, he would send shockwaves through the sport when he announced that he was retiring from basketball. In a totally out-of-left-field move, Jordan began playing minor-league baseball instead, which he pursued (with mixed results) for just over a year before returning to the NBA in 1995. He would win three more NBA titles in 1996–98 before retiring for a second and final time.

Despite his exit from the sport, Jordan's influence never waned. Since the release of his signature Air Jordan 1 high-tops in 1985, the drop of each new version had become an annual ritual. Release dates for the new "Js" were like movie premieres, and people would line up outside sneaker stores in anticipation of copping the latest pair. Each new model offered a new style and developed its own cultlike following. Arguments naturally ensued over which pair were the coolest, most stylish, and most coveted by sneakerheads.

Rewind to 1995, when Jordan has made his first NBA comeback. The Air Jordan 11s that he debuted in the playoffs that year marked his return. What distinguished these sneakers was the use of black patent leather. This material was traditionally

used for dress shoes, commonly the type worn with a tuxedo. The Concord colorway in particular, with black patent-leather trim contrasting against a white upper, looked like a basketball version of "spectators," a classic two-tone leather oxford-style shoe popular among fashionable gentlemen. The black/white contrast of the Air Jordan 11s also evokes formal shoes adorned with spats.

To use such a fashion-specific material on a shoe that was first and foremost intended for use in basketball was unusual, but it was precisely this point of difference that made the shoe so popular, and that in turn elevated its designer, Tinker Hatfield, into a revered name within the sneaker sphere. The patent leather also drove a sports-to-high-fashion crossover, as people began pairing the sneakers with more dressed-up outfits and formal wear. It is said that the 11s are Jordan's favorite AJ model. Retro versions are now released annually and still attract legions of appreciative fans all these years later. Their holy-grail-like status was aided in no small part by the fact that Jordan wore them during the 1995–96 season, during which the Chicago Bulls won seventy-two games, a record at the time, before winning another NBA title, not to mention Jordan winning the league's Most Valuable Player in both the regular season and the NBA Finals.

Jordan's success both on and off the court had turned him into the ultimate icon of hip hop, despite not being a rapper, a producer, or necessarily even a fan of rap music (so say various anecdotal accounts about his personal music preferences). As the most popular athlete in the world, one who had achieved fame and fortune playing his chosen game while making unprecedented business moves above and beyond those that other Black athletes had traditionally experienced, Jordan was the perfect success symbol for hip hop to latch onto. He represented the type of cultural dominance that the music aspired to. References to the player in numerous rap lyrics, such Jay-Z's line describing himself as the "Mike Jordan of rap" ("Hova Song [Intro]," 1999), underscore his hip hop status.

Jordan also had a direct influence on style, both within and outside of the sport. For instance, he was known for wearing his basketball shorts longer than was the traditional style. The 1980s is sometimes jokingly referred to as the "booty shorts" era, due to

OPPOSITE: During game 3 of the Eastern Conference Finals, Chicago Bulls vs. Orlando Magic, at the United Center, a fan holds up a sign referring to Michael Jordan's post-retirement number change, Chicago, May 12, 1995, photographer Jonathan Daniel.

the short length. It is said that Jordan liked to wear his University of North Carolina practice shorts under his NBA Chicago Bulls shorts, and in order to accommodate this his Bulls shorts were made longer so that the Carolina shorts would be hidden. Such was Jordan's sway that basketball shorts soon became longer and increasingly looser fitting, a change that was reflected on the court and in the streets, turning the embarrassingly out-of-style booty shorts into a joke in the process.

Yet as Jordan settled into his place atop the NBA hierarchy, a younger generation of players coming up behind him was starting to attract attention—and not all of it positive. Many had grown up on hip hop, while Jordan was coming to be seen as an elder statesman. Though he was still beloved, Jordan's success in business had started to represent the establishment.

When a group of young college players from the University of Michigan made their debut in 1991, they also debuted a style that combined Jordan's influence with a more overt embrace of hip hop. Chris Webber, Jalen Rose, Juwan Howard, Ray Jackson, and Jimmy King became known as the Fab Five. The team's rampant popularity and concurrent notoriety would turn them into the basketball equivalent of a rap group. Led by Webber, the Fab Five changed notions around youth and experience in college basketball. Whereas beforehand, a single exceptional freshman like Jordan might earn a starting spot on a college team, with this group of young men at Michigan, all five were in the starting lineup. And it was not just their basketball abilities that made a statement, it was also their look. The Fab Five took oversized shorts to the next level, wearing them longer and much baggier than even Jordan had; they often wore black socks and black Nike sneakers, instead of the traditional white; and with the exception of Howard, who the others jokingly chided as a "pretty boy," they all shaved their heads bald. The group also openly celebrated their love of hip hop, in their gestures on the court and in their interviews off of it. Naturally, this caused controversy among the traditionalists and those who hid their racial contempt behind arguments about decorum and appropriateness. But any criticism from the haters only served to make the team even more popular among fans who appreciated their authentic connection to the culture. It certainly helped that the Fab Five made up a strong team, and therefore appeared on television often, which gave yet more visibility to hip hop as influencer and trendsetter.

Another of basketball's young stars who signaled the arrival of the hip hop hoop generation was Shaquille "Shaq" O'Neal, the first overall NBA draft pick in 1992. Appearing on *The Arsenio Hall Show* that year as an NBA rookie, Shaq rapped on stage with his favorite group at the time, the Fu-Schnickens. Following the performance Jive Records offered him a contract. Shaq would go on to release multiple albums with the label, the first of which, *Shaq Diesel* (1993), actually went platinum. Following Shaq's success Sony released an album called *B-Ball's Best Kept Secrets* (1994) featuring multiple NBA players spittin' bars on the mic. What had started out as a novelty was now becoming a bit corny, as it assumed that rapping was something that anyone could do. Some years later, Master P, the No Limit Records rapper and mogul, was invited to two different NBA training camps, for the Charlotte Hornets and the Toronto Raptors.

By this time it was clear that hip hop and hoops were overlapping cultural forces that would continue to inform each other.

The 1996 NBA draft would further this narrative once more, introducing a figure who, perhaps more than any other, came to embody the cultural connections between these two worlds.

As a high-school athlete in Hampton, Virginia, Allen Iverson was a celebrated two-sports star playing both football and basketball. In 1993 he and some friends got into a fight with a group of white people at a bowling alley. Iverson suggested that racial slurs were directed at them. Though no one was seriously injured, Iverson was arrested and sentenced to fifteen years for his role. None of the white men involved were charged. Iverson was later granted clemency by Virginia's African-American governor, Doug Wilder, and his conviction was subsequently overturned on appeal. In spite of the racial injustice, upon his release many in the world of college athletics considered him too toxic. The exception was Georgetown basketball coach John Thompson.

Iverson signed with Georgetown and prospered under the mentorship of Thompson, eventually being selected as the number one overall pick in the 1996 NBA draft. That year's draft class is considered one of the best in NBA history; Kobe Bryant was drafted straight out of high school, along with other future superstars including Ray Allen, Steve Nash, and Jermaine O'Neal.

In a game against the Chicago Bulls during his 1996–97 rookie season, Iverson found himself isolated with Jordan guarding him. Iverson had worn Nike Air Jordans while playing at Georgetown, though once he entered the NBA he signed his own shoe deal with Reebok. Jordan was still a great player, but the younger, smaller, quicker Iverson used his famed crossover dribble to outmaneuver Jordan and score the basket. In that instance Iverson got the best of Jordan, giving him some measure of bragging rights over one of the greatest ever players. It also signaled Iverson's arrival in the sport. Jordan was still Jordan, but Iverson showed that he could be embarrassed too, playground style.

Iverson later wore his hair braided in cornrows, a style that at the time was commonly associated with street life and the penitentiary. Another NBA player, Latrell Sprewell, who was suspended in 1997 for choking his coach during practice, did a television commercial for AND1, a hip hop–centric T-shirt and sneaker brand, featuring him getting his hair braided as he states, "People say I'm America's worst nightmare. I say, I'm the American dream."

In 1999 Iverson would appear on the cover of *Slam* magazine rocking a blowout afro. He also began accumulating tattoos and generally carrying himself much like a rapper. When he appeared on the cover of the NBA's *Hoop* magazine in 1999 his tattoos were concealed through airbrushing and obscured by the placement of text on the cover, a controversial move highlighting the NBA's discomfort with his hip hop image, something that he openly objected to. Iverson had become the face of the hip hop hooper. He was unapologetic about his friends and his lifestyle, a stance that caused some to stereotype him as a thug. But for many others this was emboldening as he portrayed an authentic, up-from-the-streets ethos that kept him close to his ghetto roots, in spite of his mainstream success. He was uncompromising in choosing his own path and was living proof that success and authenticity were not mutually exclusive.

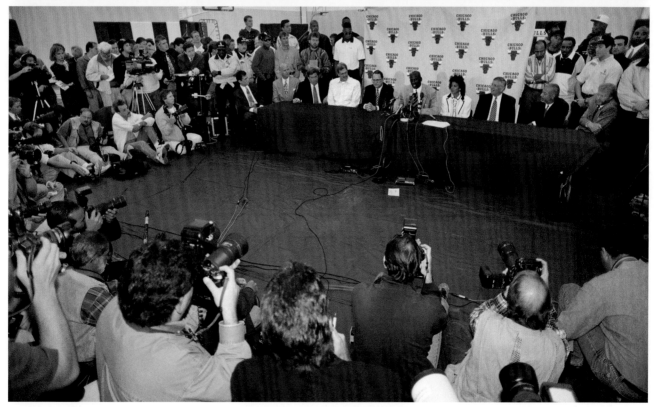

TOP: Michael Jordan victorious with trophy following the Chicago Bulls' win over the Los Angeles Lakers at the NBA Finals played at the Forum, Los Angeles, CA, June 12, 1991, photographer Richard Mackson. **BOTTOM:** Media gather around Chicago Bulls star Michael Jordan at the Berto Center as he announces his retirement from professional basketball, Deerfield, IL, October 6, 1993, photographer Mike Fisher. **OVERLEAF:** Allen Iverson (#3) of the Philadelphia 76ers faces off at the perimeter against Michael Jordan of the Chicago Bulls at the First Union Center, Philadelphia, PA, 1997, photographer Lou Capozzola.

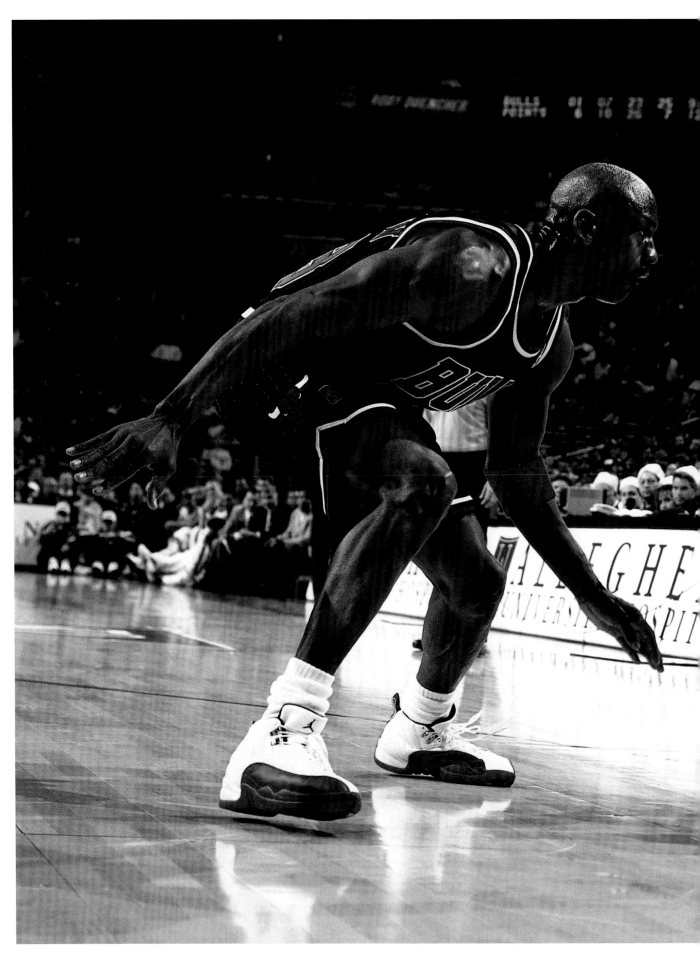

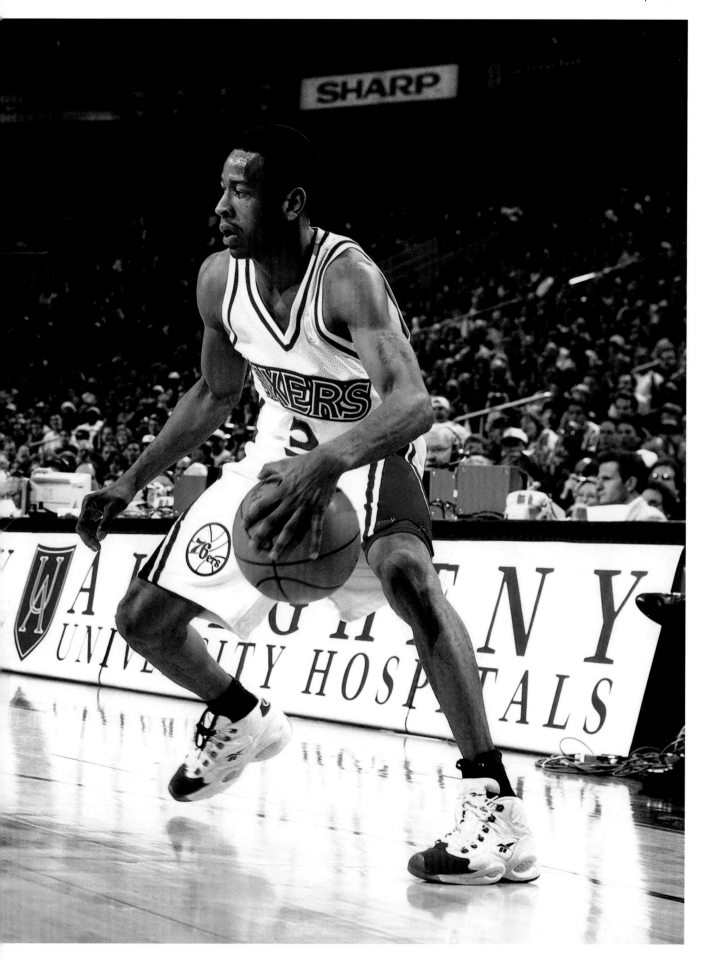

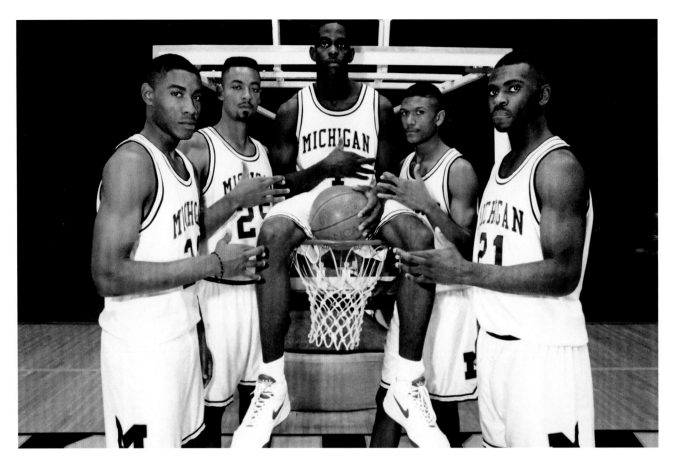

1-800-645-6027

TOP: Michigan's Fab Five, (from left) Jimmy King, Juwan Howard, Chris Webber, Jalen Rose, and Ray Jackson, Ann Arbor, MI, November 1991, photographer unknown. **BOTTOM LEFT:** Nike "1-800" print campaign featuring the Air Jordan XI, 1996. **BOTTOM RIGHT:** University of Michigan players, wearing their signature long baggy shorts, huddle during a game against Duke University, Ann Arbor, MI, December 11, 1993, photographer Manny Millan.

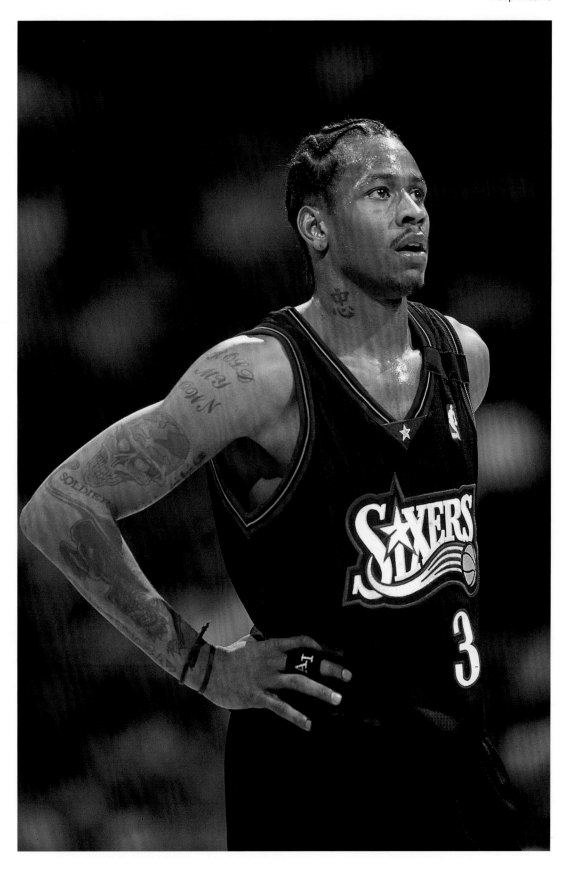

Allen Iverson of the Philadelphia 76ers during a game against the Washington Wizards at the MCI Center, Washington, D.C., November 16, 1999, photographer Doug Pensinger. The 76ers defeated the Wizards 95–73.

My EMANCIPATION Don't Fit Your EQUATION

When Lauryn Hill strode on stage at the 1999 Grammy Awards to accept the Album of the Year award from presenter Whitney Houston, her fifth Grammy of the night, she spoke with a sense of curiosity and astonishment, "Wow… this is so amazing. Thank you, God. Thank you, Father… this is crazy, because this is hip hop music." Hip hop and the Grammy Awards have a conflicted history. It was only a decade earlier that the ceremony had introduced a hip hop–specific award: Best Rap Performance. Several hip hop artists boycotted the show that year when it became apparent that the award would not be televised. Even in 1999 Hill's triumphant year, Jay-Z boycotted the Grammys because he felt that they still were not showing hip hop proper respect, citing his label mate DMX being overlooked as an example. So when Hill says, "this is crazy," it suggests that she finds her success is somehow at odds with, or perhaps has come in spite of, the ceremony's troubled history.

These contradictions not withstanding, Hill and her debut solo album *The Miseducation of Lauryn Hill* (1998) ruled the night. The album's title is a riff on the classic Carter G. Woodson book, *The Mis-Education of the Negro*, published in 1933. Hill's record perfectly combines both singing and rapping; on it she moves freely between the two unlike any artist that had come before. Squashing any perceived concerns about her skills as a rap lyricist, Hill opens the album with one of the fundamentals of hip hop battle rap, a diss track. Her verbal takedown of former collaborator and lover Wyclef Jean was scorching in the best tradition of competitive lyricism. When she shifts to singing mode she is equally outstanding. *The Miseducation of Lauryn Hill* was an impressive solo debut, an instant classic, as well as a historic achievement for a Black female artist in the world of hip hop.

Hill's clean sweep at the 1999 Grammy Awards signified hip hop crossing another important barrier, this one institutional. The Grammys represents the music industry, and Hill's ability to prevail over the limitations built into this environment represented one more hurdle that hip hop crossed with style and distinction. In twenty years hip hop had gone from being marginal to being central, from being perceived as nothing more than a novelty or mere curiosity to reaching the heights of the music industry. Critical and cultural success on its own terms. Hill's triumph was hip hop's triumph, and what came next would be truly mind blowing.

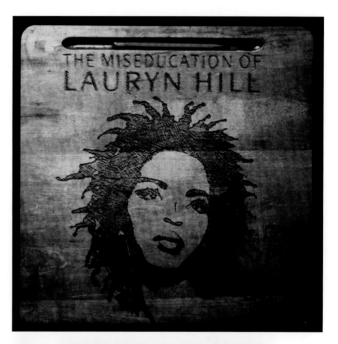

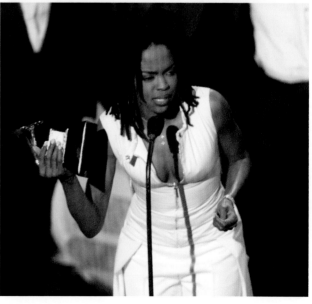

OPPOSITE: Lauryn Hill, 1998, photographer Eric Johnson. TOP RIGHT: Album cover for *The Miseducation of Lauryn Hill*, Lauryn Hill, Columbia Records, 1998, artwork by Erwin Gorostiza and Eric Johnson. BOTTOM RIGHT: Lauryn Hill receives her award for Album of the Year at the Grammy Awards, Los Angeles, CA, February 24, 1999, photographer Hector Mata.

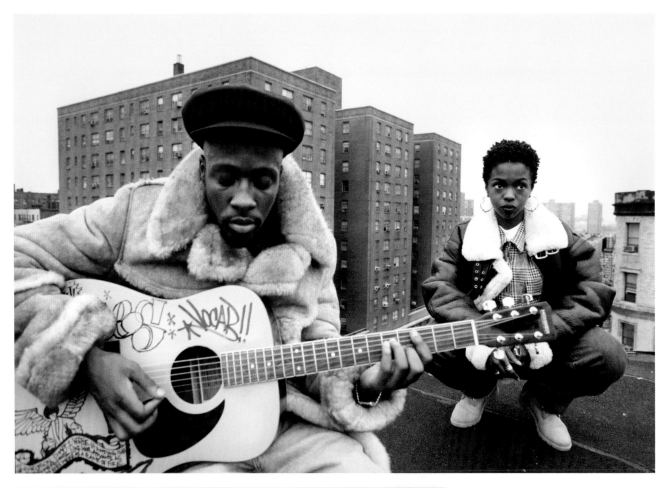

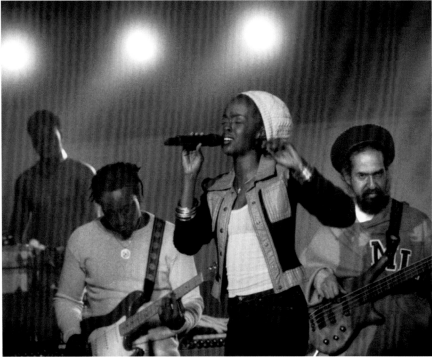

TOP: Wyclef Jean and Lauryn Hill on the video shoot for the Fugees' single "Vocab," East Harlem, New York City, NY, 1993, photographer Lisa Leone. **BOTTOM:** Lauryn Hill performs at the Mammoth Events Center, Denver, CO, February 27, 1999, photographer Larry Hulst.

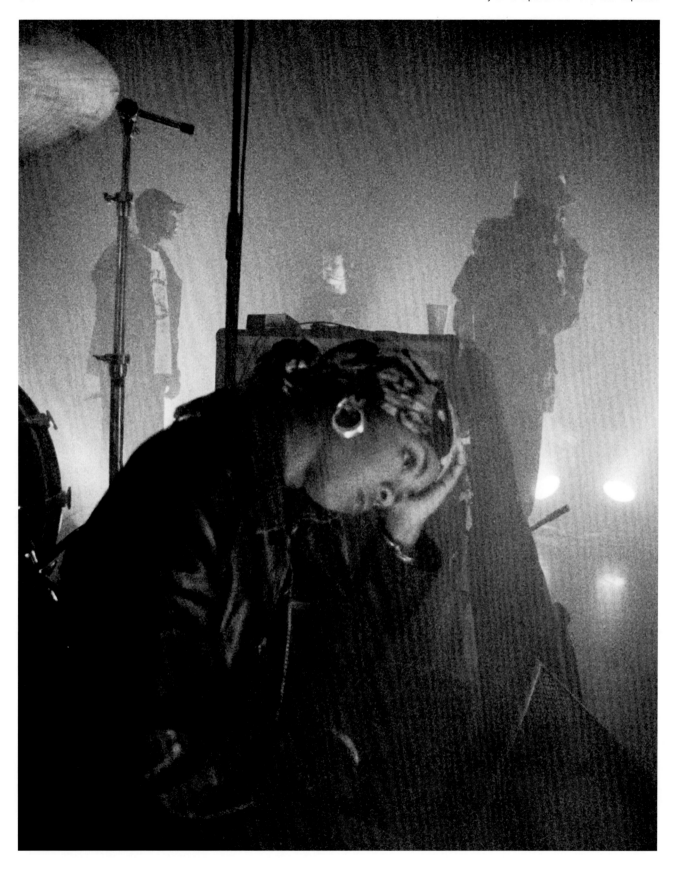

Lauryn Hill at the MTV studios, Camden, London, 1996, photographer Eddie Otchere.

WHAT MORE CAN I SAY?

KING KONG AIN'T GOT SHIT ON ME

YOU COME AT **The King,** YOU BEST NOT MISS

COCAINE IS A HELLUVA DRUG

DON'T WORRY IF I WRITE RHYMES, I WRITE CHECKS

WHAT MORE CAN I SAY?

TRAP MUSIC and the DIRTY SOUTH

The COLLEGE DROPOUT

BLACK

A SMALL PART OF THE REASON THE PRESIDENT IS

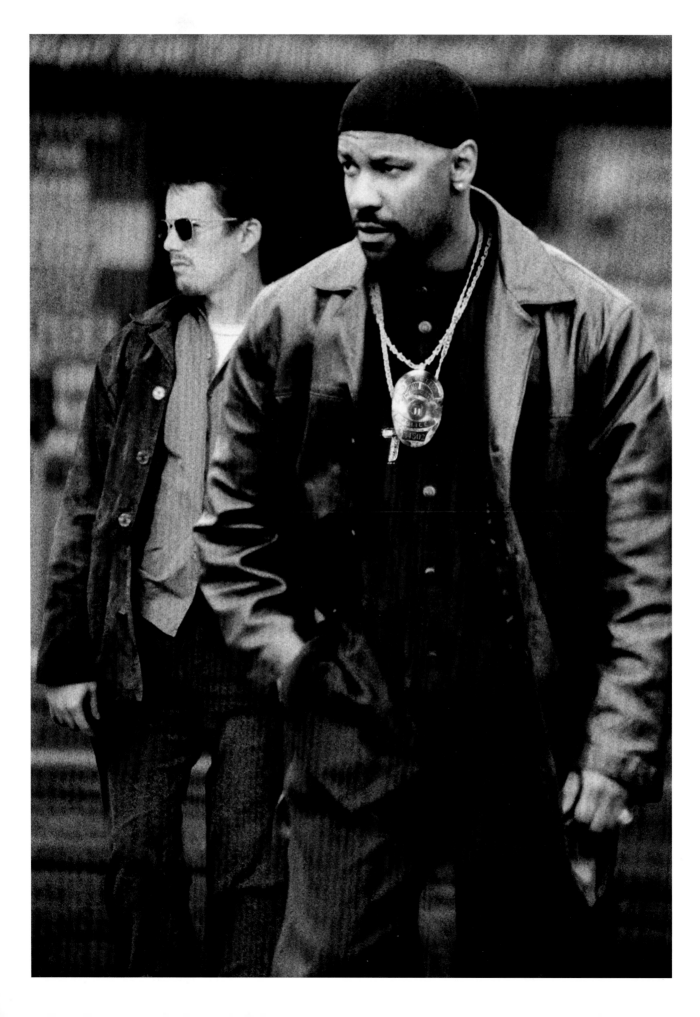

KING KONG AIN'T GOT SHIT ON ME

As the new millennium replaced the old, hip hop now stood in a position of profound influence. The promise and possibility of the twenty-first century would have to coexist with the peril, however. The 2000 presidential election resulted in a scenario where the person taking office—namely, George W. Bush—had not won the popular vote, setting a bad precedent and posing an ominous warning for what was to come. Hip hop, no stranger to navigating perilous times, would once again be tested, but unlike in the early days, the world was now watching. In the words of Mos Def, "Speech is my hammer / Bang the world into shape / Now let it fall" ("Hip Hop," 1999).

In the late 1990s a public inquiry was launched into incidents of major police corruption involving the Rampart Division of the Los Angeles Police Department. The Rampart scandal, as it came to be known, revealed numerous forms of police misconduct including unprovoked shootings, the planting of false evidence, the concealing of evidence, stealing and dealing cocaine, and bank robbery, among other charges. It also transpired that two of the cops at the center of the scandal, David Mack and Rafael Perez, had connections to Death Row Records.

The conditions of the Rampart scandal would serve as source material for Antoine Fuqua's feature film *Training Day* (2001), starring Denzel Washington as the corrupt cop Alonzo Harris. In the film Harris coerces and manipulates a naive, unsuspecting younger officer, Jake Hoyt, played by Ethan Hawke, into assisting him in a plot to rob, steal, and extort money in the hopes of preventing his own murder. Fortunately, Harris is unsuccessful in his ambitions. The film offers a journey through the dark underworld of U.S. law enforcement and the judicial system—plagued with corruption, abuse, violence, and death—implicating both in an unvarnished critique of institutional and systemic racism during the War on Drugs era.

Training Day is very much an LA movie, yet the LA represented is not the stereotypical westside areas of Malibu, Beverly Hills, and Santa Monica, which so many assume define the city. Instead, the film moves between South and East LA, offering depictions of the places that people had become familiar with through listening to gangsta rap. To this end, appearances by both Dr. Dre and Snoop Dogg add a certain authenticity to the overall texture.

It would have been a much smaller urban crime film without the presence of Washington, however, who significantly elevated the production's visibility and impact. His character is especially corrupt, and Washington's immense acting ability and charm add context and complexity to what could easily have been a one-dimensional caricature. His closing monologue has now become the stuff of legend. Cornered and out of tricks, with no one left to exploit, Harris attempts to make one last stand, but at this point all he has are meaningless words, empty threats, and delusional ramblings. No longer the untouchable menace that he was, his final claim is both compelling and highly entertaining: "King Kong ain't got shit on me!"

For his efforts Washington received the Best Actor Academy Award in 2002. This was Washington's second Oscar, his first being for Best Supporting Actor in 1990 for the film *Glory* (Edward Zwick, 1989). Washington was only the second African American to win the Academy Award for Best Actor, after Sidney Poitier in 1964. As it turned out, on that same 2002 evening, Poitier would receive the Academy's Honorary Award, a lifetime achievement recognition, linking his pioneering work and legacy with Washington's. That night Halle Berry also won the Academy Award for Best Actress for her role in *Monster's Ball* (Marc Forster, 2001): she was the first Black woman ever to have claimed the prize, making the event a resounding triumph for Black film and a landmark moment in both Hollywood and American culture. Prior to this historic evening, Hollywood had been notably stingy in giving out awards to Black performers, but the ensuing events portended an institutional shift (albeit a marginal one), and other Black actors would go on to win Academy Awards throughout the decade, including Jamie Foxx in 2005 and Forest Whitaker and Jennifer Hudson in 2007. Perhaps the most unexpected Academy Award winners in the 2000s, however, were the Memphis-based hip hop group Three 6 Mafia, who won the prize for Best Original Song for their track "It's Hard Out Here for a Pimp," from the film *Hustle & Flow* (Craig Brewer, 2005). The incongruity of Three 6 Mafia, a rap group from the so-called Dirty South, rapping about the existential struggles of the life of a pimp at the overtly formal and generally square environment of the Oscars was itself quite humorous, but it was also a moment to celebrate hip hop's continued advancement into and recognition within spaces from which it had previously been excluded.

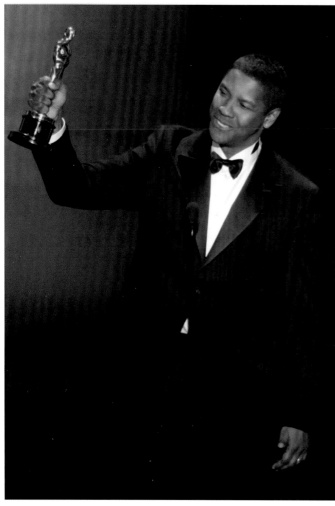

TOP LEFT: Halle Berry and Billy Bob Thornton in *Monster's Ball*, Lionsgate, 2001, dir. Marc Forster. **TOP CENTER:** Denzel Washington and Snoop Dogg in *Training Day*, Warner Bros. Pictures, 2001, dir. Antoine Fuqua. **BOTTOM LEFT:** Denzel Washington accepts his Academy Award for Best Actor for his leading role in *Training Day*, Kodak Theater, Hollywood, Los Angeles, CA, March 24, 2002, photographer Timothy A. Clary. **BOTTOM CENTER:** Denzel Washington and Ethan Hawke in *Training Day*, Warner Bros. Pictures, 2001, dir. Antoine Fuqua.

TOP: LAPD officers David Mack (left) and Rafael Perez, who had ties to Death Row Records at the time of the infamous Rampart scandal, 1997 and 1995, photographers unknown. **CENTER:** At an abandoned Westlake motel near Skid Row, LAPD CRASH (Community Resources Against Street Hoodlums) Unit officers search for a murder suspect, Los Angeles, CA, 1994, photographer Joseph Rodriguez. **BOTTOM:** LAPD chief Bernard Parks addresses the media during a press conference on the investigation into the Rampart scandal, Los Angeles, CA, May 3, 2000, photographer David McNew.

YOU COME AT The King, YOU BEST NOT MISS

With the success of *Training Day* (2001), hip hop rooted itself more firmly within the cultural zeitgeist, impacting stories up close. The film is essentially a cop movie, a genre with long roots in Hollywood, yet it is modernized by its depiction of how hip hop had seeped into areas of life where it had not been visible before, like that of law enforcement. Hip hop–inspired stories need not be about rappers or rap music even, but instead recognize the influence that hip hop culture has had on culture at large, informing and transforming those narratives.

In 2002 *The Wire* premiered on HBO. Created by former crime reporter David Simon and former police detective Ed Burns, the series is set in Baltimore and focuses on law enforcement and its relationship to various institutions—education, the media, the city's port system, etc.—during the War on Drugs era. *The Wire* was extremely well written, with Simon recruiting a number of prominent crime writers to assist in telling the story, and offered an authentic, literary version of urban life that doubled as an intense social critique on the ills pervading postindustrial America. Unlike traditional crime series, however, the show often represented the criminals as far more humane and sympathetic than the cops who pursued them.

The Wire lasted for five seasons, and it has since developed an intensely loyal following, with books written about it and quotes from the series entering the lexicon of popular culture. Alongside *The Sopranos* (1999–2007), released three years prior, *The Wire* would transform the medium of television. With filmlike narrative arcs and high-caliber writing, the two shows brought a level of storytelling traditionally associated with feature films to cable television. Yet instead of being confined to the normal two-hour run time of a feature, the series could tell its story over multiple episodes and seasons. Many would later refer to their experience of watching *The Wire* as similar to reading a great novel.

The success of both *The Sopranos* and *The Wire* set in motion a television revolution of sorts, as various cable entities began commissioning new series of a similar style and execution, though rewatching old episodes remained a popular pastime as well. Programs such as *Mad Men* (2007–15) and *Breaking Bad* (2008–13) followed suit. In time, many critics would assert that *The Wire* is one of the, if not *the*, best television series of the twenty-first century.

The Wire was not explicitly about hip hop, but at the same time it was very much about hip hop. In fact, it would have been impossible for *The Wire* to have existed without the narratives that hip hop had added to the equation, about law enforcement, education, politics, and the many other institutions that the series interrogates. To tell a story of urban America in the early 2000s is to tell a story of hip hop; the culture had become so intertwined with any definition of urban existence that it would be impossible, perhaps even foolish, to think otherwise.

TOP: Jamie Hector and Felicia Pearson in *The Wire*, season 4, HBO, 2006. **BOTTOM**: (from left) Tray Chaney, J. D. Williams, Lawrence Gilliard Jr., and Michael B. Jordan in *The Wire*, season 1, HBO, 2002.

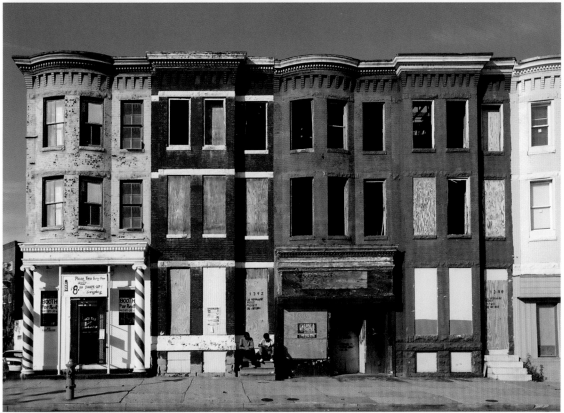

TOP: Idris Elba (left) and Wood Harris in *The Wire*, season 3, HBO, 2004. **BOTTOM:** Row houses, Baltimore, MD, November 1, 2008, photographer unknown.

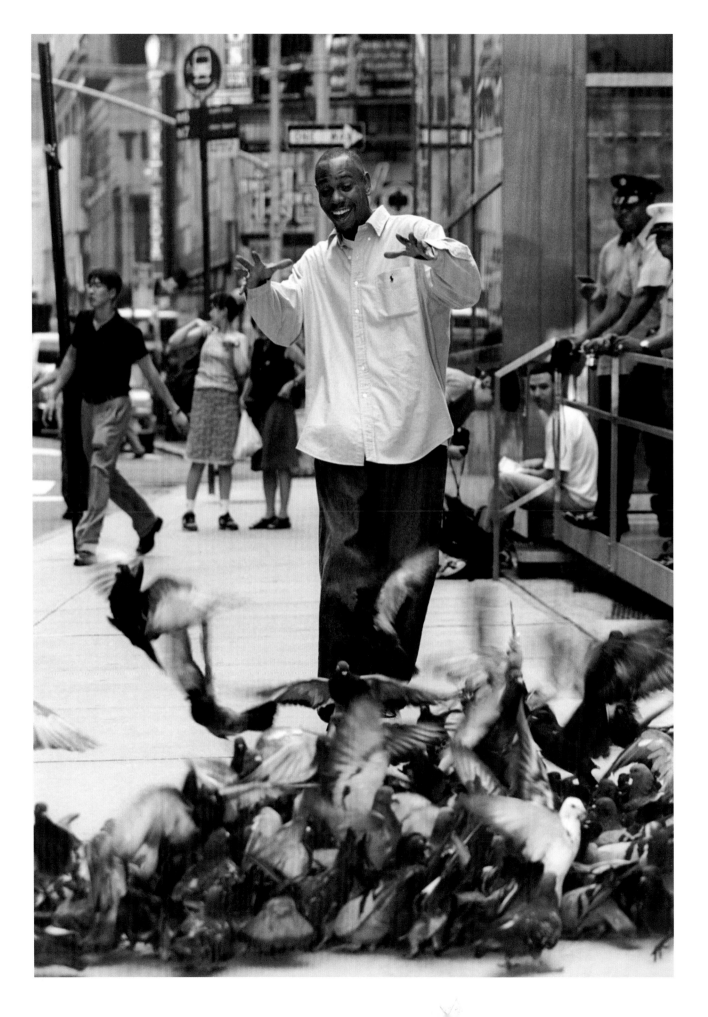

COCAINE IS A HELLUVA DRUG

Comedy has always had a place in hip hop culture, as popular programs such as *In Living Color* (1990–94) and *Def Comedy Jam* (1992–97) demonstrated in the 1990s. By the 2000s Chris Rock, one of the era's most prominent comedians, had become so successful that he was tapped for hosting the 2005 Academy Awards. Perhaps the bigger comedy success story of the new millennium, however, was that of comedian Dave Chappelle and his self-titled *Chappelle's Show*, which debuted on Comedy Central in 2003. For two seasons the sketch show, which featured appearances by rappers such as Mos Def, Talib Kweli, Snoop Dogg, and Common, deployed a unique humor that pushed against social boundaries, often using racial satire. At the height of his career, in September 2004, Chappelle also threw a concert in Brooklyn, inspired by the legendary Wattstax music festival of 1972, featuring the same hip hop artists and friends from his show. The event was documented in *Dave Chappelle's Block Party* (Michel Gondry, 2005), but by the time of its release, things were looking quite different for Chappelle.

At the end of season two of *Chappelle's Show*, the comedian signed a lucrative new deal to produce two additional seasons, yet after filming began, he started having second thoughts about the racial impact of his material. During an interview on *The Oprah Winfrey Show* in 2006, Chappelle recounted a time on set when he noticed an older white man laughing at a skit involving a blackface character in a way that made him uncomfortable. Chappelle felt as though the man was laughing *at him* as opposed to *with him*. The experience prompted a fit of consciousness, and this, among other problems Chappelle was having with the production company, meant that he ultimately left the show.

Chappelle's Show confronted issues of race in particularly provocative ways. In a parody of the PBS documentary series *Frontline* (1983–), we were introduced to Clayton Bigsby, a Black white supremacist. Bigsby was born blind and was never told that he is Black; thus, he is clueless to his situation as he spouts racist language and pledges allegiance to white supremacy. To turn something so uncomfortable into something funny speaks to Chappelle's skill as a performer. If Bigsby were actually white, his comments would be categorized as hate speech, but the idea of a blind Black man holding such problematic views is not only funny but also uses the metaphor of blindness to describe the mentality of those who harbor racial animus and hostility.

Other skits that exemplify this deft use of comedy as a means of racial and social critique include the "Racial Draft," a mock professional sports–style draft during which various celebrities are "drafted" by someone of an ethnicity different than their own; "The Nigger Family," which features a white family whose last name is actually the dreaded n-word; and "Charlie Murphy's True Hollywood Stories," in which Eddie Murphy's brother, Charlie, narrates his experiences spending time with celebrities such as Prince and Rick James, while hanging out with Eddie. In this last outlandish example, Chappelle plays both Prince and James. The James piece—which includes talking-head clips of James himself, often using the refrain, "cocaine is a helluva drug"—has to be considered one of the funniest in the history of American comedy. Chappelle's hilarious impersonation, which spawned the viral catchphrase "I'm Rick James, bitch!," and the overall absurdity of these stories detailing the excesses of James's hedonism made the skit an instant classic.

Chappelle's Show was a short-lived landmark moment in television, sparking discussions on race in ways that were original, intelligent, polarizing, but above all funny. His comedy recalls some of the best work of the OG Richard Pryor, yet the material belongs exclusively to Chappelle, to his experiences and perspectives. And yet the racial conditions of American history are such that the same things that can make you laugh can also make you cry. When edgy Black humor and uninformed white subjectivity clashed, Chappelle decided that his boundary pushing did indeed have consequences. But to create a cultural moment like *Chappelle's Show* and then decide to walk away from a massive payday is gangsta in its own way.

With the show behind him, Chappelle shifted his focus exclusively to stand-up, and in 2016 he signed with Netflix to produce his new comedy specials. Unlike his time at Comedy Central, Chappelle was now a bona fide comic superstar, and the spotlight was firmly focused on his new material. Controversy soon followed as one particular routine contained remarks about members of the trans community that many found offensive, sparking outrage both with employees of Netflix and in the culture at large. Times had changed since Chappelle's last outing, and a heightened awareness around issues of free speech and divisive discussions on the ethics of cancel culture had created an entirely new context for his work.

OPPOSITE: Dave Chappelle has his audience all aflutter in Times Square, New York City, NY, c.2000, photographer James Keivom.

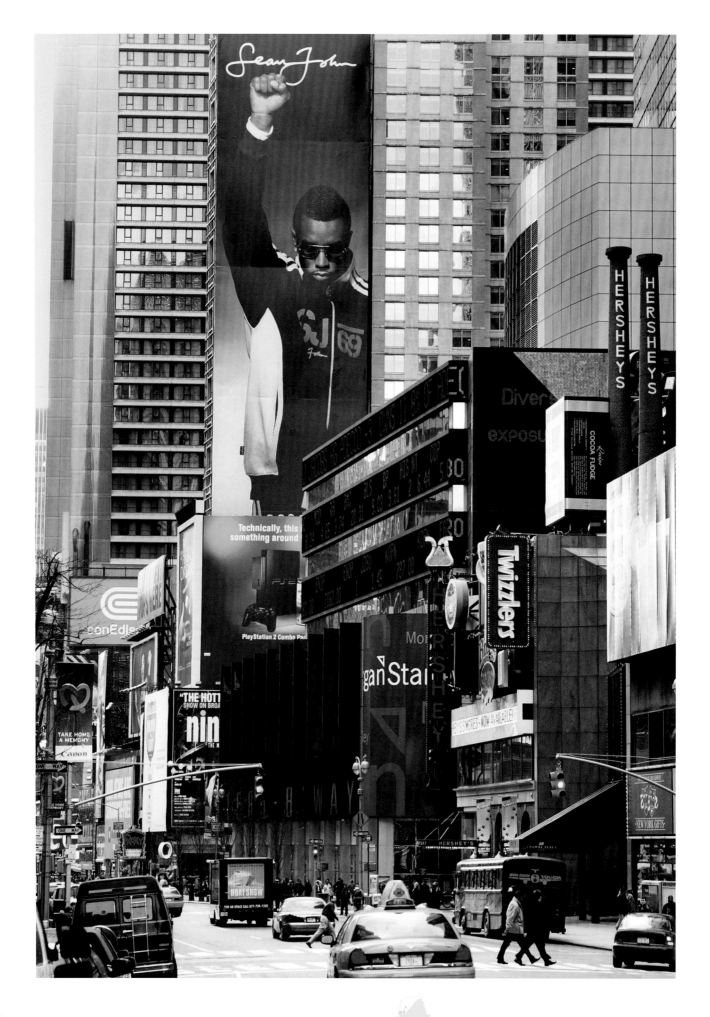

DON'T WORRY IF
I WRITE RHYMES,
I WRITE CHECKS

Another of Dave Chappelle's memorable skits from season two of *Chappelle's Show* was "Making Da Band" (2004). Here Chappelle plays hip hop mogul Puff Daddy in a sketch about the MTV reality show *Making the Band*, which saw Puff run auditions to find the best rappers and singers to create a new music group, dubbed Da Band. Similar to his impersonation of Rick James, Chappelle playing Puff as the comically megalomaniacal dictator assigning random tasks to an eager group of wannabe band members proved exceptionally funny, adding to the absurdity of what was already a hilarious reality show.

Over the years Sean Combs has gone by various names in public: Puff Daddy, Puff, Puffy, P. Diddy, Diddy, and Love. The multiple monikers speak to the numerous hats he has worn during his career, from party promoter and young music executive, to rapper, actor, and business mogul. Puff most certainly emerged from hip hop, but by the early 2000s he had transcended into that rare echelon of true American celebrity. His presence generated headlines, while his style spawned countless imitators. Beyond his skills as a rapper, Puff had become an influencer, a tastemaker, and a curator of the culture—an accomplishment that he touted when he said, "Don't worry if I write rhymes, I write checks," on his single "Bad Boy for Life" (2001).

Many hip hop purists criticized Puff because he was not, in their mind, a true MC. Key to understanding this judgment is the idea that real MCs write their own rhymes. Yet Puff's point is: whether I write rhymes or not is irrelevant, I own the label. Rather than engaging in purity tests to show who is most authentically a rapper, Puff is saying that with his ability to generate capital and move the culture forward from a position of economic strength, he is operating at a much higher and more influential level. As the hip hop industry evolved, it became necessary not only that Black people be the ones who perform the music but also that there was Black ownership of all the cultural capital being created. Economic empowerment was key to defining the sense of uplift that accompanied the rise of the music. And Puff was in a unique position to connect all of these dots.

Puff established his Sean John clothing brand in 1998, and by 2004 had opened a flagship store on New York's famed Fifth Avenue. Through the proliferation of hip hop–backed fashion labels, a dominant style had formed: oversized was in, be it plain white T-shirts worn multiple sizes too big, excessively baggy jeans, or the meticulously recreated retro Mitchell and Ness sports jerseys that were so popular. Sean John, meanwhile, was moving in a different direction, with button-up and French-cuffed dress shirts, suits, and in general a more tailored men's look. This aspirational aspect of Sean John would be compared to the upwardly mobile ethos that had long defined Ralph Lauren. Puff and his label had always promoted a type of aspirational lifestyle that Biggie Smalls's "Juicy" (1994) lays out in clear and concise terms. Achieving it was the hip hop dream writ large, and Puff added increasingly more style and sophistication to the mix.

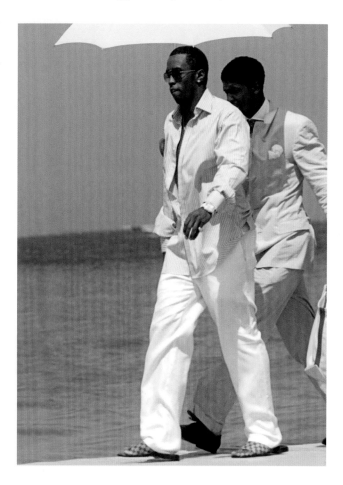

OPPOSITE: A billboard for Sean John clothing featuring Sean "Diddy" Combs in Times Square, New York City, NY, January 13, 2004, photographer Scott Gries. **BOTTOM RIGHT:** Sean Combs and his assistant Fonzworth Bentley, St. Tropez, France, July 27, 2002, photographer unknown.

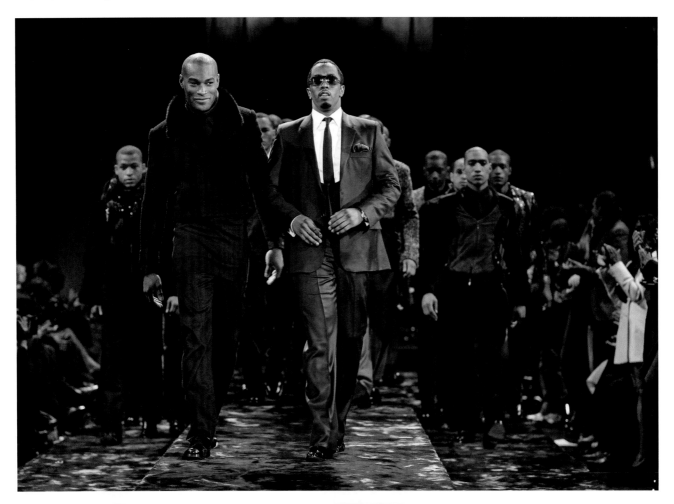

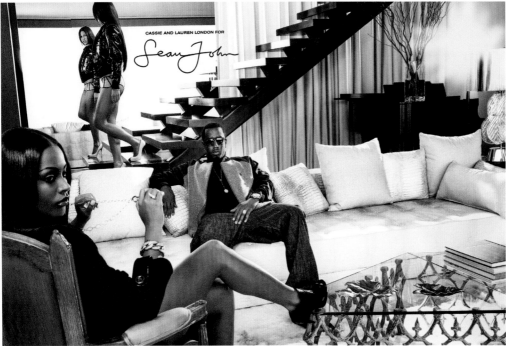

TOP: Sean Combs (right) and Tyson Beckford pose on the runway at the Sean John Fall 2008 fashion show during Mercedes-Benz Fashion Week at Cipriani, Forty-Second Street, New York City, NY, February 8, 2008, photographer Scott Gries. **BOTTOM:** Sean John advertisement featuring Cassie (center), Lauren London, and Sean Combs, 2009, photographer Randee St. Nicholas.

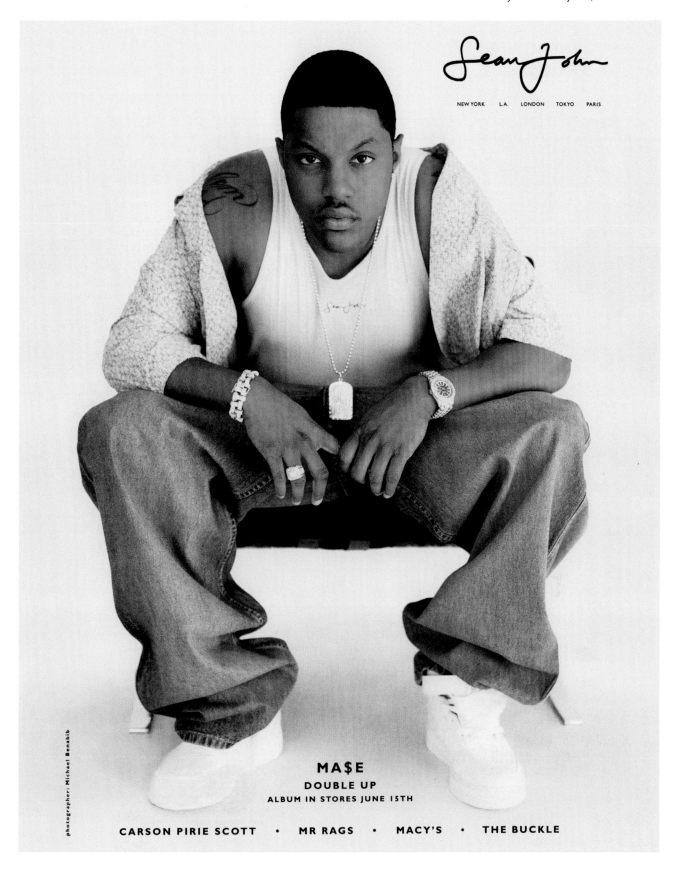

Sean John advertisement featuring Mase, New York City, NY, 1999, photographer Michael Benabib. **OVERLEAF:** Kate Moss and Sean Combs, Paris, 1999, photographer Annie Leibovitz.

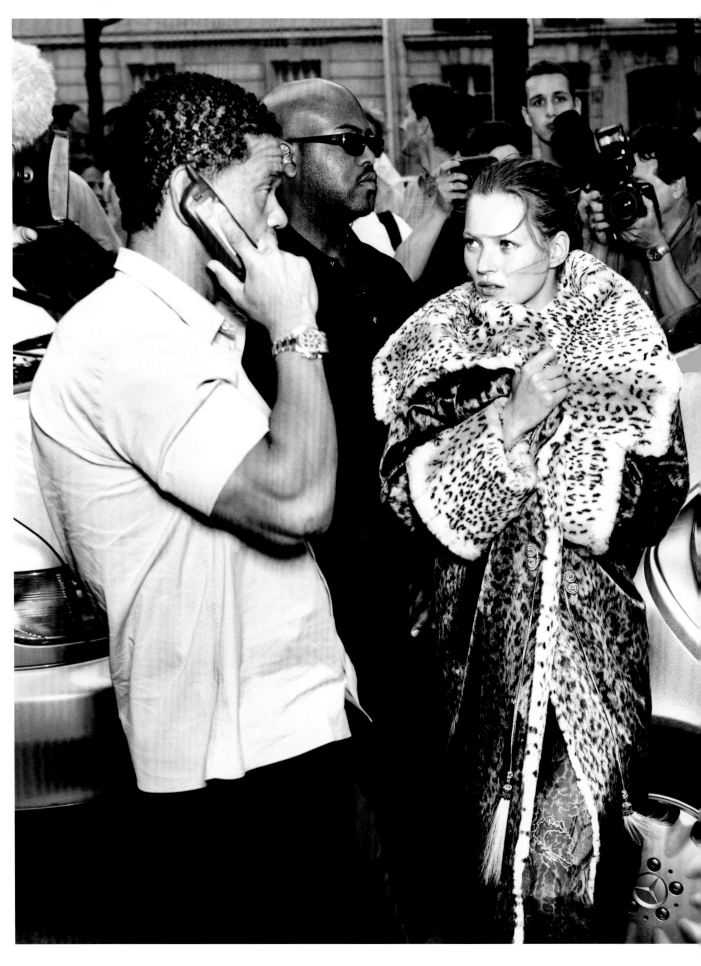

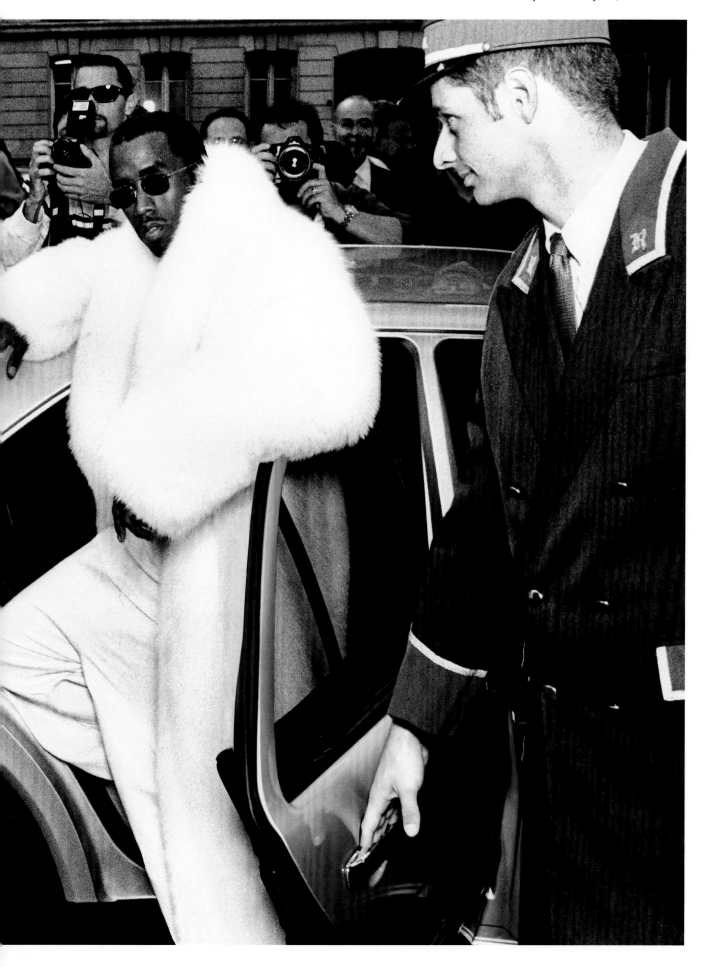

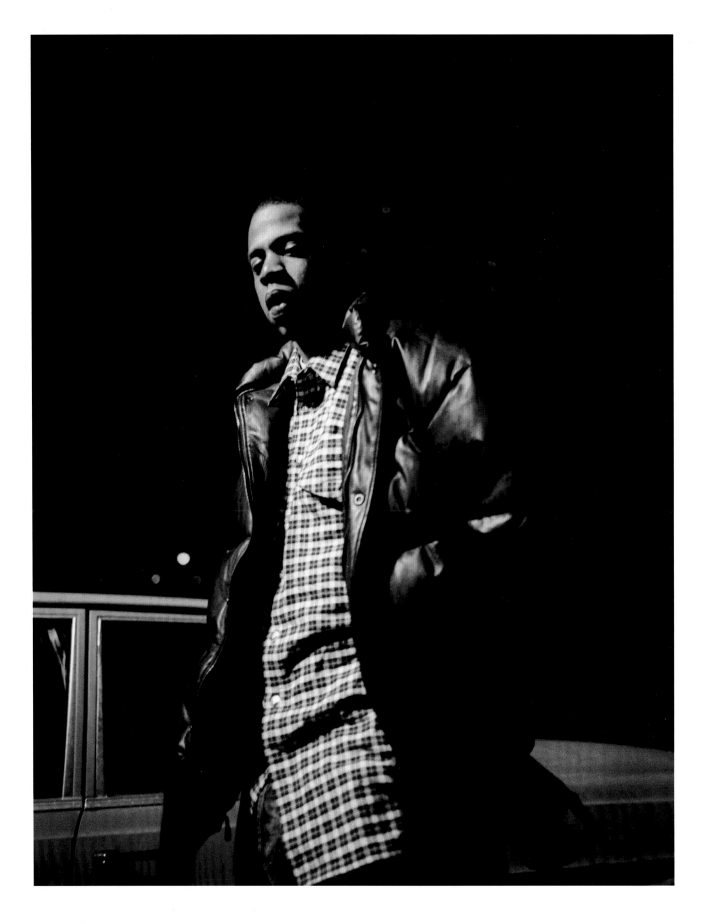

WHAT MORE CAN I SAY?

Bin Laden been happenin' in Manhattan / Crack was anthrax back then / Back when / Police was Al-Qaeda to Black men.
Jay-Z, "A Ballad for the Fallen Soldier," 2002

Shawn Carter, aka Jay-Z, was another prominent figure of the 2000s to fully articulate his own version of the hip hop dream, first through his music and then through his lifestyle. Though he had already experienced great success with a number of hit singles—"Hard Knock Life (Ghetto Anthem)" (1998), "Big Pimpin'" (2000), and "I Just Wanna Love U (Give It 2 Me)" (2000), to name a few—the release of his sixth studio album, *The Blueprint* (2001), marked a key transitional moment in his career. No one could have imagined that when September 11, 2001, was picked as the release date it would have quite such a lasting historical significance. *The Blueprint* did indeed include hits, such as "Izzo (H.O.V.A.)" and "Girls, Girls, Girls," but it also featured a searing diss track, "Takeover," wherein Jay-Z targets fellow New York rapper Nas, setting the scene for what would become one of the most hotly debated lyrical "battles" in hip hop history.

The battle rap is a time-honored tradition in hip hop, dating back to its earliest days, which traditionally sees MCs engage in an aggressive back-and-forth freestyle competition on the mic in front of an audience, with the crowd often determining who is superior—much like the legendary jazz cutting sessions, during which musicians attempted to outplay one another. Such was the style's popularity that battle rap ultimately became its own subgenre within hip hop. Of course, there are times when such battles exceed the bounds of lyrical competition and can result in individuals taking things personally. Considering the tragic way that Tupac Shakur and Biggie Smalls's lives ended—which many attribute to Biggie's "Who Shot Ya?" (1995) being a subliminal diss of Pac and Pac's explicit response "Hit 'Em Up" (1996)—many people were sensitive to the possibility of something like this happening again. Thankfully, the battle of Jay-Z and Nas stayed within lyrical confines; Nas answered "Takeover" with his own song "Ether," released the same year, 2001. Though partisans to this day still debate who actually won the battle for the "King of New York" title, the Jay-Z/Nas beef produced two excellent songs, demonstrating that competitive back-and-forth between artists definitely has its creative upsides.

An album with multiple hit singles and a hot diss track would be sufficient for many, but *The Blueprint* contained so much more. Jay-Z's narrative, of a former crack dealer who made the successful transition from the streets to the top of the rap game, was hammered home in track after track. Perhaps more than any other rapper, Jay-Z embodied the up-from-the-hood persona, telling elaborate tales with lyrical excellence and a conversational, nonchalant swagger that set him apart. *The Blueprint* was akin to some of the greatest concept albums, not only in hip hop, but across all musical genres. As it turns out, many of the tracks were created by a young Chicago-based producer named Kanye West, who gave the album a distinct sound to match its intensely vivid lyrical content. Two years later, in 2003, Jay-Z announced his intention to retire from rap, after what was supposed to be his last record, *The Black Album.* Like Michael Jordan's first retirement from basketball, the rapper's hiatus was short-lived, but the drama surrounding the announcement provided a heightened context for listening to the latest release, itself another lyrical triumph that further bolstered the expanding Jay-Z brand.

Like Puff, Jay-Z was pushing the boundaries of hip hop into other spheres of influence. In 2003, in collaboration with Reebok, he released the S. Carter sneaker, named in reference to his birth name. The shoe was an homage to the Gucci Tennis sneaker released in 1984 and the hustlers who once rocked them. Bringing this design back prompted nostalgia for followers of the culture while also linking the iconic shoe to the most influential hip hop artist of the new era. The high-end Gucci reference is not lost here, as exclusive luxury would become a staple of Jay-Z's repertoire. With the S. Carter, Jay-Z was pushing back against the prevalent hip hop fashion trends. In the *The Black Album*'s "What More Can I Say," he turns these style distinctions into a more pronounced generational difference:

And I don't wear jerseys / I'm thirty plus / Give me a crisp pair of jeans / Nigga / Button ups / S dots on my feet / Make my cipher complete / What more can I say Guru / Play the beat.

In 2005 NBA commissioner David Stern instituted a business-casual dress code for players when arriving in the arena and while sitting on the bench out of uniform, which some critics derided as racist. Somewhat ironically, the controversial rule

OPPOSITE: Jay-Z in a parking lot opposite the Soho Grand Hotel, New York City, NY, 1995, photographer Eddie Otchere.

change directly targeted the same hip hop style trends that Jay-Z had rejected in his lyrics, and one could detect a noticeable shift in street style as a result, further demonstrating his power as a tastemaker.

Jay-Z was influential down to the details, even including his beverage of choice. "Poppin" bottles of champagne was by this point a hip hop ritual, as was drinking directly from the bottle. It was a sign of nonchalant indifference, a rejection of elite standards of decorum, and implied that one had so much money that the expense of champagne was irrelevant. The brand name most often referenced in hip hop tracks was Cristal, and Jay-Z was unofficially one of its biggest promoters. In fact, Cristal had become the unofficial champagne brand of hip hop.

When Frédéric Rouzaud, CEO of Louis Roederer, maker of Cristal champagne, was asked in a 2006 interview in the *Economist* for his thoughts on the popularity of his brand among rappers, he offered an especially problematic answer. Rouzaud suggested that there was nothing they could do about rappers enjoying and publicizing Cristal, because they could not actually prevent anyone from buying it. He threw more shade by suggesting that other prominent champagne brands would perhaps appreciate the hip hop community's embrace of their brands instead. Rouzaud's dismissive remark did not go over well with Jay-Z, who felt it was especially insulting considering how much money the brand had made from hip hop's consistent endorsement of it. As a result, the rapper renounced Cristal and began a collaboration with Armand de Brignac, investing in and promoting a brand of champagne known as Ace of Spades, which he featured prominently in the music video for his song "Show Me What You Got" (2006).

In 2007 Ridley Scott released *American Gangster*, starring Denzel Washington who plays real-life Harlem kingpin Frank Lucas. Lucas was a big heroin dealer in the 1970s, renowned for cutting out the middle man and having his drugs shipped from the Golden Triangle of Southeast Asia in the coffins of dead American soldiers, whose bodies were being returned from the Vietnam War. The film is based on an article, "The Return of Superfly," published by *New York Magazine* in 2000, which details Lucas's life and his many exploits, including his rivalry with Nicky Barnes, who had also appeared on the cover of the magazine in 1977. The reference to Lucas as "Superfly" (per the 1972 gangster film *Super Fly*) demonstrated how pervasive images from Blaxploitation cinema had merged with urban street legend and subsequently hip hop iconography, with such influences providing the context for *American Gangster*. Jay-Z had wanted to do the soundtrack for *American Gangster*, but instead the producers opted for musical cues from the time period in which the film was set. (Rappers T.I., Common, and RZA did appear in the film, however.) Using *American Gangster* as inspiration, Jay-Z released his own album of the same name that same year. The record was another chapter in his continued articulation of the American dream and another excellent contribution to his overall catalogue. His use of imagery, dialogue, and other references to the film was overlaid with familiar tales of his journey from the streets to America's penthouse.

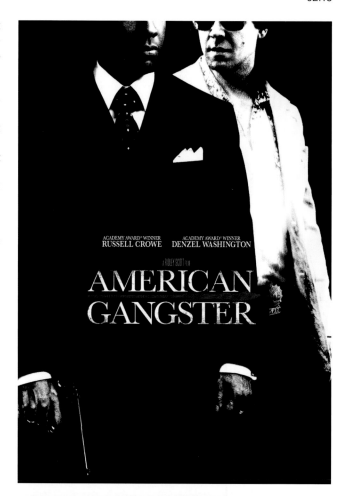

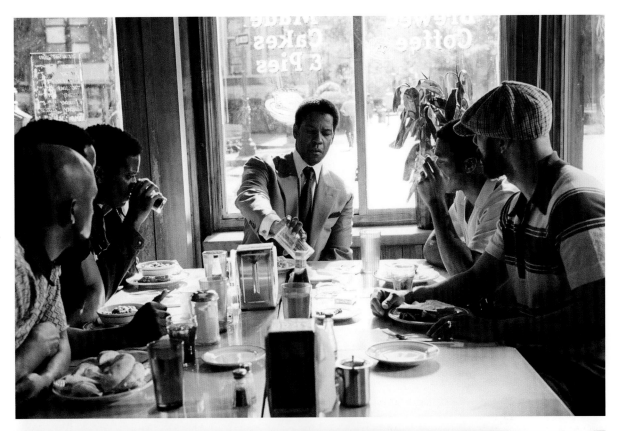

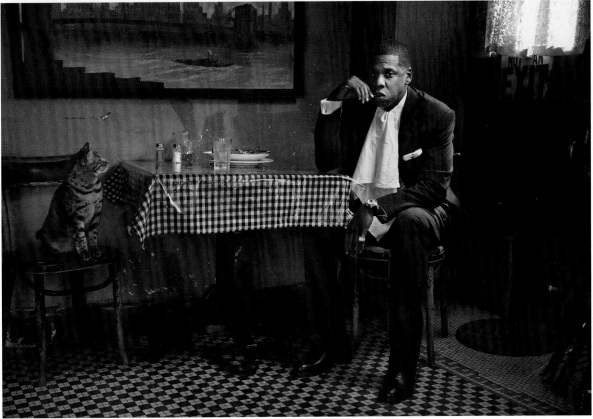

OPPOSITE TOP: Movie poster for *American Gangster*, starring Denzel Washington and Russell Crowe, Universal Pictures, 2007, dir. Ridley Scott.
OPPOSITE BOTTOM: Frank Lucas, Jersey City, NJ, 1997, photographer Antonin Kratochvil. **TOP:** Denzel Washington in *American Gangster*, Universal Pictures, 2007, dir. Ridley Scott. **BOTTOM:** Jay-Z with Cat, Little Italy, New York City, NY, October 17, 2007, photographer Martin Schoeller.

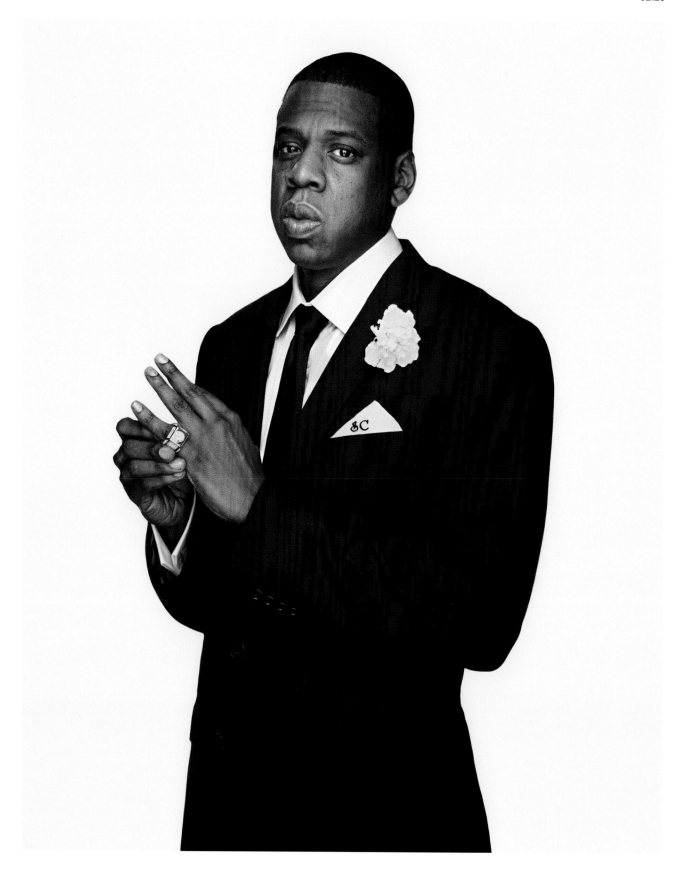

Jay-Z, Tribeca, New York City, NY, October 17, 2007, photographer Martin Schoeller.

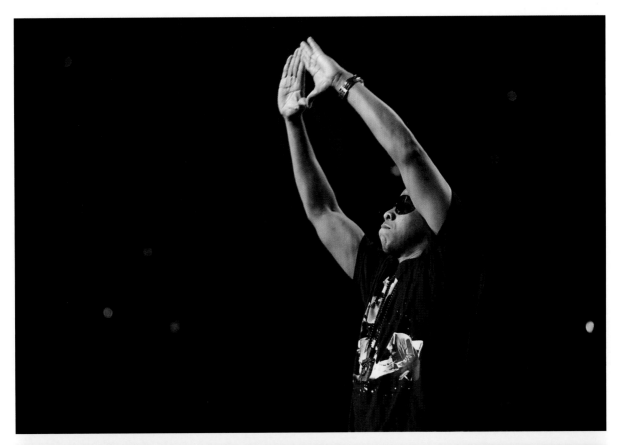

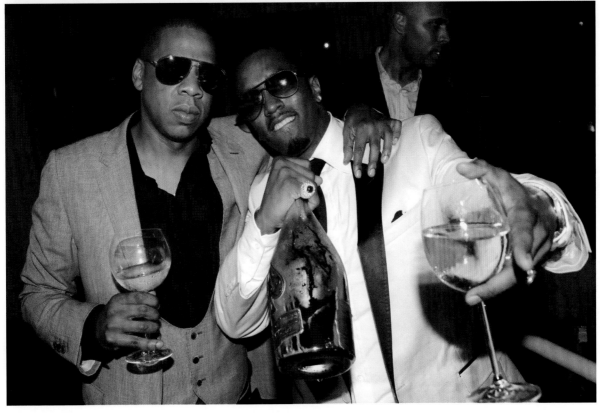

TOP: Jay-Z throws up the roc hand sign while performing at the Honda Center, Anaheim, CA, August 8, 2009, photographer Joe Scarnici.
BOTTOM: Jay-Z and Sean "Diddy" Combs at the Armand de Brignac Champagne Party at VIP Room, Cannes, France, May 23, 2008, photographer Rachid Bellak. LVMH, which owns Dom Pérignon and Moët & Chandon, holds a 50 percent stake in Jay-Z's Champagne brand, also known as Ace of Spades.

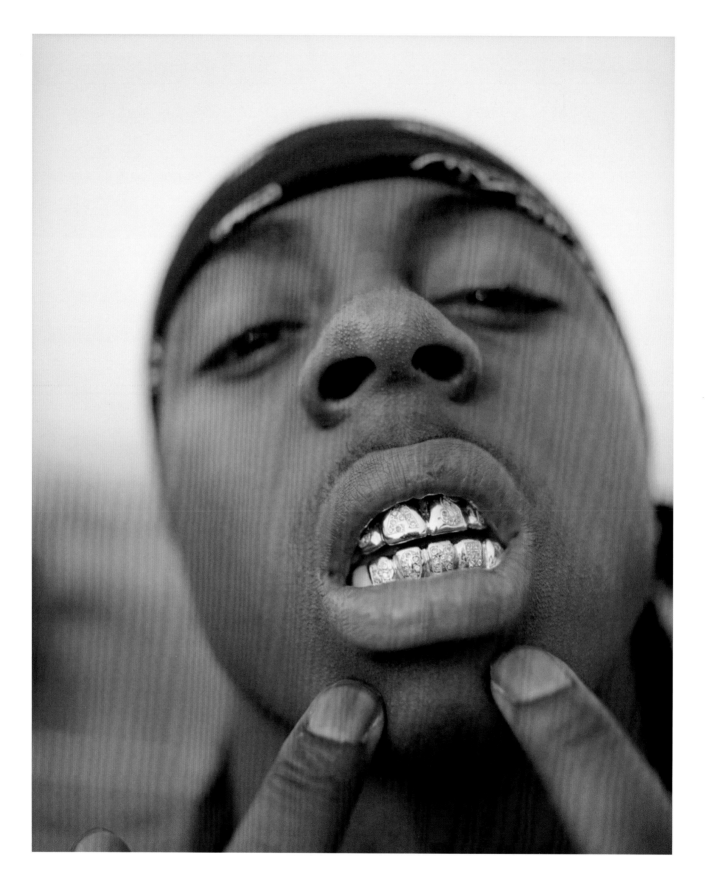

TRAP MUSIC
and the
DIRTY SOUTH

As the new millennium advanced, so did the evolution of Southern hip hop. A significant development in the early 2000s was the popularization of "trap" music, spearheaded by Atlanta-based rappers such as T.I., Young Jeezy, and Gucci Mane, as well as independent record labels such as Big Cat Records. Established by Melvin "Mel-Man" Breeden and Marlon Rowe in 1999, Big Cat released Gucci Mane's debut album *Trap House* in 2005. The word *trap* refers to the neglected or abandoned houses in Atlanta that were used to sell drugs. The site-specific sound and creation of trap music recalled the regionality associated with LA gangsta rap in the late 1980s. Rapping about drugs and life in the trap from the perspective of those on the inside proved influential, lucrative, and controversial.

As with most emerging music genres, associated fashion trends are never far behind. Young Jeezy became known for rocking a diamond-encrusted chain depicting a snowman and later began selling black T-shirts emblazoned with the snowman character who appeared to be frowning, an expression in hip hop and street slang that is often is referred to as "mean muggin." The snowman with the mean mug was used to promote Young Jeezy's album *Let's Get It: Thug Motivation 101* (2005); the snow was a metaphor for cocaine, while the snowman represented the dealer. The T-shirts were very popular across all age groups, yet some schools prohibited students from wearing them, which naturally resulted in them becoming much more desirable.

Across the South a new energy was permeating. In New Orleans Lil Wayne, aka Weezy F. Baby, of the Hot Boys, who signed with Cash Money Records at the age of twelve, had since grown into a highly skilled rapper with uniquely sharp wordplay. Releasing multiple albums and mixtapes in quick succession in what felt like an onslaught, Weezy managed to place his name in the mix for the "best rapper alive" title. In 2009 his Young Money record label, a subsidiary of Cash Money, signed both Nicki Minaj, an emerging young rapper from Queens, and Aubrey Drake Graham, known as Drake, a rapper and singer from Toronto, who began his career as a young actor on the Canadian TV program *Degrassi: The Next Generation* (2001–15). Minaj and Drake would go on to become two of the most successful artists in the game.

Meanwhile, in Houston, a culture built around the legend of DJ Screw. In the 1990s Screw had developed a new sound by remixing records to slow down the tempo of the music, creating a hypnotic, trancelike feel. The sound, known as chopped and screwed, was linked with the popular use of prescription cough syrup containing codeine and promethazine, otherwise known as lean. Users would often mix lean with Sprite to create so-called purple drank. The effects of the lean and the sluggish feel of the music went hand in hand. However, it would prove to be a deadly concoction, as DJ Screw tragically died from an overdose in 2000. Pimp C of the Port Arthur, Texas, group UGK would suffer a similar fate in 2007. Though lean has a strong connection to Houston hip hop culture, its adherents were scattered across the South. Lil Wayne has openly rapped about his consumption of the substance, and his spiral into addiction is documented extensively in *The Carter* (Adam Bhala Lough, 2009). In Memphis, Three 6 Mafia had a huge hit in 2000 with "Sippin' on Some Syrup" (pronounced "sizzurp").

In the mid-2000s Houston hip hop began to receive more mainstream coverage as rappers such as Slim Thug, Paul Wall, Mike Jones, and Chamillionaire made their names. The city's street slang and its unique car culture, built around customized and remixed Cadillacs from the 1980s, known as slabs, were introduced to the rest of the country along with the music.

In 2007 a Southern supergroup featuring UGK, OutKast, and Three 6 Mafia released the infectious hit single "International Player's Anthem (I Choose You)," which sampled Willie Hutch's original track "I Choose You" from the 1973 Blaxploitation classic *The Mack*. Miami-based rapper Rick Ross was also on the come up—Ross took his moniker from Freeway Ricky Ross, the LA drug kingpin linked to the Iran–Contra scandal of the 1980s, who later attempted to sue the rapper for appropriating his name—releasing his album *Port of Miami* in 2006. Ross's particular drug lore would recall images from *Scarface* (1983), *Miami Vice* (1984–90), and a series of other cocaine-specific references popular in the 1980s. Proving that wider cultural influences were still very much prevalent in hip hop's narrative, Ross and other rappers from across the South continued to increase the region's visibility, setting it up for future dominance.

OPPOSITE: Lil' Wayne, Los Angeles, CA, 2000, photographer David Yellen.

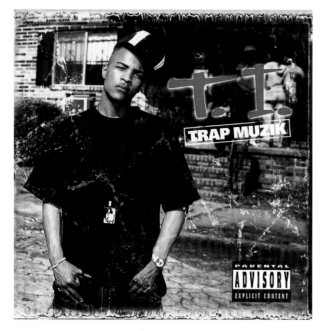

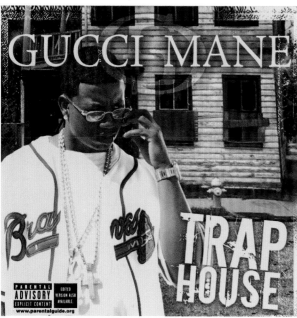

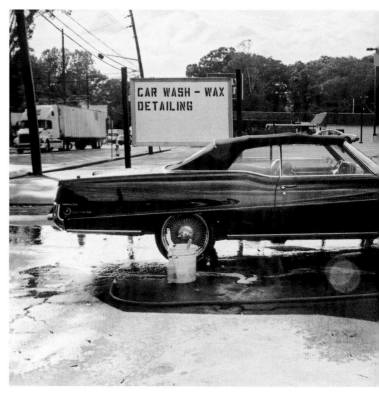

TOP LEFT: Album cover for *Trap Muzik*, T.I., Atlantic Records, 2003, photographer Kevin Knight. **TOP RIGHT AND BOTTOM CENTER:** *Untitled*, Atlanta, GA, 2008–9, photographer Michael Schmelling. From the project *Atlanta*, Chronicle Books, 2010. **CENTER LEFT:** Album cover for *Trap House*, Gucci Mane, Big Cat Records, 2005, artwork by DVS/Creative Juice.

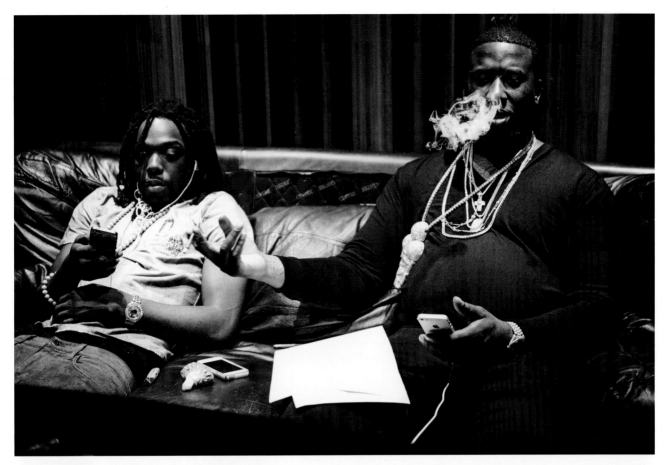

TOP: Young Scooter (left) and Gucci Mane working in the studio, Miami, FL, November 28, 2012, photographer Cam Kirk. **BOTTOM:** Lil' Wayne, New Orleans, LA, March 2003, photographer Gregory Bojorquez.

Untitled, Atlanta, GA, 2008–9, photographer Michael Schmelling. From the project *Atlanta*, Chronicle Books, 2010.

LEFT: *Untitled*, Atlanta, GA, 2008–9, photographer Michael Schmelling. From the project *Atlanta*, Chronicle Books, 2010. **RIGHT:** (top) Home studio and (bottom) Cleveland Avenue, South Atlanta, GA, 2018, photographer Vincent Desailly. From the project *The Trap*, Hatje Cantz, 2019.

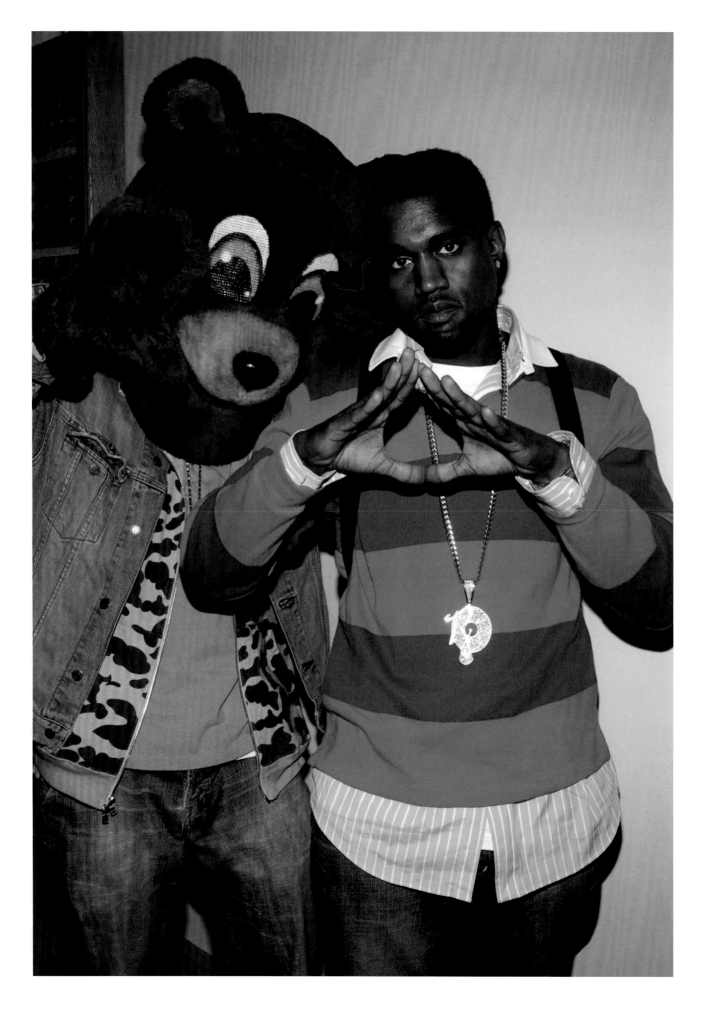

The COLLEGE DROPOUT

While the South readied for its global takeover, the producer of Jay-Z's *The Blueprint* album (2001) set out to prove that he was more than just that. Chicago-born Kanye West had gained recognition for creating highly infectious beats, but beyond his reputation as a producer, he was determined to earn respect as a rapper. The early 2000s were still dominated by gangsta rappers who rhymed about the drug trade and street culture. The importance of having street credibility meant that these rappers needed a reputation in the streets, or at least the plausible illusion of one, before they would be taken seriously. There was nothing remotely street about West's persona, however; he presented as a suburban kid and an art nerd. Fortunately for him, he recognized this and never tried to pass himself off as otherwise. His persistence and his value as a producer paid off, and in 2002, he was signed by Damon "Dame" Dash to Roc-A-Fella Records, at that time jointly run with Jay-Z and Kareem "Biggs" Burke.

West's first album, *The College Dropout* (2004), embraced this suburban, art-nerd character. While many rappers talked about moving between the streets, the penitentiary, and the recording studio, West's narrative spoke of the kid who left college to more efficiently pursue a hip hop career. The class dynamics here are interesting. Hip hop had generally been regarded as the voice of the oppressed relative to issues of race but also to those of class. West's ascendance began to shift this paradigm.

After a car accident in 2002 left him with a broken jaw, West released "Through the Wire," the first single from *The College Dropout*. The music video included graphic footage of his disfigured face, pointing to West's narcissism but equally to his vulnerability. This type of emotional exposure, along with the personal nature of the song, breached all sorts of boundaries within hip hop and became a sort of calling card for West. The songs on the album could be introspective, such as "All Falls Down," a meditation on identity, self-esteem, race, and consumption, or quasi-religious in tone, like his big hit "Jesus Walks." They could also be passive-aggressive and at times comedic. All of this meant that despite his lack of street credibility, or precisely *because* of it, West came across as an original, authentic voice who stood out among his peers. His second album, *Late Registration* (2005), expertly merged his skills as both a producer and a rapper, the latter of which showed a marked improvement.

While *Late Registration* was building momentum, a devastating hurricane touched down in New Orleans. The images of death and destruction from Hurricane Katrina were deeply disturbing; a major U.S. city with a distinct identity had been overwhelmed by nature, yet the government appeared to be indifferent. It was was especially unsettling that many of the city's Black residents had become the face of the disaster. Appearing live on NBC's "A Concert For Hurricane Relief," West blurted out, "George Bush doesn't care about Black people." The statement seemed more of a nervous reaction than a thought-out critique, but it spoke to widespread frustration with the pace and effort of the federal response. The Katrina debacle would often be cited in future as the beginning of the end for Bush. He later said that West's comments marked the "all-time low" point of his presidency.

West's third album, *Graduation* (2007), featured a collaboration with the contemporary artist Takashi Murakami, known for his manga- and anime-influenced "superflat" aesthetic. Murakami designed the album cover and animated the music video for the song "Good Morning." This partnership forged a bond between hip hop and contemporary art that would continue to blossom in the years ahead. Murakami had previously garnered acclaim for his collaboration with Louis Vuitton in the early 2000s; West debuted a three-sneaker collaboration with the brand in 2009. He also designed the Nike Air Yeezy sneaker the same year, a Grammy-worn prototype of which sold for $1.8 million at a Sotheby's auction in 2021. The coming together of West, Murakami, Nike, and Louis Vuitton shone a light on the overlapping influences between hip hop, contemporary art, high fashion, streetwear, and pop culture, in a way not really explored before. As hip hop charted its fourth decade, the environment was ripe for expanding into new mediums. Though rappers had celebrated luxury in various forms before, this redefined what qualified as luxury. Soon bragging about one's art collection would hold equal weight to the celebration of cars and jewelry.

In the same year that Louis Vuitton debuted its collaboration with West, street photographer Tommy Ton took a picture of the rapper with his friends, Don C, Taz Arnold, Chris Julian, Fonzworth Bentley, and Virgil Abloh, who were not very well-known at the time, standing outside the Comme des Garçons men's show at Paris Fashion Week. The photo serves as a snapshot of what was to come, as the hip hop and high-fashion worlds collided.

OPPOSITE: Kanye West and the Dropout Bear visit *TRL* at the MTV studios, Times Square, New York City, NY, February 10, 2004, photographer Theo Wargo.

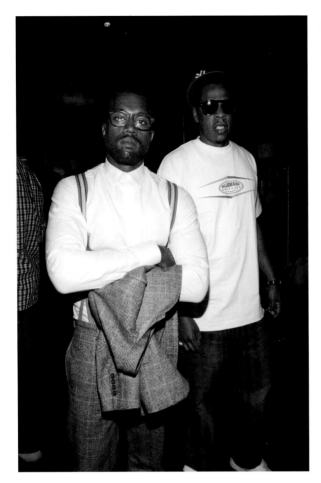

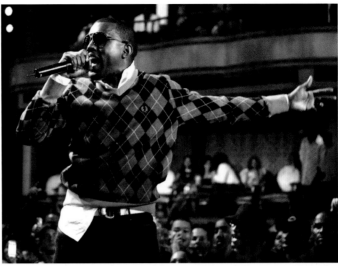

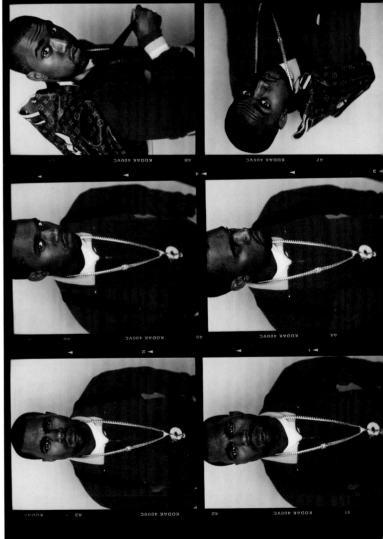

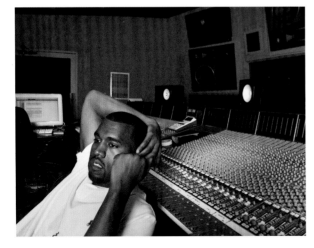

TOP LEFT: Kanye West and Jay-Z attend the Marc Jacobs Spring 2009 fashion show at New York State Armory, New York City, NY, September 8, 2008, photographer Patrick McMullan. **TOP RIGHT:** Kanye West performs at the "VH1 Hip Hop Honors" show at the Hammerstein Ballroom, New York City, NY, September 22, 2005, photographer Jeff Kravitz. **BOTTOM LEFT:** Kanye West takes a break during the recording of *Late Registration*, Los Angeles, CA, July 9, 2005, photographer J. Emilio Flores. **CENTER:** Kanye West's first press photos, Chicago, IL, 2003, photographer Nabil Elderkin.

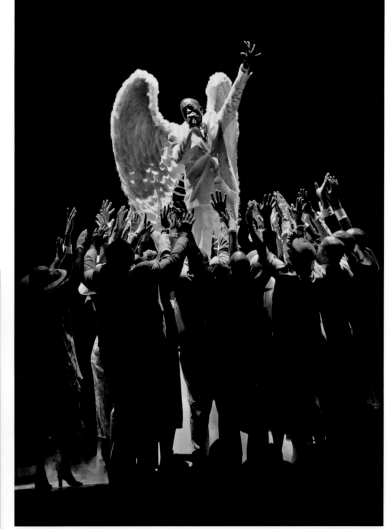

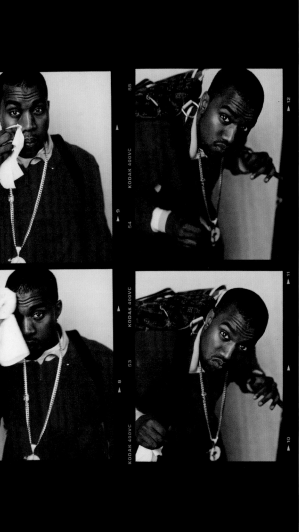

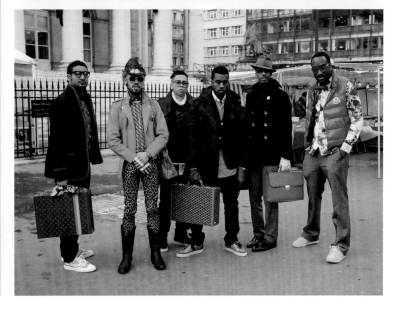

TOP RIGHT: Kanye West performs "Jesus Walks" during the Grammy Awards at the Staples Center, Los Angeles, CA, February 13, 2005, photographer Frank Micelotta. **BOTTOM RIGHT:** (from left) Don C, Taz Arnold, Chris Julian, Kanye West, Fonzworth Bentley, and Virgil Abloh outside the Comme des Garçons men's show, Paris Fashion Week, 2009, photographer Tommy Ton.

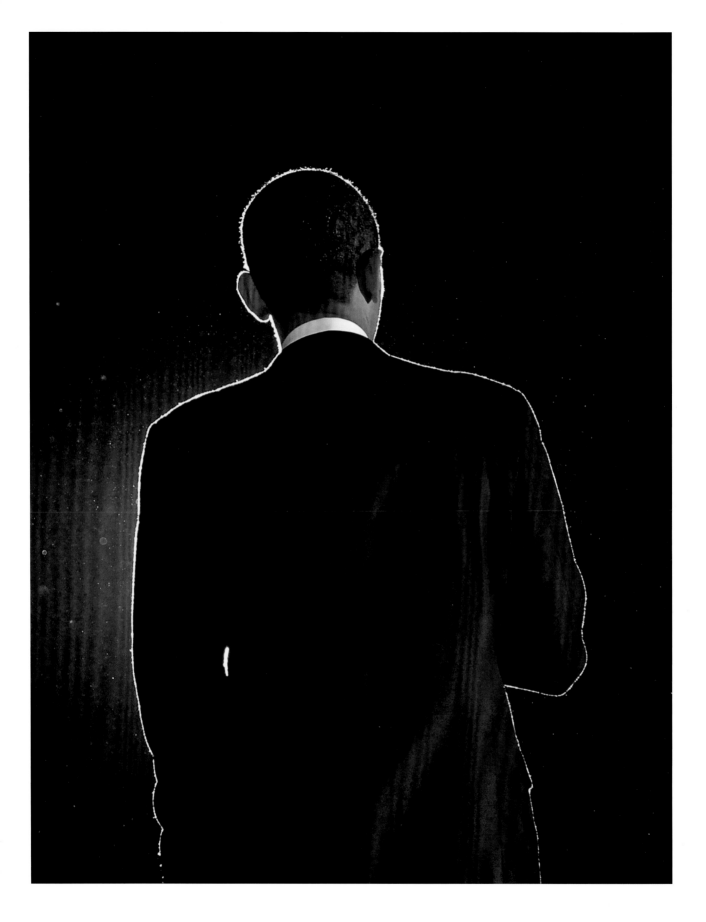

A SMALL PART OF THE REASON THE PRESIDENT IS BLACK

In 1968 it is understood that Robert F. Kennedy (RFK), then United States senator and the Democratic presidential candidate, on discussing the pace at which race relations in the United States were changing during a radio interview with the *Voice of America* network, predicted that in forty years, a Black person could win the presidency. RFK, like his brother John F. Kennedy before him, would be assassinated, not long after making this statement. Yet in 2008, forty years later, the United States did indeed elect Barack Hussein Obama as its forty-fourth president.

The new millennium had gotten off to a particularly ominous start. George W. Bush was handed the presidency in 2000 after the U.S. Supreme Court halted a ballot recount following his disputed election results in Florida. This was followed by 9/11, the invasion of Afghanistan, and the invasion of Iraq. By 2004 Bush and his war machine seemed to be rolling along undeterred as he ran for reelection. Hope was on its way, however…

In July of that year Obama, a young state senator from Illinois who was running for United States Senate, was alotted a prime-time keynote-address speaking slot at the Democratic National Convention (DNC) in Boston. The self-professed "skinny kid with the funny name" stepped on stage that night as a national political unknown, yet by the time he stepped off, it is fair to say that he, like Muhammad Ali in 1964, had "shook up the world." Four years later, Obama would become president, just like RFK had predicted.

Obama's seemingly rapid ascendance in American politics is considered one of the most spectacular in history. A low-profile community organizer, adjunct law professor, and state politician running for the U.S. Senate, Obama's performance in Boston was so well received that it would place his name into the conversation for future president of the United States. His stirring address to the nation had the same kind of star-making quality to it that had generally only come to be expected from the pop-cultural universe. This was quite in contrast to his experience only four years earlier, when he attended the DNC in Los Angeles. Upon his arrival at LAX airport, his American Express card was declined by a rental-car agency, and later, once he had arrived at the convention site, Obama discovered that he did not possess the proper credentials to attend many of the most

important events. "Busted and disgusted," as they say, and lacking any real "juice," Obama left the convention early, making his way back to Chicago in a frustrated state.

Back to that auspicious July night in 2004, as Obama moved about in preparation for his speech, he was focused on the opportunity and confident that he could take full advantage of it. "I'm LeBron, baby," he is reported to have said. "I can play on this level. I got some game." Obama was, of course, referencing NBA prodigy LeBron James, teenage rookie of the Cleveland Cavaliers who, two years prior, had appeared on the cover of *Sports Illustrated* as a mere high-school junior, being touted as "the chosen one." By making comparisons to and drawing inspiration from LeBron, Obama was also revealing his connections to hip hop culture, which often sees rappers use the exploits of sports stars as a frame of reference for their own dominance of "the game," as it were. The phrase "I got game" also evokes hoop lingo, as represented by Spike Lee's 1998 film *He Got Game,* starring NBA baller Ray Allen. Obama was playing a different, more high-stakes game, though.

Following his appearance at the convention, Obama had become a political star. Later that year he won the Illinois Senate seat that he had been campaigning for, yet calls for him to run for president were getting louder by the minute. In 2007 Obama formally announced that he was running and set about on his campaign. The United States had never elected anyone to the highest office in the land who was not a white male, so this would be an uphill climb. Hillary Clinton, a senator from New York, would be vying to make history as well, in hopes of becoming the first woman to take office.

After one of his debates with Clinton, Obama stood on stage at a campaign rally decrying the negative way that politics often devolved into attacks. His response to Clinton's criticisms was to gesture with his hands as though he were brushing imaginary dirt off his shoulders. This gesture was a direct reference to Jay-Z's song "Dirt Off Your Shoulder" (2003), in which he states, "If you're feelin' like a pimp, nigga, gon' brush your shoulders off." The humorous gesture was meant to imply moving beyond negativity, distancing oneself from the haters. Just brush it off and keep moving: don't let the negativity stop you from pursuing your goals.

Obama's reference to Jay-Z clearly indicated that he was both a fan of the rapper and more broadly invested in hip hop culture. Jay-Z was the most influential rapper at the time, and he and Obama would soon become friends, with Jay-Z repaying the shout-out by referencing the pair's connection in his lyrics. Obama's allegiance with hip hop, which was apparent throughout his run for president, reached full display once he took office; the feeling was mutual as key hip hop figures came out in strong support of the hopeful during his campaign. Unlike Bill Clinton's appearance on *The Arsenio Hall Show* in 1992, which in hindsight looked very much like a publicity stunt, Obama's embrace of both hip hop and hoops came across as genuine. The culture stood by him and cheered him on as he pursued his ultimate goal.

Perhaps the track that best sums up this relationship between Obama and hip hop is one by Young Jeezy, "My President" (2008), which includes the lyrics: "My president is Black, my Lambo's blue / And I'll be goddamned if my rims ain't too." In a moment of celebration that is pure hip hop, Jeezy links Obama's victory to his own successes, namely, his ownership of a blue Lamborghini with matching rims.

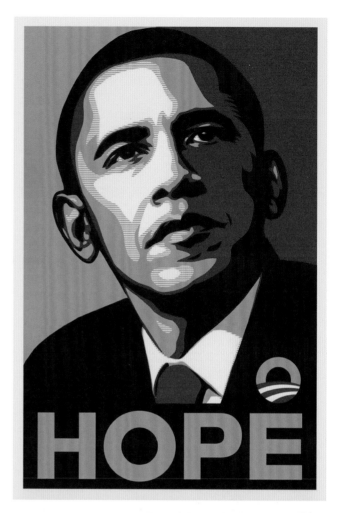

Jay-Z's song "What We Talkin' About" (2009) hears him stating, "I don't run rap no more / I run the map," indicating that he has transcended rap music to become a global influencer. As if to prove this point, he goes on to say, "a small part of the reason the President is Black." Here, Jay-Z is referring to how his influence, in part, helped to propel Obama to the White House. While some may scoff at the idea that hip hop helped elect a president, the evidence is beyond dispute. What hip hop did, over the forty-plus years that it moved in a stealthlike fashion through American society, was continually break down racial and cultural barriers. Unlike in previous generations when African Americans were encouraged to comport themselves in a manner that would not be considered offensive to white tastes and sensibilities, and to seek crossover appeal by accommodating white expectations of Blackness, today, hip hop made no such compromise. "I ain't crossover, I brought the suburbs to the hood" ("Come and Get Me," 1999), another Jay-Z line tells us.

Hip hop was the good, the bad, and the ugly of Black culture, warts and all. But it was precisely this authentic approach that made it appeal to younger generations of Americans and subsequently audiences worldwide. By 2008 there were multiple generations of all races who had grown up listening to, purchasing, and being influenced by hip hop culture. The idea of Black celebrities, Black influencers, and Black tastemakers was not at all controversial to these individuals. By this time it was simply the way things were, even if large percentages of the population still needed to catch up. The passing of the Voting Rights Act and the Immigration and Naturalization Act in 1965 enfranchised Black voters in the South and opened up more opportunities for immigrants of color to come to the United States, over time creating a much more diverse American electorate, which had fully come of age by the time Obama ran for president in 2008.

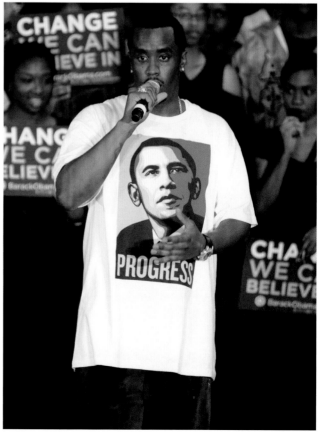

This is not to suggest that Obama's run was all peace and love, because in addition to the goodwill his election generated, it also unleashed a mob of vicious haters, as his time in office and the ensuing aftermath would reveal in no uncertain terms. The dark side of politics notwithstanding, hip hop undeniably helped to pave the way for the nation's first Black president—more than three decades after it all started in a Bronx rec room.

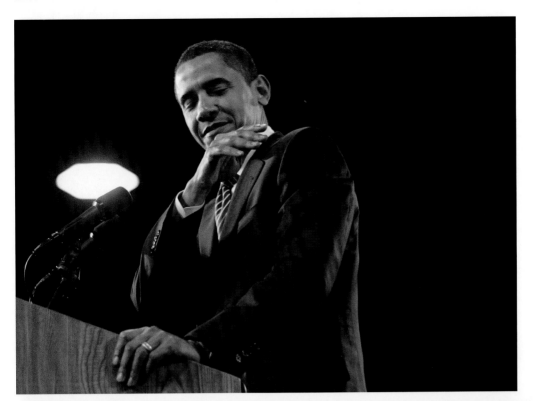

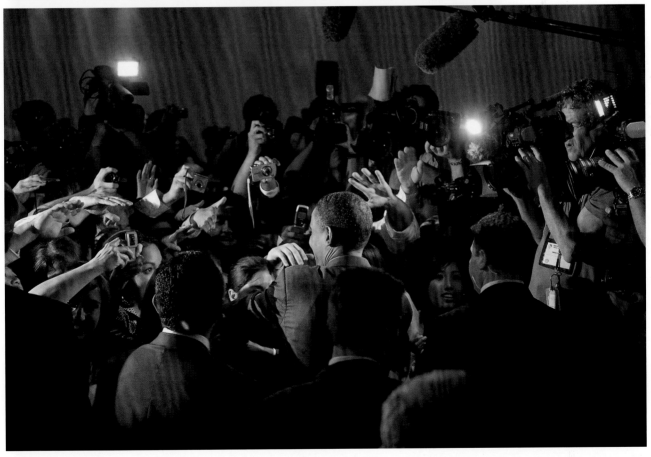

OPPOSITE TOP: Shepard Fairey, *Barack Obama "Hope,"* 2008. **OPPOSITE BOTTOM:** Sean "Diddy" Combs at the Last Chance for Change rally in support of Barack Obama, Fort Lauderdale, FL, November 2, 2008, photographer Larry Marano. **TOP:** Senator Barack Obama jokingly brushes dirt off his shoulder at a town hall meeting during his presidential campaign, Raleigh, NC, April 17, 2008, photographer Jae C. Hong. **BOTTOM:** Democratic presidential candidate Barack Obama is surrounded by supporters after making remarks at the League of United Latin American Citizens Convention in Washington, D.C., July 8, 2008, photographer Astrid Riecken.

STARTED FROM THE BOTTOM, NOW WE'RE HERE

Came Through

drippin

WHEN IT ALL

F A L S

D O W N

PICASSO

MC

DROP

THE POLITICS ISSUE

THE SOURCE

THE BIBLE OF HIP-HOP
MUSIC, CULTURE & POLITICS

UNDER NEW OWNERSHIP

HIP-HOP INSIDE IRAQ
SOLDIERS' STORIES

+

DIDDY
WYCLEF
COMMON
ICE CUBE
YOUNG JEEZY
ANDRE 3000
IMMORTAL TECHNIQUE
DADDY YANKEE
MOS DEF
LUPE FIASCO
KRS-ONE
E-40

NFL REPORT

FACE-OFF
McCAIN VS OBAMA

GOTV
GET OUT THE VOTE
THE YOUTH SPEAK!
CAN FELONS VOTE?
THE SOURCE VOTER'S GUIDE

RE-ENTRY
LIFE AFTER PRISON

OBAMA
HIP-HOP STAND UP!

The Upgrade

ISSUE #227

$4.99

11>

0 09281 03595 4

PRESIDENTIAL

What is left to do after helping elect a president? In the years since DJ Kool Herc started this thing called hip hop, the culture had reached unexpected plateaus; no longer confined to the sidelines, it has grown into a global behemoth of the highest order, asserting its influence worldwide across the realms of fashion, sports, politics, and culture. In the words of Drake, "Started from the bottom, now we're here" ("Started From the Bottom," 2013).

Barack Obama's election in 2008 and his reelection in 2012, winning both the popular and electoral college vote, would make him one of the most successful politicians in modern American history. That he won both elections without winning the majority of the white vote signaled a changed American electorate, but it also triggered an explosion of open racial hostility that has characterized politics and the country ever since. And while the immediate aftermath of Obama's time in office could be defined by this racial backlash, the former president took full advantage of his two terms, in ways that both highlighted and helped to further the culture.

Barack and Michelle Obama brought a strong cultural component to presidential affairs in a way that hip hop had not experienced before, and during the Obama years rappers were frequent guests at the White House. In a tradition that started during his time in office, Obama now releases an annual end-of-year roundup of his favorite songs, films, and books, adding tastemaker-in-chief to his long list of cultural achievements. In 2015, Obama announced that his favorite song of the year was Kendrick Lamar's "How Much a Dollar Cost," from his Grammy award-winning album *To Pimp a Butterfly*. This was followed by an invitation to the celebrated rapper, from Compton, California, to meet with the president at the White House. Obama's senior advisor, Valerie Jarrett, reported that the president had said to the young artist: "Can you believe that we're both sitting in the Oval Office?" In this statement he was acknowledging the historical implications of being the nation's first Black president and that the weight of his influence and ability to shape the culture directly resulted in these two Black guys occupying a space previously considered out of reach.

Kendrick's critical and commercial success on the Top Dawg Entertainment label, in conjunction with Dr. Dre's Aftermath

Entertainment and Interscope Records, ushered in the latest chapter of Compton's storied hip hop history. Kendrick's innovative work in the field also forged new artistic links, such as his collaboration with artist Kahlil Joseph, who in 2014 created the short film *m.A.A.d.*, which combined still and moving images depicting contemporary life in Compton and was set to a soundtrack from Kendrick's breakout album *good kid, m.A.A.d. city* (2012). The film debuted at the Museum of Contemporary Art in Los Angeles in 2015 and was presented as a split-screen installation titled *Kahlil Joseph: Double Conscience*. A strong visual narrative has always run parallel to Kendrick's introspective music. This can be seen in the Polaroid-style album cover for *good kid, m.A.A.d. city*, featuring an old family photo, as well as the artwork for *To Pimp a Butterfly* (2015), shot by Denis Rouvre, which shows a group of Black men, women, and children celebrating in front of the White House while a white judge lies at their feet. In recognition of his strides in the industry, and specifically of his 2017 album *DAMN.*, Kendrick was awarded the 2018 Pulitzer Prize for Music, the first rapper to do so in the prize's history.

Obama's acknowledgment of and appreciation for a cutting-edge figure like Kendrick Lamar demonstrates a cultural competency never before associated with the White House or with politics in general. In a society where culture serves such an important purpose, the lack of formal respect for this purpose is often disappointing. It was for precisely this reason that the legendary musical giant Quincy Jones lobbied Obama to create an ambassador for the arts, a secretary of culture. While this did not come to be, Obama's continued cultural engagement, throughout his presidency and beyond, indicated that such considerations were most certainly worthy of attention.

Another presidential tradition that Obama upheld during his two terms was inviting championship college and professional sports teams to visit the White House to honor their successes. Though this custom can be traced back to the late 1800s, the historic nature of Obama's presidency and the increasing prominence of Black visibility in sports such as basketball and American football meant that it would offer a different set of optics than had previously been the case.

Of course, there had been other presidents who were sports fans and supporters before Obama. Richard Nixon sat in the

stands for the 1969 Texas vs. Arkansas college football game that decided the national title. Interestingly, this was the last time a college football championship game was played in which neither team featured a Black player. Gerald Ford played center on two national championship football teams while at the University of Michigan; Bill Clinton attended college basketball's NCAA Championship Game in 1994, at which his home state Arkansas Razorbacks claimed the title; and George W. Bush was at one point a minority owner of baseball's Texas Rangers.

So it was perhaps not surprising when in 2009 Obama attended a Washington Wizards game to watch the local D.C. team play his favorite, the Chicago Bulls. What *was* significant about his attendance, however, was where he chose to sit: instead of in a luxury box far above the court, Obama sat in the arena's cherished courtside floor seats. One of the biggest signs of success in hip hop culture is to sit in a floor seat at an NBA game. It is the ultimate flex, as they say. The broadcast of NBA games routinely highlights the celebrities who are fortunate enough to occupy these prime seats. In fact, these celebrity sightings have become somewhat of an NBA tradition. So when Obama sits courtside, drinking a beer, and jokingly engaging with a heckling fan who is playfully trash-talking his team, this represents a connection to the culture that transcends what is normally considered presidential routine. Obama was demonstrating that he was at one with the culture and that he himself authentically embraced the game.

One could see a similar affinity between Michelle Obama and members of the Miami Heat when they attended the White House for their championship celebration in 2014. In a video used to promote the First Lady's "Let's Move!" health campaign, she videobombs the players Dwyane Wade and Ray Allen, and their coach, Erik Spoelstra, dunking on a miniature basketball rim held by LeBron James, then humorously celebrates while they all laugh at her antics. Instead of the clip being stiff, it was genuinely funny and warm, and came across totally natural, like the kind of thing that she had done before. Together, the Obamas brought a deep set of cultural experiences to the White House that allowed them to remix various presidential traditions while also forging new ones. In turn, this served to underscore a similar type of cultural and political impact that hip hop has had on various American rituals and traditions. And while this may not have been the Obamas' objective, it was precisely why the haters were so frustrated, because there was nothing they could do about it. To be able to spite your haters is quintessentially hip hop, and to do it from the White House is especially next level.

The ritual of inviting championship teams to the White House took a slightly different turn once Donald Trump became president. In one incident, Stephen Curry of the Golden State Warriors refused an invitation as he did not support Trump's policies or his continuously problematic rhetoric. Trump, attempting to shift the narrative, said that the invitation had been withdrawn. But how do you disinvite someone who has already indicated that they do not want to go? In support of Curry, LeBron tweeted on September 23, 2017: "U bum @StephCurry30 already said he ain't going! So therefore, no invite. Going to the White House was a great honor until you showed up." Calling Trump a bum was the type of humorous diss that would have been suitable for a hip hop battle rap. That year, it was the most retweeted post by an athlete and the seventh most retweeted post in the world.

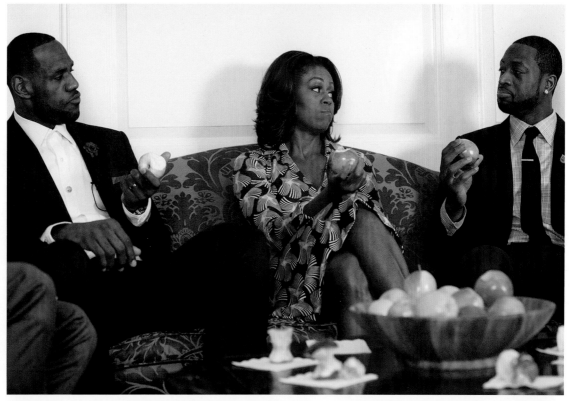

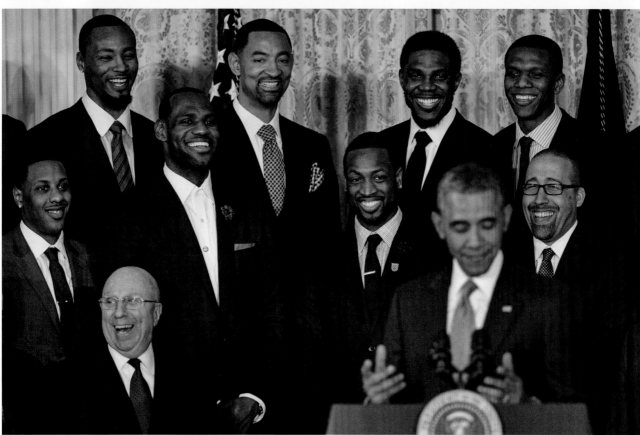

OPPOSITE TOP: Barack Obama talks with Jimmy Fallon on *The Tonight Show Starring Jimmy Fallon*, NBC Studios, New York City, NY, June 8, 2016, photographer Jonathan Ernst. **OPPOSITE BOTTOM:** Barack Obama greets a fan during a Washington Wizards vs. Chicago Bulls basketball game at the Verizon Center, Washington, D.C., February 27, 2009, photographer Gerald Herbert. **TOP:** Michelle Obama tapes a "Let's Move!" public service announcement with Miami Heat players LeBron James (left) and Dwyane Wade at the White House, Washington, D.C., January 14, 2014, photographer unknown. **BOTTOM:** Barack Obama laughs with members of the Miami Heat during an event honoring the 2013 NBA Champions at the White House, Washington, D.C., January 14, 2014, photographer Mandel Ngan.

TOP: Snoop Dogg attends a game between the Los Angeles Lakers and the San Antonio Spurs at the AT&T Center, San Antonio, TX, November 3, 2019, photographer Logan Riely. **BOTTOM:** Drake high fives Rondae Hollis-Jefferson of the Toronto Raptors during the first half of an NBA game against the Milwaukee Bucks at Scotiabank Arena, Toronto, Canada, February 25, 2020, photographer Vaughn Ridley.

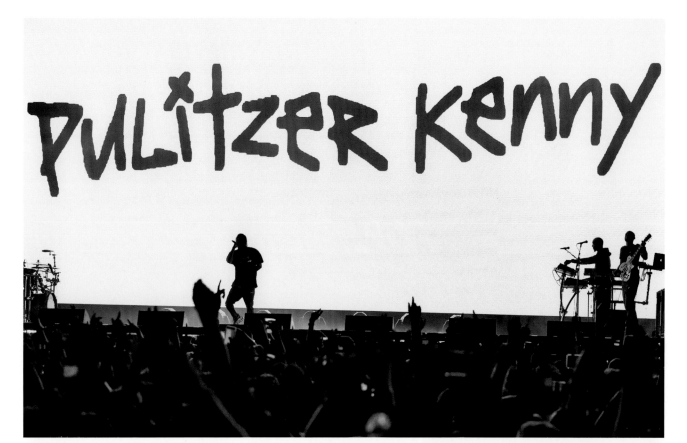

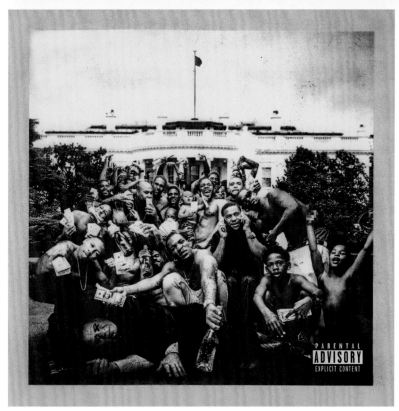

TOP: Kendrick Lamar performs during day one of Grandoozy festival, Denver, CO, September 14, 2018, photographer Jeff Kravitz.
BOTTOM LEFT: Album cover for *To Pimp a Butterfly*, Kendrick Lamar, Top Dawg Entertainment, 2015, artwork by Denis Rouvre and Roberto "Retone" Reyes. **BOTTOM RIGHT:** Kendrick Lamar accepts the 2018 Pulitzer Prize for Music for his album *DAMN.* from Columbia University President Lee Bollinger, New York City, NY, May 30, 2018, photographer Bebeto Matthews. **OVERLEAF:** Kahlil Joseph, *m.A.A.d.*, Museum of Contemporary Art, Los Angeles, CA, 2014. Double-screen projection, running time: 15 min. 26 sec.

NOTHIN' BUT KING SHIT

By 2010 LeBron James had lived up to, even exceeded, the enormous expectations placed on him while still in high school, when he had been declared "The Chosen One." Thus far his NBA career had been a resounding success. He was already considered by many to be the best player in the NBA, and with this he moved closer to the icon status held by Michael Jordan. LeBron's success represented Black excellence and was often celebrated in hip hop and wider culture—Kanye West once referred to himself as the "LeBron of rhyme," for instance—and being known as King James only solidified his position within the cultural royalty canon. It was also in 2010 that LeBron became an NBA free agent.

Having grown up in Akron, Ohio, the talented player was drafted by the local Cleveland Cavaliers, but when his contract was up, he had a choice to make: re-sign with his home team or move elsewhere. As prospective teams readied their pitches, speculation about what he would do ran rampant. Would LeBron re-up with Cleveland in the hopes of bringing a title to this city that was experiencing a longtime drought in sports championships, or would he seek out greener pastures elsewhere?

The way the NBA works is that players who become free agents are incentivized to re-sign with their current teams, and the amount of money that a player can sign for is more if they choose to remain with the same team. Considering this and his hometown connection, many assumed (and others hoped) that LeBron would stay in Cleveland. Yet he gave no clue as to what he would do. Free agency in the NBA is nothing new. It happens every year, and there is always interest in whether the best players will decide to stay or go. There was nothing routine about LeBron's next moves, though... As the debate reached a fever pitch, LeBron announced that he would broadcast his choice live on ESPN, in what was touted as "The Decision."

When the day came and reporter Jim Gray asked LeBron where he would be playing next season, he responded, "This fall... I'm going to take my talents to South Beach and join the Miami Heat." The sports world was shocked. This was completely unexpected. Of all the possibilities Miami was not high on the list of potential predictions, and the decision came with no small amount of disappointment for Cleveland fans. LeBron had rejected his home team in front of the nation, orchestrating

a situation that allowed him to team up with his friends Dwyane Wade and Chris Bosh in Miami. Though still a player in the league, LeBron leveraged his free agency in a manner normally associated with a general manager. It was a pure power move that left a bad taste in many people's mouths.

Outside of Miami the reaction to "The Decision" was generally negative. Some felt that broadcasting the event on television was an unnecessary spectacle, narcissistic to the core. Others, like the Cavaliers' owner Dan Gilbert, who wrote a nasty public letter criticizing LeBron, felt that it was unprofessional and served to throw Cleveland and his own teammates under the bus. A video of Cleveland fans burning LeBron's jersey circulated on social media; images of workers removing the player's iconic banner from the Cleveland arena made the rounds as well.

When LeBron and his new Miami Heat teammates threw an extravagant pep rally in South Florida a few days later, he openly bragged about how many titles the team would win. With this posturing LeBron's transformation from hero to villain seemed complete. Previously embraced for his success and his positive demeanor, he was now seen as an antagonist. When his new team, loaded with talent, reached the NBA Finals in his first season, they were defeated by the Dallas Mavericks. In hindsight this was the best thing that could have happened to LeBron: the loss had a humbling effect. He would later admit that playing the villain was not his style. LeBron returned to the court with a vengeance; learning from his misstep, he made it back to the Finals in 2012, and this time came out victorious, winning his first NBA title.

"The Decision" as a media spectacle drew a lot of criticism, yet looking back it is clear that this moment was symbolic of a new era for sports. LeBron wresting control of his professional future anticipated what many now refer to as the "player empowerment era." Certainly, not every athlete enjoyed the leverage that LeBron commanded, but soon many others would assert more agency and authority in the financial direction of their careers. Increasing salaries coupled with the expansion of social media also meant that athletes felt more emboldened to communicate directly with their fans, enabling them to write their own narratives and encouraging a power shift from the the teams, leagues, and media that had once controlled them.

OPPOSITE: Cleveland Cavaliers' LeBron James throws his chalk into the air at the Staples Center, Los Angeles, CA, December 25, 2009, photographer Wally Skalij. OVERLEAF BOTTOM: Police stand guard near a banner of LeBron James after the announcement that he will play for the Miami Heat next season, Cleveland, OH, July 8, 2010, photographer J.D. Pooley.

Normally, elligble players are encouraged to sign maximum-length contracts that will guarantee them the most money allowable. LeBron, however, has consistently signed shorter-length contracts, which offer less money but have allowed him more freedom to pick and choose his teams. This level of autonomy has carried through to his investments outside of the NBA as well: in 2020 he founded SpringHill, a Hollywood entertainment and production company. He has also had stakes in Beats by Dre, Dr. Dre and Jimmy Iovine's headphones enterprise later purchased by Apple; Major League Baseball's Boston Red Sox; and Liverpool Football Club, the English Premier League soccer team, among others. Such business decisions have helped to advance his career beyond basketball in ways that were not possible for previous generations. On the philanthropic side, LeBron also opened I Promise, a public school for low-income students in his hometown of Akron.

After winning two titles over four seasons with the Miami Heat, LeBron returned to Cleveland in 2014, where he took the team to four NBA Finals, winning the first title in the Cavaliers' history in 2016 and the first title for a Cleveland professional sports team since the 1960s.

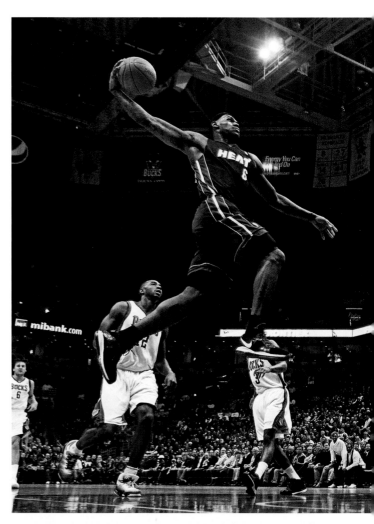

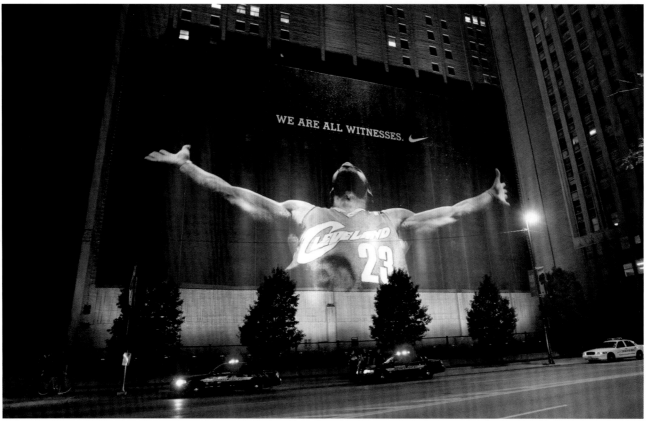

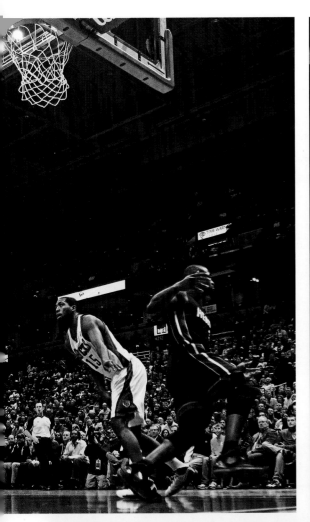

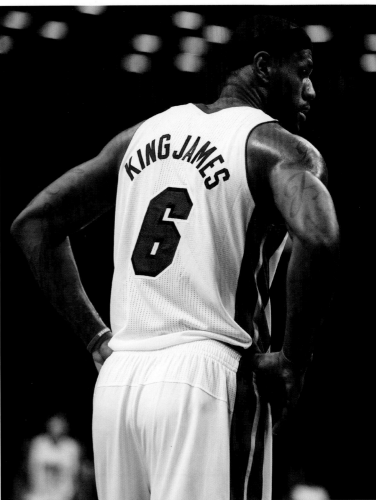

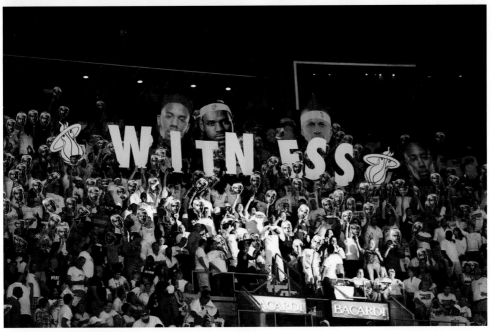

TOP CENTER: LeBron James (#6) of the Miami Heat goes up for a dunk against the Milwaukee Bucks at the Bradley Center, Milwaukee, WI, December 6, 2010, photographer Jonathan Daniel. **TOP RIGHT:** LeBron James is seen with his nickname, King James, on the back of his jersey during a game against the Brooklyn Nets at the Barclays Center, Brooklyn, NY, January 10, 2014, photographer Al Bello. **BOTTOM LEFT:** Fans hold a sign for the Miami Heat before a game against the Chicago Bulls during the 2013 NBA Playoffs at the American Airlines Arena, Miami, FL, May 6, 2013, photographer David Alvarez.

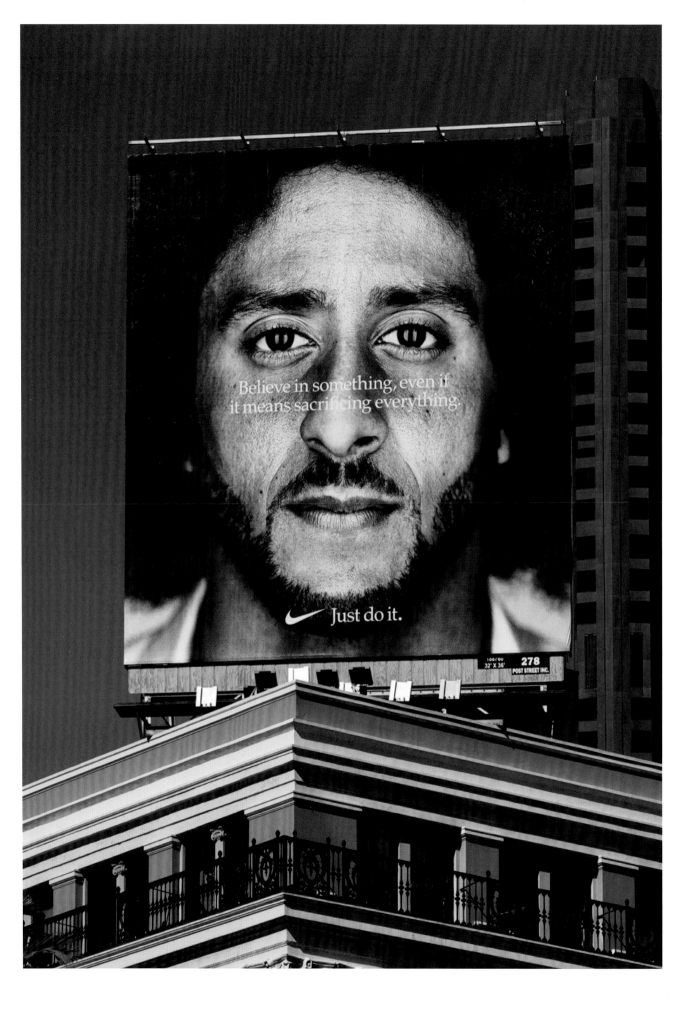

TAKE A KNEE

As Barack Obama moved toward winning his second term in 2012, a disturbing trend began to emerge across the country. In Sanford, Florida, Trayvon Martin, an unarmed seventeen-year-old Black kid, was followed and fatally shot by George Zimmerman. The shooter claimed that he had killed Martin in self-defense, and Florida's problematic stand-your-ground laws ultimately resulted in Zimmerman's acquittal at trail. At the time of his death, Martin was carrying a bag of candy and an iced tea, and was wearing a hoodie, which Zimmerman regarded as "suspicious behavior."

In David Fincher's 2010 film *The Social Network*, which recounts the story of Mark Zuckerberg and the rise of Facebook, Zuckerberg, portrayed by Jesse Eisenberg, wears a hoodie as a rebelliously informal and unconventional style statement that distinguished the young emerging tech mogul from the corporate "suits" of the previous business generation. Zuckerberg became a ridiculously wealthy man wearing a hoodie, while Martin ended up dead for no reason at all.

As attention around the case unfolded, LeBron James posted a photo on Twitter of himself and his Miami Heat teammates all wearing their hoodies with the hoods pulled up over their heads. The photo was hashtagged #WeAreTrayvon. Knowing that it would attract significant attention, LeBron used his platform to make a political statement and as a means of protest; other athletes would soon follow suit.

If only this were a one-time affair… instead, Martin's death seemed to initiate a fresh wave of killings of unarmed Black boys and men at the hands of the police. The death of Michael Brown in Ferguson, Missouri, Eric Garner in Staten Island, New York, and twelve-year-old Tamir Rice in Cleveland, Ohio, are but a few examples. Members of the St. Louis Rams entered the field with a "hands up, don't shoot" gesture to protest the killing of Brown, while players such as Derrick Rose, LeBron, Kobe Bryant, and others wore T-shirts during their pregame warm-ups stating, "I Can't Breathe," the last words Garner uttered before his tragic death.

Public response to the killings reached a new level when, at a 2016 preseason NFL game, San Francisco 49ers quarterback Colin Kaepernick remained sitting on the bench during the national anthem, as a way to indicate his opposition to racial injustice and police brutality. After speaking with a former Green Beret, Nate Boyer, Kaepernick decided that kneeling during the anthem would be a more effective gesture than staying seated. Soon he was joined by several of his teammates, and the action spread across the NFL, as well as to athletes in other sports, such as members of the WNBA's Indiana Fever and women's soccer star Megan Rapinoe. "Taking a knee" quickly became a hotly debated cultural issue, sparking fierce disputes on issues of free speech, patriotism, and honoring or disrespecting the flag—all of which coincided with the later stages of the divisive 2016 presidential campaign. Kaepernick would become a hero to some and a traitor to others.

When the 49ers informed Kaepernick in 2017 that they were going to release him from the team, he decided to opt out of his contract instead of being cut. This meant he was a free agent. No one knew at the time, not even Kaepernick, that he had taken his last NFL snap; he would not be picked up by another team, and his NFL career was effectively over. Many suggested that Kaepernick had been blackballed, punished for speaking out on racial issues and denied an opportunity to practice his craft based on the expression of his political beliefs.

Even though Kaepernick's career ended prematurely, he would soon become a much larger figure in the culture than he had ever been as an NFL player. He became an icon of protest who paid the price for his outspokenness, a martyr for the cause. The world of sports had not seen this type of activism in a long time. NFL commissioner Roger Goodell, the son of a former U.S. senator, who did not support Kaepernick originally, later came around to saying that he wished "[the league] had listened earlier" to the issues that Kaepernick was attempting to bring attention to. Kaepernick eventually reached a settlement in a collusion case against the NFL.

The activist spirit of Kaepernick and of all the other empowered athletes of his generation was stoked once more following the murder of George Floyd by Minneapolis police officer Derek Chauvin in 2020 during the Covid-19 pandemic. In a direct action movement that rapidly spread worldwide, protestors flooded the streets, where songs such as Kendrick Lamar's "Alright" (2015) and Lil Baby's "The Bigger Picture" (2020) served as anthems.

OPPOSITE: A billboard featuring Colin Kaepernick as part of Nike's "Dream Crazy" ad campaign, Union Square, San Francisco, CA, September 2018, photographer Robert Alexander.

After yet another police shooting—this time of Jacob Blake in Kenosha, Wisconsin—NBA teams collectively staged a one-game protest during the playoffs. Due to the pandemic the NBA had created a "bubble" with all of the playoff teams in Orlando, Florida, to avoid canceling the season. Many players had been reluctant to go into the bubble in the first place, suggesting that it would distract from the energy behind the marches sparked by Floyd's murder. As a gesture of solidarity, the NBA allowed players to wear various social-justice slogans printed on their jerseys, and it also emblazoned the phrase "Black Lives Matter" prominently on the court.

Nevertheless, the protest went ahead, initiated by the Milwaukee Bucks, the team from Wisconsin, where Blake had been shot, leading to the cancellation of that day's games. The protests con-tinued for the next three days. A conversation between Obama, National Basketball Players Association president Chris Paul, and LeBron ultimately convinced the players to resume the playoffs, but their walkout set a new precedent for protest within pro sports. The collective ability to cancel games, and by doing so directly impact the financial bottom line, was no longer an empty threat. This sent a clear message to all those paying atten-tion that the era of player empowerment was more than just a slogan, it was indeed a reality.

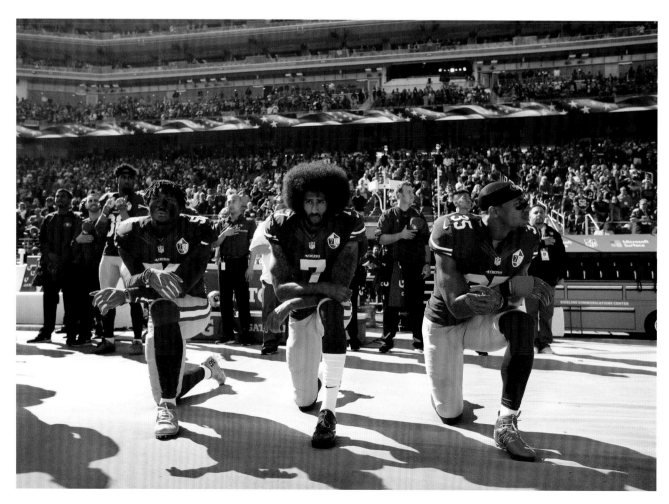

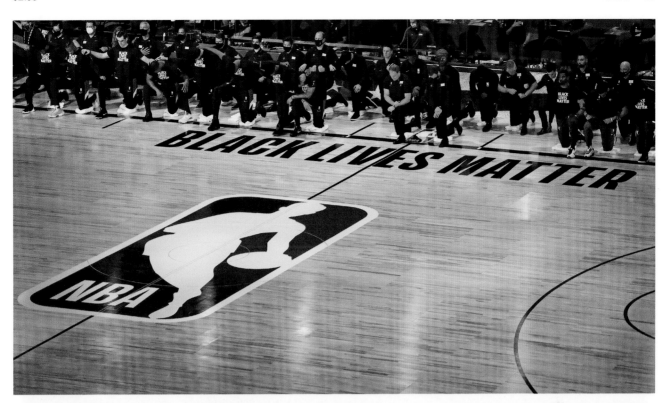

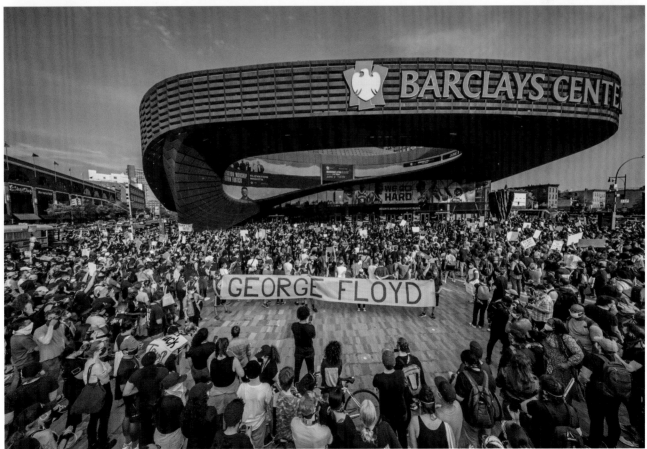

OPPOSITE TOP: Black Lives Matter graphics. **OPPOSITE BOTTOM:** (from left) Eli Harold, Colin Kaepernick, and Eric Reid of the San Francisco 49ers kneel for the national anthem prior to a game against the Tampa Bay Buccaneers at Levi's Stadium, Santa Clara, CA, October 23, 2016, photographer Michael Zagaris. **TOP:** NBA players take a knee during the national anthem before a game between the Memphis Grizzlies and the Portland Trail Blazers at the State Farm Field House, Walt Disney World, FL, August 15, 2020, photographer Kevin C. Cox. During the Covid-19 pandemic, players were placed in a "bubble" at the ESPN Wide World of Sports Complex so that the NBA playoffs could continue. **BOTTOM:** Protesters hold a giant banner reading "George Floyd" outside the Barclays Center, Brooklyn, NY, May 29, 2020, photographer Erik McGregor.

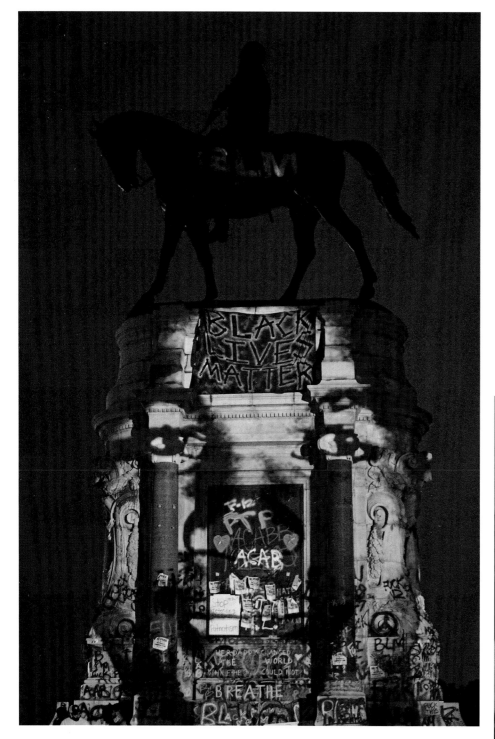

TOP LEFT: An image of Trayvon Martin, a seventeen-year-old Black teenager who was fatally shot in Florida by George Zimmerman, is projected onto the Robert E. Lee monument in Richmond, VA, July 1, 2020, photographer Astrid Riecken. Work crews had removed another statue nearby of Confederate general Stonewall Jackson just hours earlier. **BOTTOM CENTER:** Protestors chant "Say His Name, George Floyd" near a memorial for George Floyd at the intersection of Thirty-Eighth Street and Chicago Avenue, Minneapolis, MN, June 2, 2020, photographer Salwan Georges.

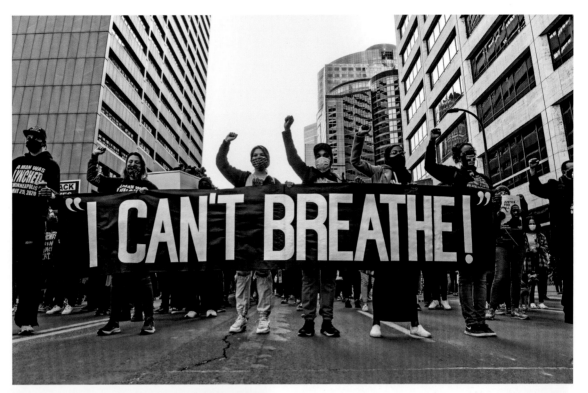

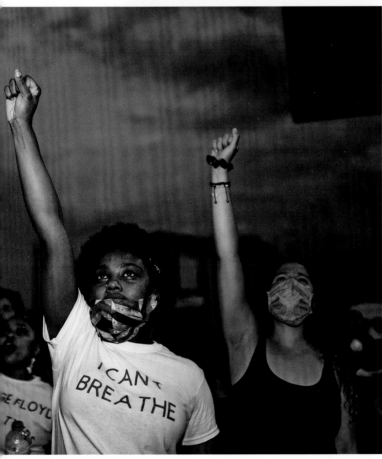

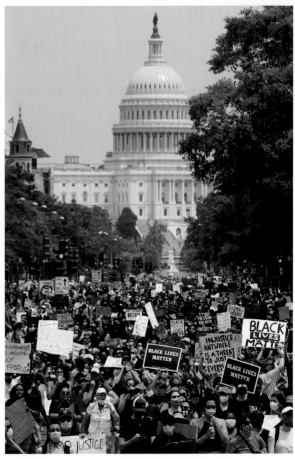

TOP RIGHT: Demonstrators hold a banner during the I Can't Breathe: Silent March for Justice in front of the Hennepin County Government Center, the day before the trial of former Minneapolis police officer Derek Chauvin, charged with murdering George Floyd, begins, Minneapolis, MN, March 7, 2021, photographer Chandan Khanna. **BOTTOM RIGHT:** Demonstrators march down Pennsylvania Avenue during a protest against police brutality and racism, Washington, D.C., June 6, 2020, photographer Drew Angerer.

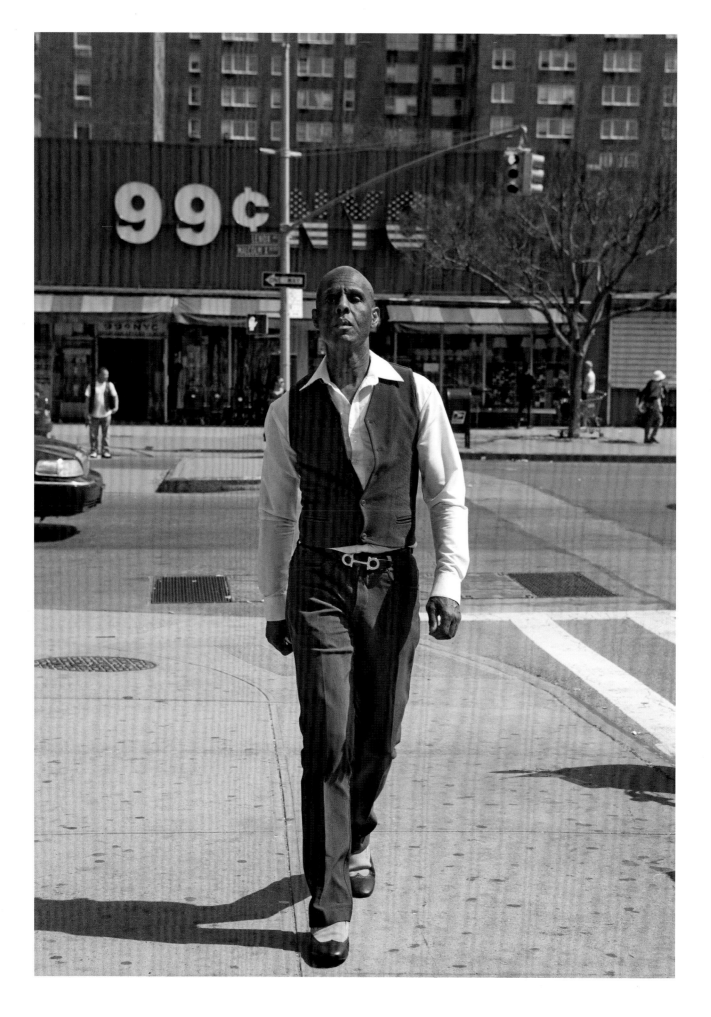

The DAPPER DAN REMIX

When the high-fashion brands that Dapper Dan had been "knocking up" took him to court, his business was sidelined and he was forced to close his Harlem boutique in 1992. Other than the occasional resurfacing of an old photo or a fleeting mention in a rap lyric, Dapper Dan tended on live on only in legend. A 2012 video on Jay-Z's Life+Times website and a 2013 feature in the *New Yorker* hinted at a comeback; however, an incident in 2017 would inadvertently throw him firmly back into the mix.

That year, as part of it's 2018 Cruise collection, Gucci unveiled a fur bomber jacket with large balloonlike sleeves featuring the brand's double-G logo. Conversations circulating on social media began pointing out that the jacket looked very similar to one that Dapper Dan designed for Olympic gold medalist Diane Dixon in 1989. Dapper Dan's jacket featured Louis Vuitton sleeves but was otherwise almost identical. Dixon posted a photo on Instagram featuring both jackets side-by-side, stating that Dapper Dan deserved credit for his original creation. Others online concurred. After mounting public pressure, Gucci admitted copying the original, although they called it an homage as opposed to outright appropriation. But more than this, Gucci reached out to Dapper Dan to begin a new collaboration.

The irony, of course, is that Dapper Dan had made his name remixing luxury brands to create his own unique designs, yet ultimately he was sued out of business. Now here was Gucci, a global fashion label, knocking off the knockoff, appropriating the appropriator. Much like sampling in hip hop, in which remixes of the remix are part of an endless cycle of creativity, Dapper Dan's inspirations and aspirations had come full circle. Debates about the distinction between homage and appropriation are ongoing across culture, but remixing in hip hop was, in many ways, a tool to help reverse the power dynamics. A local Harlem businessman with limited resources, Dapper Dan took what was available to him and used it to create something unique for his clients. Gucci, the historic Italian fashion house with a global reach and corporate strength behind it, recognized that its brand had been elevated among a now deeply influential hip hop audience. When confronted with its lapse in judgment, Gucci did the right thing, partnering with Dapper Dan and reviving his career in the process.

The 2017 Nielsen Year-End Music Report confirmed that, for the first time ever, hip hop was the most consumed genre in the United States. In its early years hip hop was especially aspirational, and the remixed designs of Dapper Dan played to these aspirations, conferring social status on people who had historically been denied it. By 2017 the roles had been reversed, and hip hop was now in a position to confer status on others. For Gucci, the culture represented a type of hipness, clout, and relevance that it could not achieve on its own. Instead of Gucci making hip hop cool, hip hop was making Gucci cool.

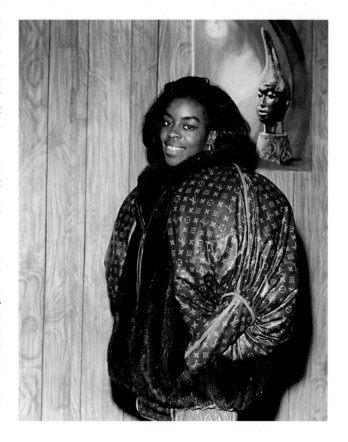

OPPOSITE: Dapper Dan in Harlem, New York City, NY, 2014, photographer Janette Beckman. **BOTTOM RIGHT:** Olympic gold medalist Diane Dixon wears a custom Dapper Dan Gucci jacket, New York City, NY, 1989, photographer unknown.

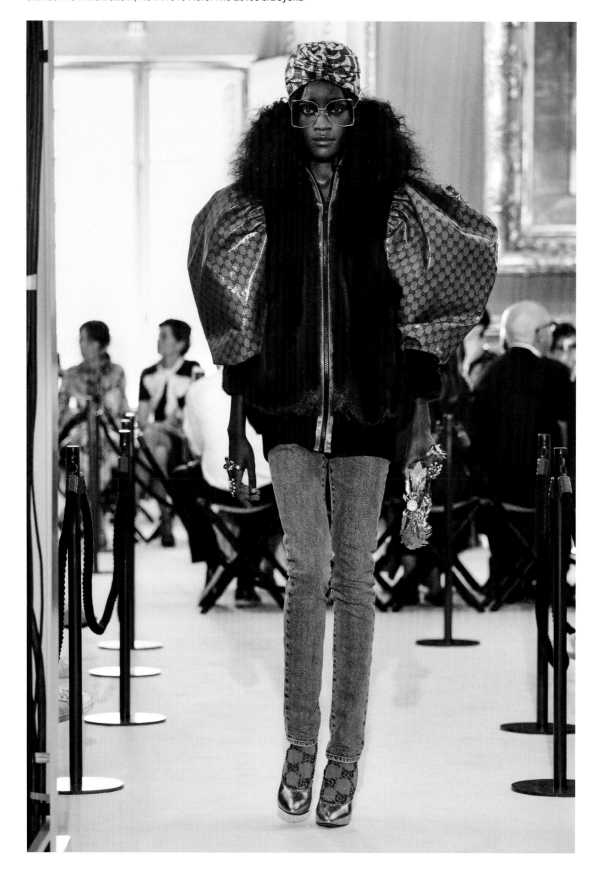

A model walks the runway at the Gucci Cruise 2018 show at Palazzo Pitti, Florence, Italy, May 29, 2017, photographer Pietro D'Aprano.

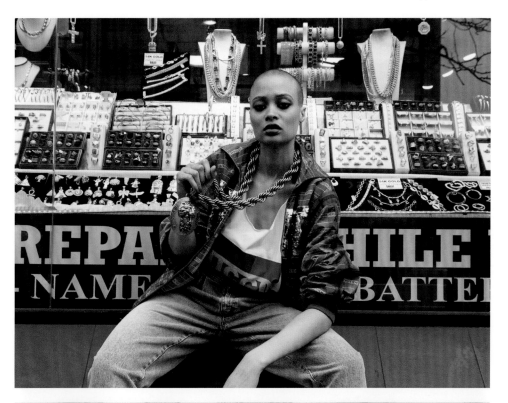

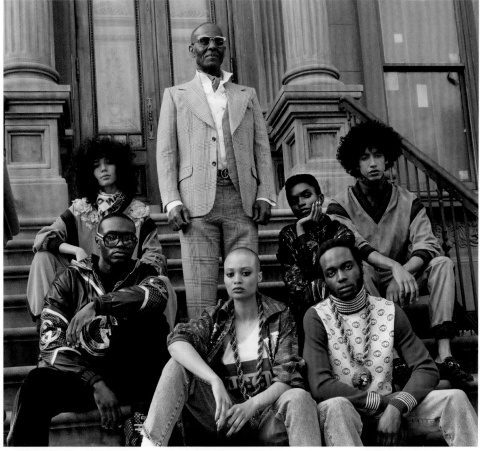

TOP: A model wears clothing from Dapper Dan's Gucci collection, Harlem, New York City, NY, 2018, photographer Janette Beckman.
BOTTOM: Dapper Dan with models wearing his Gucci collection on the stoop of his atelier, Harlem, New York City, NY, 2018, photographer Janette Beckman.

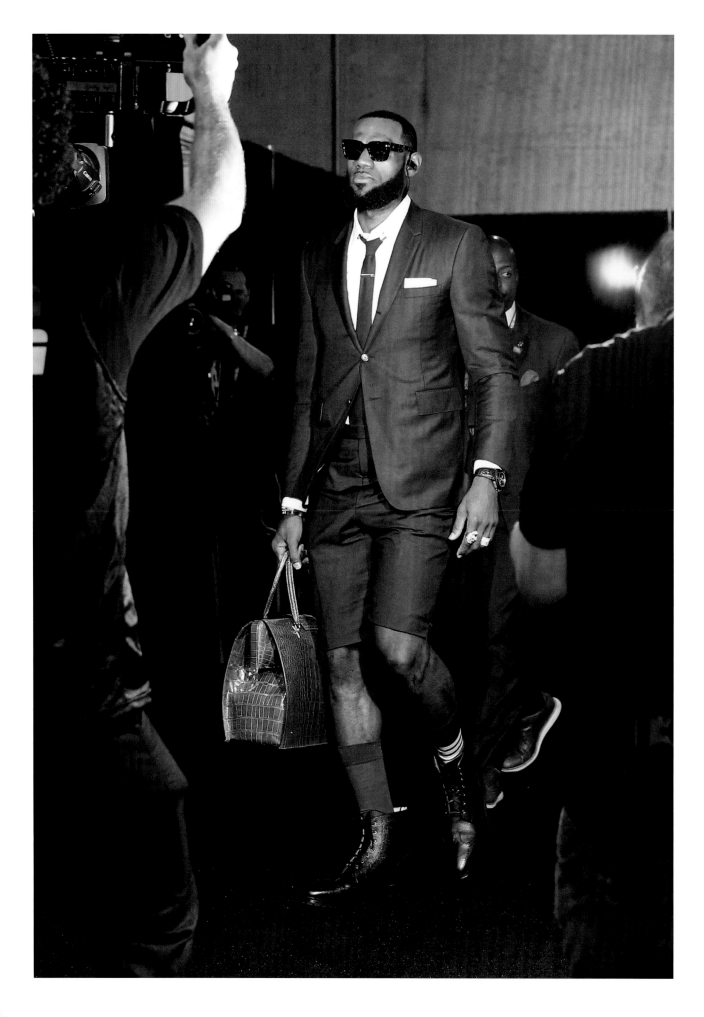

Came Through
drippin

As hip hop entered the 2010s, its relationship with high fashion had become mutually beneficial. No longer content simply to rap about wearing designer labels, hip hop now sat front row at events such as Paris Fashion Week, New York Fashion Week, and the Met Gala. Hip hop and high fashion also began prominent collaborations, with rappers featured on the runways, in advertisements, and also creating their own lines under established brands. Jay-Z could rap, "I don't pop molly / I rock Tom Ford" ("Tom Ford," 2013), while actually kickin' it with Tom Ford.

Where sneakers and streetwear were once the holy grail of hip hop attire, high-end items had now become rap-style staples. "You know I don't fuck with no rumors / Rockin' red bottoms like they Pumas," as Future said on "Thought It Was a Drought" (2015), suggesting that Christian Louboutins had replaced Pumas as his everyday shoe. Conversely, sneakers were increasingly being adopted by high fashion, resulting in some of the most sought-after collabs in sneaker history: Dior teamed up with Nike's Jordan Brand to release the Air Dior; Prada partnered with adidas to create the Prada for adidas Limited Edition Superstar shell toe; and both Gucci and Balenciaga launched a whole suite of sneaker remixes with adidas.

As the sting of former NBA commissioner David Stern's controversial "dress code" in the mid-2000s subsided and the role of social media and cultural influencers shifted, NBA players—much like their hip hop counterparts—would reemerge as fashion icons. Paparazzi-style shots of players arriving at the arena in their best off-court looks turned the walks to the locker room (or "tunnel walks") into a fashion runway. Judging the best "fits" of the day is now as commonplace as reporting on the best on-court performances, and many players employ stylists, along with physical trainers and nutritionists, as part of their team.

Perhaps the most inspirational story to surface amid these changing cultural currents was that of designer Virgil Abloh. Pictured at the beginning of his career in the now-iconic Tommy Ton photograph, alongside Kanye West and several other friends and creatives, at Paris Fashion Week in 2009, Abloh first trained as an architect and engineer before joining West's design team. (He would later be promoted to art director.) In this role he produced the artwork for *Watch the Throne* (2011), West and Jay-Z's collaborative album, which earned him a Grammy nomination.

He launched his first fashion label, Pyrex Vision, in 2012, swiftly followed by Off-White in 2013. Over the course of his career, Abloh engaged in an extraordinary number of collaborations with brands, ranging from Nike and Ikea to Mercedes-Maybach, and in 2018 he was tapped to head up the role of artistic director for menswear at Louis Vuitton. It was a historic moment: a *Vanity Fair* article identified Abloh as "the first Black man in Louis Vuitton's 164-year history to debut a menswear line."

One of Abloh's most well-known collaborations with Nike was known as "The Ten," which saw him remix ten classic Nike sneakers to create his own unique deconstructed and accessorized versions. In the contemporary world of sneaker culture, where the hottest designs are often released in limited quantities and their success trades on rarified status, it is not unusual for some to resell for thousands or even tens of thousands of dollars. Another Abloh–Nike creation, the Louis Vuitton × Nike Air Force 1, reportedly sold for more than $350,000 for a single pair; the same Sotheby's auction of two hundred pairs generated $25.3 million. Abloh's collaborations were often traded more like paintings than sneakers, underscoring both the artistic and high-fashion elements inherent in his work. Abloh very sadly passed away from cancer in 2021, but not before elevating his ambitious creative vision to places previously deemed off-limits. He accomplished a great deal in a short space of time, and in so doing pioneered connections across music, fashion, art, and design quite unlike any other cultural figure before him.

That is not to say, however, that there were not others before him. Laying the foundations for Abloh's rapid ascent, Pharrell Williams was in fact one of the first in the industry to expand the cultural boundaries of hip hop. He rose to prominence in the early 2000s as a music producer, as part of the Neptunes, and as a performer in the group N.E.R.D., alongside his creative partner Chad Hugo. Whereas Hugo largely worked behind the scenes, Pharrell became increasingly visible as a cultural innovator, soon establishing the fashion brands Billionaire Boys Club and ICECREAM with Nigo, founder of the cult clothing brand A Bathing Ape. Other cross-cultural collaborators included the artists Takashi Murakami and KAWS, as well as the world-renowned architect Zaha Hadid. Somewhat fitting to the legacy, in early 2023 it was announced that Pharrell would succeed Abloh as the new men's creative director at Louis Vuitton.

OPPOSITE: LeBron James of the Cleveland Cavaliers arrives for game one of the NBA Finals at Oracle Arena, Oakland, CA, May 31, 2018.

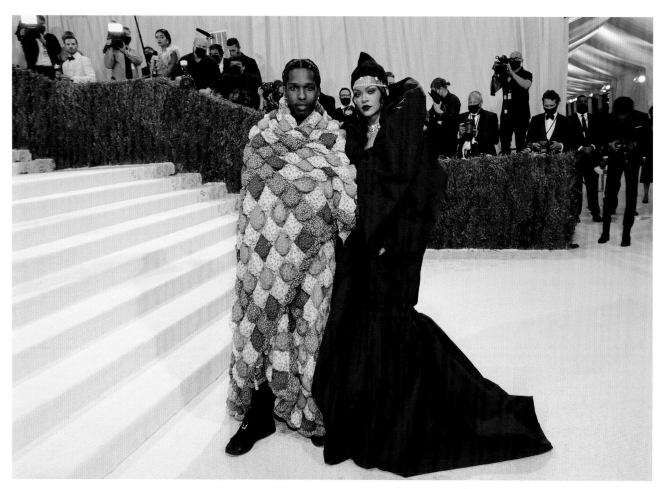

TOP AND BOTTOM LEFT: A$AP Rocky and Rihanna, and Frank Ocean at the Met Gala, "In America: A Lexicon of Fashion," Metropolitan Museum of Art, New York City, NY, September 13, 2021, photographer Mike Coppola. **BOTTOM RIGHT:** (from left) Offset, Quavo, and Takeoff of Migos at the Met Gala, "Heavenly Bodies: Fashion and the Catholic Imagination," Metropolitan Museum of Art, New York City, NY, May 7, 2018, photographers Sean Zanni and Patrick McMullan.

TOP: (from left) Nicki Minaj, Anna Wintour, and Grace Coddington (far right) at the Carolina Herrera Spring 2012 fashion show at the Lincoln Center Theater, New York City, NY, September 12, 2011, photographer Mike Coppola. **BOTTOM LEFT:** James Harden of the Philadelphia 76ers arrives at Madison Square Garden, New York City, NY, December 25, 2022, photographer Nathaniel S. Butler. **BOTTOM CENTER:** P.J. Tucker of the Houston Rockets arrives at Madison Square Garden, New York City, NY, February 13, 2021, photographer Nathaniel S. Butler. **BOTTOM RIGHT:** Dennis Schroder of the Oklahoma City Thunder arrives at the Chesapeake Energy Arena, Boston, MA, April 9, 2019, photographer Zach Beeker.

TOP LEFT: Pharrell Williams at the Louis Vuitton headquarters, photographed for the cover of *New York Times*, Paris, June 18, 2023, photographer Sam Hellman. **TOP RIGHT:** Pharrell Williams photographed for *Harper's Bazaar Korea* on the debut of his Chanel Pharrell Collection, 2019, photographer Frederike Helwig. **BOTTOM LEFT:** adidas AW22 Samba Capsule collection by Pharrell campaign photograph, 2022.
BOTTOM CENTER: Project MAYBACH, a collaboration between Virgil Abloh and Mercedes-Maybach that reinterpreted design and luxury, 2021–22.

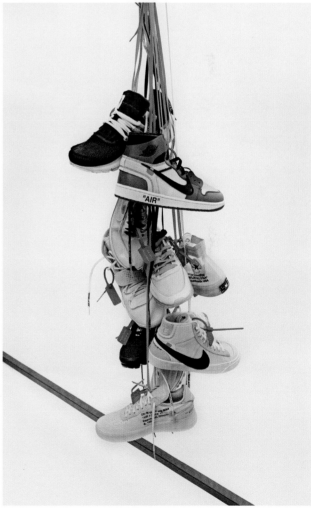

TOP LEFT: Kendrick Lamar headlines the Pyramid Stage at Glastonbury Festival, Worthy Farm, Pilton, England, June 26, 2022, photographer Joseph Okpako. **TOP RIGHT:** Nike × Louis Vuitton Air Force 1 and Pilot Case, designed by Virgil Abloh, 2022. **BOTTOM RIGHT:** The Ten: Nike × Virgil Abloh Collection campaign image, 2017.

TOP: Virgil Abloh at the Louis Vuitton headquarters, Paris, 2018, photographer Alex Majoli. **BOTTOM:** Virgil Abloh at the Louis Vuitton headquarters the day before his Spring/Summer 2019 fashion show, Paris, 2018, photographer Alex Majoli.

<u>TOP:</u> Virgil Abloh on the runway at the close of his debut Louis Vuitton Spring/Summer 2019 fashion show, Paris Fashion Week, June 21, 2018, photographer Swan Gallet. **<u>BOTTOM:</u>** First look before Virgil Abloh's debut Louis Vuitton Spring/Summer 2019 fashion show, Paris, 2018, photographer Alex Majoli.

ICE CUBE CELEBRATES THE EAMES

CELEBRATE THE ERA THAT CONTINUES TO INSPIRE THE WORLD: ART IN L.A. 1945–1980

OCT 2011 TO APR 2012
pacificstandardtime.org

PACIFIC
STANDARD
TIME

PICASSO *baby*

In the 1980s Run-D.M.C. made "My Adidas"; in the early 2000s Nelly released "Air Force Ones," a song celebrating Nike's famous basketball sneakers turned streetwear staple; by 2013, Jay-Z was spittin' bars about his art collection. There is perhaps no other song in hip hop that is more reflective of its evolution from the streets to the stratosphere than "Picasso Baby" (2013). Rapping over a Timbaland-produced Adrian Younge sample, Jay name-checks not only Pablo Picasso but also Mark Rothko, Jeff Koons, Jean-Michel Basquiat, and Andy Warhol, along with the Louvre art gallery in Paris and London's Tate Modern. The video for the song, titled *Picasso Baby: A Performance Art Film*, features Marina Abramović and drew influence from her famed 2010 performance at the Museum of Modern Art, New York, *The Artist Is Present*.

Hip hop's relationship with postwar and contemporary art really took off during the 2010s. The Art Basel art fair, for instance, joined the ranks of international fashion weeks and the Met Gala as another prominent event on the hip hop social itinerary. One of the most prominent American artists of the 2000s was Kara Walker, whose 2014 installation, *A Subtlety, or the Marvelous Sugar Baby*, a giant, sugar-coated Black female figure wearing nothing but an Aunt Jemima–style headscarf, placed on display inside a former Domino Sugar Factory in Brooklyn, attracted immense interest. Walker was already well-known for her panoramic wall installations depicting highly sexualized, at times brutal, and often darkly comedic images of debauchery, recalling the slave era in the Deep South. Her work frequently inverts the myths of Southern gentility, instead using provocatively satirical representations that foreground the violent sexual repression so endemic to slavery. This historical remixing anticipated the kind of transgressive representation that later emerged in cinematic form with Quentin Tarantino's Blaxploitation spaghetti western and slave revenge fantasy *Django Unchained* (2012). Tarantino's films have longed sampled scenes, dialogue, and themes from genres previously considered dismissable, such as Blaxploitation and martial arts. While promoting *Django Unchained* on the *Charlie Rose* talk show in 2012, Tarantino also cited the influence of hip hop on his style of filmmaking: "There is, for lack of a better word, a hip hop aesthetic of taking something that already exists. Taking what you like from what already exists and putting it into your own work. And by the way you do it, the way you frame it,

creating something that didn't exist before. It has taken a while for that to be respected, all right. But that's always where I've been coming from."

Other such explorations of art and identity would follow, including Solange, who took over the Guggenheim Museum in New York for her performance-art project *An Ode To* (2017), which explored themes of Black representation and social history from her album *A Seat at the Table* (2016). Ice Cube, a former architecture student, could also be seen extoling the virtues of designer and architect duo Charles and Ray Eames in "Ice Cube Celebrates the Eames," a promotional campaign, which included a film of him touring the famous Eames House in the Pacific Palisades neighborhood of Los Angeles and was made for the citywide exhibition and public programming event *Pacific Standard Time: Art in L.A. 1945–1980* (2008–12).

While Basquiat has long held name recognition in hip hop circles, his *Untitled* skull painting from 1982 sold for a record $110.5 million to Yusaku Maezawa during a Sotheby's auction in 2017. Then, in 2021, Beyoncé and Jay-Z featured alongside the rarely seen Basquiat painting *Equals Pi* (1982) in a Tiffany & Co. ad campaign entitled "About Love," underscoring the artist's continued prominence so many years after his untimely death in 1988. Sean "Diddy" Combs turned out to be the mystery buyer of Kerry James Marshall's *Past Times* (1997) in 2019; the purchase of $21.1 million represented the highest price ever paid for an artwork by a living Black artist. And producer Kasseem "Swizz Beatz" Dean and his wife, Alicia Keys, possess what is known as the Dean Collection of art, featuring an impressive array of prominent Black artists, including Kehinde Wiley, Mickalene Thomas, Henry Taylor, and Nina Chanel Abney, among many others. Abney also created the cover art for Meek Mill's 2021 album *Expensive Pain*, while Drake's *Certified Lover Boy*, released the same year, features the work of Damien Hirst.

TOP LEFT: Installation view of Kara Walker, *A Subtlety, or the Marvelous Sugar Baby*, a project of Creative Time, Domino Sugar Refinery, Brooklyn, NY, 2014. Polystyrene foam and sugar, approx. 35½ × 26 × 75½ ft (10.8 × 7.9 × 23 m). **CENTER LEFT:** Installation view of Kara Walker, *Slavery! Slavery! Presenting a GRAND and LIFELIKE Panoramic Journey into Picturesque Southern Slavery*, 1997, Hammer Museum, Los Angeles, CA, 2008. Cut paper and adhesive on wall, 11 × 85 ft (3.4 × 25.9 m). **BOTTOM LEFT:** Nina Chanel Abney, *Untitled*, 2021. Collage on panel, 58 × 59 in (147.3 × 149.9 cm); album artwork for *Expensive Pain*, Meek Mill, Atlantic Records/Maybach Music Group, 2021.

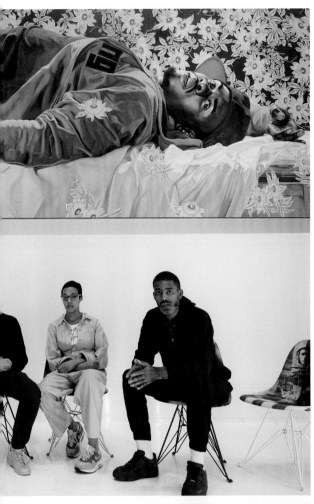

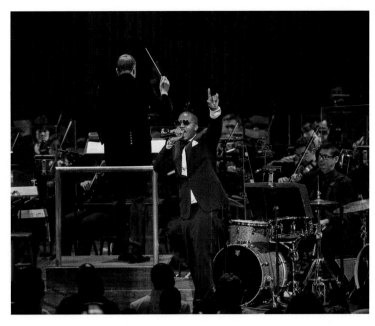

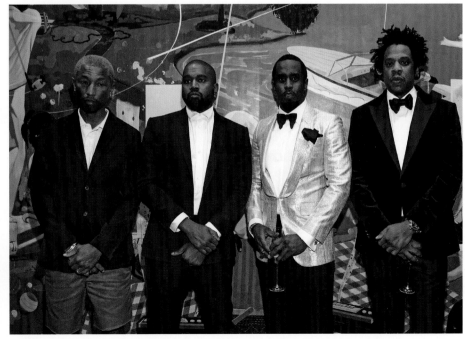

TOP CENTER: Kasseem Dean, aka Swizz Beatz (second from left), at home with (from left) Nina Chanel Abney, KAWS, Jordan Casteel, and Cy Gavin, Englewood, NJ, 2019, photographer Jason Schmidt. Above them is Kehinde Wiley's *Femme Piquée par un Serpent*, 2008.
TOP RIGHT: Nas performs *Illmatic* with the National Symphony Orchestra at the Kennedy Center, Washington, D.C., March 28, 2014, photographer Kyle Gustafson. **BOTTOM CENTER:** Jay-Z and Marina Abramovic during the filming of "Picasso Baby," Pace Gallery, New York City, NY, 2013, photographer Yana Paskova. **BOTTOM RIGHT:** (from left) Pharrell Williams, Kanye West, Sean "Diddy" Combs, and Jay-Z at Combs's fiftieth birthday party, Los Angeles, CA, December 14, 2019, photographer Kevin Mazur. Behind them is Kerry James Marshall's *Past Times*, 1997.

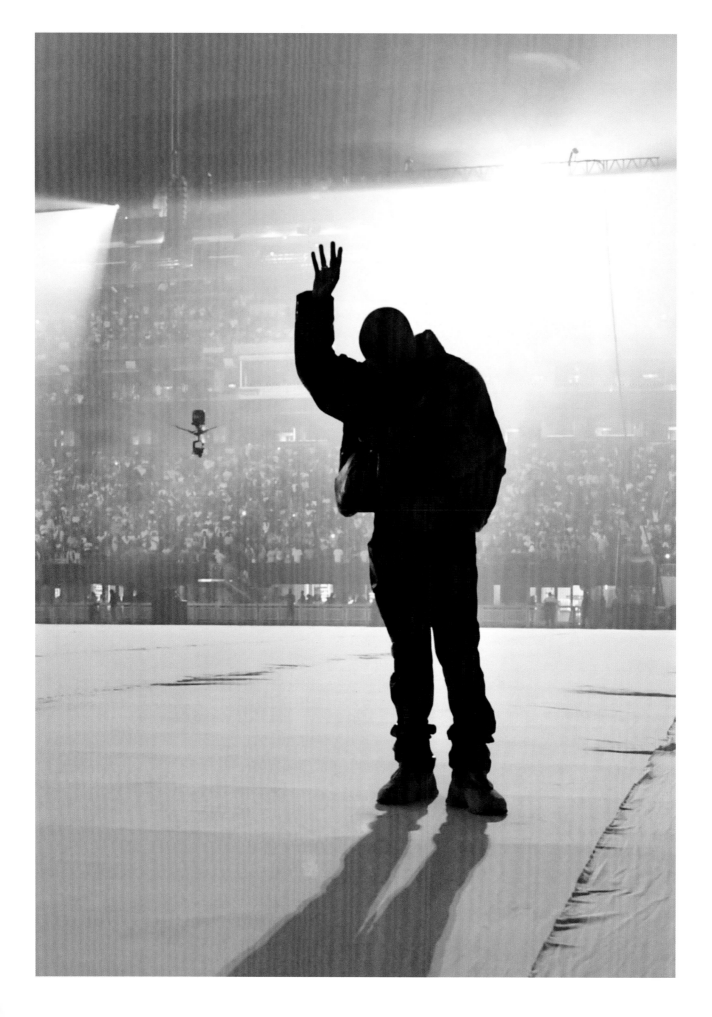

ꟿHEN IT ALL FALLS DOꟿN

As hip hop entered its fifth decade, by which point the triumph of a cultural movement had transformed the United States and spread its influence globally, it was inevitable that someone might very well attempt to "fuck up the game." Sadly, it turned out to be someone who had initially done so much to make connections across hip hop, high fashion, and contemporary art, but who would become increasingly problematic in the worst possible ways. The individual in question is, of course, none other than Kanye West. Once the leading curator of hip hop lifestyle culture, with album covers by George Condo, artistic collaborations with Vanessa Beecroft, and forays into fashion with Balenciaga, Louis Vuitton, and his own especially popular Yeezy line with adidas, the former "College Dropout" publicly outed himself as a bigoted antagonist and a full-blown MAGA (Make America Great Again) supporter. Not long after the contentious 2016 presidential election when Donald Trump rose to power, West, speaking from the concert stage, stated that he did not vote, but if he had he would have "voted on Trump." Not long after, West visited Trump in Trump Tower in a highly publicized meeting reminiscent of Sammy Davis Jr.'s ill-fated embrace of Richard Nixon in 1972.

Over time West became increasingly engaged in the MAGA campaign, even wearing the infamous red cap emblazoned with the slogan during an embarrassingly obsequious visit to the White House for another meeting with Trump in 2018. West stated that wearing the MAGA cap made him "feel like Superman." A string of ridiculous comments, perhaps epitomized by his "slavery was a choice" statement during a 2018 TMZ interview, seemed to continue nonstop, but without the same humor, cleverness, and snarky sarcasm that had once defined his lyrical output as a rapper. By 2022 West appeared to be firmly on a path to self-destruction; during his Yeezy fashion show at Paris Fashion Week, he wore a "White Lives Matter" T-shirt, a slogan widely identified as hate speech. His litany of anti-Black statements had become commonplace, but soon he added a series of anti-Semitic remarks to his repertoire, intensifying his public campaign of bigotry. He also made a point of palling around with other members of the MAGA universe, such as white nationalist and Holocaust denier Nick Fuentes, who dined with West and Trump at Trump's Mar-a-Lago resort in Palm Beach, Florida, in November 2022.

To say that West is a disappointment is an understatement. He is far worse. In his 2005 song "Crack Music," a scathing critique of racism and the War on Drugs, West posed this provocative question: "How we stop the Black Panthers? / Ronald Reagan cooked up an answer." The line references the Panthers' legally armed appearance at the California State Capitol to protest a bill that would make carrying loaded firearms in public illegal, while Reagan, who was governor at the time, was on Capitol grounds. Though today Republicans often oppose any form of gun control, the bill was designed to work in opposition to the Panthers and their right to be armed. West's lyrics also refer to Reagan's open hostility toward the Black Panthers and the Black Power movement in general. Yet, just a decade later, West had made a complete turnaround, with his professed MAGA beliefs not only contradicting his previous lyrics but also completely selling out his former cultural allegiances. While the worlds of art, fashion, and music are far from perfect, at their best they promote creativity, self-expression, and humanism. West's Black self-hatred and his anti-Semitism would eventually make him a pariah, as adidas, Balenciaga, and others began disassociating themselves from him. West's creative endeavors seemed to be a secondary consideration to the reprehensible political spectacle that he had become.

It should probably be pointed out that for many years before Trump became a politician running for office, rappers namechecked him in their songs. Trump was considered a symbol of wealth and power in the United States and rappers often used his name in an aspirational context. The same could not be said for YG and Nipsey Hussle and their 2016 song "FDT" ("Fuck Donald Trump") or for New York native Hakeem Jeffries—elected as the minority leader of the U.S. House of Representatives for the Democratic Party in 2023—when he quoted Biggie Smalls, "And if you don't know, now you know!" ("Juicy," 1994) in a rebuttal to the facetious question, "Why are we here?" from one of Trump's lawyers during the former president's first impeachment trial in 2020.

Other rappers besides West, such as Lil Wayne and 50 Cent, also supported Trump's 2020 presidential candidacy. While it is obviously an individual's prerogative to vote for whom they choose, there has always been an abiding sense of what one might call cultural libertarianism that has circulated through hip

hop spaces. Though not without its shortcomings, hip hop is, at its roots, a progressive and empowering space. While West's drift to the dark side seemed very much in opposition to these moral underpinnings, it could also be considered emblematic of what happens when success, visibility, wealth, narcissism, entitlement, and an abiding need for continuous attention take over. To quote from his own lyrics, perhaps this is what happens "when it all falls down"?

In looking at the troubled case of West, one might recall the chess prodigy Bobby Fischer, who popularized chess in the United States when he defeated his Russian opponent Boris Spassky in the 1972 World Chess Championship at the height of the Cold War. Fischer was considered a hero in his triumph over the Soviet Union, but over time his eccentricities and virulent anti-Semitism came to tarnish his once-celebrated status. This all brings us to an age-old question: Is it possible to separate the art from the artist?

What does one do with all the great music that West created? The designs on some of those Yeezy sneakers were certainly eye-catching. Does one sell them, stop wearing them, throw them away, or perhaps hand them out on skid row as West had someone do with his White Lives Matter T-shirts? The advances he made in the culture were significant, but his behavior was indefensible. So can we separate West from his own uncomfortable history of antagonistic bigotry, offensive and hateful statements, and his overall toxic identity? The answer is no, we cannot.

West represents the good, the bad, and the ugly of the culture, in the same way that he represents the good, the bad, and the ugly of the United States. Ultimately, though, he represents himself. Hip hop has never risen, fallen, or been defined by the actions of one individual. The culture is not monolithic. Art and culture are created by humans and humans are inherently flawed, though some more extensively than others. This does not change because West decided to take a swim in such a fetid pool. Here, one is reminded again of his own lyrics from "Runaway" (2010): "Let's have a toast for the douchebags / Let's have a toast for the assholes / Let's have a toast for the scumbags." It is fair to assume that he was always simply toasting himself.

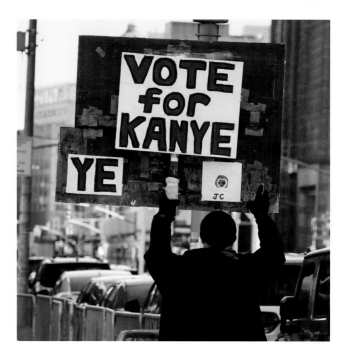

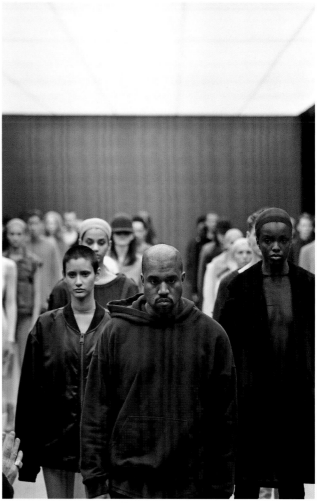

TOP RIGHT: A Kanye West for president supporter holds a sign outside of the Manhattan District Attorney's Office, New York City, NY, March 27, 2023, photographer Luiz C. Ribeiro. **BOTTOM RIGHT:** Kanye West on the runway at the adidas Originals × Kanye West Yeezy Season 1 fashion show at Skylight Clarkson Square during New York Fashion Week, NY, February 12, 2015, photographer Theo Wargo.

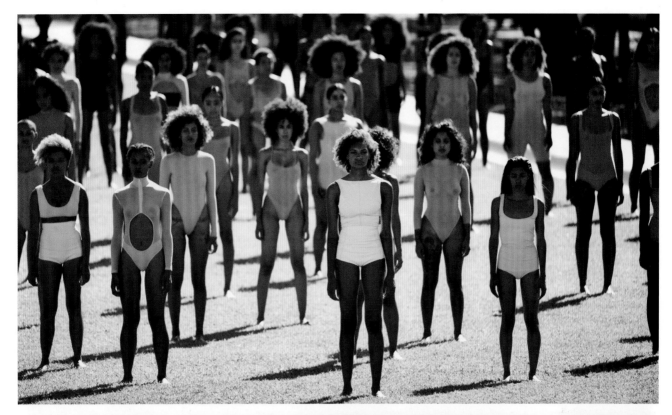

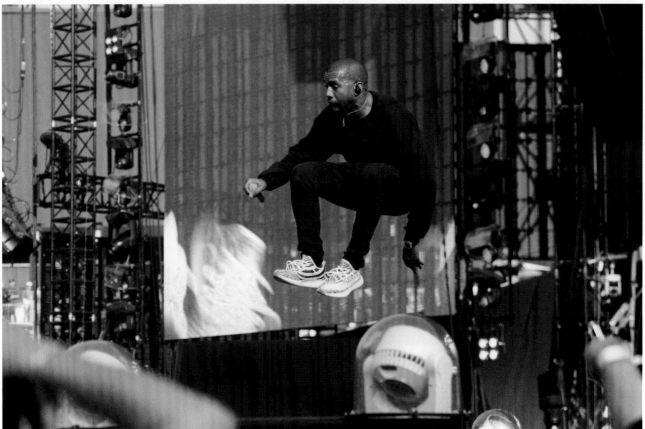

TOP: Models pose on the runway at the Kanye West Yeezy Season 4 fashion show, New York City, NY, September 7, 2016, photographer Bryan Bedder. **BOTTOM:** Kanye West performs in a surprise appearance at "Chance the Rapper's Magnificent Coloring Day" event, Chicago, IL, September 24, 2016, photographer Cindy Barrymore.

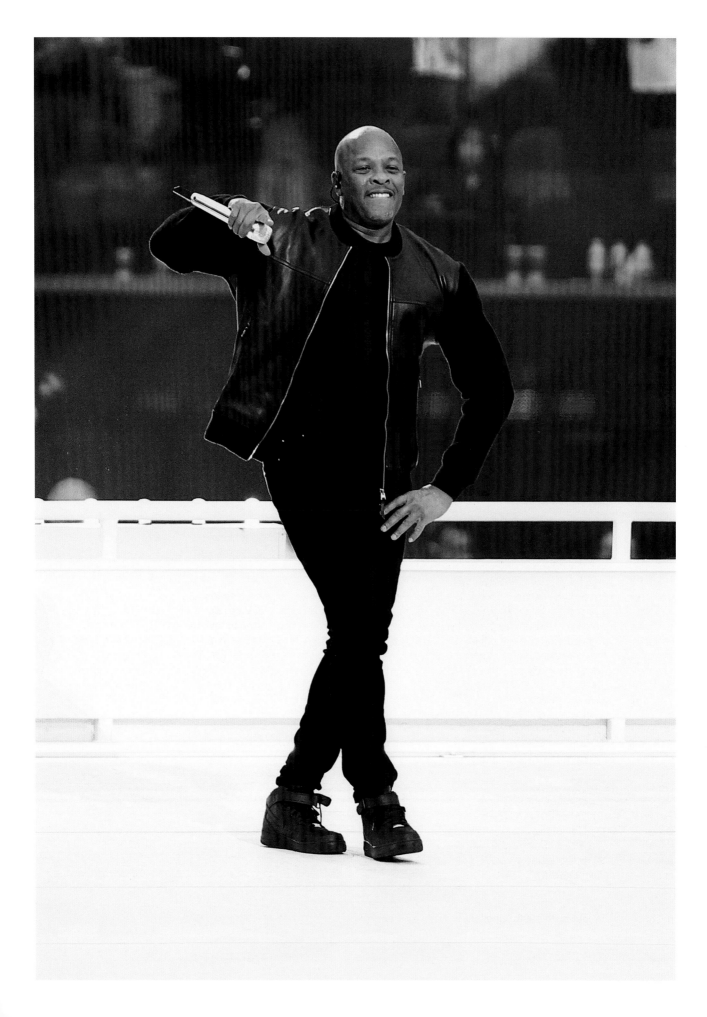

MC DROP

At the end of Eddie Murphy's stand-up performance *Delirious* (1983), the comedian famously drops the microphone. He would do so again as the character Randy Watson, aka Sexual Chocolate, in his film *Coming to America* (1988). The so-called mic drop would become a metaphor in hip hop. An emphatic gesture as one exits the stage, it communicates that there is nothing more to say. In other words, "I will exit the stage with a bang, not a whimper. My performance speaks for itself. I'm out!"

Hip hop's mic drop, relative to this story, would occur during the halftime show of Super Bowl LVI at Inglewood, California's Sofi Stadium on February 13, 2022. Led by Dr. Dre, and also featuring Snoop Dogg, Mary J. Blige, Eminem, 50 Cent, and Kendrick Lamar, the landmark performance was the first in Super Bowl history to focus exclusively on hip hop.

Dre and Snoop represent Compton and Long Beach, cities that make up part of the greater Los Angeles area. This duo and their work on Dr. Dre's *The Chronic* (1992), released in the aftermath of the Rodney King riots, expanded hip hop's reach indefinitely, while generating all sorts of controversy in the process, including attempts by various outside forces to censor the work and involving frequent encounters with law enforcement. The fact that the performance took place in Inglewood, another city in greater Los Angeles—and one that Dre famously shouts out, "Inglewood, always up to no good," in the Tupac track "California Love" (1995)—was also hugely significant. It underscored not only the importance of these homegrown icons of the industry but also the fundamental role that LA has played in the history of hip hop culture. Along with "California Love," Dre and Snoop also performed "The Next Episode" and "Still D.R.E." (both from the album *2001*, 1999), which closed the show.

Other Dr. Dre–produced classics performed included Mary J. Blige's "No More Drama" (2001) and "Family Affair" (2001), Eminem's "Forgot About Dre" (2000), and 50 Cent's big hit "In Da Club" (2003). Compton's own Kendrick Lamar represented the new generation, performing his songs "m.A.A.d. city" (2012) and "Alright" (2015) alongside a team of suited dancers draped in sashes reading "Dre Day."

A lot had changed since the last time a Super Bowl had been hosted in Los Angeles. In 1993 Super Bowl XXVII was played in Pasadena's famous Rose Bowl stadium; the halftime show that day featured the King of Pop himself, Michael Jackson, and his performance signaled the beginning of a new approach for America's most watched television program of the year.

A year earlier, *In Livin' Color*, the popular hip hop–influenced sketch-comedy show, decided to engage in counterprogramming. Super Bowl halftime shows were generally quite forgettable during this time, with Elvis impersonators, college marching bands, ice skaters, and aging comedians among the types of unexciting performers who might grace the stage. In the hopes of encouraging people away from the halftime show, *In Livin' Color* began promoting the fact that their show would air at the same time, relying on some of their most popular skits to accomplish their goals. It worked; enough people turned away from the Super Bowl, generating ample discussion and some serious competition. The next year, the Super Bowl, having learned its lesson, booked Jackson, setting a new standard for halftime shows in the process.

While Jackson was the most popular entertainer alive when he performed at the Super Bowl, his music did not represent the cutting edge, nor was it even necessarily hip at this point. He was extremely popular in mainstream entertainment, but it was the music of Dr. Dre's *The Chronic* that represented hipness, controversy, and the cultural zeitgeist. There was no way in hell, however, that Dr. Dre and Snoop Dogg would be afforded the opportunity to perform on the Super Bowl stage in 1993. Gangsta rap, with its direct connection to the streets, was simply too controversial to be allowed to participate in such a mainstream cultural space.

By the mid-1990s the NFL no longer had a team in the LA area, the second-largest media market in the country; the Los Angeles Raiders had relocated back to Oakland and the Los Angeles Rams had moved to St. Louis. The league didn't return to the City of Angels until 2016, when the Rams moved back and the Chargers relocated from San Diego. This meant that the city could host Super Bowls again. Perhaps the most significant development in the Super Bowl's cultural shift happened in 2019, when the NFL partnered with Jay-Z's Roc Nation to act as a consultant for all future halftime shows, on the choice of entertainment and on issues of social justice. Bringing us to 2022…

OPPOSITE: Dr. Dre performs during the Super Bowl LVI halftime show at the SoFi Stadium, Inglewood, CA, February 13, 2022, photographer Ronald Martinez.

So what changed between 1993 and 2022? For one, the storied history of the legendary group that introduced Dr. Dre to the public, N.W.A., had recently been told through F. Gary Gray's feature film biopic *Straight Outta Compton* (2015); a year earlier Apple had acquired Beats by Dre, the headphone company established by Dr. Dre and the head of Interscope Records, Jimmy Iovine; and in 2013 Dr. Dre and Iovine successfully funded the opening of the University of Southern California's (USC) Iovine and Young Academy, devoted to arts, technology, and the business of innovation. For a hip hop legend such as Dr. Dre to endow an academy at a prestigious university like USC was not something anyone would have predicted back in the 1990s. By the 2020s Dre, Snoop, and the culture that they represented were no longer thought of in the same way: their popularity had eclipsed their notoriety, and the music could even be described as nostalgic.

On Super Bowl Sunday in 2022, the impressive Es Devlin set design stood out: a composite Compton street featuring various landmarks from the city that Dre had helped to put on the map during his N.W.A. days. Snoop performed in a blue and yellow outfit with a bandana motif, attire often associated with LA gang culture. Eminem took a knee while performing, referencing the contentious gesture that led to Colin Kaepernick's premature exit from the league a few years earlier. Considering the image-conscious nature of the NFL and its desire to avoid controversy at all costs during the halftime show, the 2022 performance was without a doubt the most edgy representation ever experienced in that space. Yet it went off without a hitch in about as mainstream a fashion as one could expect.

So, when Jay-Z suggested that hip hop did not cross over, instead it "brought the suburbs to the hood" ("Come and Get Me," 1999), that's exactly what this halftime performance did, and what the culture had done steadily over five decades—it brought the suburbs to the hood. In other words, it brought mainstream America into contact with Black culture in such a way that it would transform both entities. The 2022 Super Bowl halftime performance was a triumph and indicated how much has changed over time; what was once marginal now sits firmly in the center of American social, cultural, and political influence. From its emergence in the 1970s to celebrating its fifty-year anniversary in 2023, hip hop had not only conquered the United States, it had effectively created a world of its own. And with this, there is only one thing left to do, and that, of course, is to drop the mic!

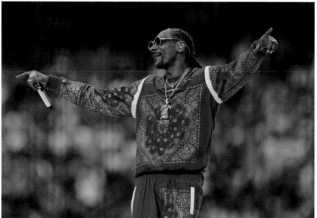

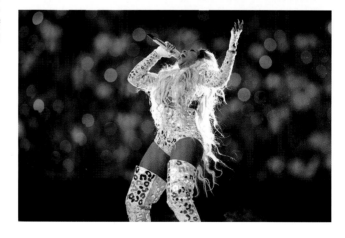

TOP CENTER: Dr. Dre performs during the Super Bowl LVI halftime show at the SoFi Stadium, Inglewood, CA, February 13, 2022, design and creative direction Es Devlin. **CENTER AND BOTTOM:** Snoop Dogg and Mary J. Blige perform during the Super Bowl LVI halftime show at the SoFi Stadium, Inglewood, CA, February 13, 2022, photographer Kevin C. Cox. **OPPOSITE TOP RIGHT:** 50 Cent rehearses for the Super Bowl LVI halftime show at SoFi Stadium, Inglewood, CA, February 13, 2022, photographer Kevin Mazur. **OPPOSITE CENTER:** Kendrick Lamar performs during the Super Bowl LVI halftime show at the SoFi Stadium, Inglewood, CA, February 13, 2022, photographer Wally Skalij.

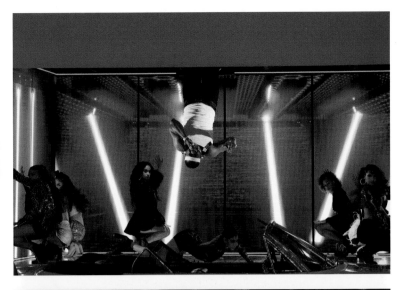

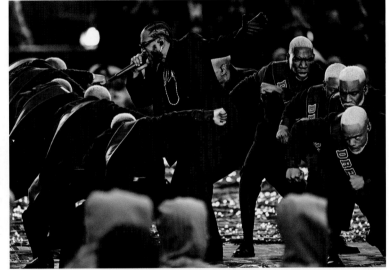

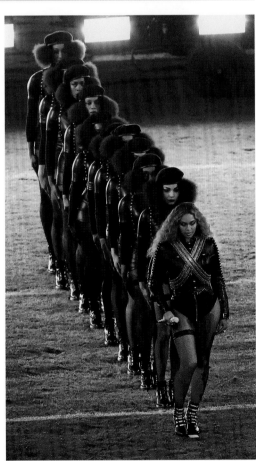

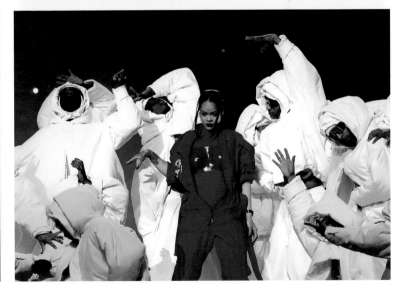

BOTTOM LEFT: Beyoncé performs during the Super Bowl 50 halftime show at Levi's Stadium, Santa Clara, CA, February 7, 2016, photographer Tony Avelar. **BOTTOM RIGHT:** Rihanna performs during the Super Bowl LVII halftime show at the State Farm Stadium, Glendale, AZ, February 12, 2023, photographer Kevin Mazur. **OVERLEAF:** (from left) Eminem, Kendrick Lamar, Dr. Dre, Mary J. Blige, 50 Cent, and Snoop Dogg perform during the Super Bowl LVI halftime show at the SoFi Stadium, Inglewood, CA, February 13, 2022, photographer Ronald Martinez.

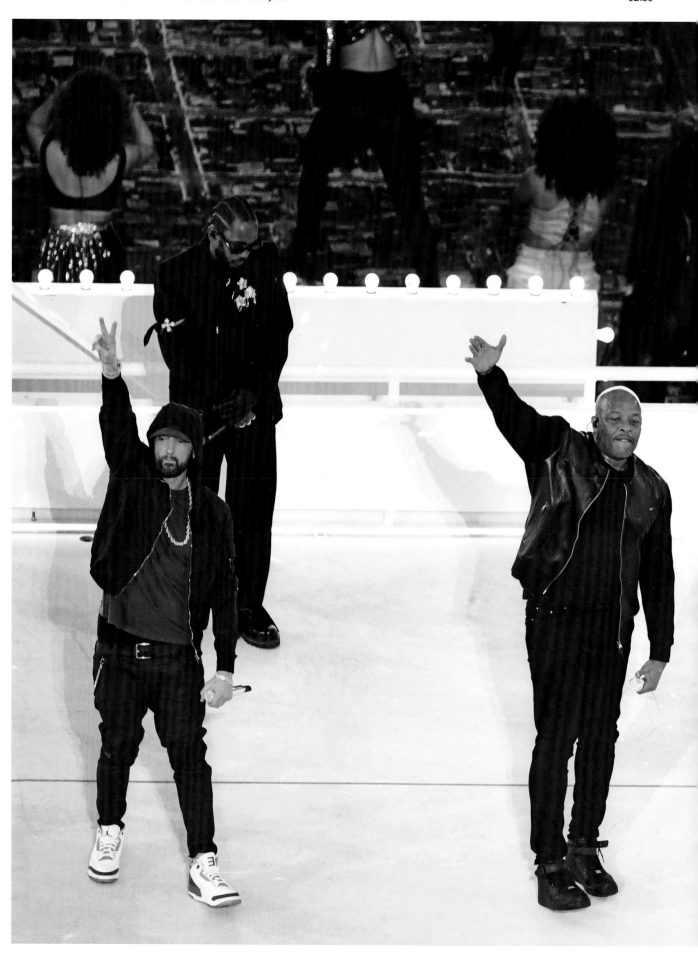

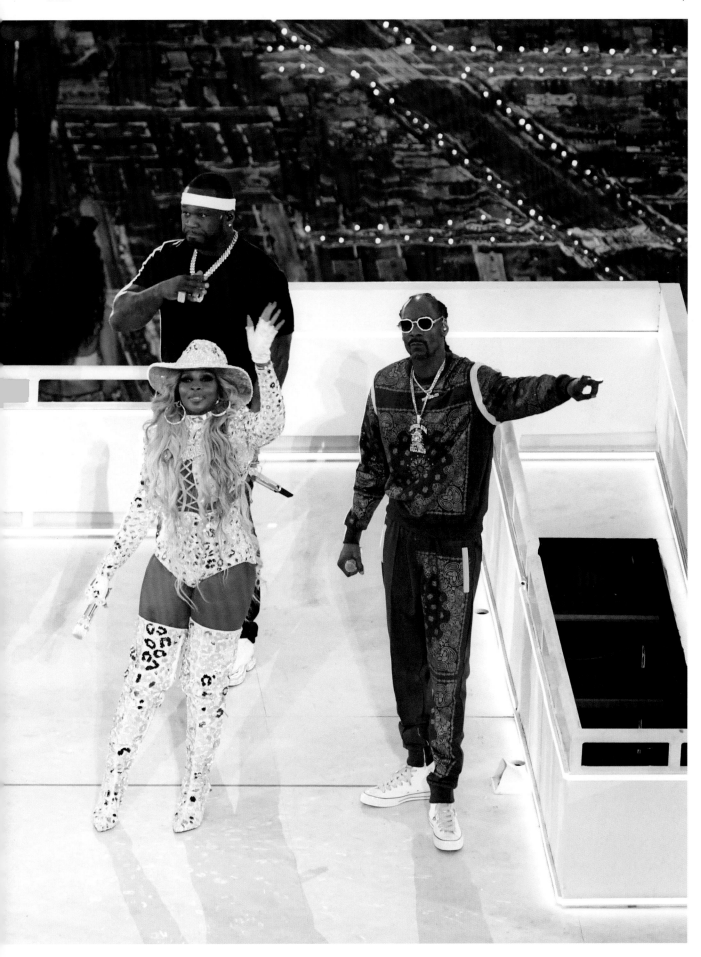

PICTURE CREDITS

T = top; B = bottom; L = left; R = right; C = center

4th & Broadway / Ron Contarsy / Records / Alamy 114 (TR); © A. Abbas / Magnum Photos 58 (BL), 58–59 (BC); © Nina Chanel Abney 270 (BR); © ADAGP, Paris and DACS, London 2023 52 (BR); © adidas 2022 264 (BL); Charlie Ahearn 78, 80–81; ALA, photographer Robert Wotherspoon 62–63 (BC); Robert Alexander / Getty Images 250; Alpha Stock / Alamy 207 (B); American International Pictures / Getty Images 44–45 (C); © 2023 The Andy Warhol Foundation for the Visual Arts, Inc. / Licensed by DACS, London 60 (BL); Andychi / Shutterstock 252 (T); Drew Angerer / Getty Images 255 (BR); AP Photo / Alamy 34 (TR), 192 (T); AP Photo / Alamy / Mike Fisher 189 (B); Greg Gibson 139 (B); Gerald Herbert 240 (B); Jae C. Hong 235 (T); Mark Lennihan 166 (TL); Bebeto Matthews 243 (BR); Dave Pickoff 92–93; Reed Saxon 139 (T); Nick Ut 125 (T); Sal Veder 32; Archive Photos / Getty Images 66 (B); Tony Avelar / EPA / Shutterstock 279 (BR); B+ for Mochilla 146 (BR), 175 (TR); Anthony Barboza / Getty Images 45 (TR); Cindy Barrymore / Shutterstock 275 (B); © Janette Beckman 129 (TR), 259; Janette Beckman / Getty Images 100–1 (BC), 106, 117 (B), 142 (B), 256; Bryan Bedder / Yeezy Season 4 / Getty Images 275 (T); Rachid Bellak / Abaca Press / Alamy 221 (B); Al Bello / Getty Images 249 (TR); Michael Benabib 148; Erica Berger / Newsday RM / Getty Images 142 (T); Alex Berliner / BEI / Shutterstock 180 (BL); Bettmann / Getty Images 35 (B), 46 (TL), 62 (B), 115 (T); Howard Bingham / TV Guide / Everett Collection 28–29 (C); Wil Blanche / Sports Illustrated / Getty Images 59 (BR); Courtesy of Blue Note Records under license from Universal Music Enterprises 184 (BL); Gregory Bojorquez / Getty Images 225 (BR); Raymond Boyd / Getty Images 143 (B), 144 (T), 158–9 (TC); Melvin Breeden and Marlon Rowe, owners Big Cat Records 224 (BL); Lindsay Brice / Getty Images 135 (B, TR); Drew Carolan 114 (TL), 115 (BL); Chris Carroll / Corbis / Getty Images 184 (T); Cash Money Records, artwork by Shawn Brauch of Pen & Pixel Graphics, Inc 157 (TR); CBW / Alamy 91 (B); Henry Chalfant 82–83; Stephanie Chernikowsk / Michael Ochs Archives / Getty Images 71 (BR); Josh Cheuse 91 (T), 98, 101 (TL); © 2022 Christie's Images Limited 22–23; © Chrysalis / EyeBrowz / Alamy 184 (BR); Cinq Records, photographer Kevin Knight 224 (TL); Barron Claiborne 170; Rich Clarkson / Sports Illustrated / Getty Images 108 (T); Timothy A. Clary / AFP / Getty Images 202 (BL); © Columbia Pictures / Everett Collection 60 (TL), 76 (TL); © Columbia Records / Ben Molyneux / Alamy 195 (T); Mike Coppola / Getty Images 262 (T); Mike Coppola / Mercedes-Benz Fashion Week / Getty Images 263 (T); Wyatt Counts 115 (BR); Kevin C. Cox / Getty Images 253 (T), 278 (C, B); Dan Cronin / NY Daily News Archive / Getty Images 26 (B); Courtesy of the Cross Colours Archive 178, 179, 182 (TR); Kevin Cummins / Getty Images 126; Lachlan Cunningham / Getty Images 260; Dapper Dan of Harlem 113, 257; Pietro D'Aprano / Getty Images 258; © Dan Wynn Archive and Farmani Group, Co LTD 25; Jonathan Daniel / Getty Images 248–9 (TC); Jonathan Daniel / Stringer / Getty Images 186; Clarence Davis / NY Daily News Archive / Getty Images 174 (T); Courtesy of Def Jam Recordings under license from Universal Music Enterprises 100 (BL); Vincent Desailly 227 (TR, BR); © Detroit Free Press / ZUMA Wire / Alamy 35 (TL); Courtesy of Es Devlin 278–9 (TC); Rick Diamond / Getty Images 157 (BR); © Disney / Moviestore Collection Ltd. / Alamy 167 (C); Carmine Donofrio / NY Daily News Archive / Getty Images 114 (B); Patrick Downs / Los Angeles Times / Getty Images 150 (L); Steve Eichner / Getty Images 153 (BR); Nabil Elderkin 230–1 (C); Electra Entertainment, photographer Kwaku Alston 147 (TL); Entertainment Pictures / Alamy 43 (BR); © Estate of Jean-Michel Basquiat. Licensed by Artestar, New York 84, 86 (TL, BL, BR); Everett Collection / Alamy 74; Illustration courtesy of Shepard Fairey / obeygiant.com 234 (T); © Guy Ferrandis / Gramercy Pictures / Alamy 110 (B); © FILA, photographer Blakeslee-Lane, Inc. 109 (BL); Flagg Bros. 45 (BR); J. Emilio Flores / Corbis / Getty Images 230 (BL); George Freston / Hulton Archive / Getty Images 66–67 (TC); GAB Archive / Redferns / Getty Images 57 (BL); Swan Gallet / WWD / Penske Media / Getty Images 267 (T); General Motors 43 (TR); Salwan Georges / Washington Post / Getty Images 254–5 (BC); © Bob Gomel 54; Bob Gomel / Getty Images 122–3 (TC); Granamour Weems Collection / Alamy 70 (TR); © Gravitas Ventures / Everett Collection / Alamy 203 (TR); Scott Gries / ImageDirect / Getty Images 159 (TR); Scott Gries / IMG / Getty Images 212 (T); Scott Gries / Getty Images 210; © Gucci 1984 109 (BR); Kyle Gustafson / Washington Post / Getty Images 271 (TR); © David Hammons, courtesy of the artist and Tilton Gallery, New York 30; © David Hammons, courtesy of the Museum of Modern Art, New York / Scala, Florence 120; © HBO / Landmark Media / Alamy 204, 205, 206–7; Sam Hellmann 264 (TR); Frederike Helwig 264 (TR); Paul Hoeffler / Redferns / Getty Images 185; Holloway House, courtesy of the Book Lady Bookstore, Georgia 45 (TL); Larry Hulst / Michael Ochs Archives / Getty Images 196 (B); i4images_music / Alamy 174 (BR); Eric Johnson / @upstairsaterics 146 (BL), 147 (TR), 174 (BL), 175 (TL), 194; Dimitrios Kambouris / Met Museum / Vogue / Getty Images 262 (BL); Art Kane, courtesy of and copyright © Art Kane Archive 182 (TL); Karl Kani 180 (TR); James Keivom / NY Daily News Archive / Getty Images 208;

© Vijya Kern, Basel, Switzerland – represented by Artstübli Gallery, Basel 85; Chandan Khanna / AFP / Getty Images 255 (T); © Kino Lorber / Everett Collection 38 (BR); Cam Kirk 225 (T); © Axel Koester / Corbis / Getty Images 130 (B), 131 (T); Peter Kramer / Getty Images 21; Antonin Kratochvil 218 (B); Jeff Kravitz / FilmMagic 230 / Getty Images (TR), 243 (T), 152–3 (TC); Johan Kugelberg hip hop collection, #8021. Division of Rare and Manuscript Collections, Cornell University Library 23 (BR); kwfourto / Shutterstock 252 (CL); Largo International NV / Getty Images 124 (T); © Alain Le Garsmeur. All rights reserved 2023 / Bridgeman Images 20 (T), 65; Warren K. Leffler and Thomas J. O'Halloran, Prints & Photographs Division, Library of Congress, ppmsca 04303 39 (L); © Annie Leibovitz 214–15; Lisa Leone 146 (T), 166 (B), 196 (T); Letterform Archive / © Emory Douglas / DACS 2023 36–37, 38 (TL); Andrew Lichtenstein / Corbis / Getty Images 175 (B); © Glenn Ligon, courtesy of the artist, Hauser & Wirth, New York, Regen Projects, Los Angeles, Thomas Dane Gallery, London, and Galerie Chantal Crousel, Paris, photographer Joshua White / JWPictures.com 77 (T), 77 (B); Belly, courtesy of Lions Gate Films, Inc. 167 (B); © Lionsgate / Photo12 / pandora Filmproduktion / Alamy 167 (CR); © LMPC / Getty Images 24 (BR), 40, 46 (BR), 50 (BL); Catherine McGann / Getty Images 159 (BL); Erik McGregor / LightRocket / Getty Images 253 (B); Richard Mackson / Sports Illustrated / Getty Images 189 (T); David McNew / Online USA / Getty Images 203 (BR); © Alex Majoli / Magnum Photos 266, 267 (B); Jonathan Mannion 154; Larry Marano / Getty Images 234 (B); Ronald Martinez / Getty Images 276, 280–1; Hector Mata / AFP / Getty Images 195 (B); Kevin Mazur / Roc Nation / Getty Images 279 (TR, BR); Kevin Mazur / Sean Combs / Getty Images 271 (BR); Kevin Mazur / Universal Music Group / Getty Images 272; Courtesy of Mercedes-Benz AG 264–5 (BC); Dave Meyers 268; © MGM / Lifestyle Pictures / Alamy 52 (T); © MGM / LMPC / Getty Images 24 (BL); Frank Micelotta / Getty Images 231 (TR); Michael Ochs Archives / Getty Images 47 (B), 48, 52 (BL), 53 (TL), 53 (B), 117 (T); Manny Millan / Sports Illustrated / Getty Images 61 (BR), 192 (TR); Mike Miller Photo 151, 152 (BL), 176, 177 (T); Movie Poster Image Art / Getty Images 44 (TR), 124 (B); Moviestore Collection Ltd / Alamy 67 (b), 137 (TL, B), 202–3 (BC); Permission of Ms. magazine, © 1975 24 (TL); © MTV / Everett Collection 116; The Museum of Contemporary Art, Los Angeles. Gift of the artist 244–5; Bill Nation / Sygma / Getty Images 96; The National Archives and Records Administration 123 (B); National Museum of American History, Smithsonian Institution, Division of Political and Military History 35 (T); Paul Natkin / Getty Images 158 (TL); Copyright NBAE 2013, photographer David Alvarez / Getty Images 249 (B); Copyright 2019 NBAE, photographer Zach Beeker / Getty Images 263 (BR); Copyright 1985 NBAE, photographer Andrew D. Bernstein / Getty Images 102; Copyright 2021 NBAE, photographer Nathaniel S. Butler / Getty Images 263 (BL, BC); Copyright 1997 NBAE, photographer Lou Capozzola / Getty Images 190–1; Copyright 1974 NBAE, photographer Jim Cummins / Getty Images 60–61 (C); Copyright 2019 NBAE, photographer Logan Riely / Getty Images 242 (T); © New Line Cinema / Everett Collection 173; © New York Beat Films LLC by the permission of the Estate of Jean-Michel Basquiat, photographer Edo Bertoglio 86–87 (TC), 88; Newsweek, 1992 138; Mandel Ngan / AFP / Getty Images 241 (B); © Nike, Inc 104, 105 (BL), 108 (BR), 192 (BL), 265 (BR); © Nike, Inc., 2023 courtesy of Sotheby's 265 (TR); No Limit Records, artwork by Shawn Brauch of Pen & Pixel Graphics, Inc 157 (TL); Johnny Nunez / WireImage / Getty Images 181 (TL); Joseph Okpako / WireImage / Getty Images 265 (TL); oksubu / Shutterstock 252 (CR); Estevan Oriol 153–4 (BC); Estevan Oriol / PYMCA / Avalon / Getty Images 131 (B); Eddie Otchere 162 (B), 163 (B), 197, 216; Ernie Paniccioli 100 (TL), 112, 144–5; Don Paulsen / Michael Ochs Archives / Getty Images 68; © Paramount Pictures / Alamy 76 (TR); © Paramount Pictures / Collection Christophel / Alamy 76 (B); © Paramount Pictures / Steve Schapiro / Corbis / Getty Images 44 (BL); Gordon Parks, courtesy of and copyright © The Gordon Parks Foundation 26 (T), 182 (BL); Yana Paskova 270–1 (BC); Penguin Random House LLC 122 (B); Doug Pensinger / Allsport / Getty Images 193; Al Pereira / Michael Ochs Archives / Getty Images 88, 100 (TR), 101 (BR), 128–9 (TC), 140, 147 (B), 162 (T), 163 (TL, TR), 177 (B); Keith Perrin, courtesy of the Queens Memory Collection at the Archives at Queens Library 180–1 (BC); Jan Persson / Redferns 51, 51–52 (T); Photo 12 / Alamy 218 (T); Pictorial Press Ltd / Alamy 71 (BL); © Polydor / Records / Alamy 46 (BL); J.D. Pooley / Getty Images 248 (B); Priority Records, photographer Mario Castellanos 128 (BL); Professional Sport / Popperfoto / Getty Images 109 (T); Susan C. Ragan (American, born 1947). Straight Outta Compton. Color coupler print, sheet: 11 × 14 in. (27.9 × 35.6 cm). Brooklyn Museum, Gift of the artist, 1992.256.4. © artist or artist's estate 152 (TL); Rap-A-Lot Records 156 (T); Aaron Rapoport / Corbis / Getty Images 132; Bill Ray / The LIFE Picture Collection / Shutterstock 58 (TR), 58–59 (TC), 59 (BR); Records / Alamy 29 (CR), 46 (TR), 51 (BL), 53 (TR), 57 (TR), 160; Ken Regan / NBAE / Getty Images 62 (TL); Ken Regan / Camera 5 94; Reuters / Jonathan Ernst 240–1 (TC); Luiz C. Ribeiro / NY Daily News Archive / Getty Images 274 (TR); Vaughn Ridley / Getty Images 242; Astrid Riecken 232, 235 (B), 254 (TL); Ebet Roberts / Getty Images 156–7 (BC);

Joseph Rodriguez / Gallery Stock 203 (CR); Mel Rosenthal, courtesy of the Museum of the City of New York 20 (B); Mario Ruiz / Getty Images 125 (B); Ruthless Records, photographers David Provost and Peter Dokus 128 (TL); Joe Scarnici / WireImage / Getty Images 221 (T); Steve Schapiro / Corbis / Getty Images 66 (TL); Joe Schildhorn / Patrick McMullan / Getty Images 230 (TL); Michael Schmeling 224 (TR), 224–5 (BC), 226, 227 (TL, BL); Martin Schoeller / AUGUST 219 (B), 220; ScreenProd / Photononstop / Alamy 202 (TL); © Sean John, photographer Michael Benabib 213; © Sean John, photographer Randee St. Nicholas 212 (B); Robert Abbott Sengstacke / Getty Images 123 (TR); Jamel Shabazz 99; John Shearer / The LIFE Picture Collection / Shutterstock 58 (TL); © Shoes in the Bed Productions / Everett Collection 28 (TL); SIPA / Shutterstock 211; Wally Skalij / Los Angeles Times / Getty Images 246; Collection of the Smithsonian National Museum of African American History and Culture 28 (BR), 34 (BL), 108 (BL); Gift of Andrew Breitbart and Michael Silver 34 (TL); Gift of T. Rasul Murray 39 (CR); Gift of Elaine Nichols 29 (BR); © The Regents of the University of California. Courtesy of Special Collections, University Library, University of California, Santa Cruz. Ruth-Marion Baruch and Pirkle Jones Photographs 38 (TR); Courtesy of SneakerFreaker 61 (BR), 62–63 (TC), 63 (R); Sony Music Entertainment 165; Sony Music Entertainment, photographer Danny Clinch 166–7 (TC); Sony Music Entertainment, photographer Don Hunstein 57 (TL); Ted Soqui © 1992 134 (B), 135 (TL), 136; © 1996 SoSouth Music Distribution, photographer Demo Sherman 158–9 (BC); Soul Train / Getty Images 28 (CL), 29 (T), 50 (TL), 70 (B), 71 (T); The Source magazine 238; The Source magazine, photographer Shawn Mortensen 129 (BR); Bill Stahl Jr. / NY Daily News Archive / Getty Images 64; Steve Starr / Corbis / Getty Images 130 (T); Thirstin Howl The 3rd Archives 180 (TL); Tommy Boy Records, photographer Bart Everly 101 (TR); Tommy Ton 231 (BR); Top Dawg Entertainment, photographers Denis Rouvre and Roberto "Retone" Reyes 243 (BL); trekandshoot / Alamy Stock Photo 128–9 (BC); Trunk Archive, artwork by Kehinde Wiley, courtesy of Sean Kelly, New York, photographer Jason Schmidt 270–1 (TC); United Archives GmbH / Alamy 137 (TR), 219 (T); © Universal Music Group / David Lichtneker / Alamy 50 (BR); © Universal Music Group / Records / Alamy 150 (TL); Universal Pictures / © 40 Acres & a Mule Filmworks / Alamy 105 (T, BR); © Universal Pictures / ScreenProd / Photononstop / Alamy 110 (T); Courtesy of the University of Houston Libraries 158 (BL); USC Digital Library. Independent Commission on the LAPD, 1991 Collection (https://creativecommons.org/licenses/by/4.0/) 134 (T); Camilo José Vergara 18; Installation view of Kara Walker, A Subtlety, or the Marvelous Sugar Baby, an Homage to the unpaid and overworked Artisans who have refined our Sweet tastes from the cane fields to the Kitchens of the New World on the Occasion of the demolition of the Domino Sugar Refining Plant, Domino Sugar Refinery, A project of Creative Time, Brooklyn, NY, 2014. Polystyrene foam, sugar, approx. 35½ × 26 × 75½ feet (10.8 × 7.9 × 23 m). Artwork © Kara Walker, courtesy of Sikkema Jenkins & Co. and Sprüth Magers, photographer Jason Wyche 270 (TL); Installation view of Kara Walker, Slavery! Slavery! Presenting a GRAND and LIFELIKE Panoramic Journey into Picturesque Southern Slavery or "Life at 'Ol' Virginny's Hole' (sketches from Plantation Life)." See the Peculiar Institution as never before! All cut from black paper by the adept hand of Kara Elizabeth Walker, an Emancipated Negress and leader in her Cause, 1997, from Kara Walker: My Complement, My Enemy, My Oppressor, My Love, Hammer Museum, Los Angeles, CA, 2008. Cut paper and adhesive on wall, 11 × 85 feet (3.4 × 25.9 m). Artwork © Kara Walker, courtesy of Sikkema Jenkins & Co. and Sprüth Magers, photographer Joshua White 270 (CL); Wallace Terry Archive, New York Public Library 31; Theo Wargo / adidas / Getty Images 274 (BR); Theo Wargo / WireImage / Getty Images 229; © Warner Bros. / Alamy 43 (TL), 200; © Warner Bros. / Everett Collection / Alamy 202–3 (TC); © Warner Bros. / John Kisch Archive / Getty Images 47 (T); © Warner Bros. / LMPC / Getty Images 67 (TR); © Alex Webb / Magnum Photos 44 (TL); Theo Westenberger / Sports Illustrated / Getty Images 103; White House Photo / Alamy 241 (T); © Xenon Entertainment / Everett Collection / Alamy 159 (BL); © Yeah, Inc. / Collection Christophel / Alamy 43 (BL); David Yellen / Corbis / Getty Images 222; Michael Zagaris / San Francisco 49ers / Getty Images 252 (B); Sean Zanni / Patrick McMullan / Getty Images 262 (BR); Zig-Zag 150 (TR).

Every reasonable effort has been made to acknowledge the ownership of copyright for photographs included in this volume. Any errors that may have occurred are inadvertent and will be corrected in subsequent editions provided notification is sent in writing to the publisher.

WORKS CITED

Introduction: Thinkin' of a Master Plan

6 Eric B. and Rakim, "Paid in Full," *Paid in Full*, 4th & Broadway, 1987
7 Wu-Tang Clan, "Protect Ya Neck (The Jump Off),"
 The W, Columbia Records/Loud Records, 2000
 Big Daddy Kane, "Smooth Operator," *It's A Big Daddy Thing*, Cold Chillin', 1989
8 Public Enemy, "Fight the Power," Motown, single, 1989
 Eric B. & Rakim, "I Ain't No Joke" and "I Know You Got Soul,"
 Paid in Full, 4th & Broadway, 1987
 Terror Squad, "Lean Back," *True Story*, Street Records Corporation/
 Universal Music Group, 2004
 Public Enemy, "Rebel Without a Pause," *It Takes a Nation of Millions
 to Hold Us Back*, Def Jam, 1988
10 Nas, "The Last Real Nigga Alive," *God's Son*, Columbia Records, 2002
 Notorious B.I.G., "Juicy," *Ready to Die*, Bad Boy Entertainment, 1994
 The Game, "Dreams," *The Documentary*, Aftermath Entertainment/G-Unit/
 Interscope Records/Czar Entertainment, 2005
 Rick Ross, "Mafia Music," *Deeper Than Rap*, Maybach Music Group/
 Slip-N-Slide Records/Def Jam, 2009
 Kendrick Lamar, "Backseat Freestyle," *good kid, m.A.A.d. city*,
 Top Dawg Entertainment/Aftermath Entertainment/Interscope Records, 2012
 Meek Mill, "Dreams and Nightmares (Intro)," *Dreams and Nightmares*,
 Maybach Music Group/Warner Bros. Records, 2012
11 The Last Poets, "When the Revolution Comes," *The Last Poets*,
 Douglas Records, 1970
13 Slum Village, "Fall in Love," *Fantastic, Vol. 2*, Good Vibe Recordings, 2000
 Nas, "Life's a Bitch" and "The World Is Yours," *Illmatic*, Columbia Records, 1994
 Nas, "Hate Me Now," *I Am...*, Columbia Records, 1999
14 Makaveli (2Pac), "Hail Mary," *The Don Killuminati: The 7 Day Theory*,
 Death Row Records/Interscope Records, 1996

Right on for the Darkness: The 1970s

65 Grandmaster Flash and the Furious Five, "New York New York,"
 The Message, Sugar Hill Records, 1982
69 Sugarhill Gang, "Rapper's Delight," Sugar Hill Records, single, 1979

How You Like Me Now?: The 1980s

79 Blondie, "Rapture," *Autoamerican*, Chrysalis, 1980
85 N.W.A., "Fuck tha Police," *Straight Outta Compton*, Ruthless Records/
 Priority Records, 1988
89 Jay-Z, "Blue Magic," *American Gangster*, Roc-A-Fella Records, 2007
90 Gil Scott-Heron, "B Movie," *Reflections*, Arista, 1981
 Grandmaster Flash and the Furious Five, "The Message," *The Message*,
 Sugar Hill Records, 1982
 Afrika Bambaataa and the Soul Sonic Force, "Planet Rock,"
 Tommy Boy Records, single, 1982
 The Last Poets, "When the Revolution Comes," *The Last Poets*,
 Douglas Records, 1970
95 Run-D.M.C., "It's Like That," Profile Records, single, 1983
97 Doug E. Fresh and the Get Fresh Crew, "La-Di-Da-Di," *The Show/La-Di-Da-Di*,
 Reality Records, 1985
 Run-D.M.C., "Rock Box," *Run-D.M.C.*, Profile Records, 1984
 Run-D.M.C., "My Adidas," *Raising Hell*, Profile Records, 1986

It Was All a Dream: The 1990s

118 Notorious B.I.G., "Juicy," *Ready to Die*, Bad Boy Entertainment, 1994
139 2Pac, "How Do U Want It," *All Eyez On Me*, Death Row Records/
 Interscope Records, 1996
122 Public Enemy, "Fight the Power," Motown, single, 1989
156 OutKast, "Player's Ball," LaFace Records/Arista, single, 1993
171 Notorious B.I.G., "Juicy"
 Lil' Kim, "Big Momma Thang," *Hard Core*, Undeas Entertainment/
 Big Beat Records/Atlantic Records, 1996
172 Jay-Z, "Where I'm From," *In My Lifetime, Vol. 1*, Roc-A-Fella Records, 1997
183 A Tribe Called Quest, "Verses From the Abstract," *The Low End Theory*,
 Jive Records, 1991
187 Notorious B.I.G., "Things Done Changed," *Ready to Die*, Bad Boy Entertainment, 1994
 Jay-Z, "Hova Song (Intro)," *Vol. 3... Life and Times of S. Carter*,
 Roc-A-Fella Records/Def Jam, 1999
195 Lauryn Hill, "Lost Ones," *The Miseducation of Lauryn Hill*, Columbia Records, 1998

What More Can I Say?: The 2000s

201 Mos Def, "Hip Hop," *Black on Both Sides*, Rawkus Records, 1999
211 P. Diddy & The Bad Boy Family, "Bad Boy for Life," *The Saga Continues*,
 Bad Boy Records, 2001
217 Jay-Z, "A Ballad for the Fallen Soldier," *The Blueprint² The Gift & The Curse*,
 Roc-A-Fella Records, 2002
 Jay-Z, "What More Can I Say," *The Black Album*, Roc-A-Fella Records, 2003
233 Jay-Z, "What We Talkin' About," *The Blueprint 3*, Roc Nation, 2009
 Jay-Z, "Dirt Off Your Shoulder," *The Black Album*, Roc-A-Fella Records, 2003
234 Young Jeezy, "My President," *The Recession*, Def Jam, 2008
 Jay-Z, "What We Talkin' About"
 Jay-Z, "Come and Get Me," *Vol. 3... Life and Times of S. Carter*,
 Roc-A-Fella Records/Def Jam, 1999

Started From the Bottom, Now We're Here: The 2010s & Beyond

236 Drake, "Started From the Bottom," *Nothing Was the Same*, Cash Money Records/
 Republic Records, 2013
239 Drake, "Started From the Bottom"
247 OutKast, "Peaches (Intro)," *Southernplayalisticadillacmuzik*, LaFace Records, 1994
261 Cardi B, feat. Migos, "Drip," *Invasion of Privacy*, Atlantic Records/KSR Group, 2018
 Jay-Z, "Tom Ford," *Magna Carta... Holy Grail*, Roc-A-Fella Records/Roc Nation, 2013
 Future, "Thought It Was a Drought," *DS2*, Epic Records/A1 Recordings/
 Freebandz, 2015
273 Kanye West, "All Falls Down," *The College Dropout*, Roc-A-Fella Records, 2004
 Notorious B.I.G., "Juicy," *Ready to Die*, Bad Boy Entertainment, 1994
274 Kanye West, "Runaway," *My Beautiful Dark Twisted Fantasy*,
 Roc-A-Fella Records, 2010
277 2Pac, "California Love," Death Row Records/Interscope Records, single, 1995
278 Jay-Z, "Come and Get Me," *Vol. 3... Life and Times of S. Carter*,
 Roc-A-Fella Records/Def Jam, 1999

Phaidon Press Limited
2 Cooperage Yard
London E15 2QR

Phaidon Press Inc.
111 Broadway
New York, NY 10006

phaidon.com

First published 2024
© 2024 Phaidon Press Limited

ISBN 978 1 83866 622 4

Commissioning Editor: Deb Aaronson
Project Editor: Robyn Taylor
Research Assistant: Tiana Alexandria Williams
Production Controller: Adela Cory
Design: 12:01—Office of Hassan Rahim

Printed in China

Author's Acknowledgments

I have thoroughly appreciated the opportunity to lay out my creative vision in this book. With this in mind, I would like to acknowledge several people, whose guidance and substantial support helped to make it all possible. To begin, I would like to thank Deborah "Deb" Aaronson of Phaidon for initially reaching out to me to discuss the series of ideas that eventually grew into *Rapper's Deluxe*. Our conversations about fashion, art, and culture, among other cool topics, were informative and inspiring. Thank you for recognizing the game in me, for appreciating my style, and for having confidence in my abilities. I would also like to thank Robyn Taylor, the book's editor. Your overall editorial input has been especially helpful and greatly appreciated as we have moved through the multiple phases of this project. Thank you for helping me to execute my vision. Another thank you goes out to my assistant on this book, Tiana Williams. Your dedicated efforts and assistance certainly helped to bring this project to life. A special shout out goes to Hassan Rahim and his "anti-disciplinary creative studio" 12:01 for the book's impressive overall visual design. Team work makes the dream work, as they say. Thank you all.

Editor's Acknowledgments

The editor would first and foremost like to thank Dr. Todd Boyd for his passion, insight, vast knowledge, steadfast commitment, and patience during the making of this book. This particular and personal story could not have been written by anyone else, and it has been an absolute honor to work with you on it. Special thanks also to Hassan Rahim, Natalie Kelapire, and Bryan Chu at 12:01 agency for realizing the perfect design for this most important of subjects, and for going above and beyond in order to get it right; Tiana Williams for your detailed and rigorous work; Rosie Pickles, Felicity Shaw, and Jen Veall for your herculean efforts on the picture research; to all the artists, photographers, institutions, and organizations who have so generously provided such iconic imagery to document this monumental movement; as well as Adela Cory, Robert Davies, Julia Hasting, Linda Lee, João Mota, Mitra Parineh, Joe Pickard, Phoebe Stephenson, and Pilar Wyman for their invaluable contributions.